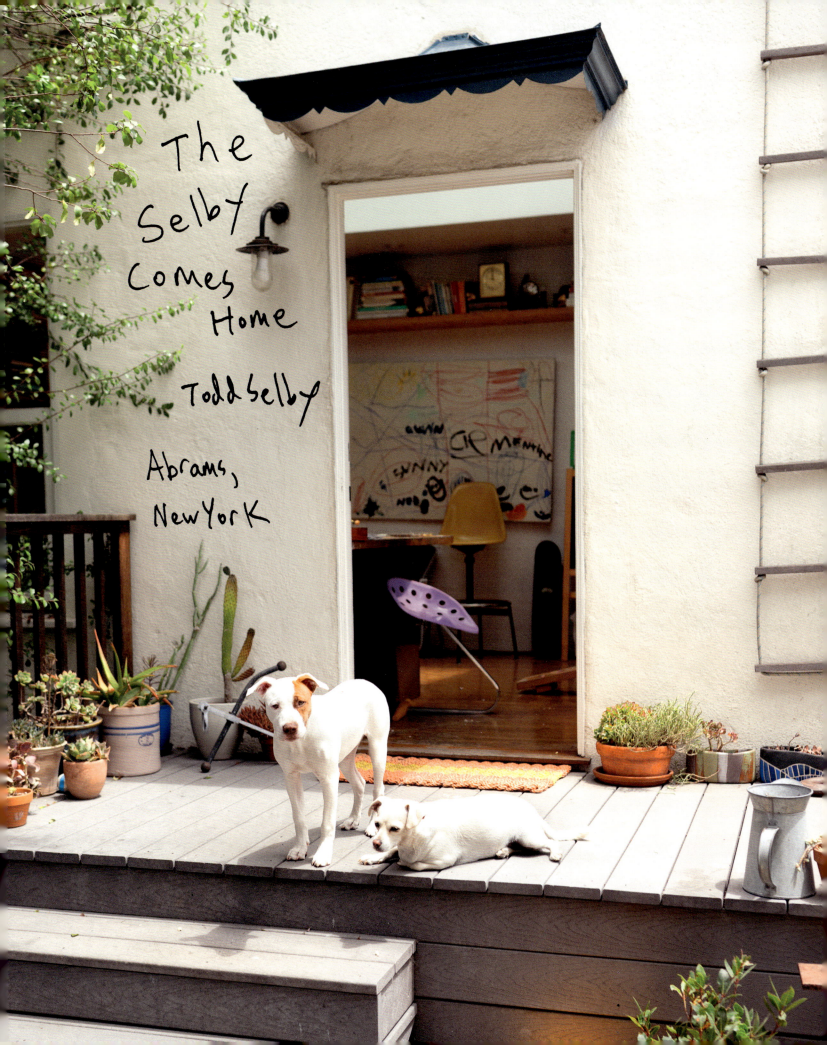

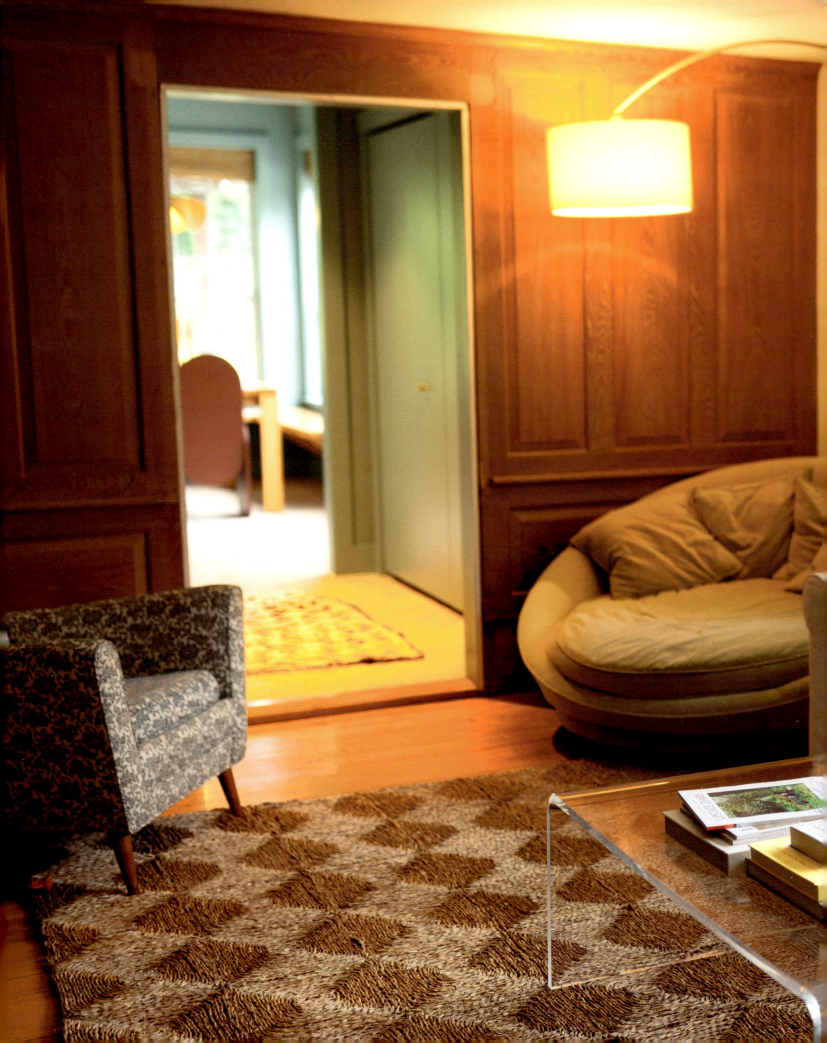

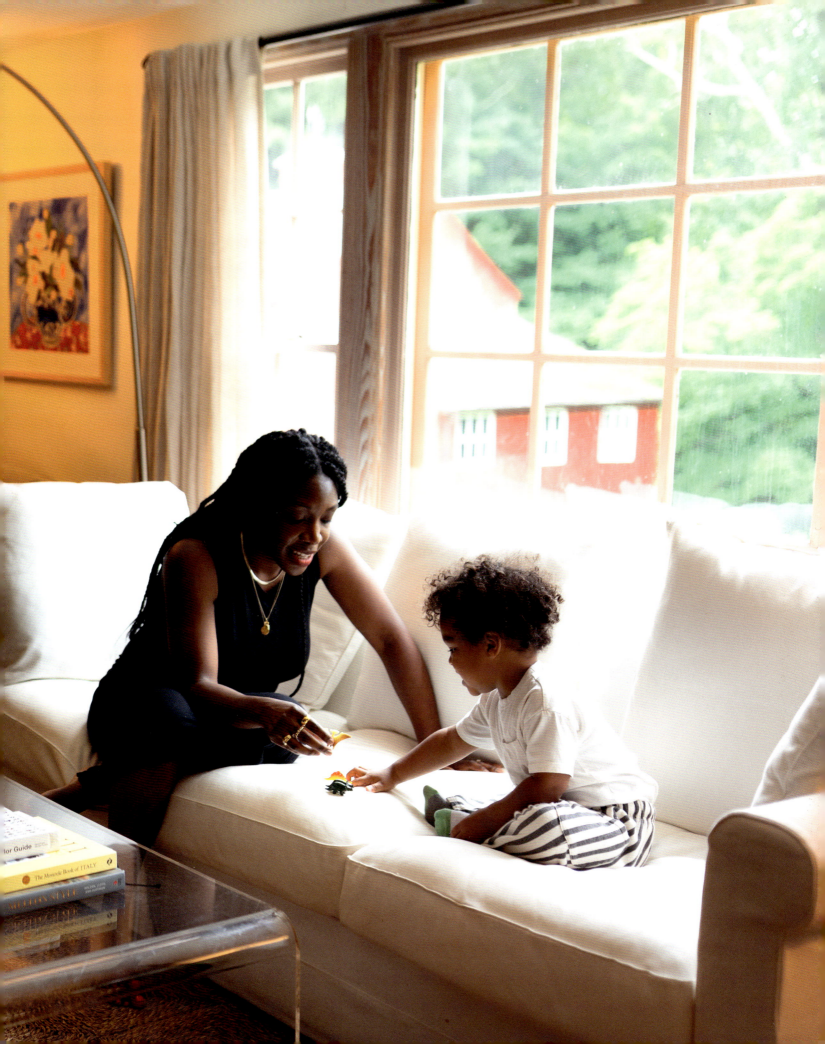

CONTENTS

Introduction
8

Benji Wagner & Nahanni Arntzen with Olive, Azriel & Sparrow
12

Lissy & Rudi Robinson-Cole with Jamie, Jazmin, Ross, Christian & Mia
20

Isabelle Tuchband with Max
28

Kanako & Yusuke Shibata with Tomoya & Hona
34

Joseph & Morgan Leary with River
40

Maurice & Robin Ayers-Lee with Theo & Vivien
48

Caroline Rodrigues with Milo
54

Bérénice Eveno & Serban Ionescu with Zélie & Azure
62

Jason Kreher & Eirik Anderson with Rex & Tennessee
70

Chanelle & Ben Kalfas with Felix
150

Ashley Torrance & Gyasi with Juliette, Olivia & Estella
156

Amanda & Christopher Brooks with Coco & Zach
164

Vadis Turner & Clay Ezell with Gray & Vreeland
172

Nikki Fenix with True & Brave
184

Eric Ross & Katherine Lincoln with Clay & Julian
192

Prem & Puneet Kumta with Sabina, Rajan & Ishaan
180

Maya Mori & Micah Kassell with Ethan, Aidan, Frankie & Coco
200

Serena Mitnik-Miller with Wild & Una Faye Moon
206

Kyohei & Mikiko Ogawa with Sena, Kouki & Yuka
216

Bryan & Megan Edwards with Arlo Rey & Max Wylder
224

AN INTRODUCTION ABOUT A HAT ON A LAMP

by Todd Selby

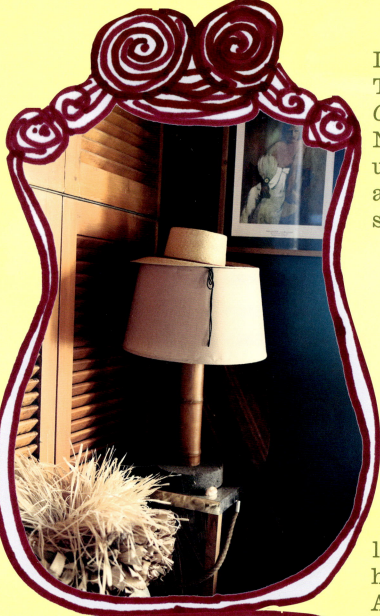

Nicolas Malleville's lamp with hat from 2023

IT'S EASTER SUNDAY, 2023. The last shoot day for *The Selby Comes Home* at Francesca and Nico's house in Bora Bora. I wake up with my daughter Simone, and we sneak out to watch the sunrise over the dock.

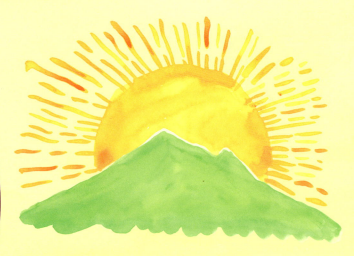

I photograph down the length of the dock, toward the sun hiding behind Mount Otemanu. A perfect blue-sky morning.

Simone has never been interested in photography or my big camera. I've asked her before, "What does your dad do?" Shrug. No interest. But now she's

The Selby Comes Home

looking at the camera like she's noticed it for the first time.

We walk back to the house for breakfast and I show her how to focus the lens. I point the camera at Nico's lamp with the hat on it. Simone focuses and clicks the shutter. I pull up the image on the back of my camera and feel a bolt of lightning jolt through me. I start crying.

Because it brings me back to the moment when I first got the idea for *The Selby*. It was 2007 in Tom Wolfe's apartment in the Upper East Side of New York. On the desk in his study, he had a lamp with a hat on top of it. I was fascinated by that lamp. It said something about him that words could not describe. My portrait of Tom Wolfe was okay. But my photograph of Tom Wolfe's lamp was spectacular. At least to me. I realized that people's spaces and possessions have stories to tell, and all of my books can be traced back to this moment.

Now I've come full circle. It's the last day of shooting for my fourth book, and my younger daughter has taken her first-ever photo—of a hat on a lamp.

Our younger daughter, Simone, Oaring a crab

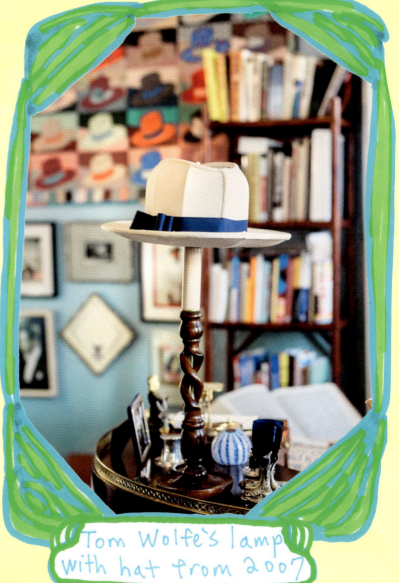

Tom Wolfe's lamp with hat from 2007

Simone: Why were you crying?

Todd: Because it was so emotional. It's hard for Daddy to explain, but seeing your photo felt like a Moment in my life.

Danielle: That's so special. That's the intro to your book.

Nico: That's beautiful.

Todd: Yeah. It's the beginning and the ending.

Francesca: Simone, you want to have your pancake?

Simone: Yes.

Todd: Love you, honey. Can I have a kiss?

Simone: Yes.

Todd: Thank you, Simone. Love you. Sit here. Have your pancake.

Francesca: Very nice.

Nico: Very beautiful, buddy.

Simone: Where's the honey?

Nico: I'm sorry. I threw the honey away because a gecko got inside and peed and it looked like an explosion.

Todd: The gecko did an explosion. That's the most disgusting thing I've ever heard.

Simone: The gecko's in the honey?

Todd: The gecko went crawling, went pee-pee, and did an explosion.

Simone: Geckos are bad.

Todd: No, they're not bad. They're just bad to have in your honey.

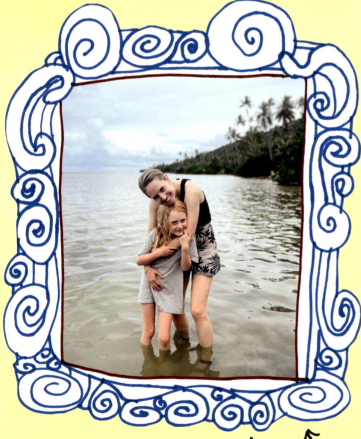

My wife, Danielle, and our elder daughter, Ella

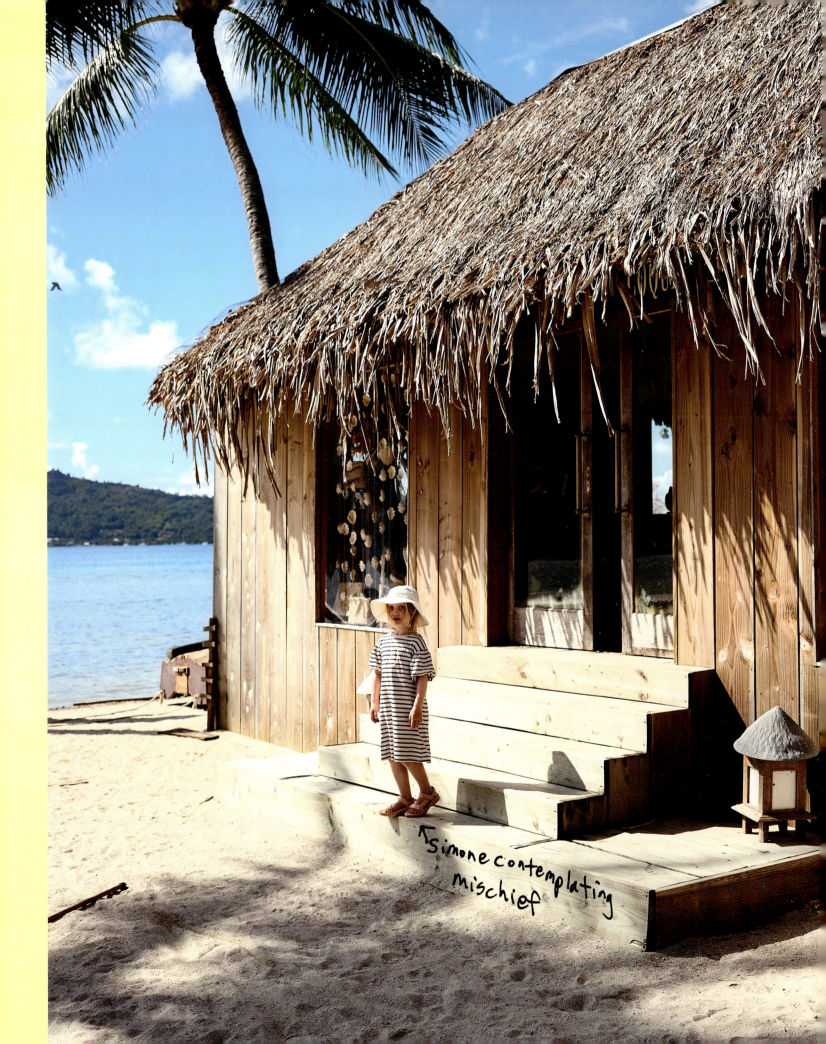
Simone contemplating mischief

BENJI WAGNER & NAHANNI ARNTZEN
with Olive, Azriel & Sparrow in Washougal

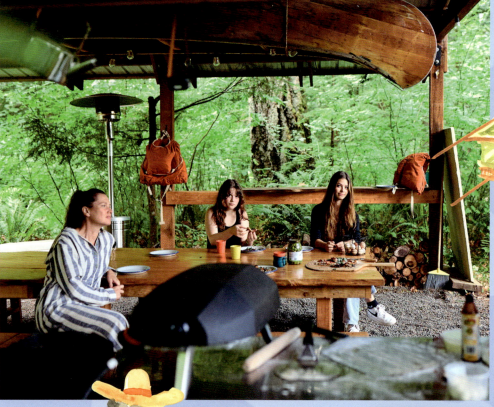

"Having a place that's rooted in the natural world, and connecting them to animals and to the river, is super important to us."

"Having a space where you're not being completely monitored all the time is rare," says Nahanni Wagner, who was born in a tepee at a tree planting camp in British Columbia. "I wanted to give our kids some idea of the freedom that I experienced when I was a child." Her early experiences helped inspire this twenty-acre wilderness retreat outside of Portland. The property sports a chic rustic cabin full of mid-century flourishes, a swimming hole, ceramics workshop, open-air kitchen, guest tent, and spaceship bubble sauna. It is also home to a dozen ducks, two dozen chickens, four dogs, and four donkeys. "The chance to be rooted in nature, to the animals and to the river—it's super important to us and we are really grateful," says Benji.

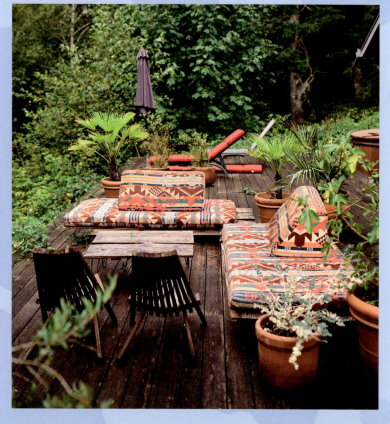

"Two donkeys became three donkeys, and one needed a friend, so it became four."

Legendary outhouse with a mossy view of the river →

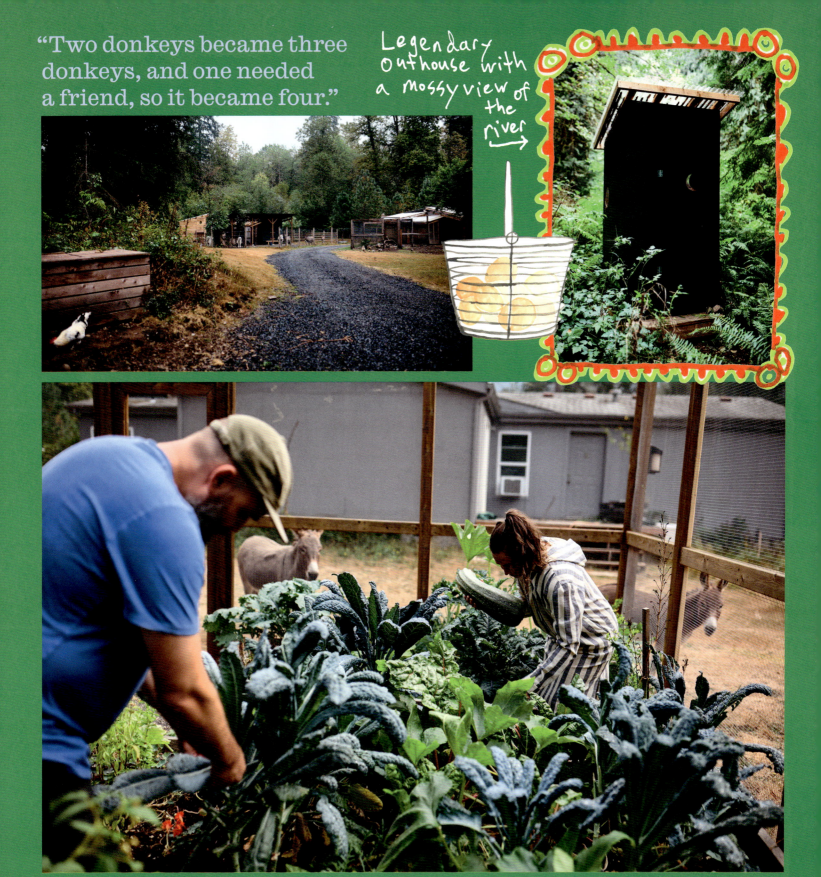

"I was reading recently that a hundred years ago, 40 percent of all the food in the country came from small home gardens, and now it's 0.1 percent. So, if everyone had a garden of that size, which is really not that big, it would really change our entire food system and economy."

Strawberry didn't really want to come inside, but we bribed him with treats.

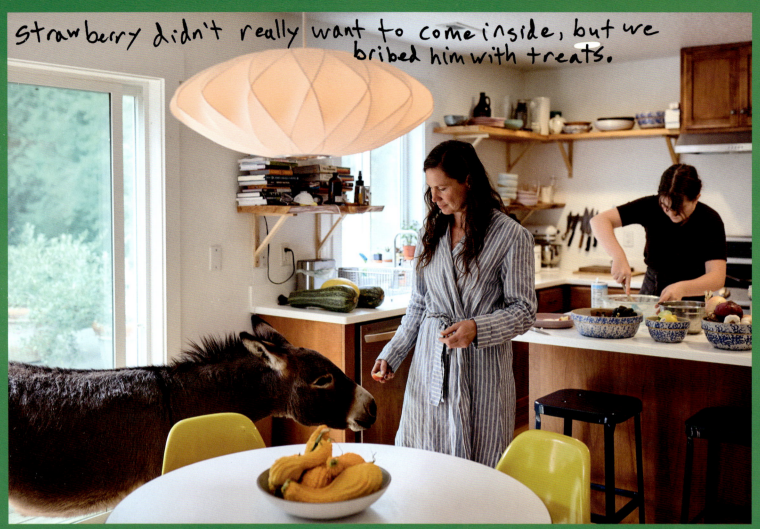

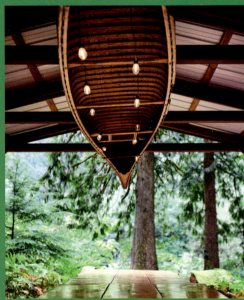

"The chandelier is a no-longer-seaworthy handmade canoe."

"Strawberry doesn't really know if he's a donkey, or a dog, or a human."

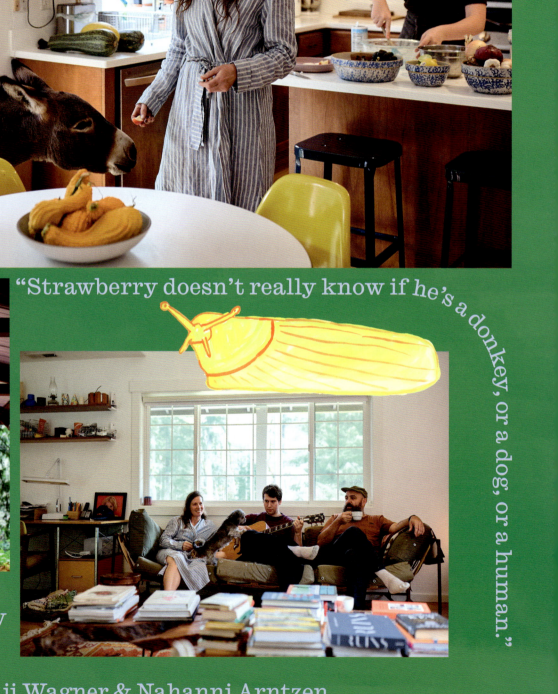

Benji Wagner & Nahanni Arntzen
with Olive, Azriel & Sparrow

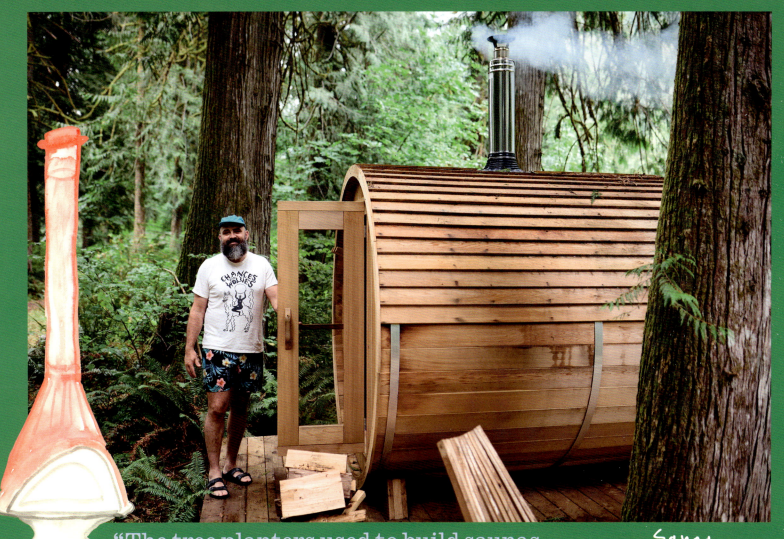

"The tree planters used to build saunas, because that was the only way to get warm enough to jump into really cold water to get clean."

Sauna with river view 2

Nahanni's design studio.

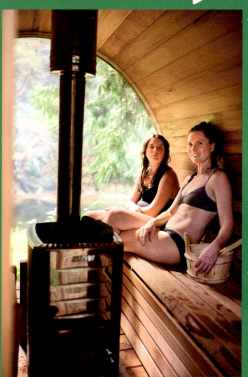

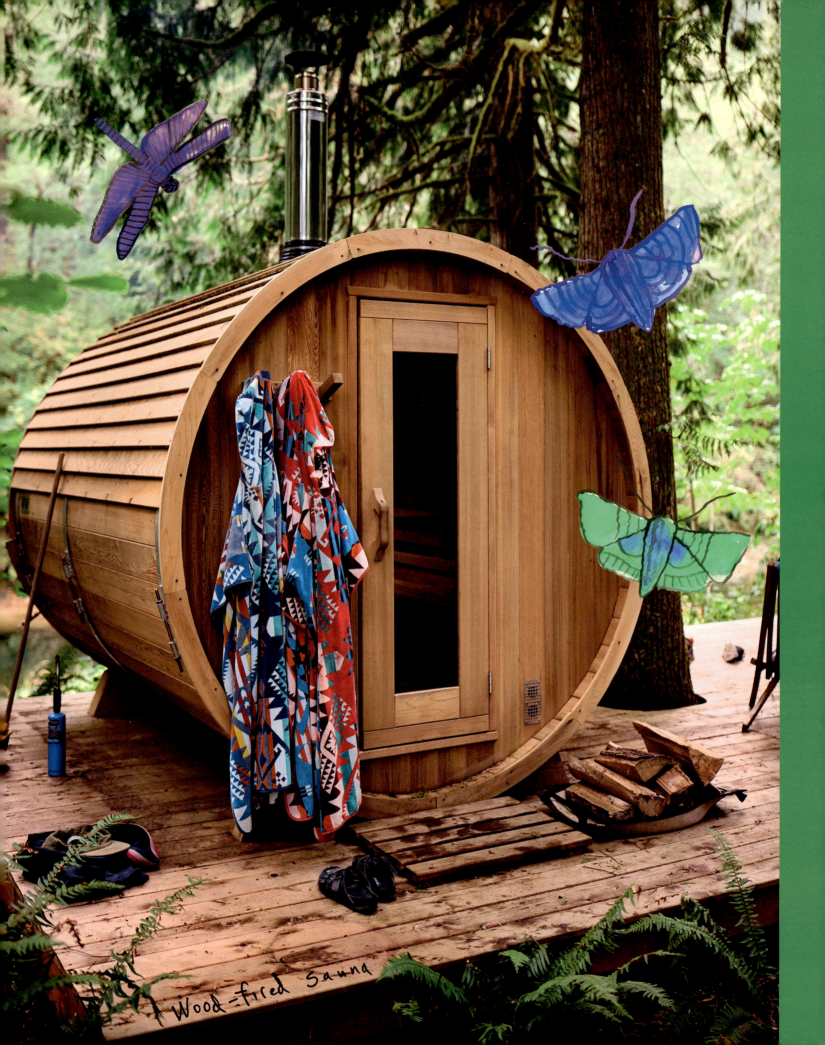
Wood-fired Sauna

strawberry snacking

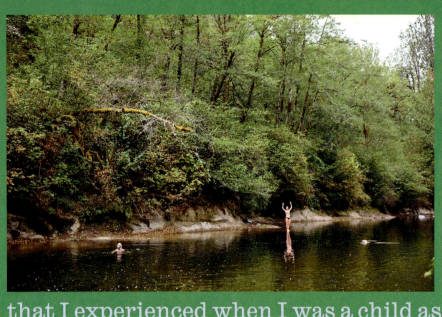

"I wanted to give them some idea of freedom that I experienced when I was a child as well, where you just have your imagination, and what you can make for yourself without being constantly stimulated by something else, and see where your interests go."

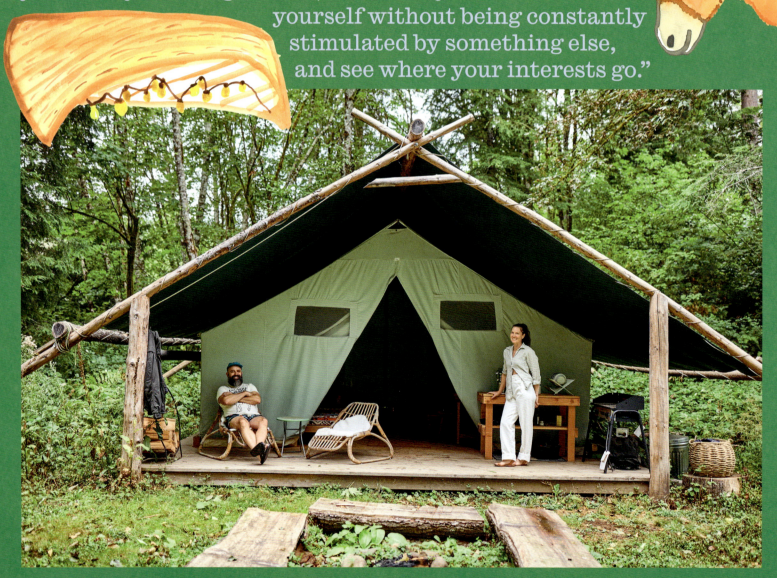

Benji Wagner & Nahanni Arntzen
with Olive, Azriel & Sparrow

Hi Nahanni, Benji, Olive + Sparrow (+Azriel)! Nahanni could you design some furniture for the river beach area?

Benji could you design floats for your family for the river?

Sparrow what are the keys to awesome outdoor cooking?

Water. earth. fire. air. Long ago the four nations where at war but now they live together in harmony. in my kitchen.

Olive where do you want to travel to, and what do you want to do there? I want to go to mexico. I would love to swim in the ocean, learn about the culture, and get super tan.

Benji could you design a floating sauna + pizza oven?

Azriel how can the forrest inspire music?

The quiet helps to create without distraction. It also allowes you the space to be loud.

LISSY & RUDI ROBINSON-COLE
with Jamie, Jazmin, Ross, Christian & Mia in Auckland

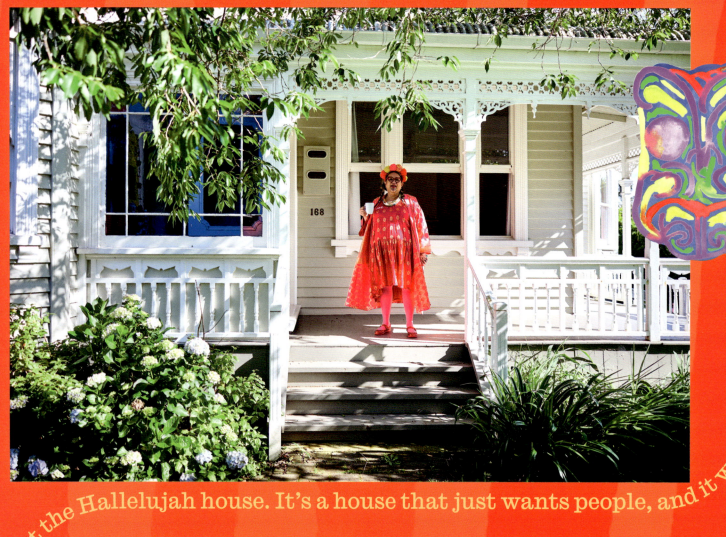

"We call it the Hallelujah house. It's a house that just wants people, and it wants gatherings."

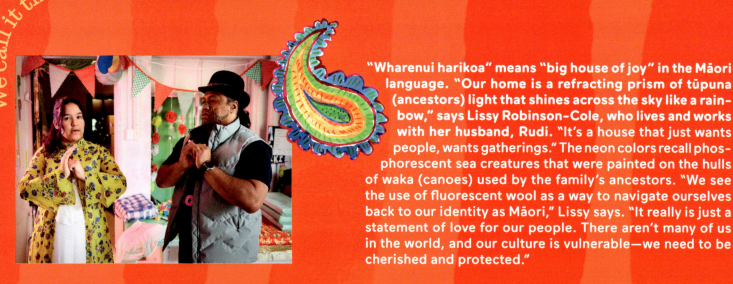

"Wharenui harikoa" means "big house of joy" in the Māori language. "Our home is a refracting prism of tūpuna (ancestors) light that shines across the sky like a rainbow," says Lissy Robinson-Cole, who lives and works with her husband, Rudi. "It's a house that just wants people, wants gatherings." The neon colors recall phosphorescent sea creatures that were painted on the hulls of waka (canoes) used by the family's ancestors. "We see the use of fluorescent wool as a way to navigate ourselves back to our identity as Māori," Lissy says. "It really is just a statement of love for our people. There aren't many of us in the world, and our culture is vulnerable—we need to be cherished and protected."

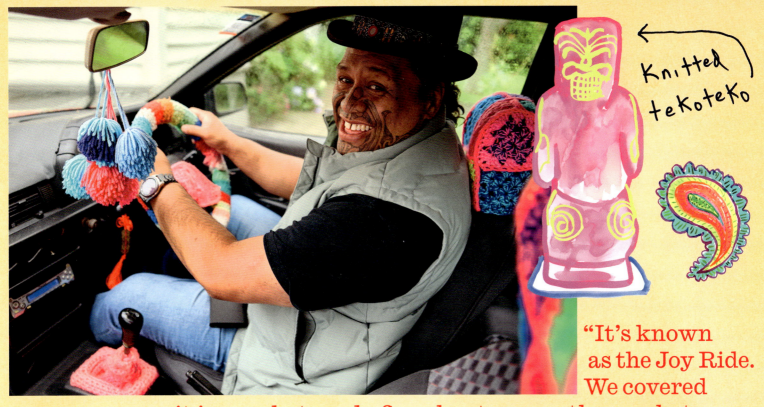

Knitted tekoteko

"It's known as the Joy Ride. We covered it in crochet, and after about a year, the crochet was starting to fade from the sun. But when we took it off the car, the car looked so sad that I was like, 'Okay, we have to paint something on it.'"

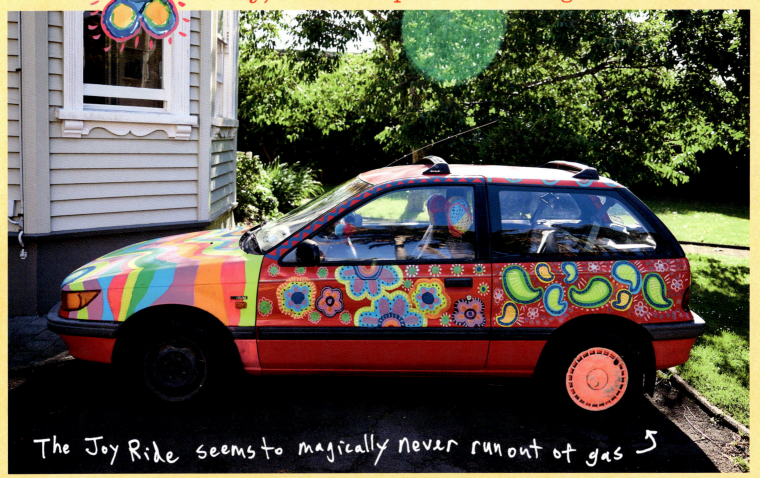

The Joy Ride seems to magically never run out of gas

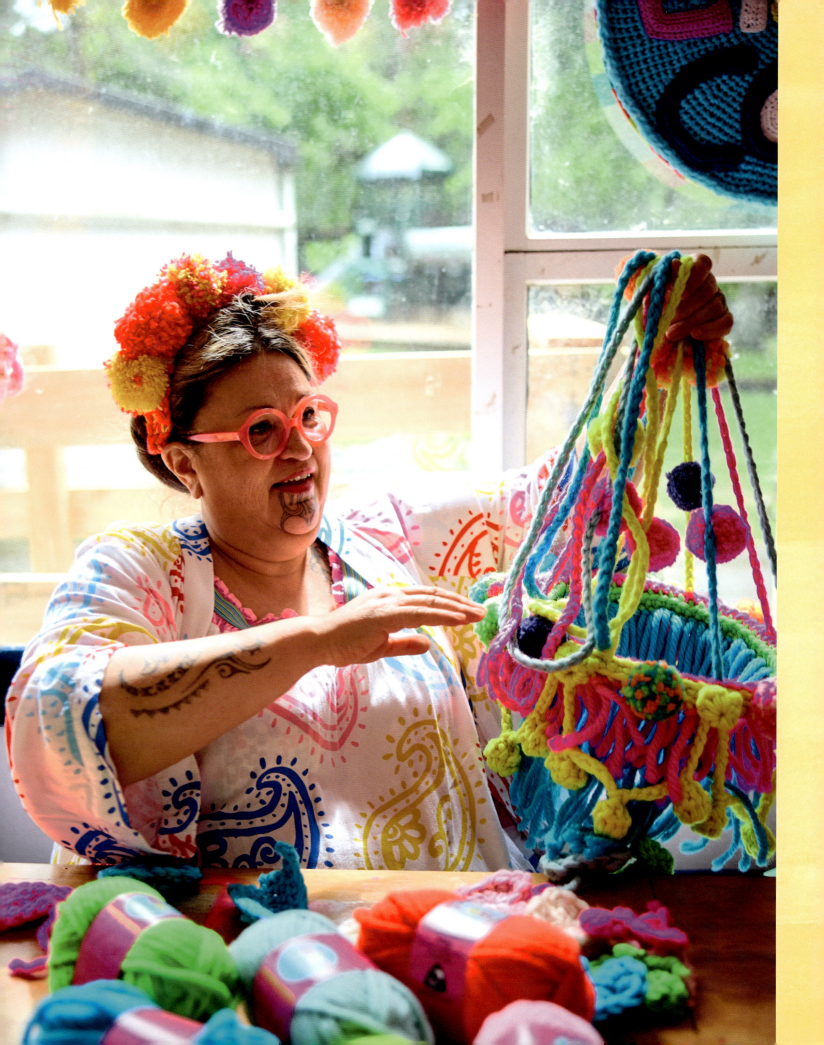

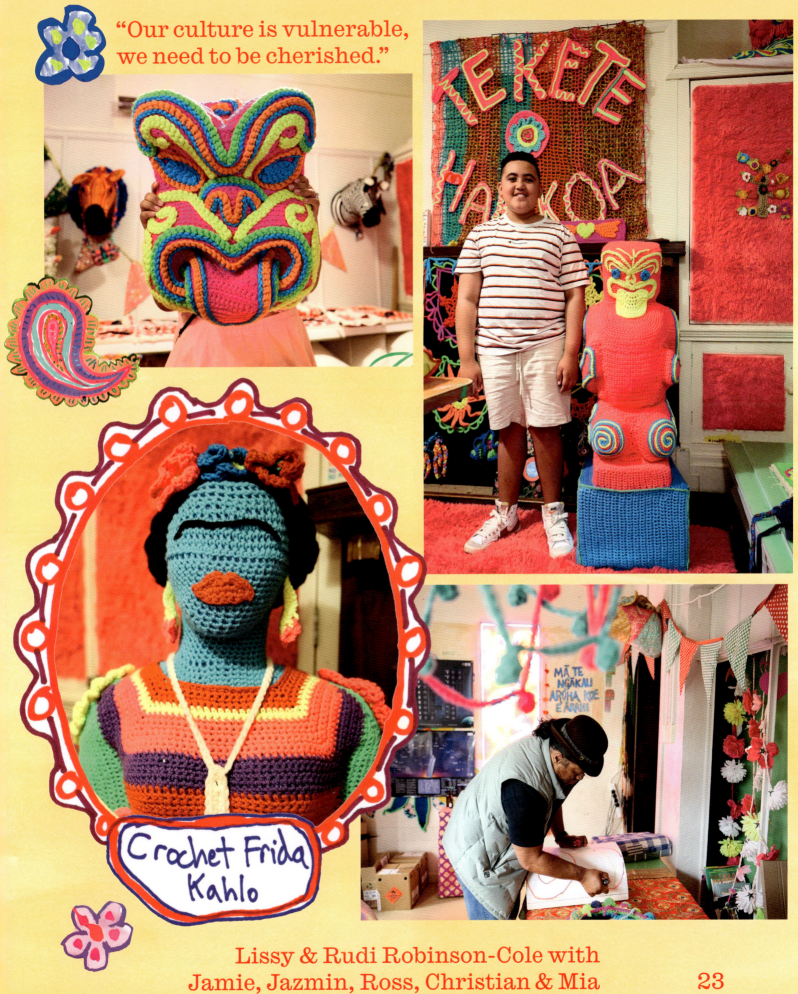

"Our culture is vulnerable, we need to be cherished."

Crochet Frida Kahlo

Lissy & Rudi Robinson-Cole with Jamie, Jazmin, Ross, Christian & Mia

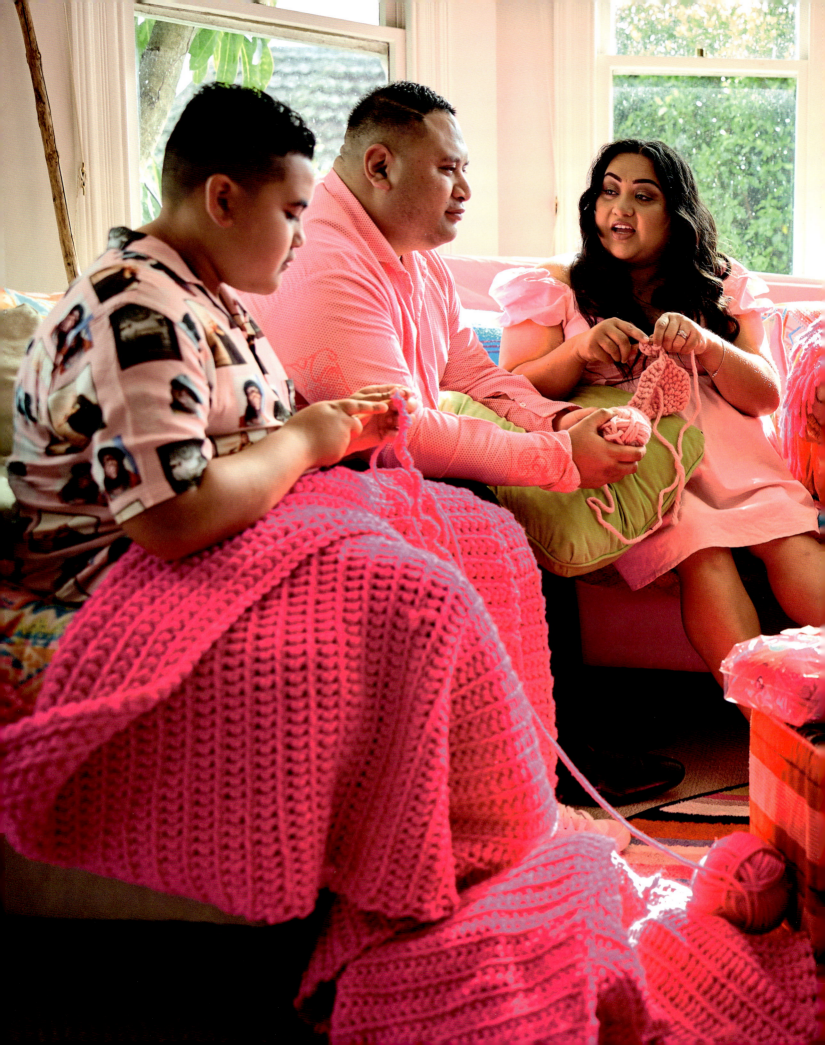

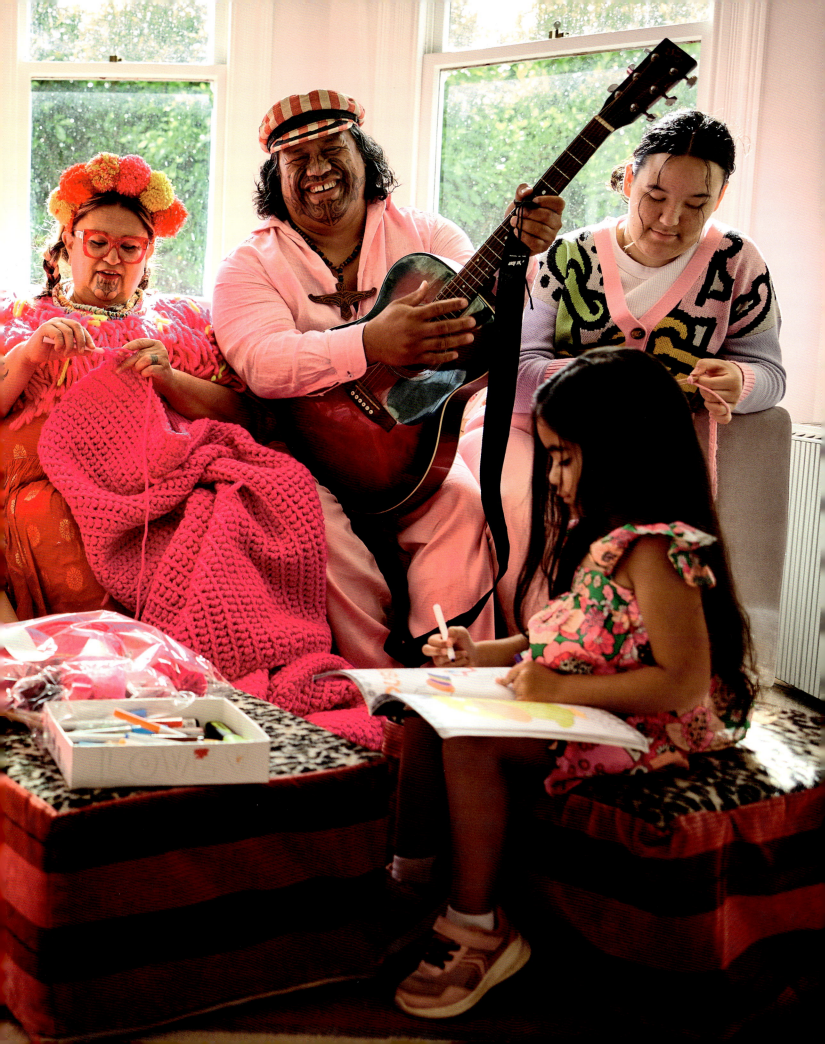

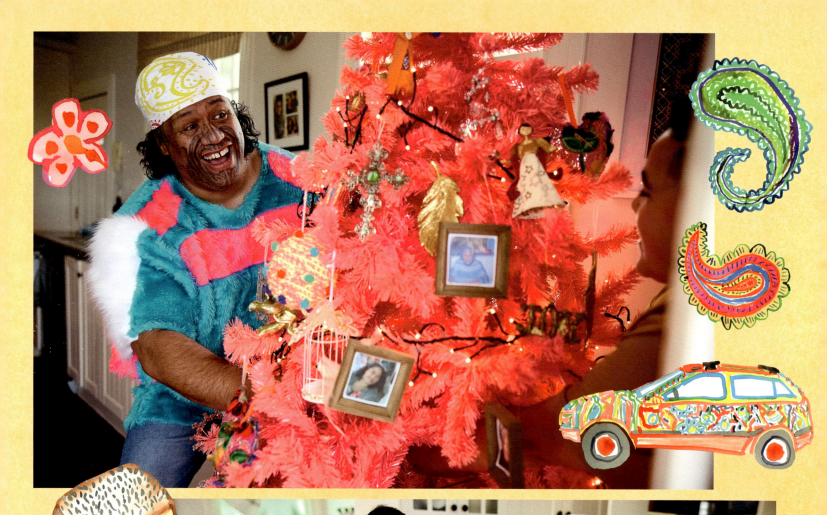

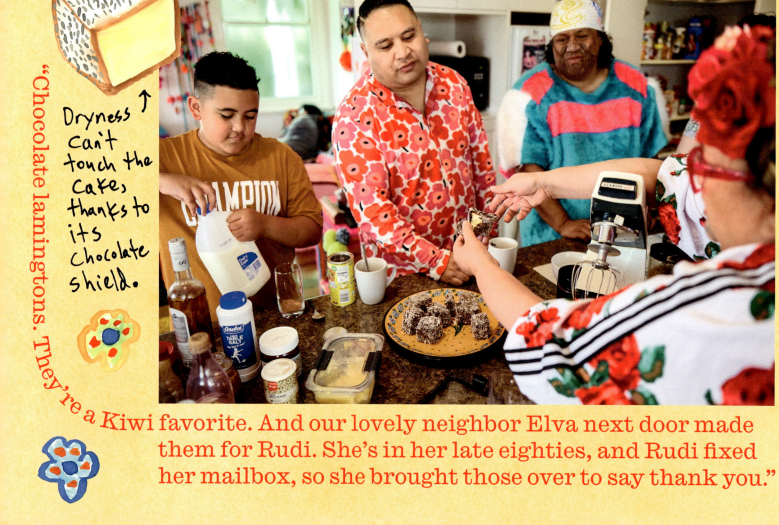

"Chocolate lamingtons. They're a Kiwi favorite. And our lovely neighbor Elva next door made them for Rudi. She's in her late eighties, and Rudi fixed her mailbox, so she brought those over to say thank you."

Dryness can't touch the cake, thanks to its chocolate shield.

Hi Lissy, Rudy, Jamie, Jazz, Ross, Christian + Mia! Lissy how can crochet connect people?
Lissy - Through coming together and through the act of connecting loops, and connecting to memories. The soft medium of crochet allows people to access soft spaces within connecting them to beloved people who have crocheted for them. Being together while crocheting together creates a space of safety & warmth where people feel safe to open up & share experiences.

Rudy what are the meanings of some of the colors of your colors of yarn? Harikoa (pink) is our kaitiaki (guardian) for joy
Waimarie (yellow) is our kaitiaki (guardian) for good fortune

Jamie what do you like about science?
Never liked science until this year but I really enjoyed it. Biology/Sciences worked well in my head

Jazz what are tips to keep artists organized?
Open communication, be open to going with the flow. Artists/creatives usually have big feelings that show in their work, being able to roll with their creative flow makes work easier. Use a shared calendar.

Christian what can art teach kids?
That an easy question for me it can help kids express themselfs. in not words but in art.

Lissy could you draw a Wheku inspired by family ↘

Rudy could you draw a Wheku inspired by a loving heart ↘

ISABELLE TUCHBAND
with Max in São Paulo

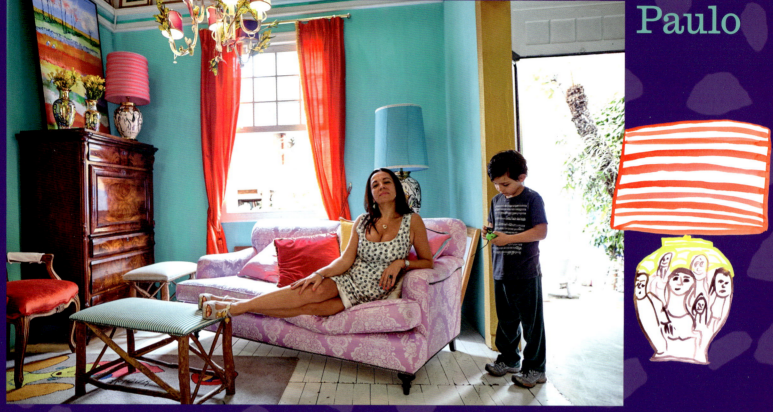

"I am authentic, positive, I love my life, my conquests. I am proud of being whom I've turned today."

"My art is spontaneous," writes Isabelle. "I was born in the studio of my father, a great artist named Emile Tuchband—an incredible father who taught me to love the world, people, faith, nature, everything. My mother also inspires me a lot, always. I've lived with many great women, strong women, and beautiful ones. Because of that I paint mostly the feminine. My style is flamenca, Romani, Hindi. I am always in my pajamas, like my father in his atelier. My house is from 1927, a simple fisherman's house. I painted it blue and pink so it had the feeling of being in the middle of a rose garden with a sweet perfume, the blue of the sky. Fantasy and a fragrant home. My son, Max, is a free and happy child with his mother, dancing, painting, and creating a wonderful universe."

Louis XV chair

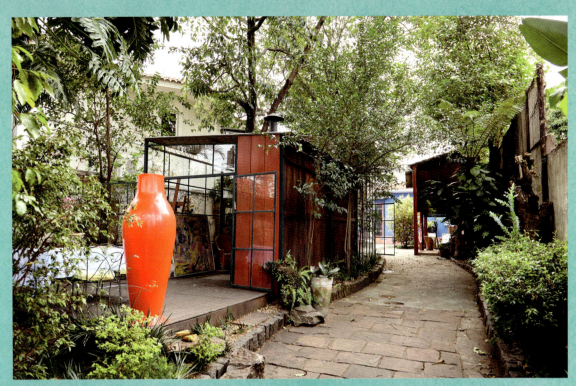

"This is my atelier, my sacred temple. It has a photograph of my friend Moonie Ezra, my paint, and two eighteenth-century 'tocheiro' lamps that belong to my mother-in-law, Riza Catao."

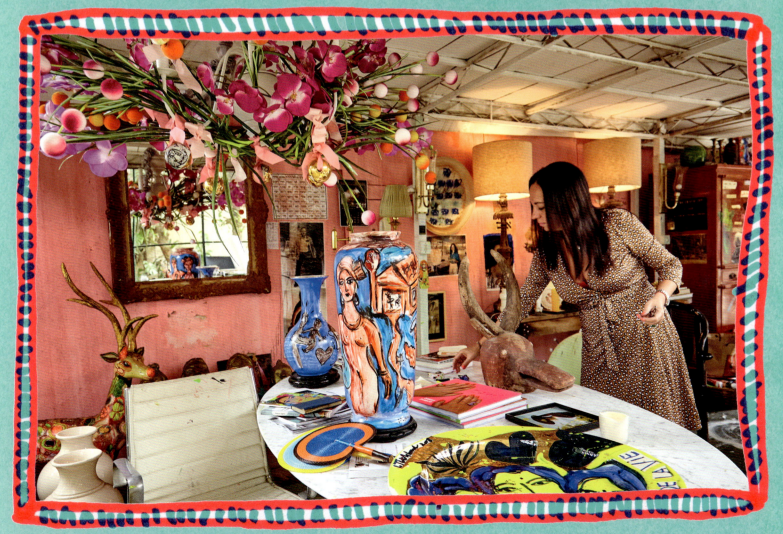

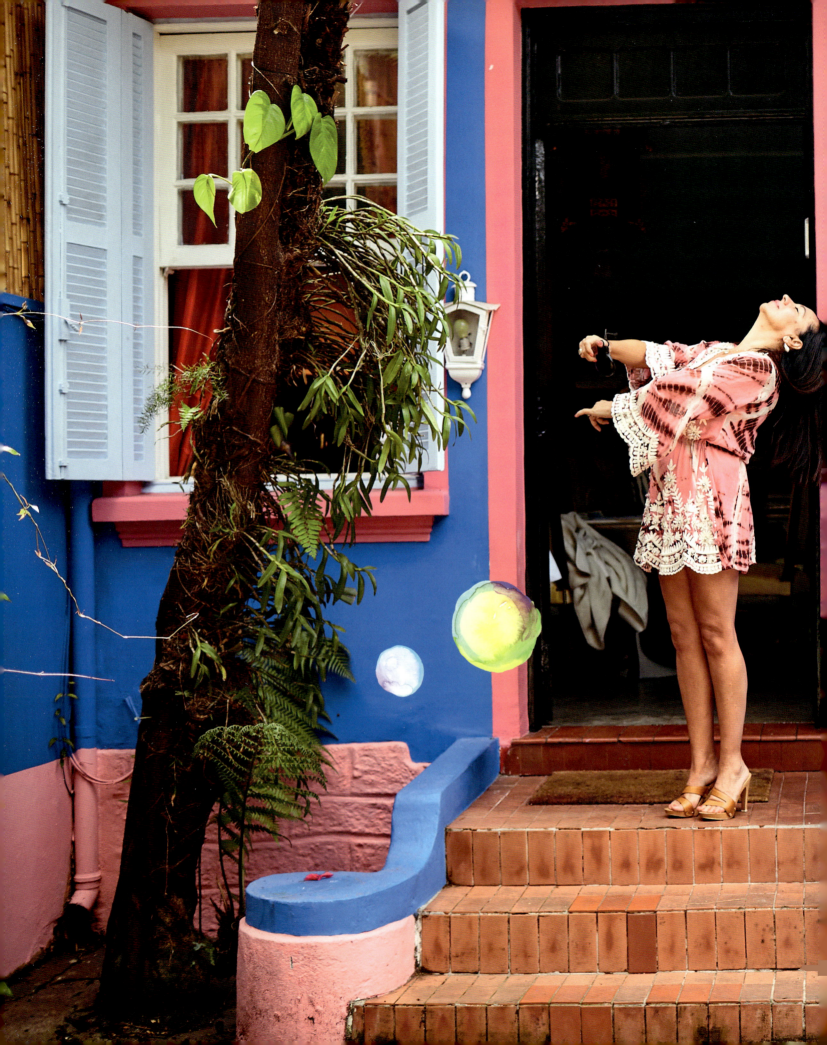

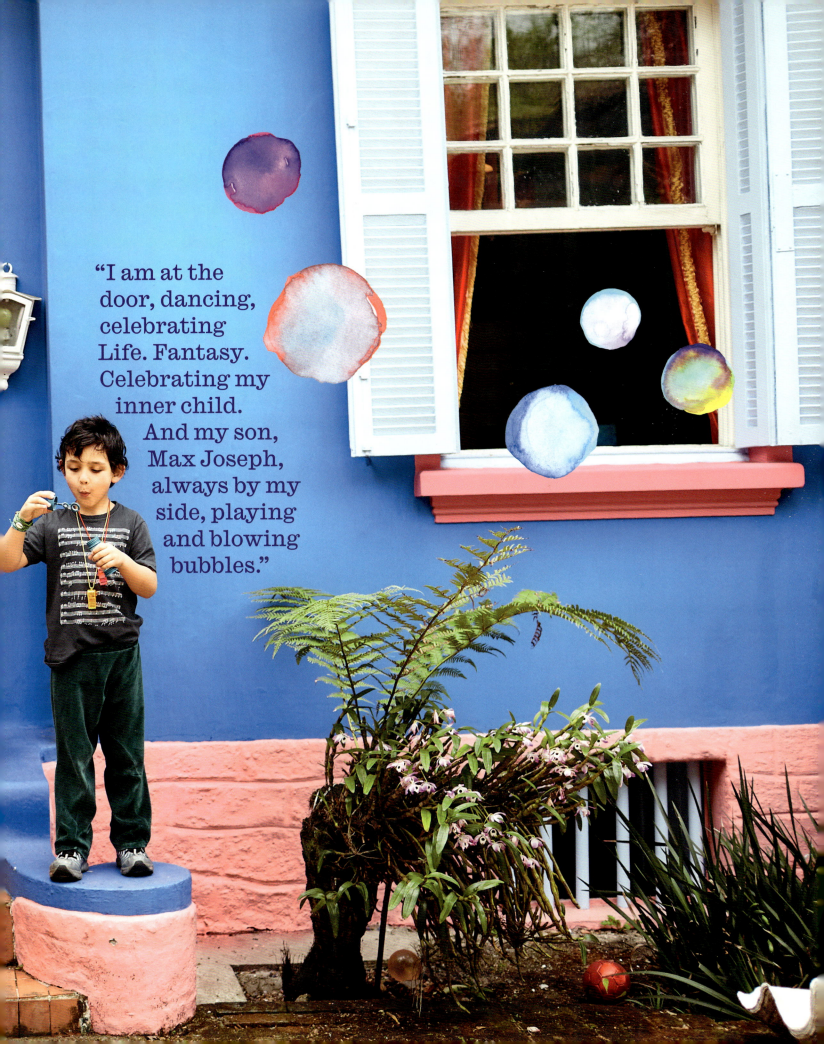

"I am at the door, dancing, celebrating Life. Fantasy. Celebrating my inner child. And my son, Max Joseph, always by my side, playing and blowing bubbles."

← pots waiting to be painted

"My style is very flamenca, Romani, Hindi; I love wearing kimono."

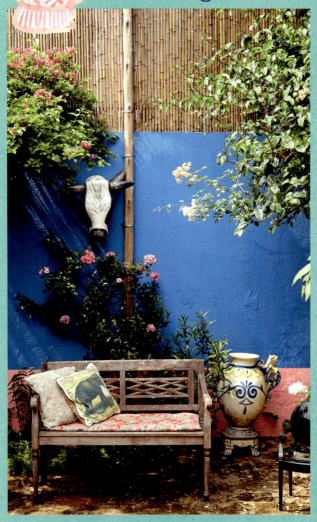
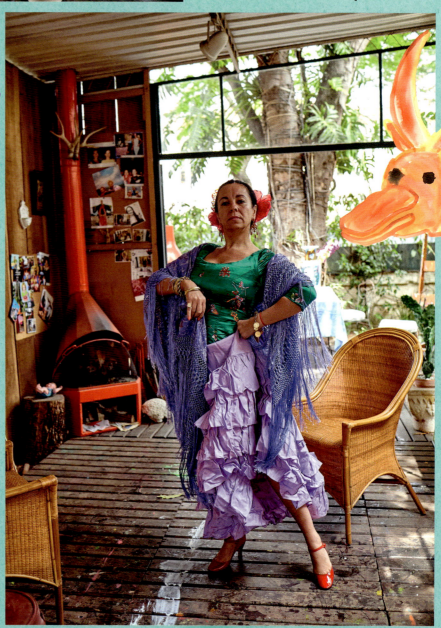

Isabelle Tuchband with Max

Hi Isabelle! Could you draw your father's house on the beach?

Could you draw Brazil?

Could you draw your favorite tree at your house?

Could you design your dream shoes?

los tacones!!!

SIBIPIRÚNA
ÁRVORE da vida

Could you draw your chandelier at Holiday time
Could you draw your favorite things in paris?

MONTMARTRE

KANAKO & YUSUKE SHIBATA
with Tomoya & Hona in Kawasaki City

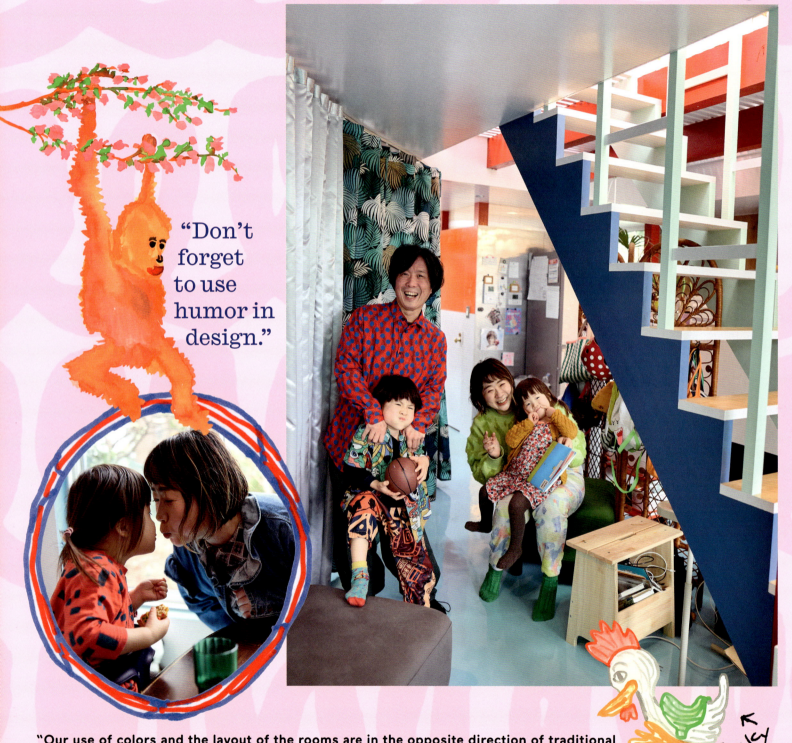

"Don't forget to use humor in design."

← Funky duck spring rider

"Our use of colors and the layout of the rooms are in the opposite direction of traditional Japanese home design," says Yusuke. "Our home is a colorful one-room apartment with three staircases. Storage is limited, so shelves and other items are important for function as well as decoration." Yusuke, a graphic designer, and Kanako, an art director, have a playful affection for unusual shapes and colors. "It's important to have fun and laugh," says Yusuke. "We love our family and wanted to design a house that would change as the children grew."

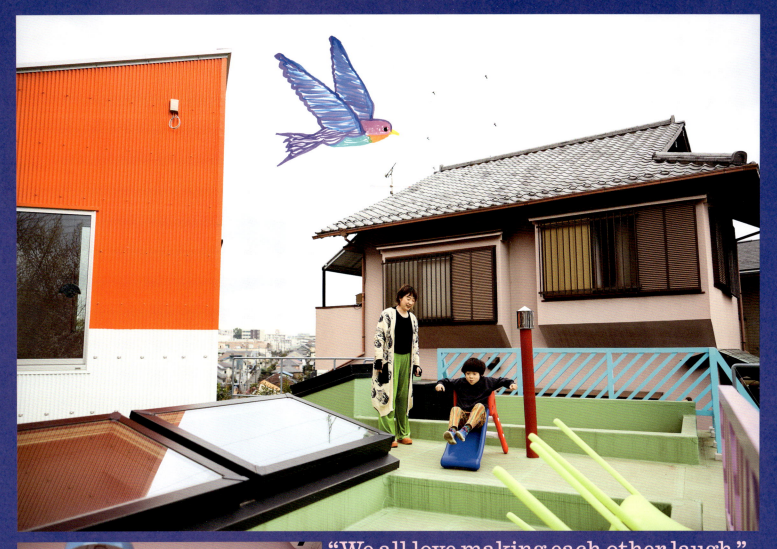

"We all love making each other laugh."

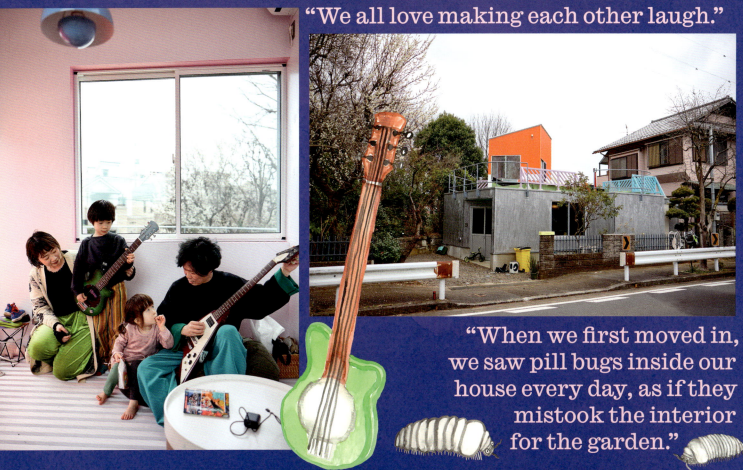

"When we first moved in, we saw pill bugs inside our house every day, as if they mistook the interior for the garden."

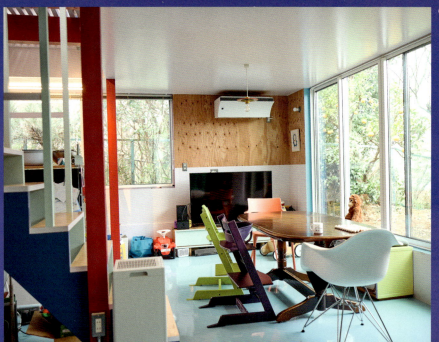

"We can cook and watch our kids playing in the park."

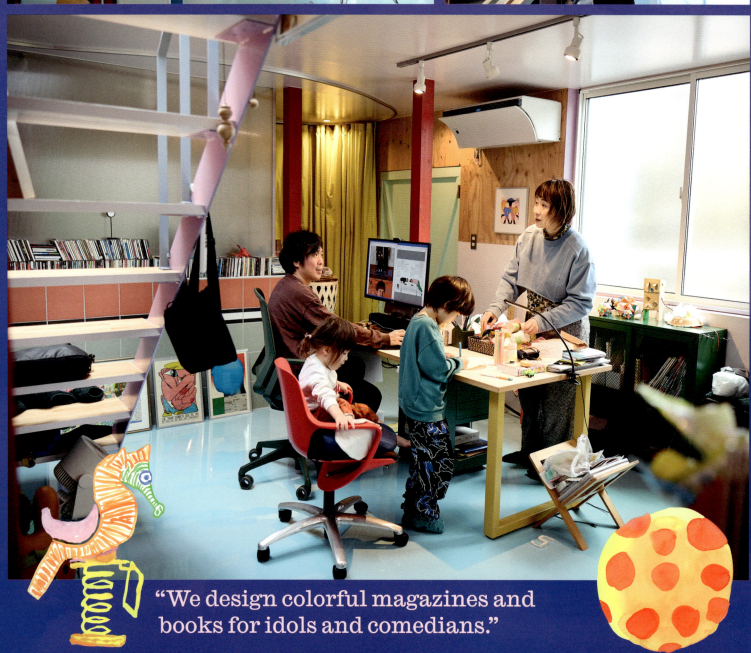

"We design colorful magazines and books for idols and comedians."

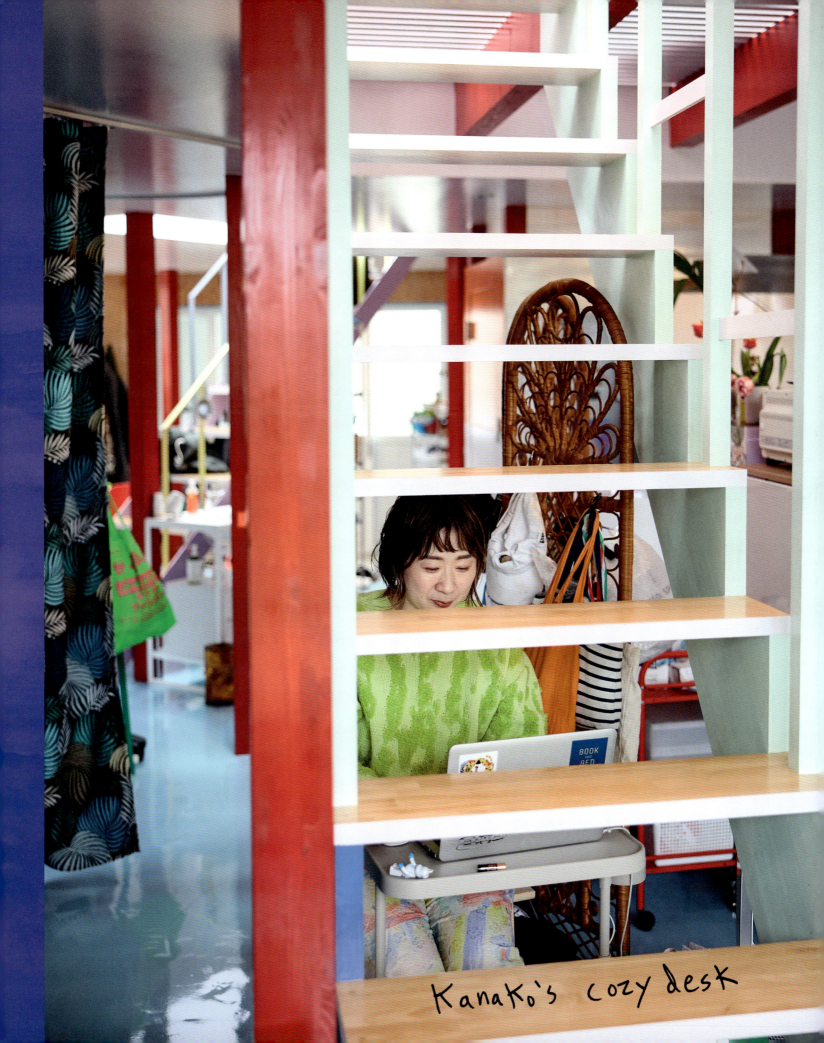
Kanako's cozy desk

Yusuke prefers patterned clothes. Kanako wears flashy colors and collects unusual socks.

"We wanted to sleep close together until our children grew up."

The Shibatas all sleep in this huge striped bed.

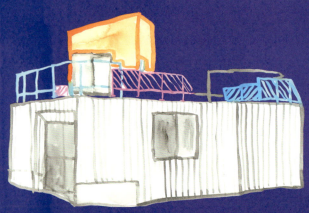
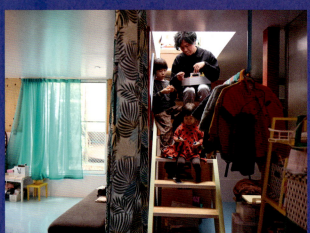
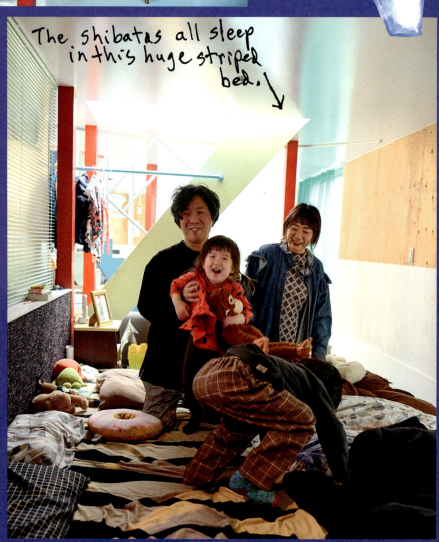

Kanako & Yusuke Shibata with Tomoya & Hona

Hi Yusuke-san, Kanako-san, Tomoya-kun and Hona chan! Yusuke-san could you design a poster about your house ↘

Kanako-san could you design a poster about your family ↘

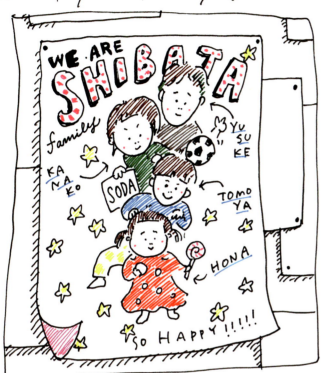

Yusuke-san + Kanako-san could you design cookies inspired by your favorite objects ↘

Tomoya-kun could you draw a robot for your sister ↘

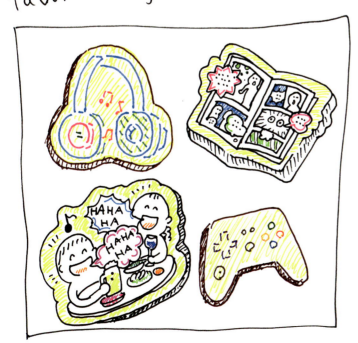

JOSEPH & MORGAN LEARY
with River in Auckland

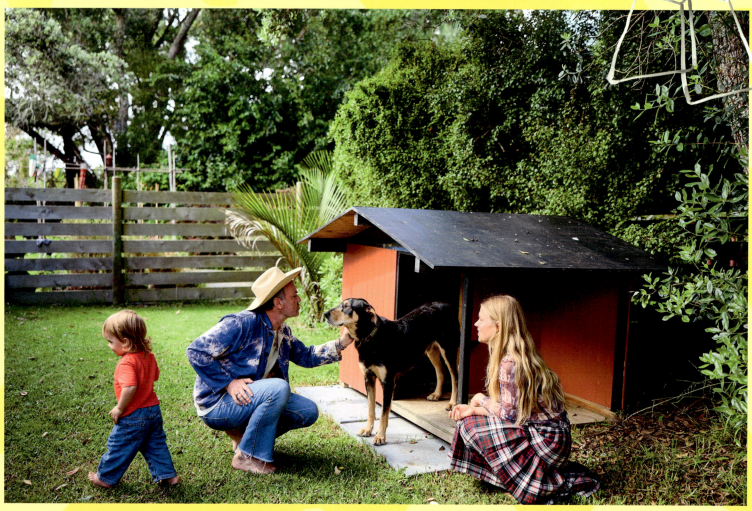

"**Living here, you start to find a rhythm.**" Joseph and I are in the backyard as the tide rises into the mangrove trees. "Everything looks different depending on the light, and the colors are always changing." It's no surprise that Joseph is a production designer and artist, while Morgan is a filmmaker and musician. Their entire home feels like an art piece with an earthy, retro-bohemian style that connects with the nature around it. "The previous owners had painted everything white and gray," says Joseph. "It just needed to be pushed back to where it belongs." The couple was inspired by photos of the first owners, which showed the home as it was initially built. "There's the original cork in the laundry, and we put some walnut ply back throughout the house, and did a pink kitchen floor." Morgan fell in love with the home's traditional Kiwi bach style. "It's got a classic little 1960s getaway by the sea vibe. It's like a mirror to the childhood I had in the country. We'll hang out and play guitar, or oh, let's hop in the canoe and get tacos."

"It's just, like, the same thing every day, but it's always different. We just love that. I never get bored."

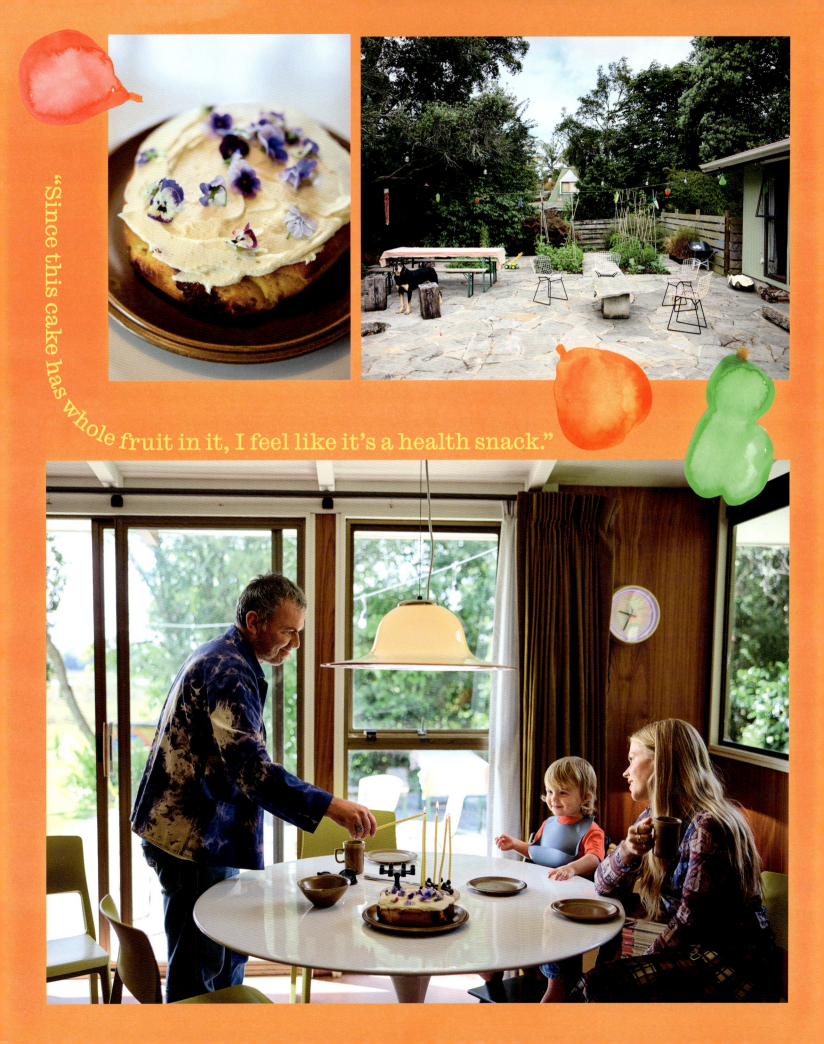

"Since this cake has whole fruit in it, I feel like it's a health snack."

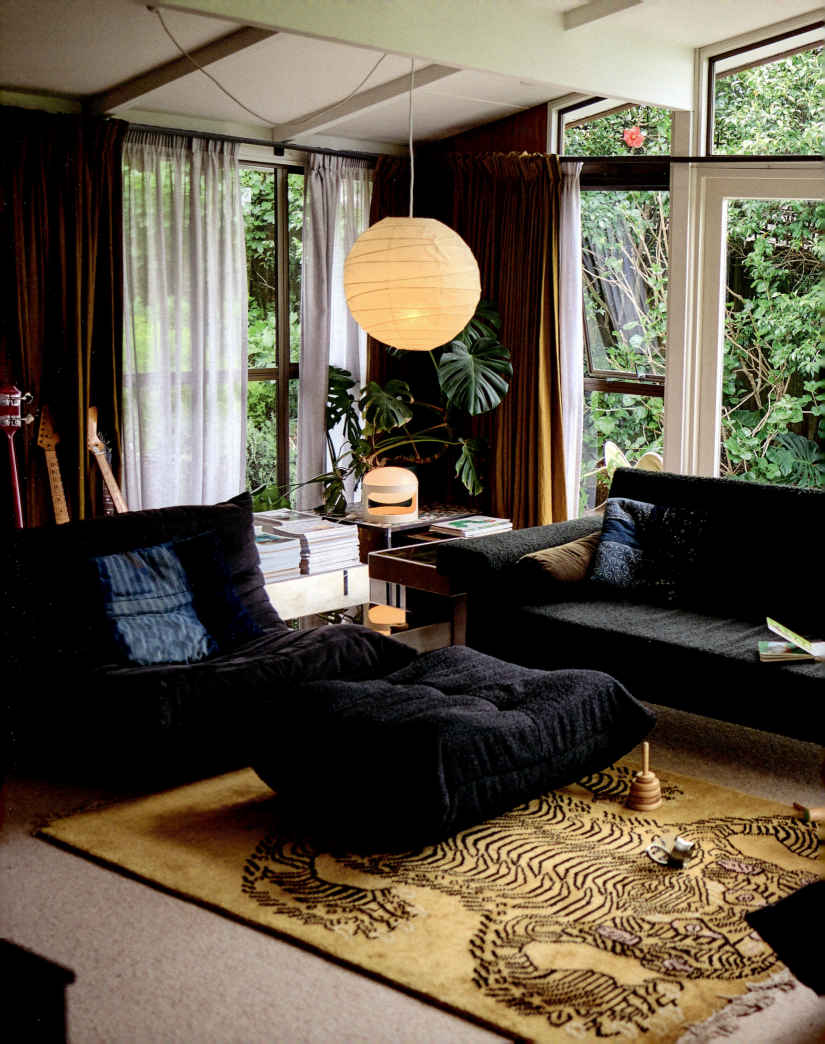

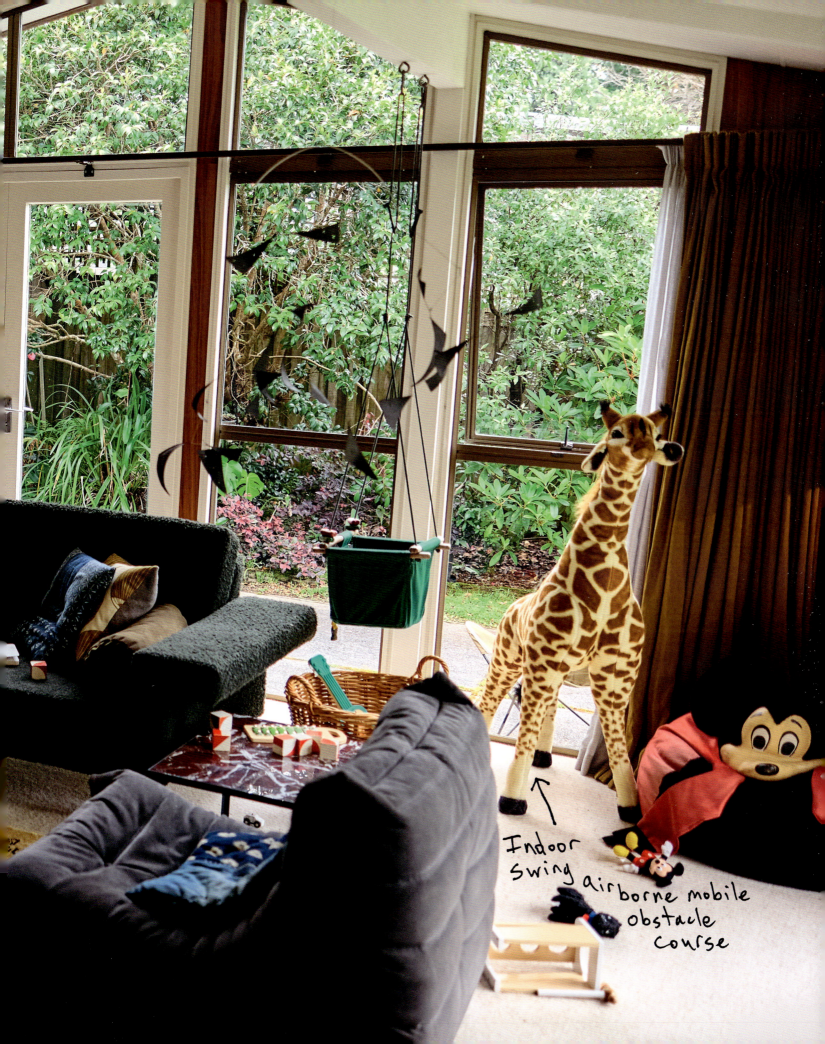

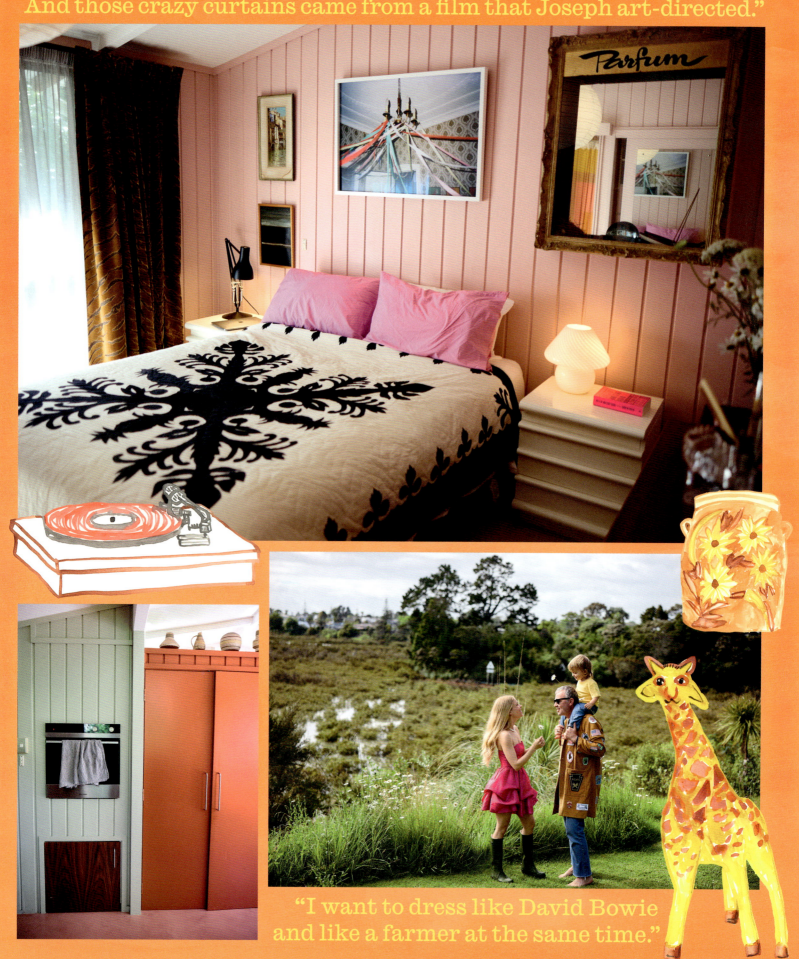

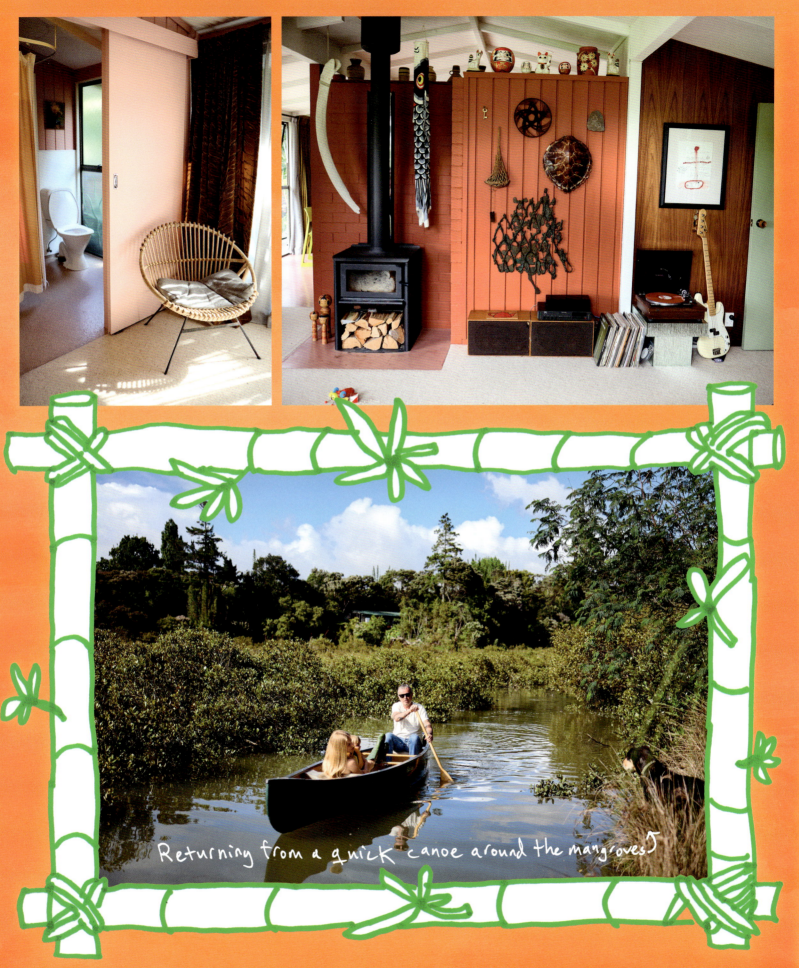

Returning from a quick canoe around the mangroves

Joseph & Morgan Leary with River

Hi Morgan, Joseph + River! Morgan can I get the recipe for your cake? FOR SURE. Boil 3 oranges for an hour, drain, blitz the WHOLE thing, peel & all. In another bowl beat 6 eggs, add one cup sugar, one & a bit cups ground almonds, stir thru the orange, bake at 180°C / 350°F for one hour. I frost it with coconut buttercream

Joseph could you draw your dream canoe?

Morgan could you describe your house? LIFE HACK → MARRY A PRODUCTION DESIGNER. Everything's beautiful but functional, and we have magic little themed areas - a play area, a music area, I never have to leave....

Morgan + Joseph could you design a truck for River to race in?

Morgan + Joseph could you design a bird house for outside your home?

MAURICE & ROBIN AYERS-LEE
with Theo & Vivien in San Francisco

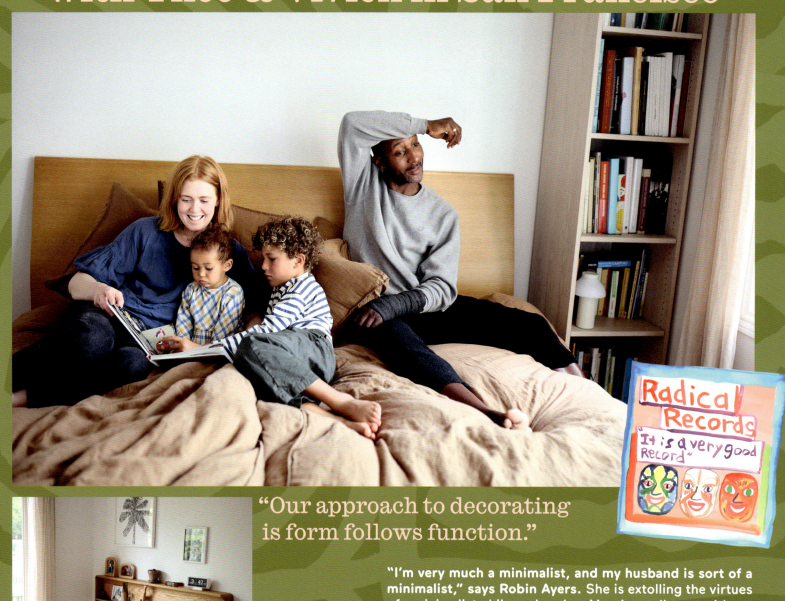

"Our approach to decorating is form follows function."

"I'm very much a minimalist, and my husband is sort of a minimalist," says **Robin Ayers.** She is extolling the virtues of a minimalist philosophy when Maurice walks out with yet another vintage duffel bag—this one made by Marshall Wells in the 1970s. "It's a weakness," says Maurice. "I see bags and if they're old and made well and of a certain era, I can't help myself." Robin revises her earlier description: "Maybe he's more of a restrained collector." Simplicity, restraint, and purpose-built craftsmanship are themes throughout the house. "We like a lot of natural materials like wood and leather," says Robin. "And for upholstery, I gravitate toward natural fibers like wool and cotton." Robin works at an investment firm, while Maurice takes on full-time dad duty at home in addition to coaching tennis. His creativity is on display as the kids romp around the yard in felt costumes Maurice made for Halloween. "Theo had so much fun in his octopus costume, he wore it to school for days."

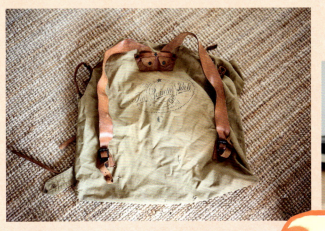

"I know where the records are, for the most part."

"This has a big strap that you wrap around your forehead to counterbalance all the weight of the bag."

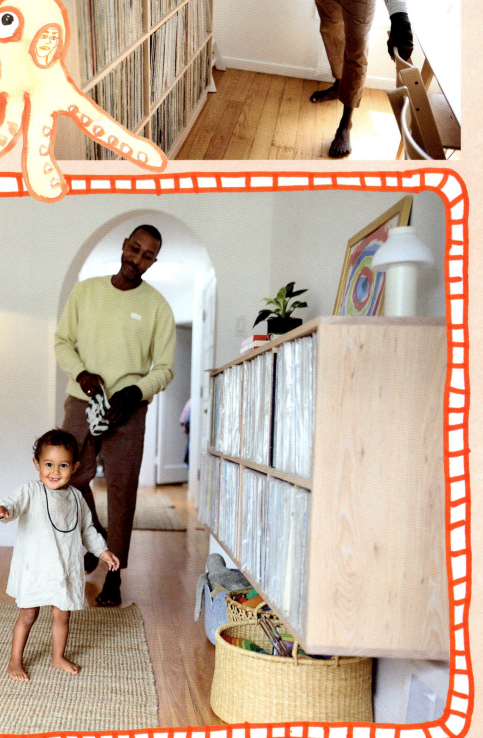

"I just think that people don't need that much stuff, and I really like the simplicity of having really what you need and maybe a little bit of sentimental stuff here and there, but not much."

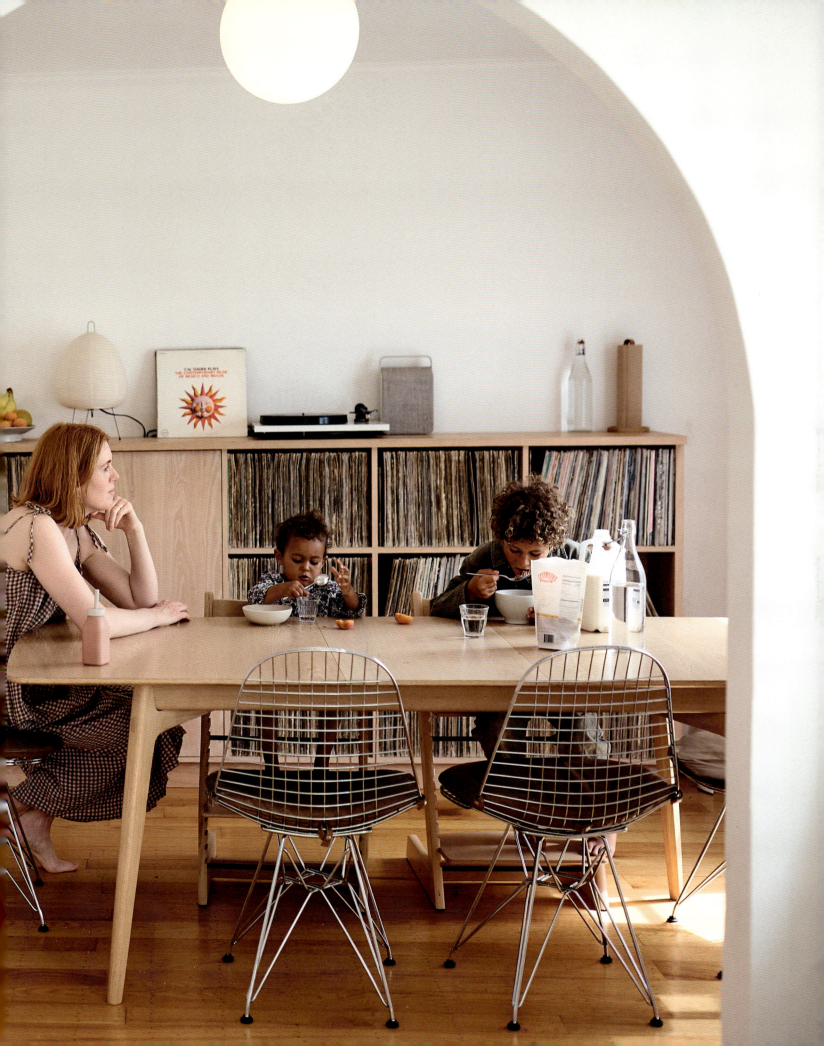

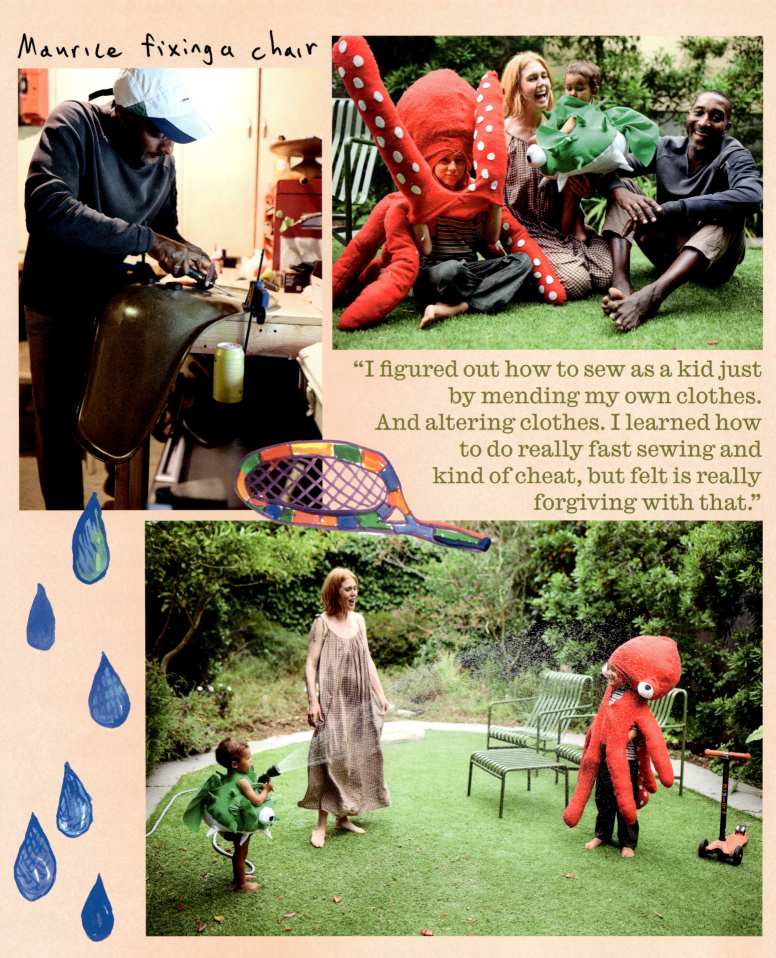

Maurice fixing a chair

"I figured out how to sew as a kid just by mending my own clothes. And altering clothes. I learned how to do really fast sewing and kind of cheat, but felt is really forgiving with that."

Maurice & Robin Ayers-Lee with Theo & Vivien

Hi Robin, Maurice, Theo + Vivien! Robin could you design a fish lamp for Vivien?
Maurice could you design a tent for Theo?

Noguchi-style fish light w/ 25w incadescent bulb for that soft glow.

spider-proof tent (theo hates spiders)
- inflatable mattress (attached)
- zip
- 6'
- 12'
- screen
- door/mat (zips close)
- converts easily down to small duffel bag

* tent has an infinite, undetectable, 100% effective, organic, all-natural yellow jacket, tick, fly, mosquito & spider repellent. (*repels mosquitos to 400 yards)

Theo could you draw an aquarium for your family?

Maurice could you describe two of your ultimate vintage bag finds?

I had a massive leather carrier bag. Italian, 60's or 70's. I forget who made it. I got rid of it because it was awkward. I regret it, but it was huge and only had one handle. I traveled with it once and it drove me crazy so I got rid of it. sorry no more space for #2

Maurice + Robin could you design + label an ultimate hifi for your country house?

fantasy minimal all-in-one (sans speakers) Hi-Fi system:
- cassette player
- silicone fluid
- somehow all compmts fit inside (amp & everything else)
- speakers invisible flat panel Magnepan?
- no rack needed

CAROLINE RODRIGUES
with Milo in Portland

"I grew up not having accessibility to nice toys as a child, so I am very conscious about what I buy for my shop and my home."

Adorable stuffed donkey doll

Seven-year-old Milo Rodrigues is living the dream, with parents who own a boutique toy store in Los Angeles that is named after her. Caroline says, "My family is Korean immigrants in Los Angeles and I grew up really poor. Everything that I buy for the store, I'm like, 'Oh my gosh, I wish I had this as a kid.' My husband will ask me if the store is for Milo or for me. And I think it's for both." Caroline and Jason moved to Portland shortly after opening the store. "We felt connected to Portland. Just having Milo be immersed in nature and all the food. She's always outside. Our home is very much a reflection of us as a family, a family that loves to travel and collect treasures we find along the way. I seek out items that are eco-friendly and sustainably made. Heirloom pieces that could be passed down for generations. All my friends also own small businesses or are artists. We all support each other."

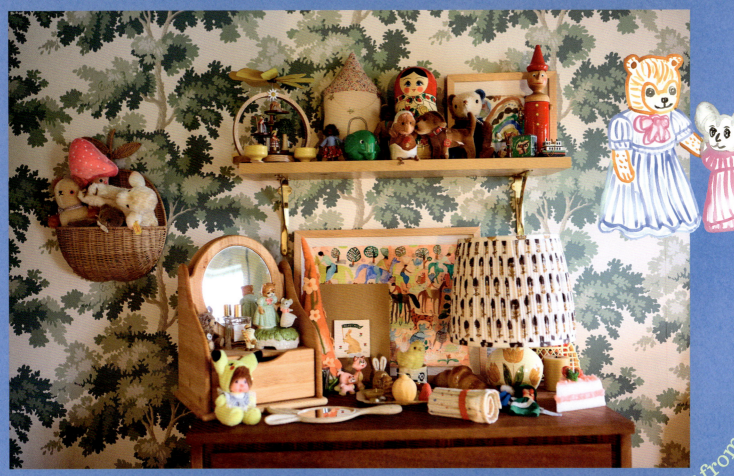

"Everything in Milo's room was a damaged item or returned from a customer from our store."

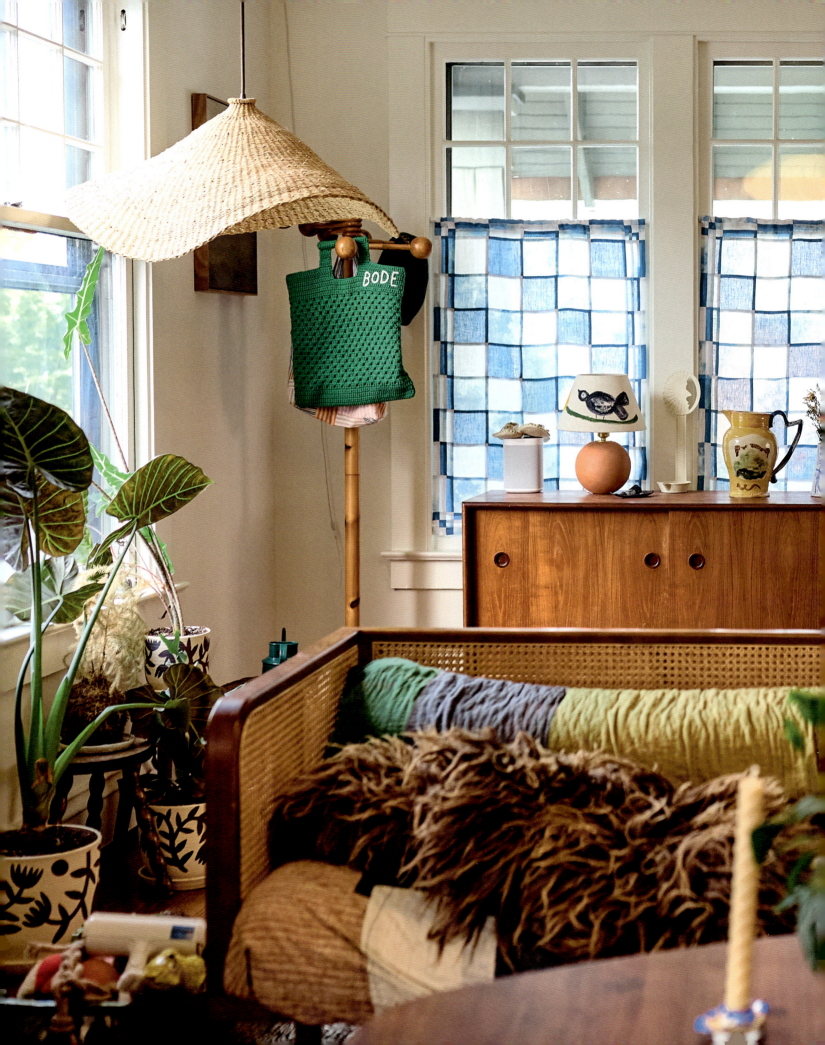

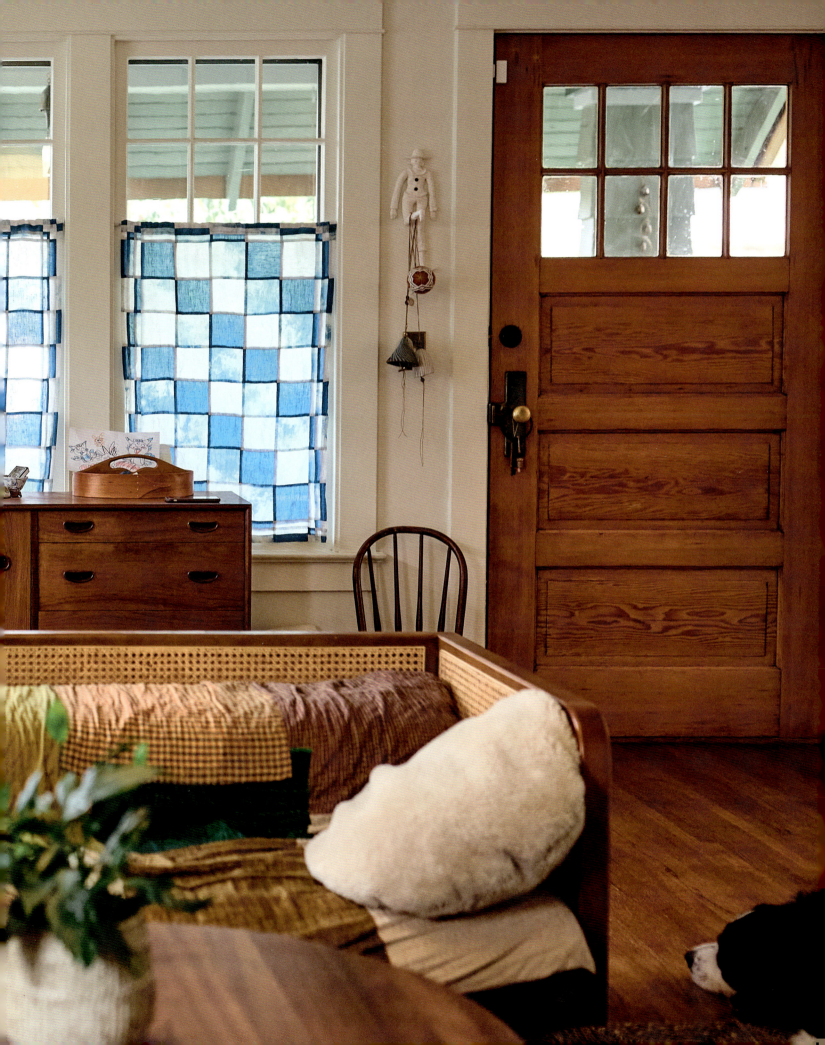

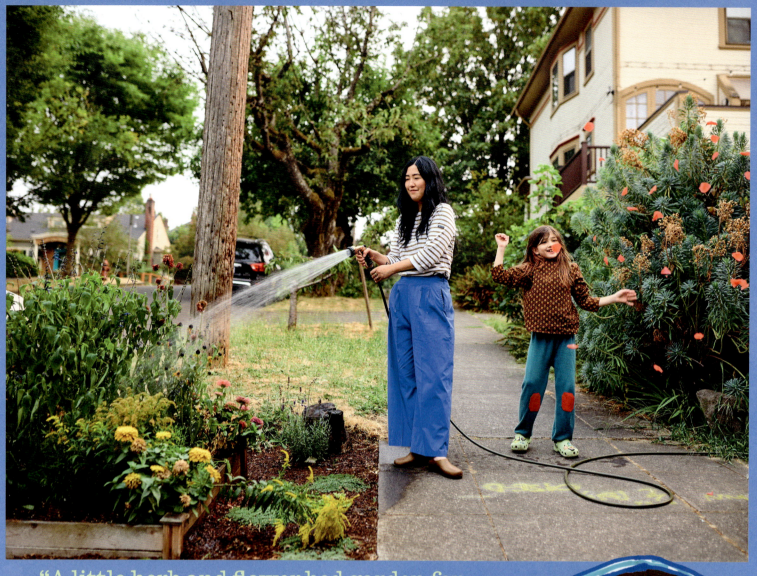

"A little herb and flower bed garden for the community to pick and enjoy."

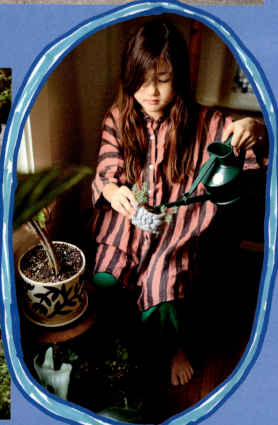

"It's a different mishmash of eclectic things in my home because they're all just things I collect."

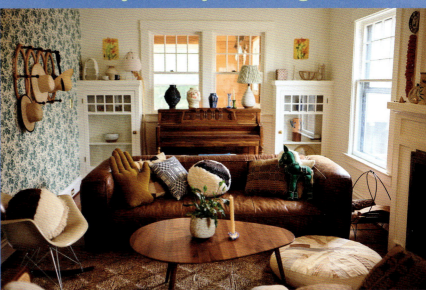

"I gather objects made by a friend or someone that I've met and connected with."

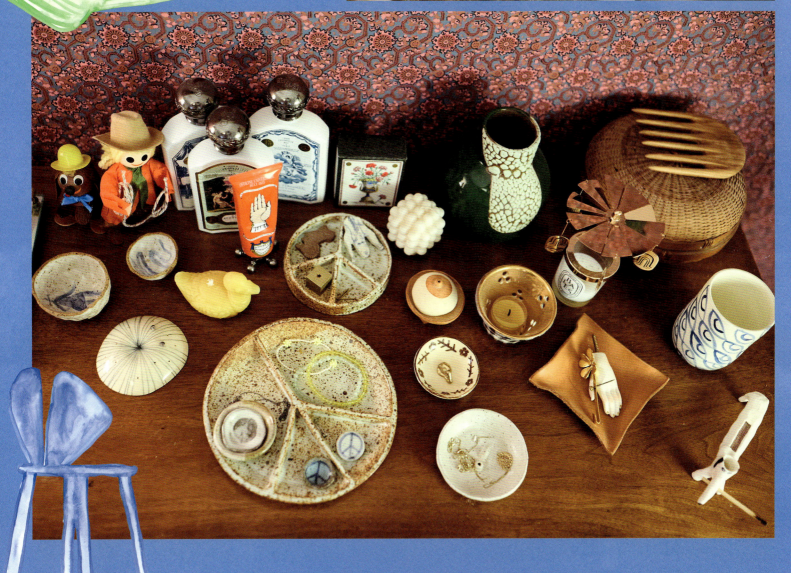

Caroline Rodrigues with Milo

59

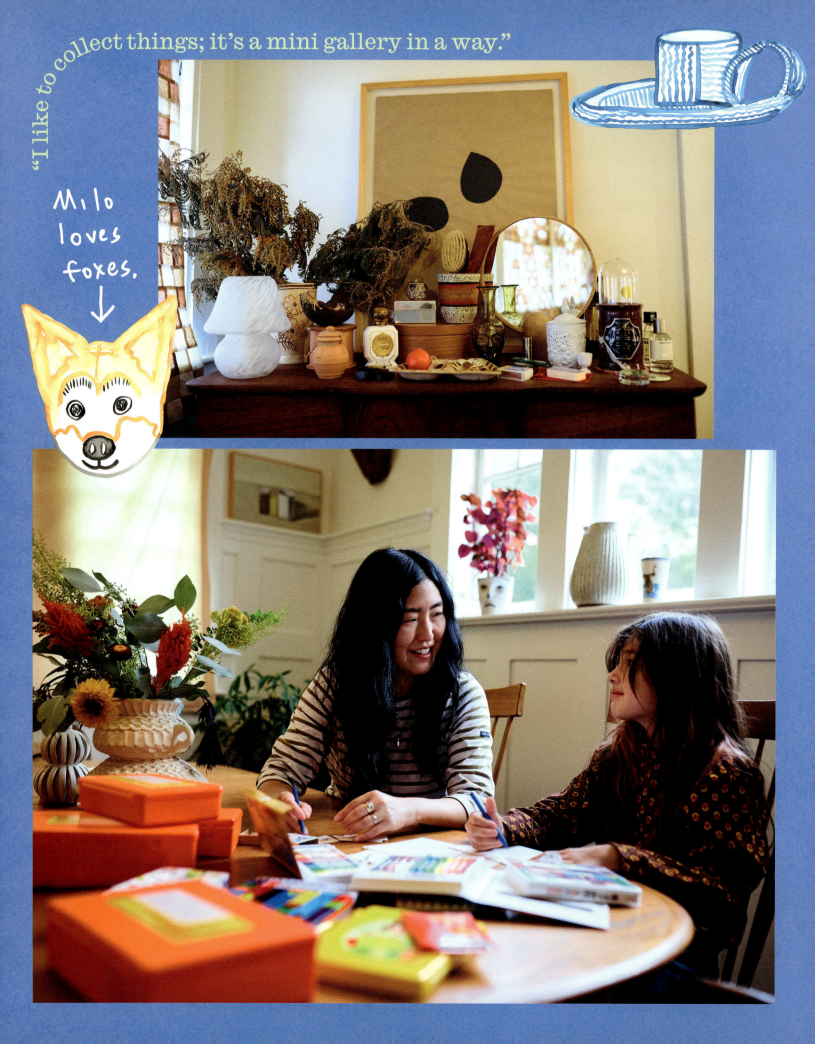

"I like to collect things; it's a mini gallery in a way."

Milo loves foxes.

Hi Caroline + Milo! Milo could you draw a Rat dog ↴

Caroline could you draw a flower bed for bees ↴

Caroline could you draw yourself riding Goldie ↴

Milo could you draw a worm dog ↴

GOLDIE

Caroline what 6 things are you looking for/thinking about when you buy kids toys for your store?
① FUN ④ MAGICAL
② UNIQUE ⑤ WHIMSICAL
③ JOYFUL ⑥ COOL

Milo could you draw some magical foxes ↴

BÉRÉNICE EVENO & SERBAN IONESCU

with Zélie & Azure in Brooklyn

"Bérénice and I built this apartment together, and it was parallel to us assembling our relationship."

"This place is like a metaphor for our relationship," says Serban. "Originally it was going to be my bachelor pad, and during that time I fell in love with Bear. By her second day here in the apartment, she was helping me put polyurethane on the bare pine floor. We had two children here, two home births. It's changed as we changed." Their Brooklyn apartment lives on the border of Red Hook, Cobble Hill, and the Columbia Street Waterfront District. "It's a small apartment, but there are always activities. We build things with blocks, clay, and paint. We love to draw. We love to play games amd dance. I hope the kids will be inspired—all we can do is create a world where it feels like there's always something unique and exciting for them and for us."

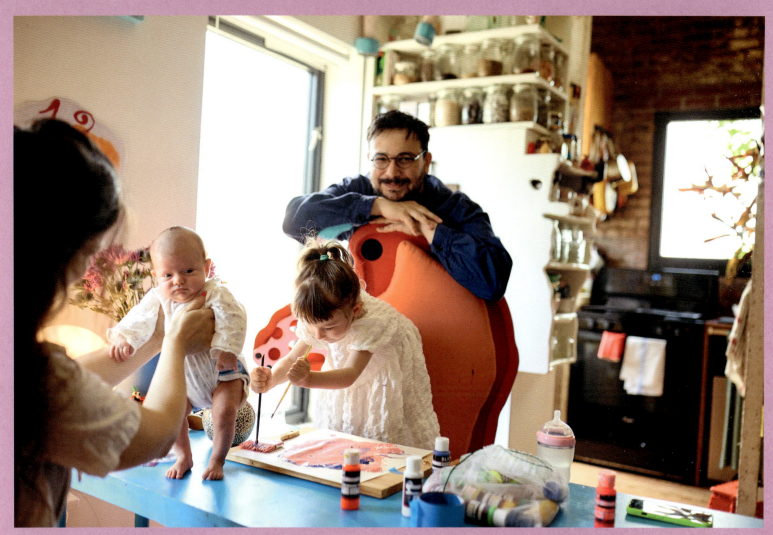

"We had children here, two home births. I cut the umbilical cords."

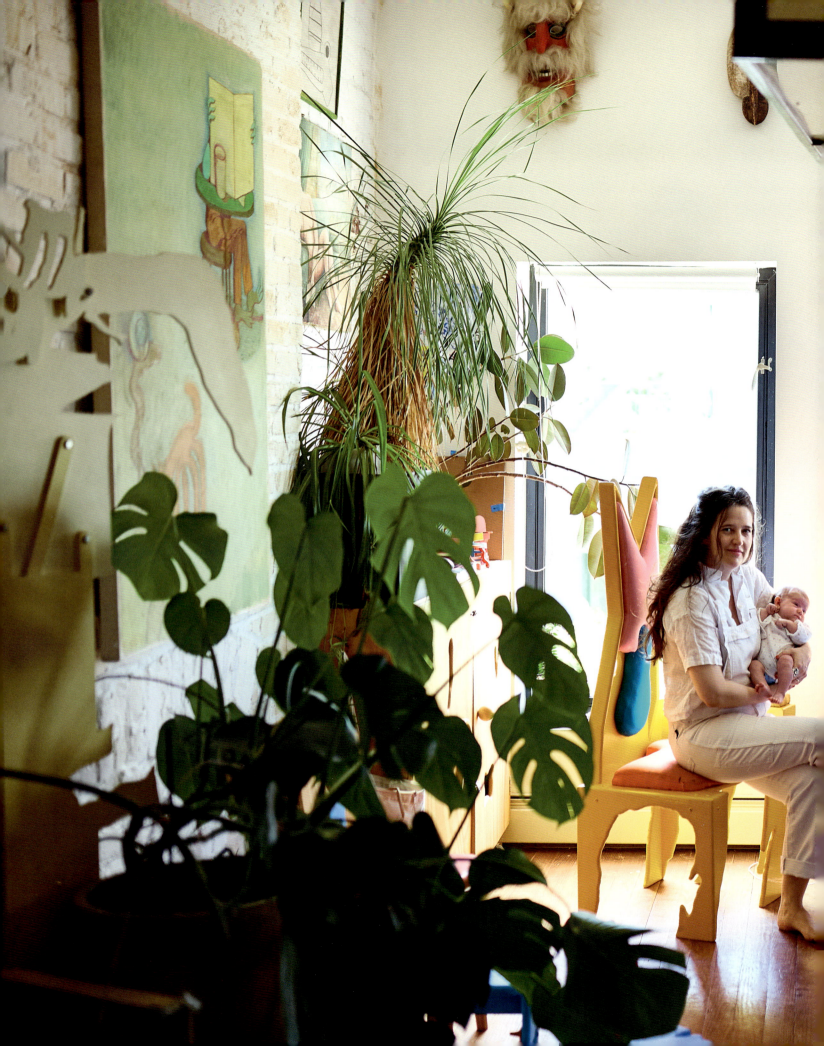

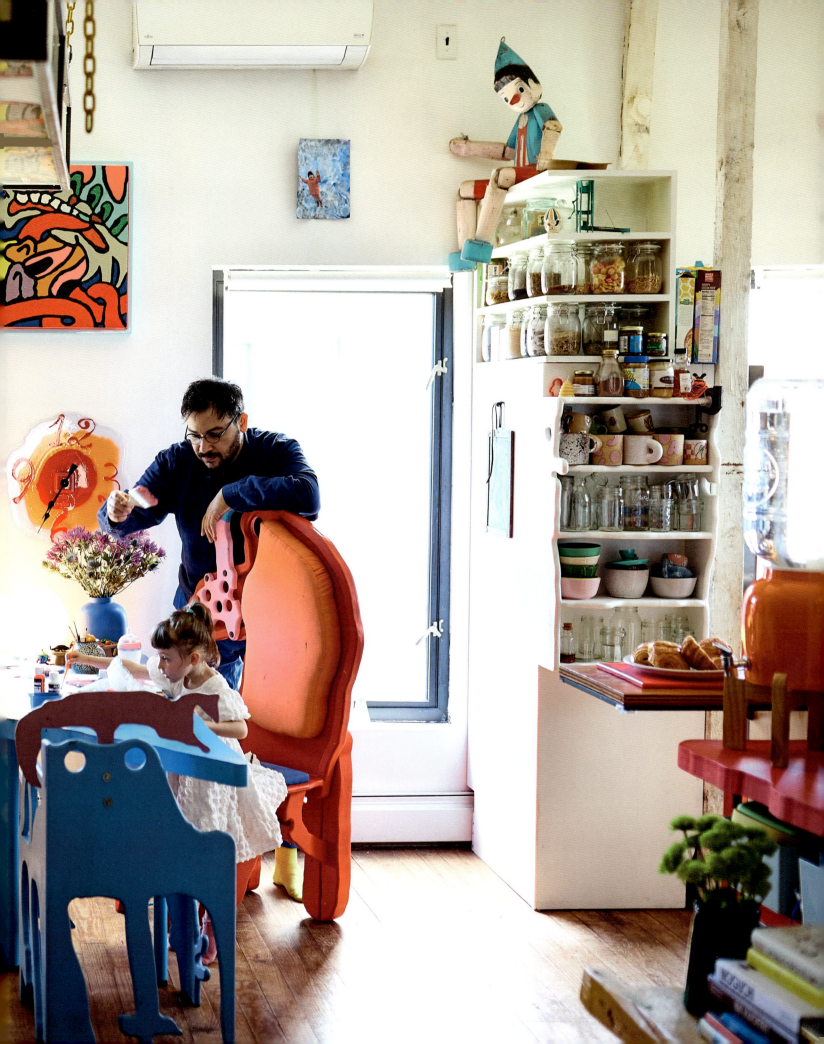

This light fixture is called "sun."

"The sharp steel yellow chair is called Ferdinand."

Bérénice Eveno & Serban Ionescu with Zélie & Azure

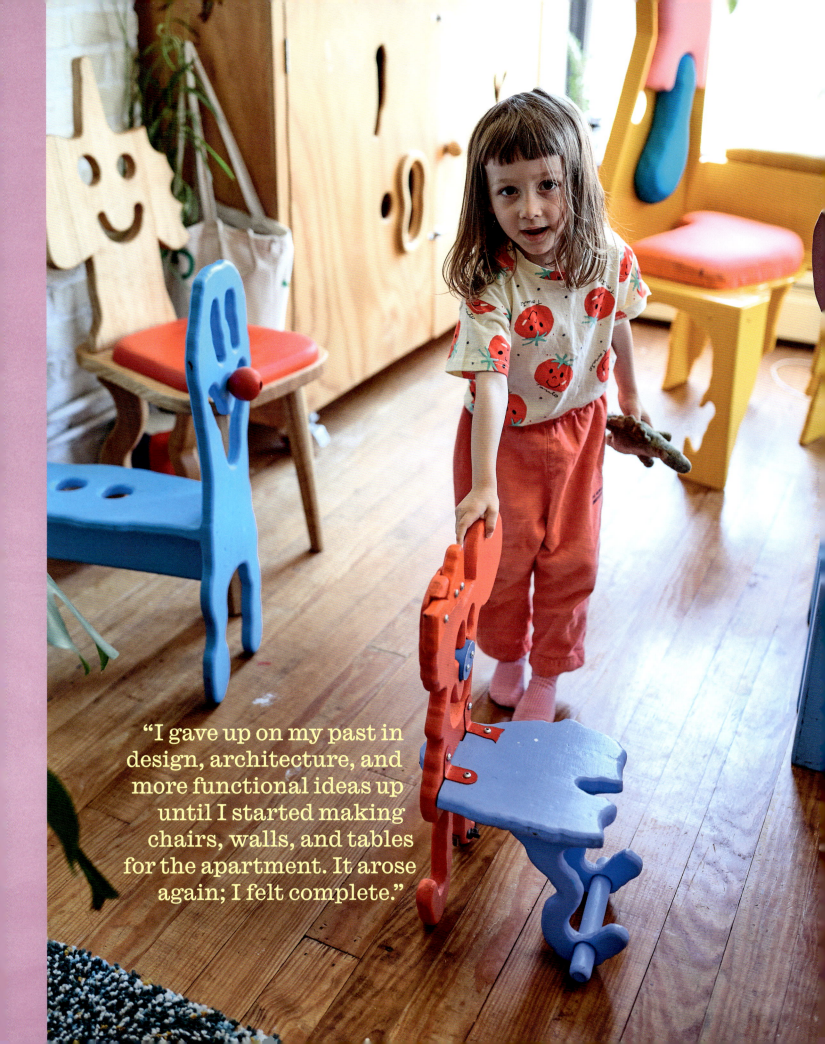

"I gave up on my past in design, architecture, and more functional ideas up until I started making chairs, walls, and tables for the apartment. It arose again; I felt complete."

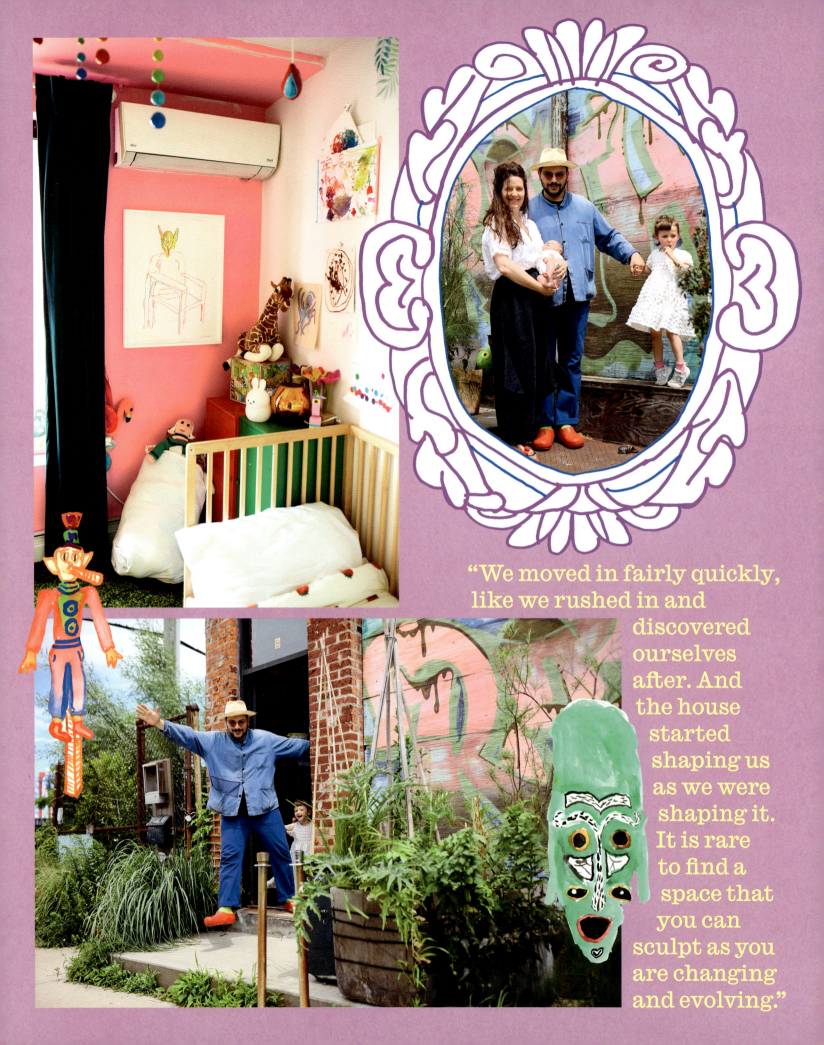

"We moved in fairly quickly, like we rushed in and discovered ourselves after. And the house started shaping us as we were shaping it. It is rare to find a space that you can sculpt as you are changing and evolving."

Hi Serban, Bérénice, Zélie, Azure! Serban could you design a hat for baby Azure ↵

Bérénice could you draw a colorful cloud ↵

Zélie could you design a chair for daddy ↵
Serban could you design a chair for the statue of liberty ↵

Serban how is fatherhood fun? Like riding your bike down a hilly street, faster and faster the more fun but any pothole, wet sewer cap, car backing out of a driveway can tumble you down...

Bérénice how is being a mother fun? Getting to be a kid again... but this time being the boss. ♥ Most of all, all the cuddles & all the LOVE!

JASON KREHER & EIRIK ANDERSON
with Rex & Tennessee in Portland

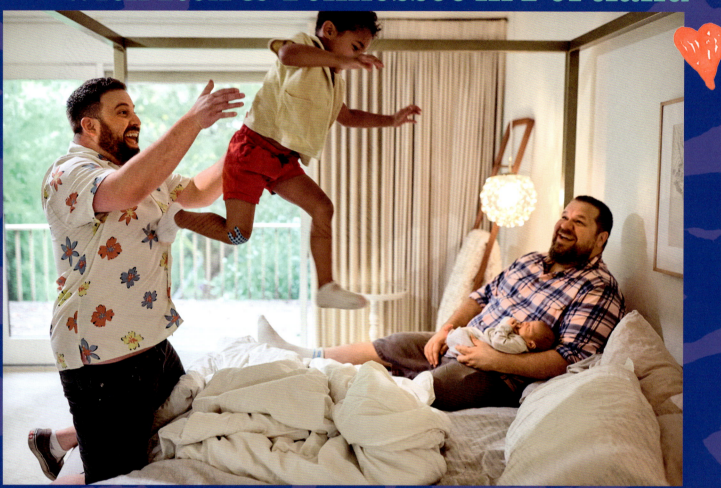

"We are a whole house full of boys, and so it sort of smells bad in here."

Eirik's grandparents built this house in the sixties. They were big partiers, so it's definitely a house built for entertaining. Eirik is a stay-at-home dad, camp counselor, physical trainer, amateur mycologist, and Dungeons & Dragons expert. Jason is a creative director and writer, originally from Georgia. At thirty he moved to Portland, came out of the closet, started on a dating app, and went on exactly two miserable dates. He found Eirik's profile on a local newspaper's dating website. "He said yes to a date with me. He was my third gay date, my first boyfriend overall, and then we got married. That was not the plan, but he tricked me into it, and we're now here with the most weird, beautiful family I could have ever dreamed up." Jason describes the current household's vibe as "The get-down-in-the-bunker-and-get-through-it-without-any-sleep part of life."

"Eirik spends most of his time alternating between the coffee machine and the formula machine."

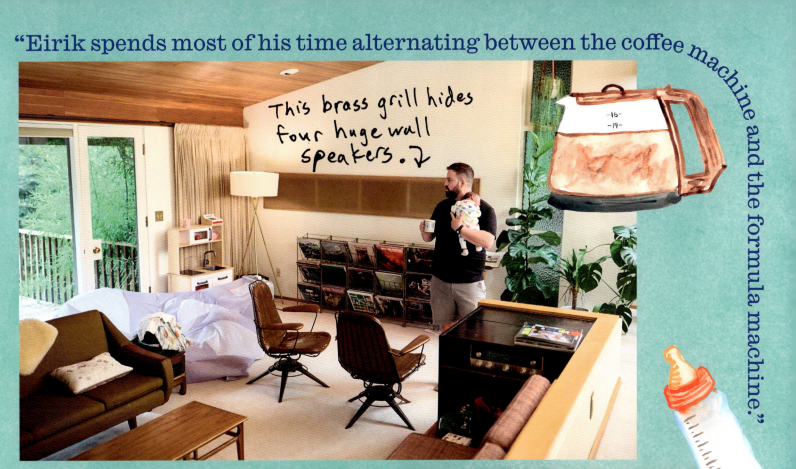

This brass grill hides four huge wall speakers.

Beautiful white McIntosh receiver

JFK + MLK

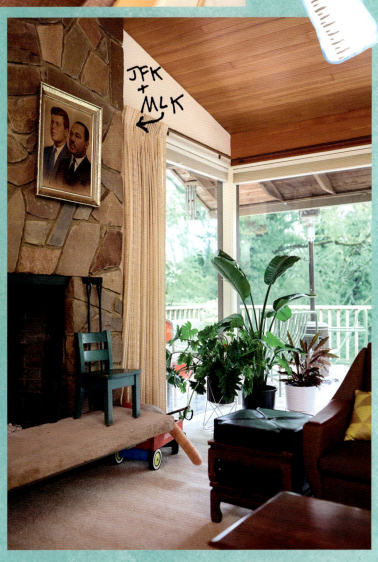

"This used to be the dining room. But there is white carpet, which seems like a bad idea for a dining room, and two kids."

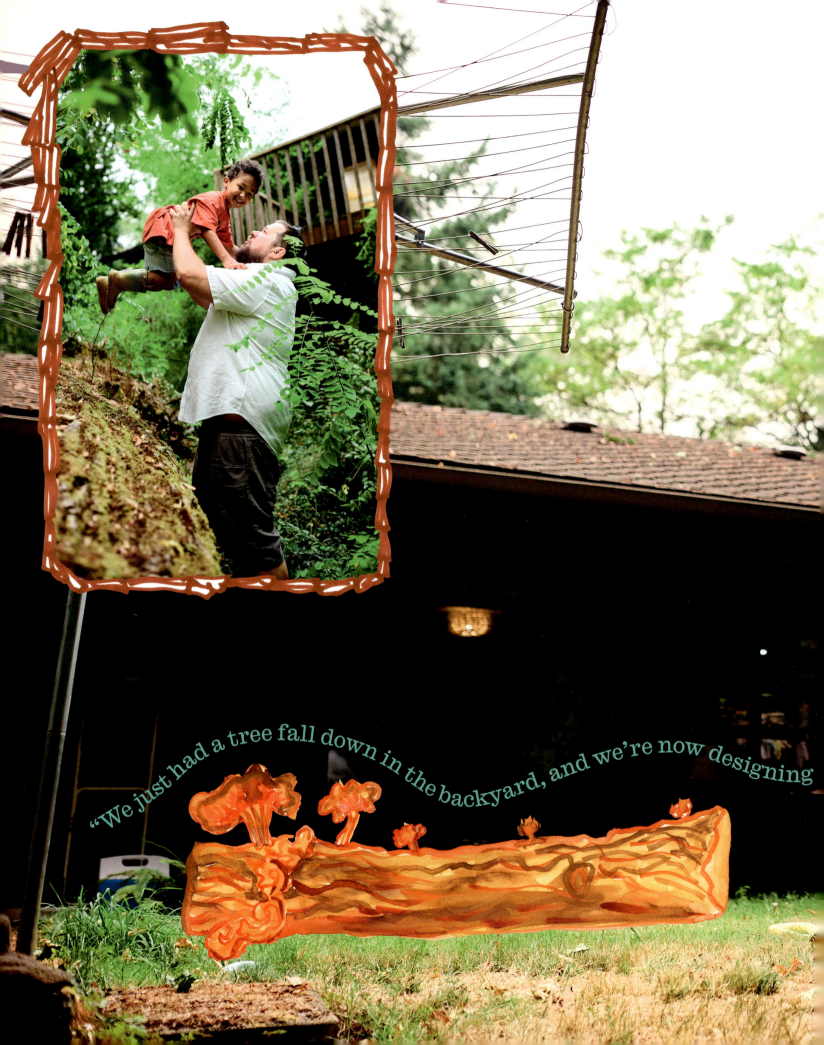

"We just had a tree fall down in the backyard, and we're now designing

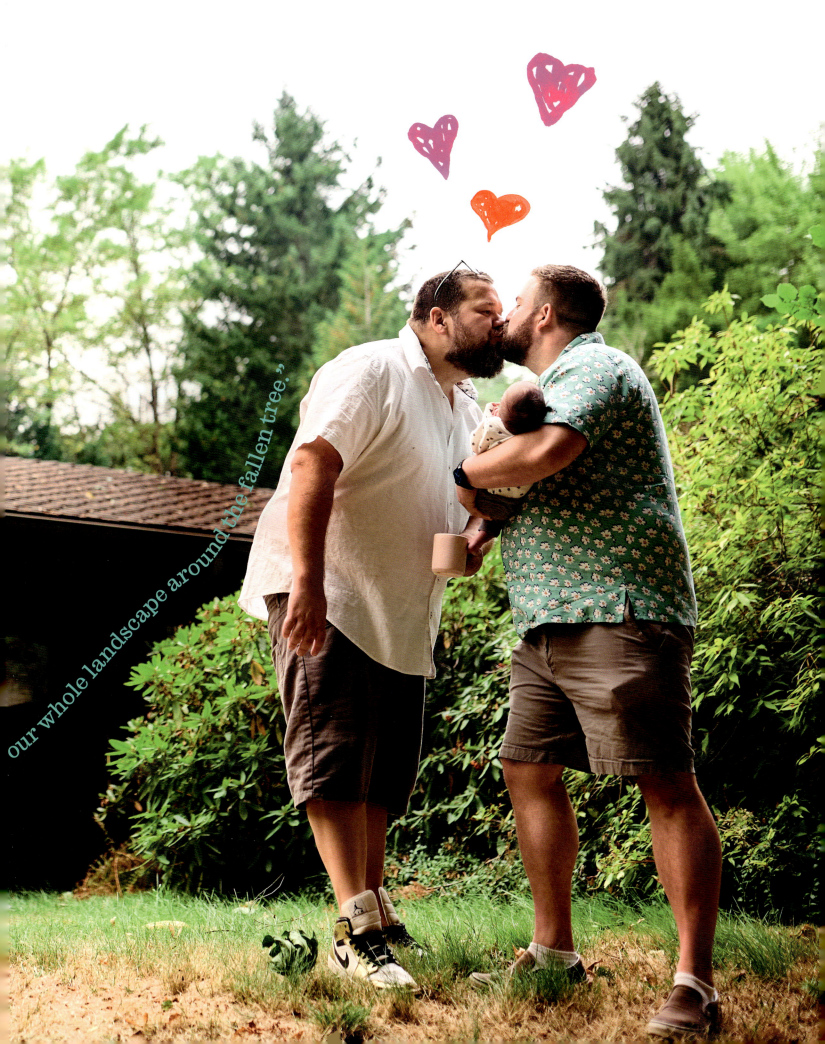

"our whole landscape around the fallen tree."

"I think Tennessee is probably a little bit more laid-back than Rex, if I can say anything about a two-week-old."

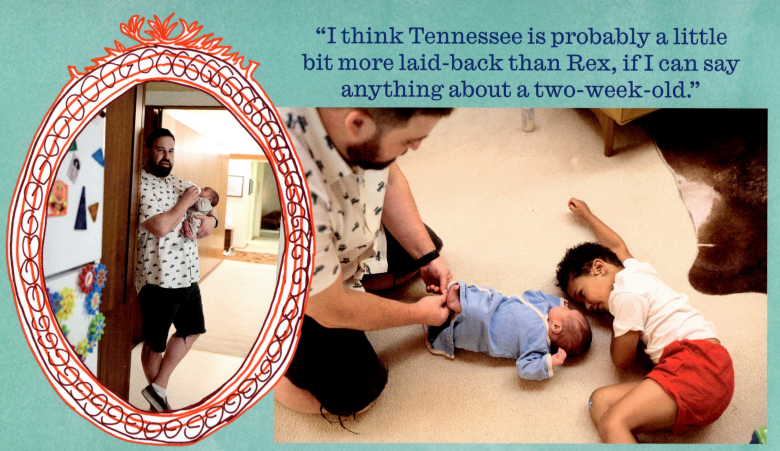

"The only exercise I'm able to get around this house is taking huge logs and throwing them into the air and catching them."

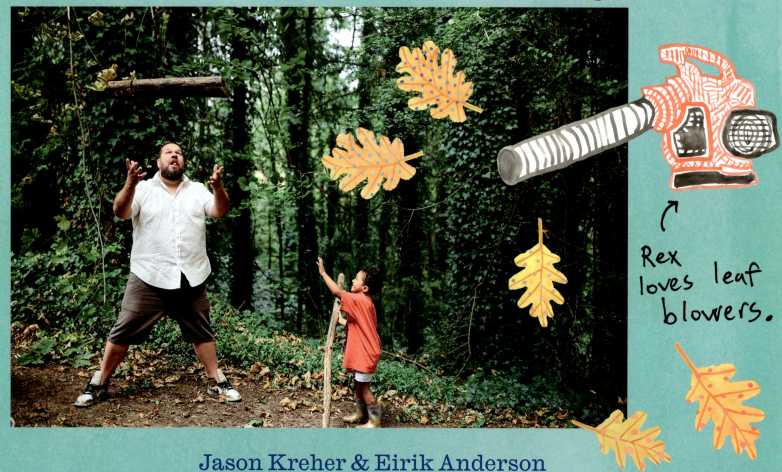

Rex loves leaf blowers.

Jason Kreher & Eirik Anderson with Rex & Tennessee

Hi Eirik, Jason, Rex + Tennessee! Hi Rex could you draw a treasure map of where the treasure in your house was hidden →

Eirik could you describe your ideal player character to defeat the evil moss monster?

Jason what are funny things to teach your kids? TRY USING THEM TO COMMUNICATE PASSIVE-AGGRESSIVE COMPLAINTS ABOUT YOUR PARTNER. "DADA EIRIK, WAS SAVING THIS ONE TABLESPOON OF LEFTOVER RICE IN THIS HUGE TUPPERWARE A GOOD CHOICE?" IT'S ALWAYS FUNNY.

Jason draw your most prized gem →

Eirik could you design an obstacle course for the whole family?

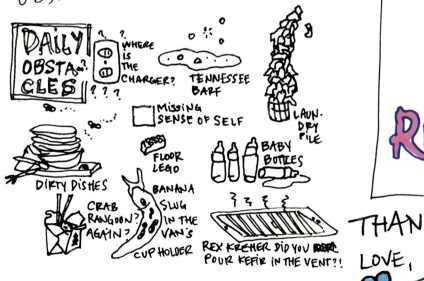

THANK YOU, TODD "THE" SELBY!
LOVE,
JASON, EIRIK, REX & TENNESSEE

DARYA & GIDON BING
with Eli & Mika in Auckland

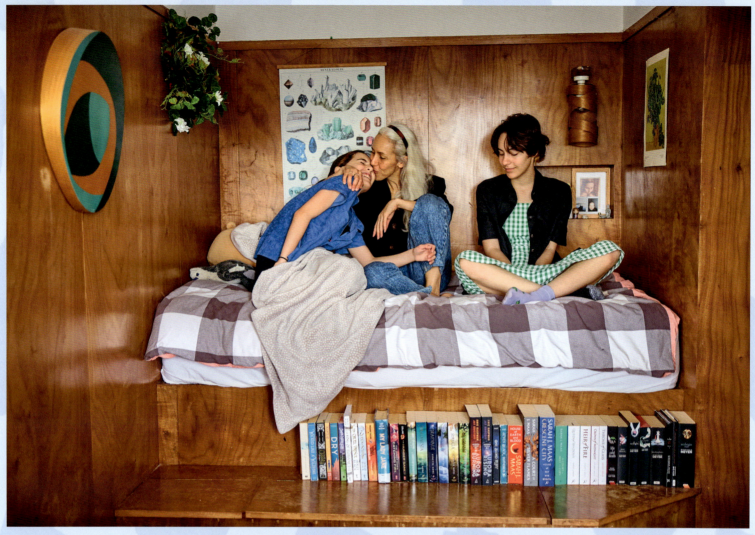

"I want the kids to understand that if you can visualize it, you can make it," says Darya. "You are the creator in your life." She and Gidon met in a Dadaist artist village in Israel, where Darya was born. "A Hungarian Jew who was the co-inventor of Dadaism immigrated to Israel to escape Nazism. My parents were a part of the founding members." The family's plywood-clad house was built in 1947 by Gidon's grandfather Henry Kulka, a key figure in and principal in the development of the avant-garde architectural movement known as Raumplan. Gidon recalls his grandparents' reverence for skilled craft and manual processes. "Whenever there was a bricklayer or roofer, they'd shove me in to watch." The Bings also run Raumform, a small multidisciplinary architectural studio perched over the sea in a nearby artistic community. "The area is full of interesting characters," says Gidon.

"Our house was built in 1947 by my grandfather, who was an avant-garde architect. He co-developed a style of architecture [with his partner Adolf Loos] called Raumplan, a method of three-dimensional spatial design. This method of designing created interlocking cubic niches rather than floor levels. It was about intimate spaces with multiple functionalities."

"Trying to decipher a pattern for a dress that Eli wants to make."

"This is a very early work of mine when I was still developing the steam-bending plywood pieces."

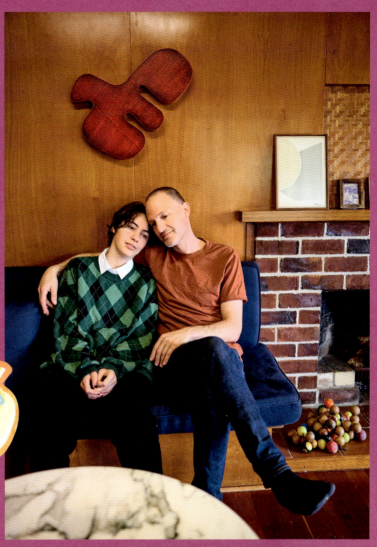

Gidon's artwork ↓

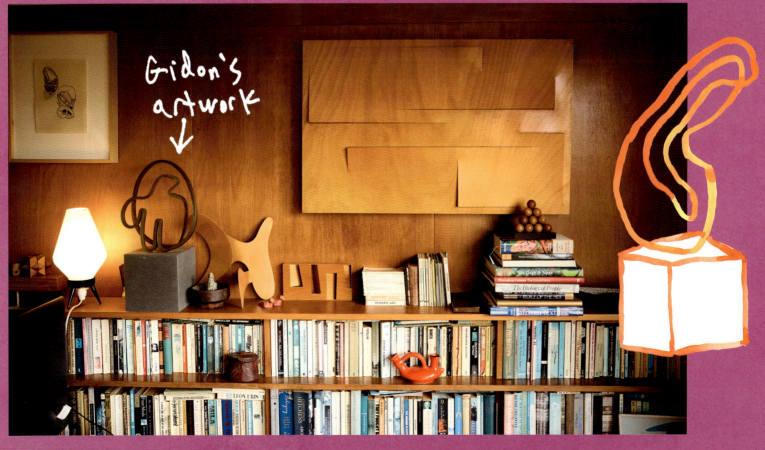

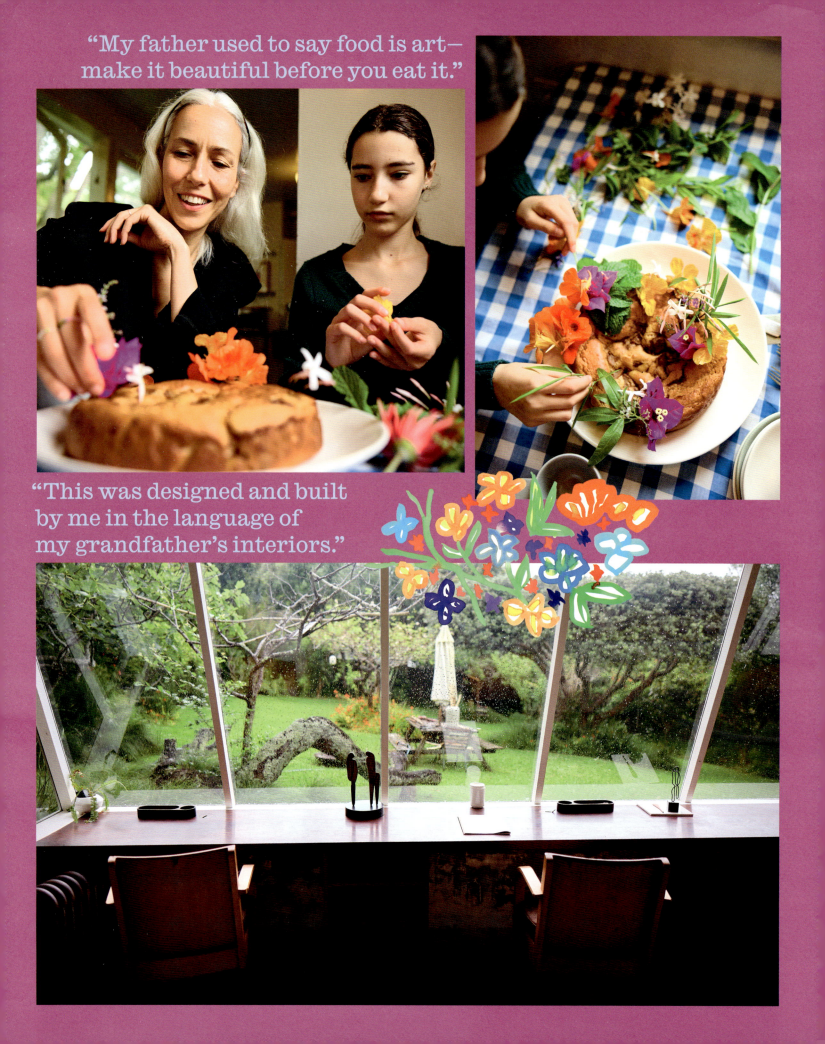

"My father used to say food is art—make it beautiful before you eat it."

"This was designed and built by me in the language of my grandfather's interiors."

"Hey, Eli, have you finished your schoolwork? Let's build a tree house."

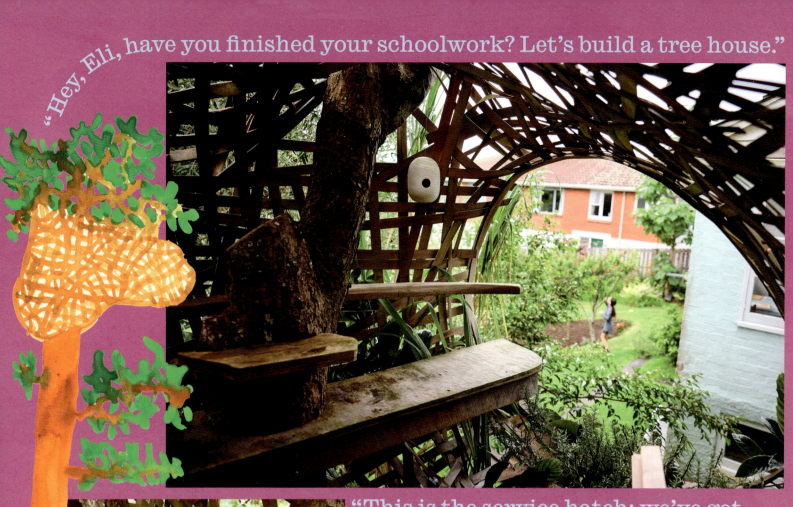

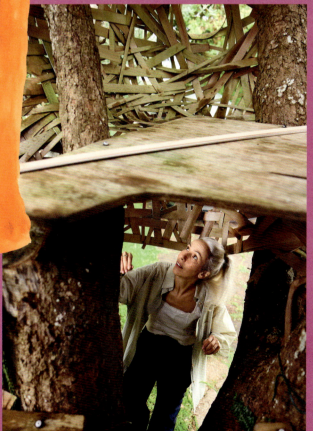

"This is the service hatch; we've got a little gantry winch, so that the girls can service themselves and get special deliveries."

Darya & Gidon Bing with Eli & Mika

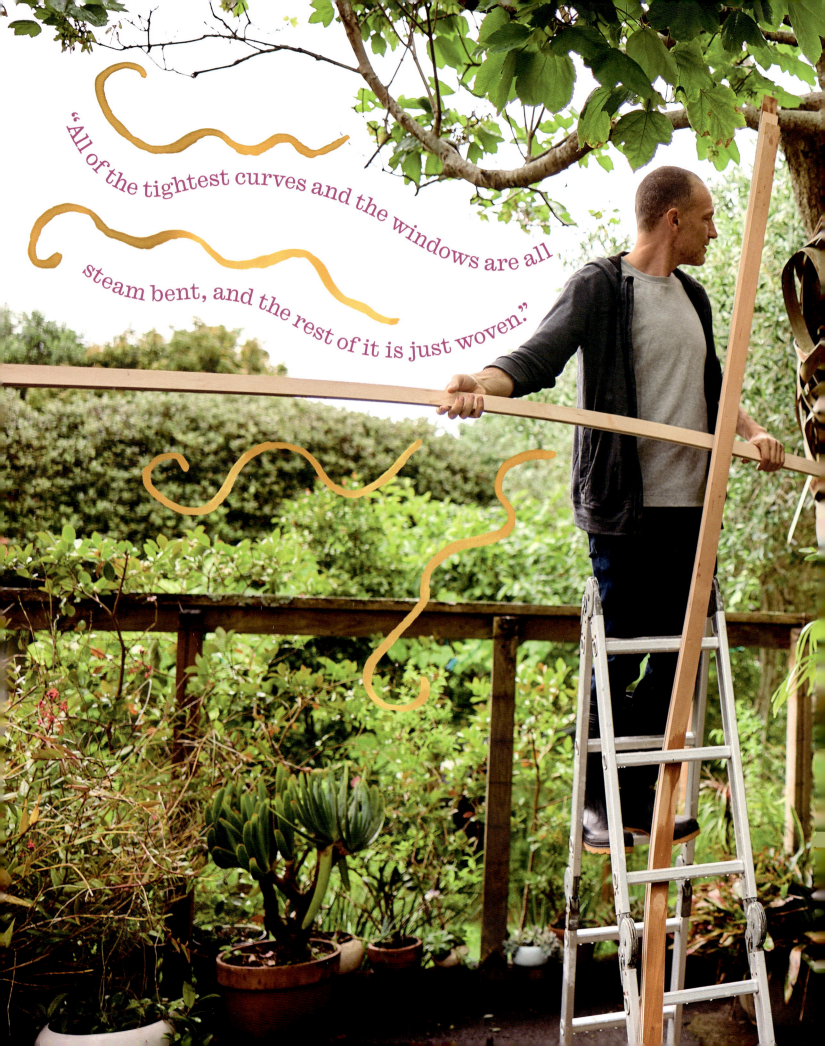

"All of the tightest curves and the windows are all steam bent, and the rest of it is just woven."

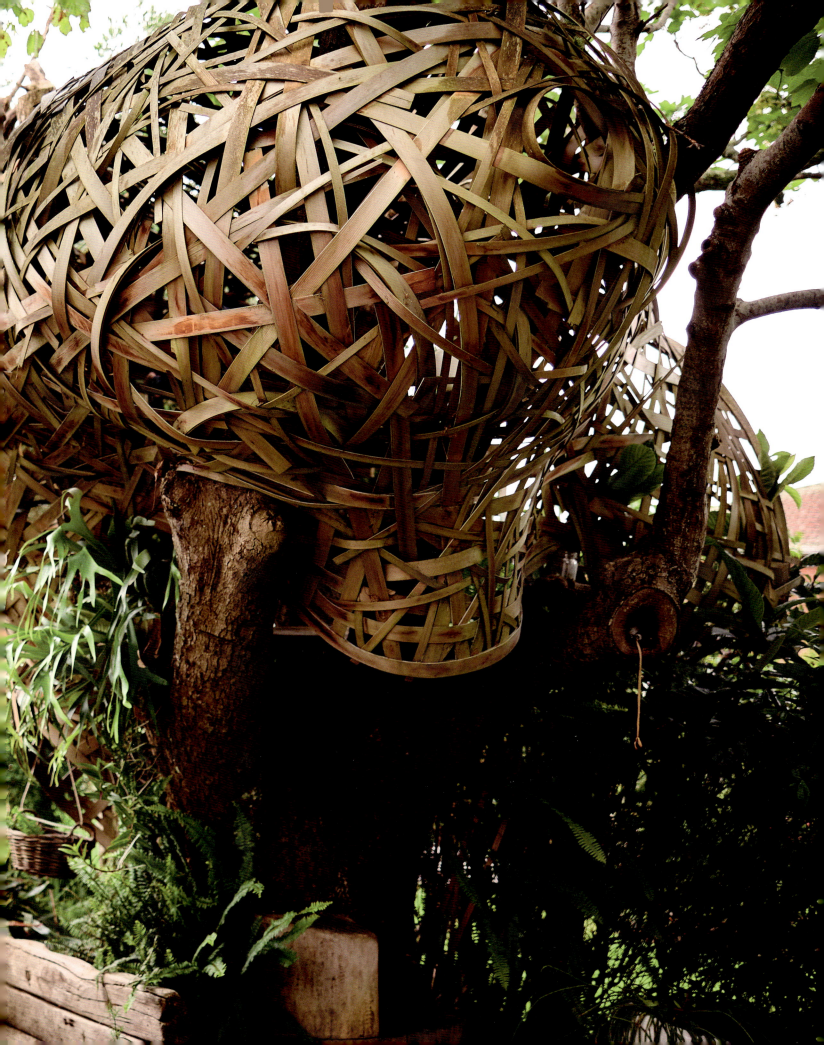

"Our studio's favorite neighbor is an idealist, polemicist environmental architect who wanders around with his pet pig."

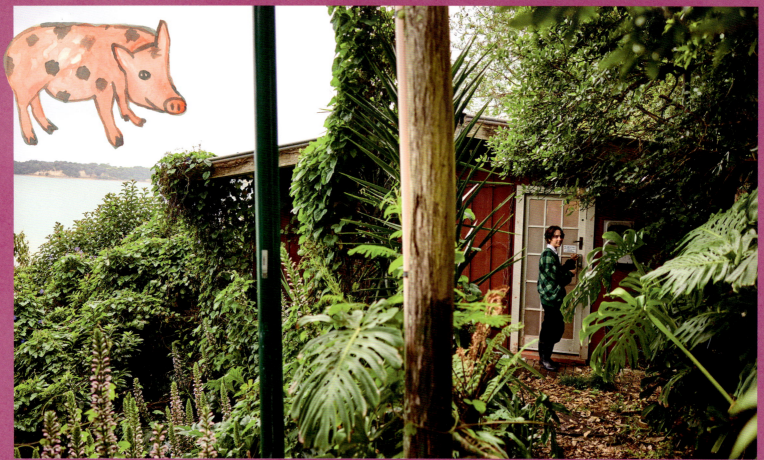

"We planted sugar cane in the garden and every summer, we make sugar cane juice."

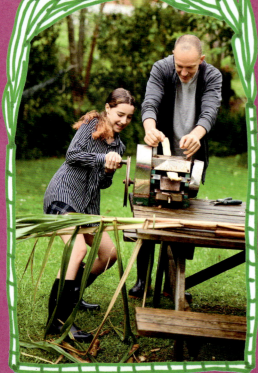

Harvesting edible flowers in the backyard

Darya & Gidon Bing with Eli & Mika

Hi Darya, Gidon, Eli + Mika! Mika could you draw a landscape of your garden →

Eli could you do a drawing inspired by your cat →

Gidon could you design an interior for your dream tent to take to the Sinai desert →

Darya could you draw a meal to wow a cat →

could the family all design a beach animal paradise →

BEATRICE VALENZUELA & RAMSEY CONDER

with Astrid & Dimitri in Echo Park

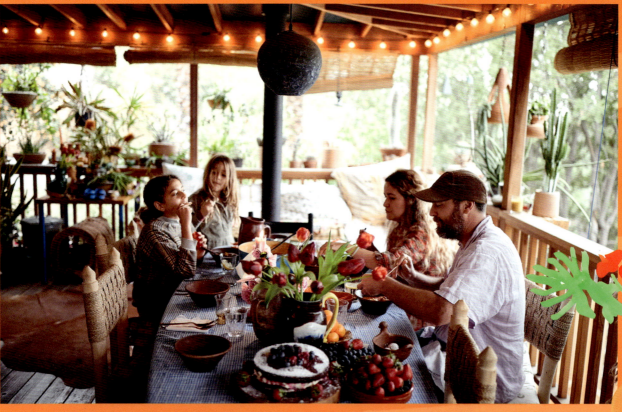

"We have a big deck, so there's a lot of time being spent out there. It has a roof, but it's almost like being outside, but with a roof. And then it's a pretty small house, but because of that deck, it makes it feel so much bigger."

"You don't need much space to create an environment that feels lovely," says Beatrice. "I think the smallness of the house helps keep us closer together." Beatrice and Ramsey found their cozy treehouse in the hilly heart of LA. Beatrice says she manifested it from a magazine. "We've been living in Echo Park for twenty years, getting to know the community in a deep way. I saw a picture of a house that looked just like this, and I cut it out and put it on my fridge. And our house is exactly that." Most of the objects in the house were collected during travels or made by Beatrice and Ramsey themselves. "Anywhere we go, we always try to bring something wonderful home. Rugs from Athens and Oaxaca. We went to Hawaii and brought back embroidered pillows." The family, including daughter Astrid, loves to cook. "We love eating outside. My kids have grown up eating with so many different people and seeing so much pleasure in food. We have sunsets every night. It's just magical."

"My family likes to call this the seafood bonanza. I like to use at least five to seven kinds of sea creatures. I make the broth with a salmon head, so it is very delicate and rich; it almost tastes like you put cream in it."

Old photo of Dimitri "cooking"

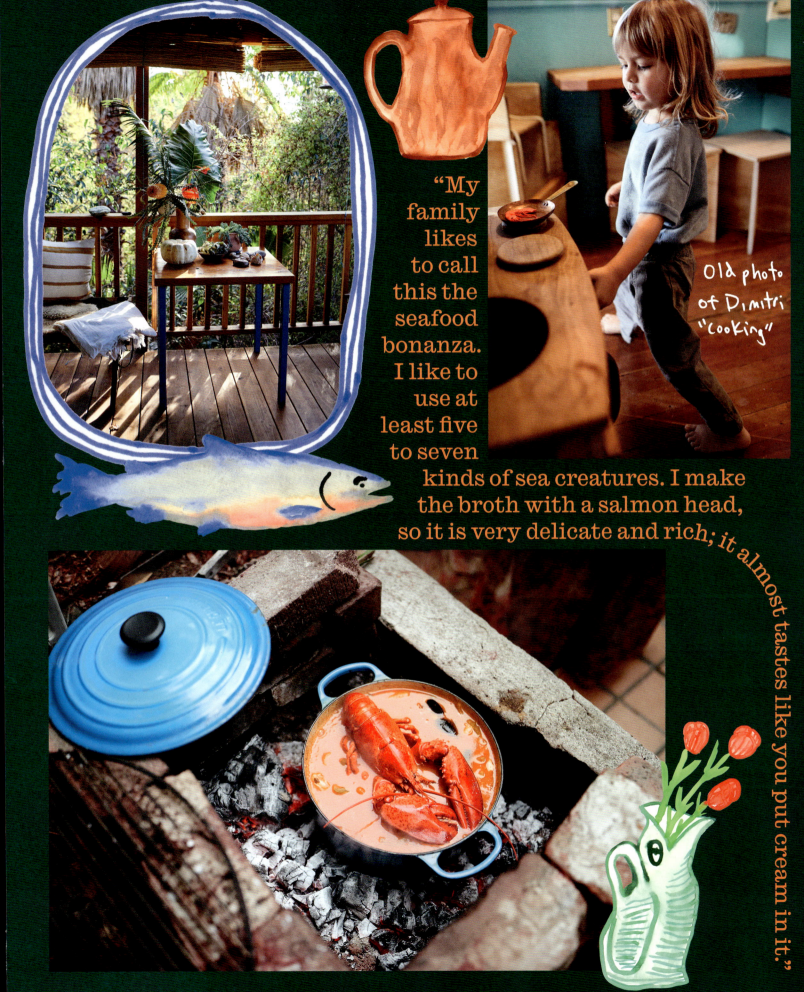

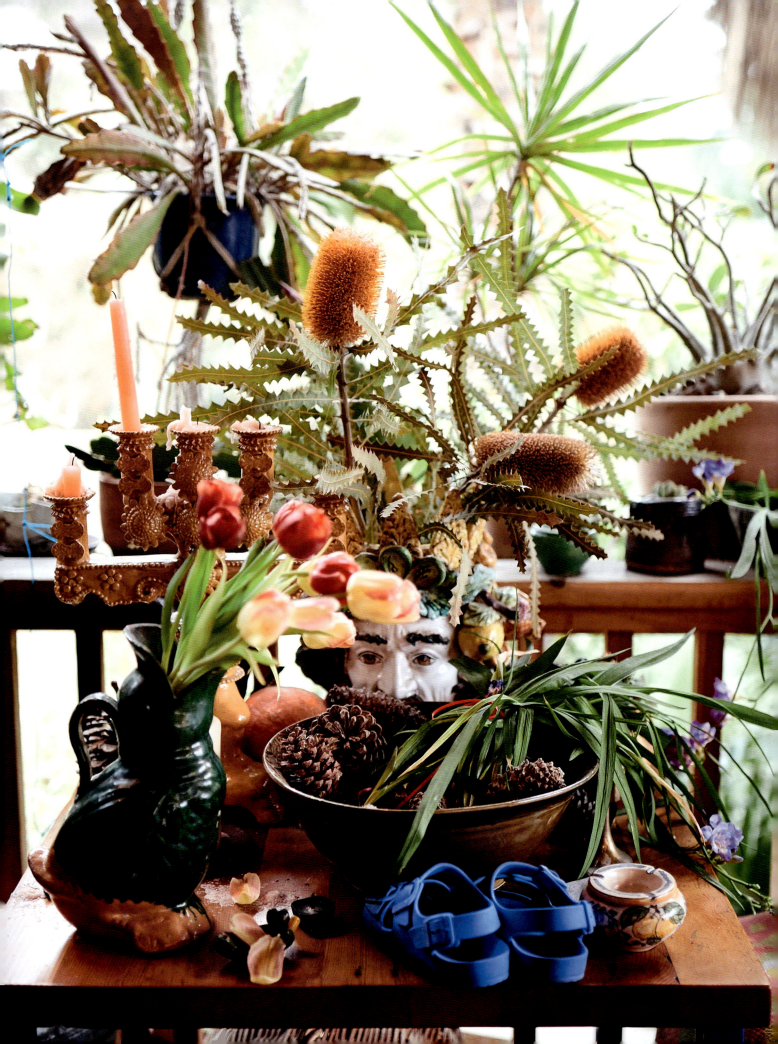

"Cabinets don't really work for me, because I like to see what I have to work with."

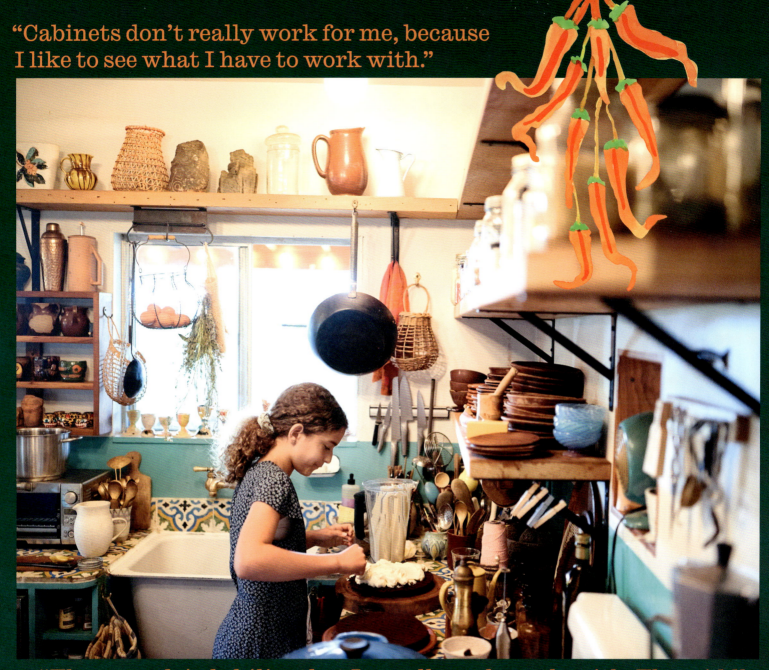

"These are dried chilies that I usually make mole with. The middle jar is brown sugar, and then the one on the right is black tea."

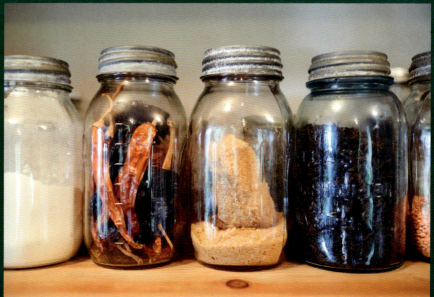

"Burnished clay is a precolonial technique. The finish is rubbed on with a stone. When porcelain plates touch, they make this kind of high-pitched sound; with this clay, it's just a soft, deep sound."

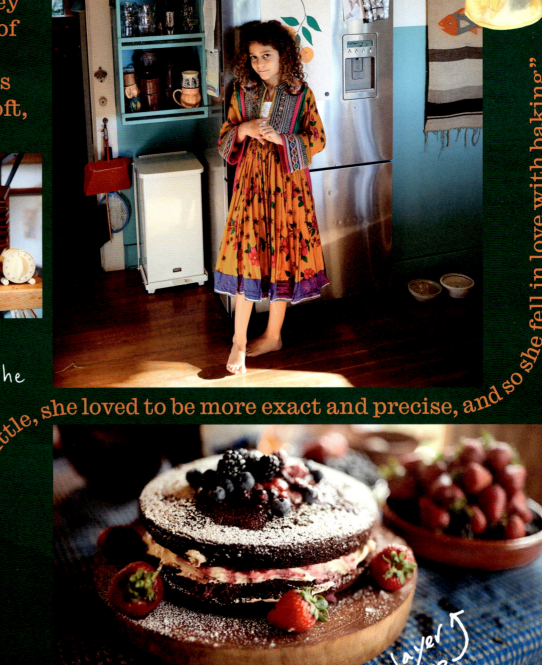

Stained glass on the front door

"Since Astrid was really little, she loved to be more exact and precise, and so she fell in love with baking."

Astrid's three-berry layer cake

Beatrice Valenzuela & Ramsey Conder

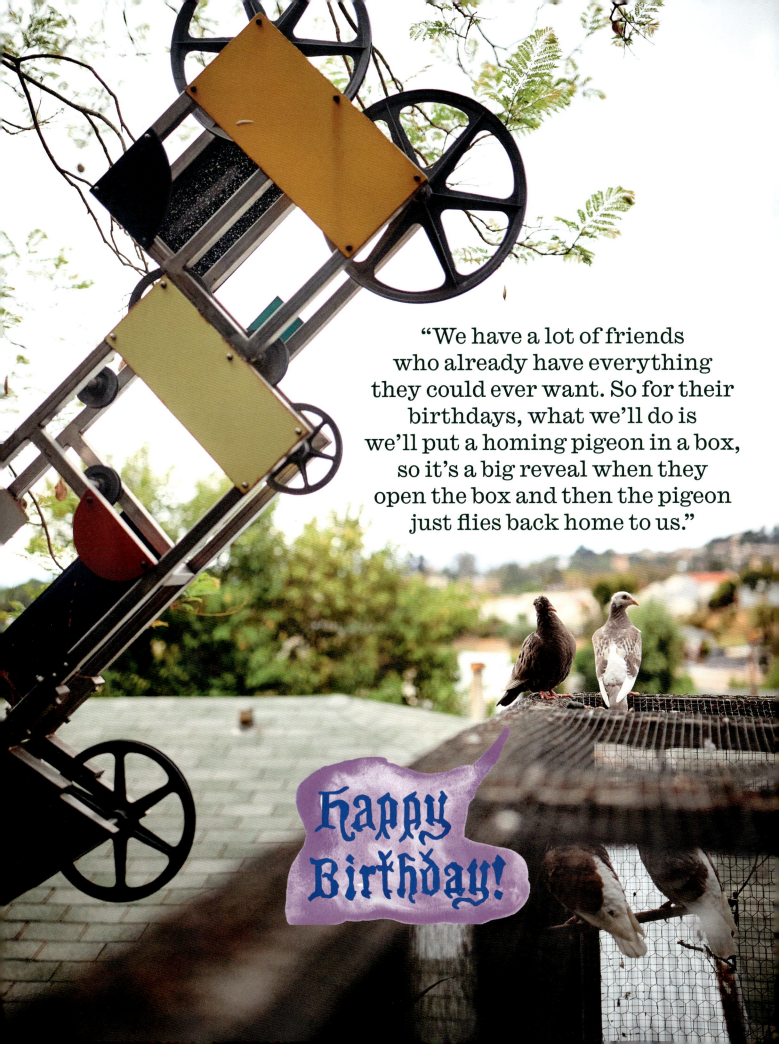

"We have a lot of friends who already have everything they could ever want. So for their birthdays, what we'll do is we'll put a homing pigeon in a box, so it's a big reveal when they open the box and then the pigeon just flies back home to us."

Happy Birthday!

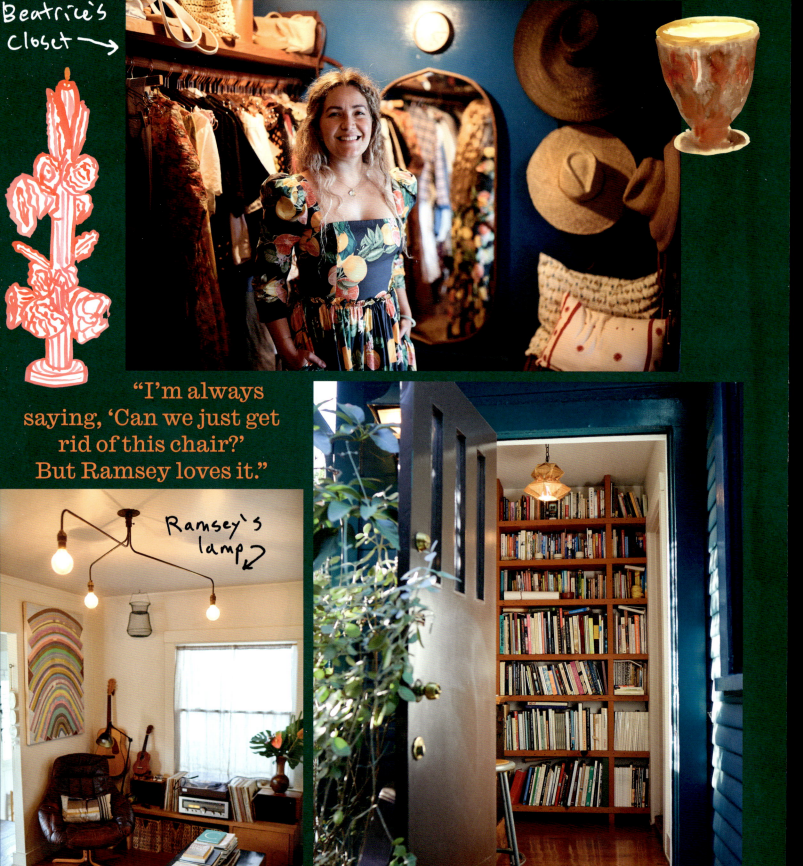

Beatrice's closet →

"I'm always saying, 'Can we just get rid of this chair?' But Ramsey loves it."

Ramsey's lamp ↘

Hi Beatrice, Ramsey, Astrid + Dimitri! Beatrice could you design a dress for a shrimp

Ramsey could you design a pull for Uncle Johnny's cactus cabinet

RUFFLE CAMARÓN DRESS
#BVmoda

It works best with a push to open latch.

Astrid could you draw some eyes, dogs + people

Dimitri could you make up + draw a new kind of dinosaur

Beatrice could I get a recipe for a cocktail inspired by Echo Park?

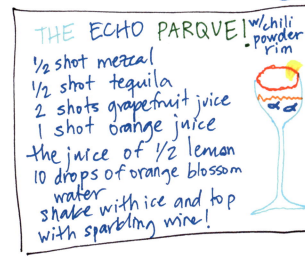
THE ECHO PARQUE! w/ chili powder rim
½ shot mezcal
½ shot tequila
2 shots grapefruit juice
1 shot orange juice
the juice of ½ lemon
10 drops of orange blossom water
shake with ice and top with sparkling wine!

RACHEL & SONIA KANAZAWA
with Luella in Tokyo

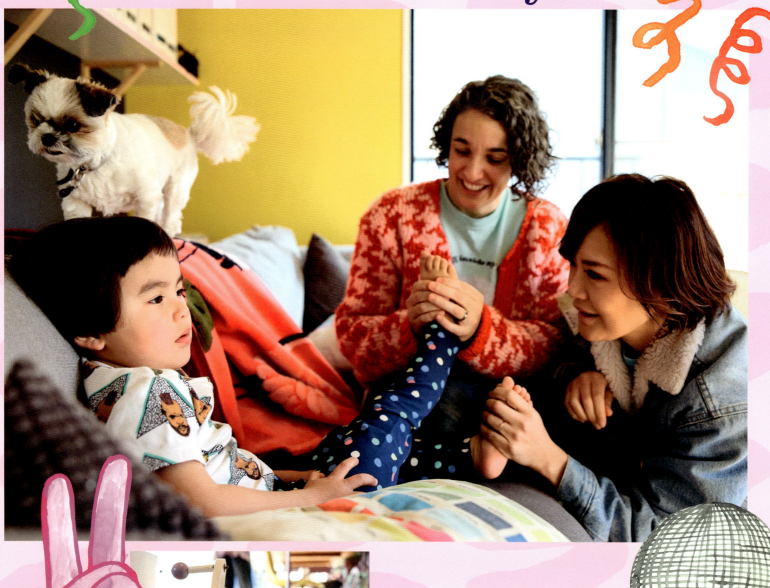

"Lulu is the first grandchild in both families, so she gets endless pampering."

"It's not common in Japan to see families that look like us, but we exist," says Sonia. "We're an all-female blend of cultures, languages, and characters." The Kanazawas feel at home in the heart of Tokyo's funky and colorful Shimokitazawa district. Rachel is an advocate for upcycling used clothes and objects. "I love eighties memorabilia, dancing, nature, camping, dogs, and sweets. I've had my favorite pair of jeans since university more than twenty years ago." Sonia says, "I like to keep my style simple with a touch of personality. Our flat is the closest thing that a small apartment in Tokyo can get to being like the apartment Tom Hanks has in the movie *Big*. We love spending our time eating, drawing, and loudly clacking on a keyboard. But mostly laughing!"

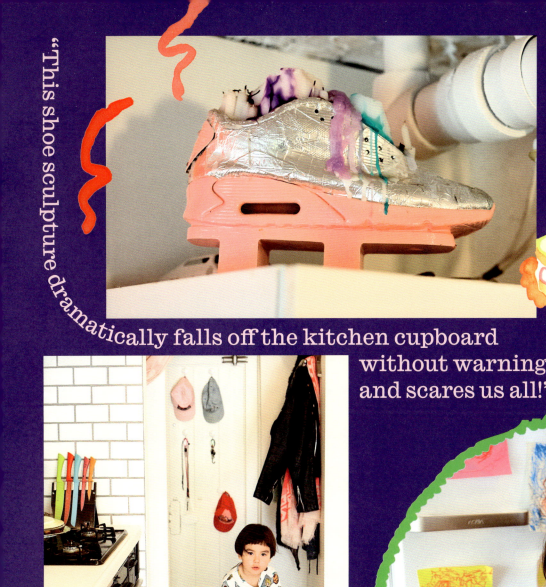

"This shoe sculpture dramatically falls off the kitchen cupboard without warning and scares us all!"

Wedding Donut Pile

"At our wedding, we opted for a donut tower instead of a traditional cake, because a conventional wedding cake just wasn't our vibe, especially since the venue was a pizza restaurant."

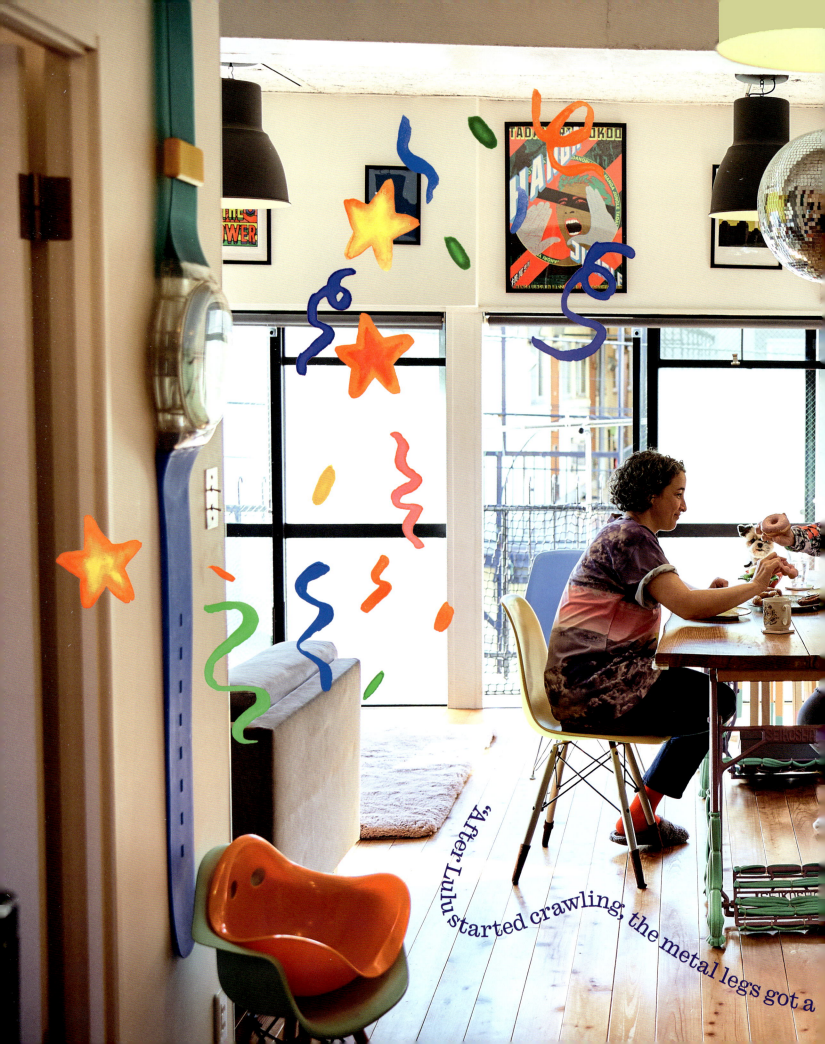

"After Lulu started crawling, the metal legs got a

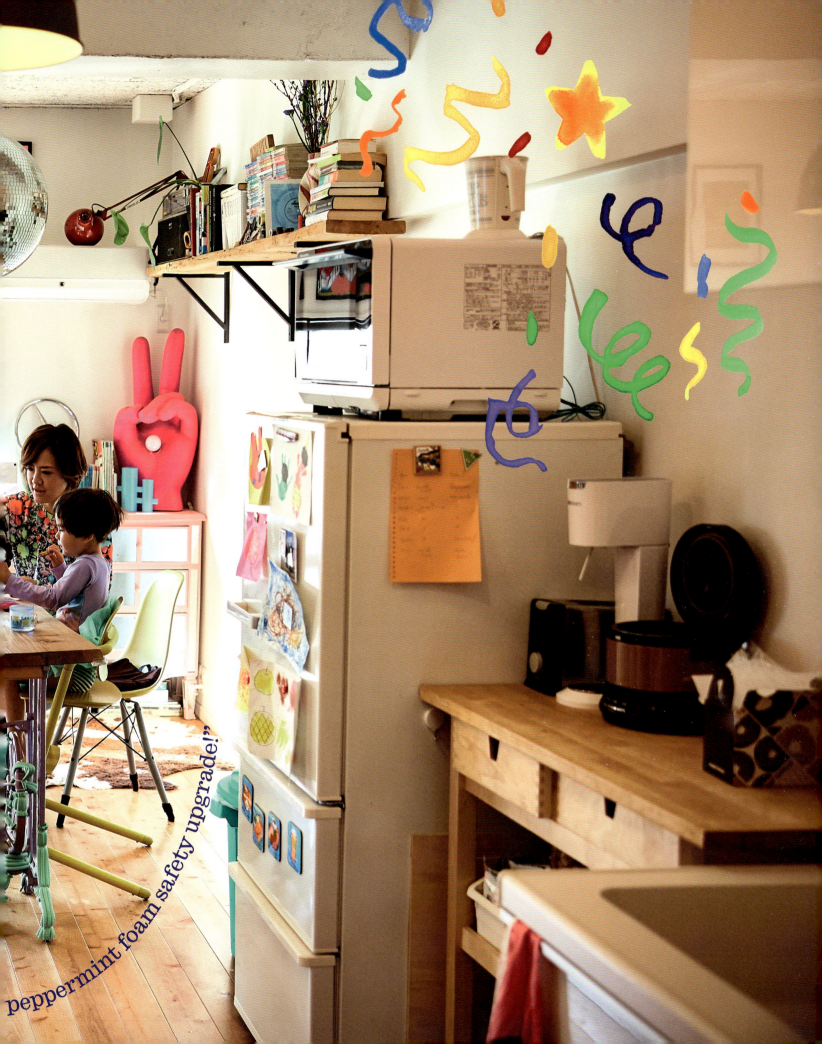

"I found two of these dogs being given away; they are maybe supposed to be garden ornaments? One was a Doberman and the other a sort of spaniel. I carried them to my studio—which was about a thirty-minute walk—but I was grinning the whole time!"

Leftover glasses from a fashion show

Dog one

Dog two

Concrete shoe sculpture

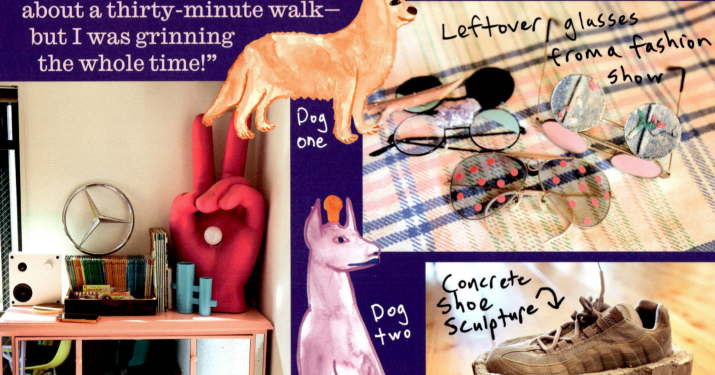

"I love Rachel and her creativity, but the amount of times I hit my poor toe on this…"

Rachel & Sonia Kanazawa with Luella

Hi Rachel-san + Lulu-chan! Rachel-san could you design some concrete
Sonia-san shoes for ~~an~~ acorns? Sonia-san what are 6 fun things that happened at a hooka bar

① SMOKING ④ Impromptu dance party
② Sitting between lawyers and backpackers ⑤ SMOKING
③ SMOKING ⑥ Making local friends

Rachel-san could you design an outfit for Lulu-chan to do Aqua Aerobatics in ↓

Lulu tell me what you love about your mommies?
"I Love choco from Mama!"
"I Love mummy at the animal park!"

Sonia-san could you draw someone farting ↓

Rachel-san + Sonia-san could you design some Hookas ↓

ELIZABETH DOWLING KAUPAS & NATAS KAUPAS

with Clementine & Sunny in Santa Monica

"Natas and I fell in love as pen pals before we actually met."

"Our relationship started in an old-fashioned manner," says Elizabeth. "I was in New York, and Natas was in San Clemente. We exchanged postcards and letters and became pen pals. He invited me on a surf trip to Fiji with a group for Thanksgiving. We actually hadn't met at the time. But he said, 'Worst-case scenario, it'll be a great trip. And best-case scenario, we'll be in love.'" Since retiring from professional skateboarding, Natas has gravitated toward art and graphic design while spending plenty of time with daughter Clementine, five-year-old Sunny, and the three family dogs. "I lived next door to this house for the first ten years of my life," says Natas. "My dad was curious about the home next door, which is the home we live in now. He bought it for some crazy small amount of money, and that's how it ended up in the family."

Natas found his dad's router and, just to make sure it worked, made this marble run.

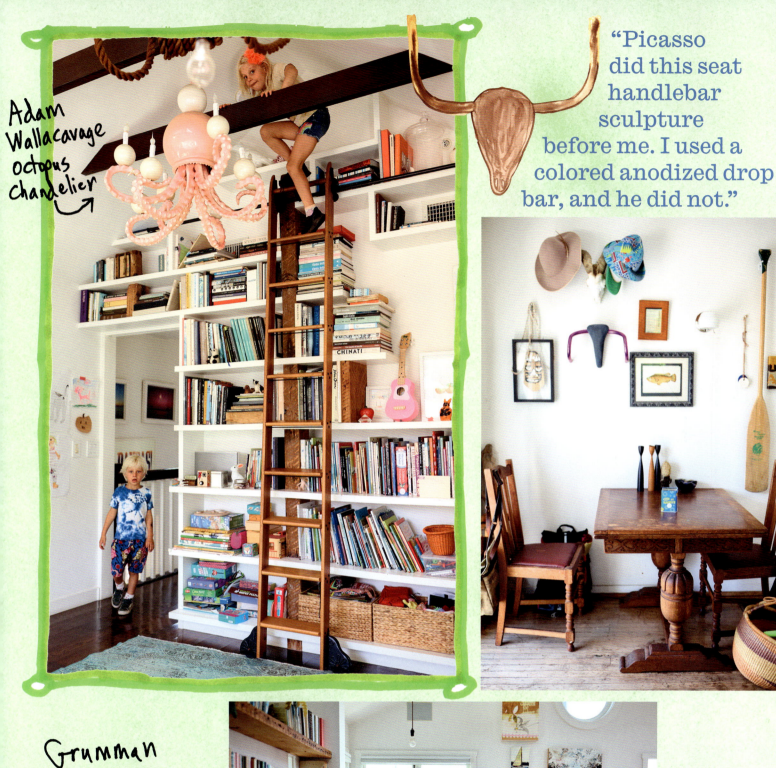

Adam Wallacavage octopus chandelier

"Picasso did this seat handlebar sculpture before me. I used a colored anodized drop bar, and he did not."

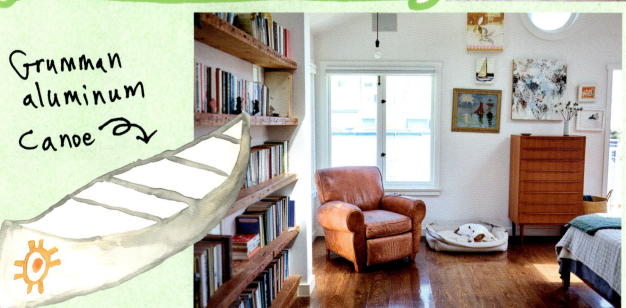

Grumman aluminum canoe

The shelves are made from old floor joists.

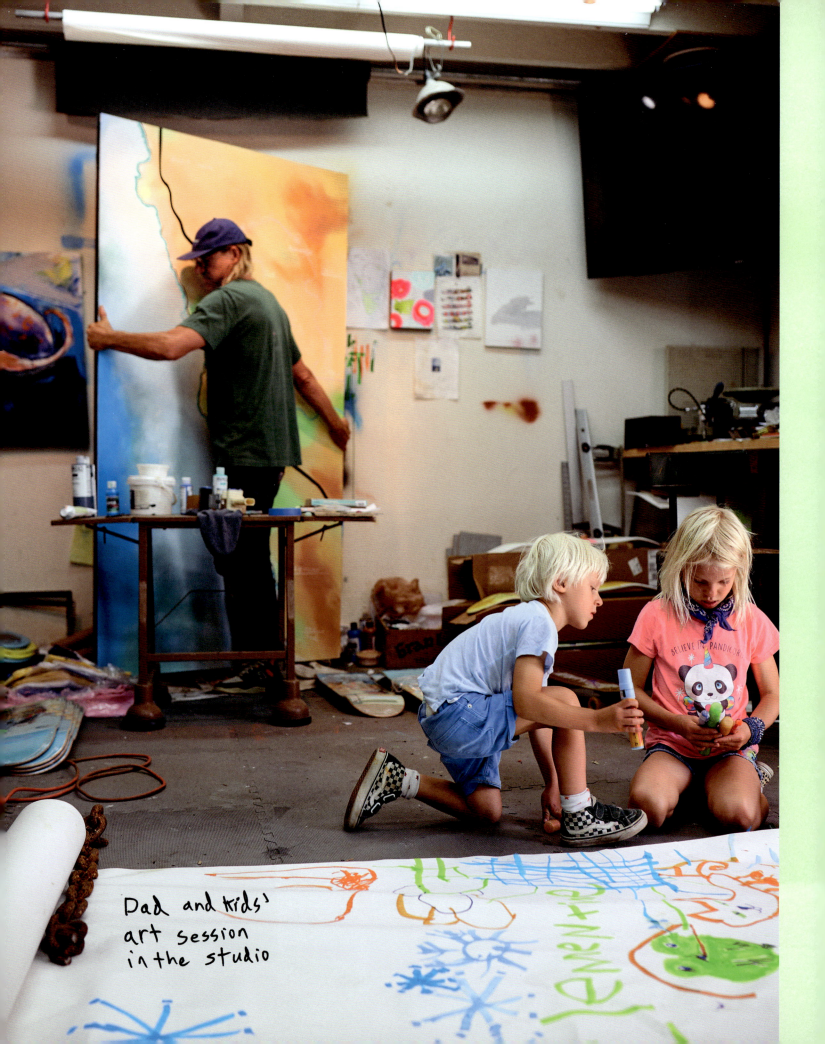

Dad and kids' art session in the studio

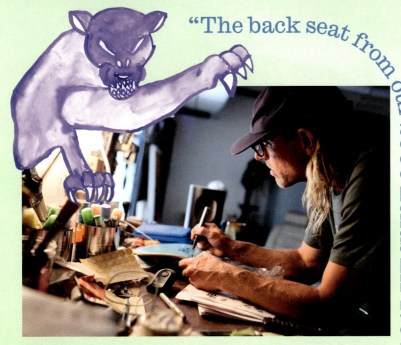
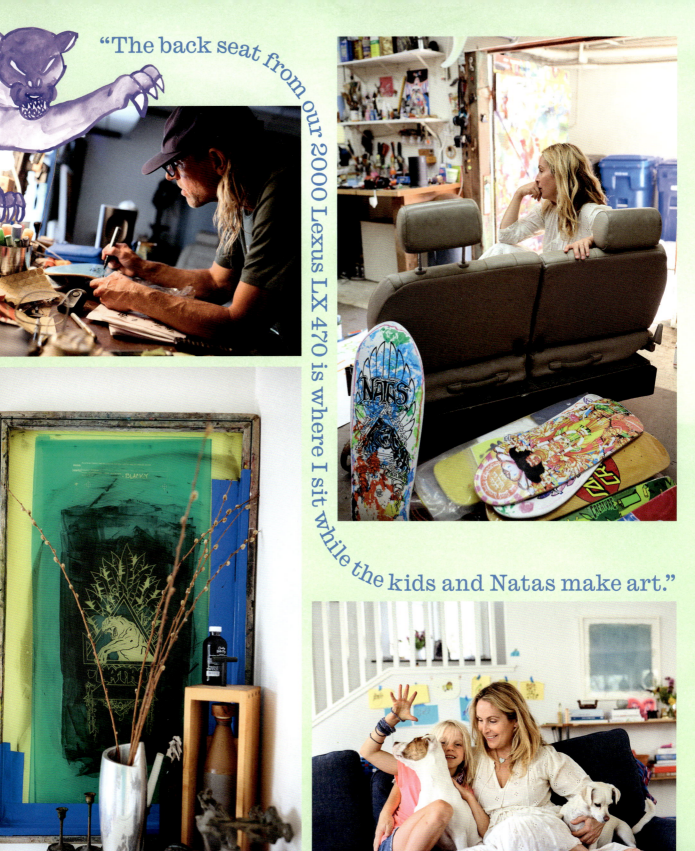

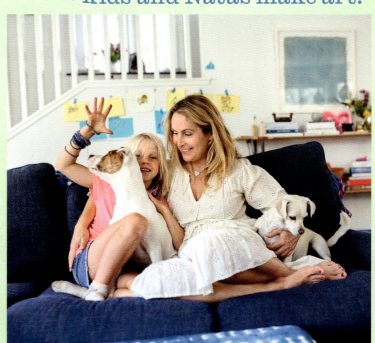

"The back seat from our 2000 Lexus LX 470 is where I sit while the kids and Natas make art."

Elizabeth Dowling Kaupas & Natas Kaupas with Clementine & Sunny

101

"In that old ammo box is a doorbell. He can ring the doorbell as much as he wants or as long as he wants. Also we made a bunch of light switches with different light bulbs for the kids to play with."

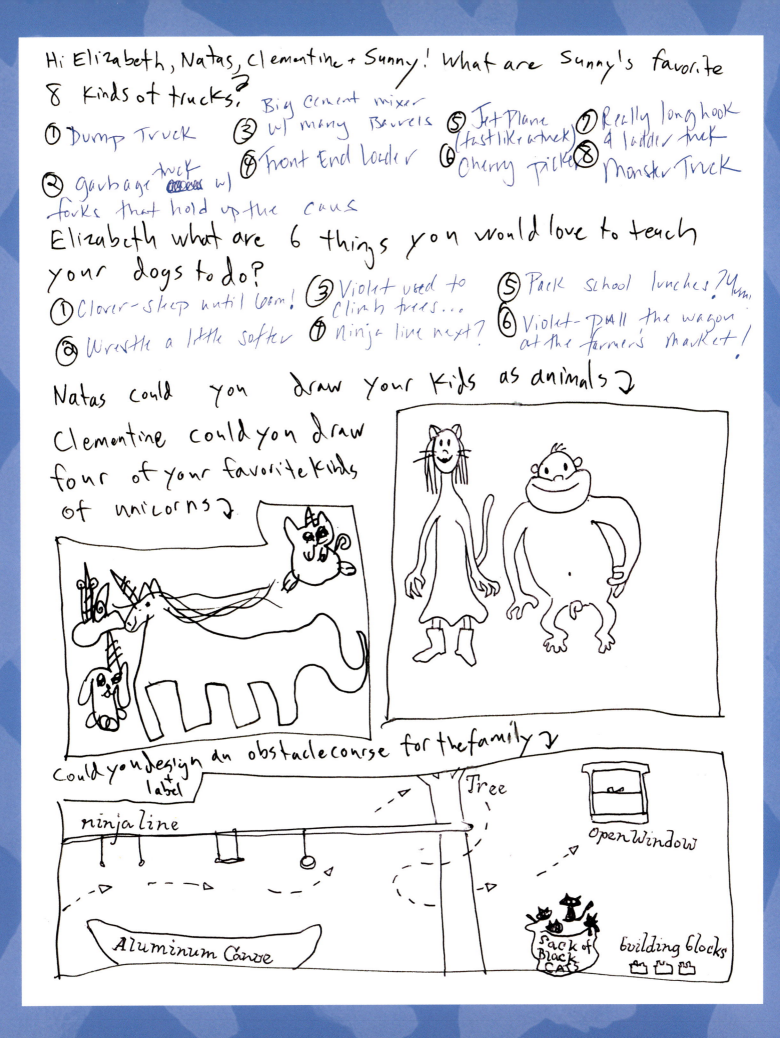

GLENN O'BRIEN & GINA NANNI

with Oscar in Litchfield County

"I was a crazy obsessive collector of ceramics."

These photos from 2010 were part of my inspiration for publishing this series. Gina and Glenn had amassed a renowned art collection, including work by their friends Andy Warhol and Jean-Michel Basquiat. Glenn passed away in 2017, and Gina tells me a lot has changed since then. "It didn't hit me at once, but it's good to redecorate. Now I'm in de-acquisition mode." The house, built in the 1930s, displays Bauhaus and Frank Lloyd Wright influences. "The stonework is very flat, and the low ceilings wrap around the windows so that your eyes look outside." Glenn's sense of humor is evident in many of the quirky objects around the house. "People get fake owls to scare away birds. We had a plastic Mr. T head that did the same thing," says Gina. "Too many birds were crashing into the big windows, so one of the previous owners covered the bottom half with wood. It was just unused, empty space. We had bookshelves installed across the living room to make it functional. It's all to save the birds." Oscar, who was ten at the time of these pictures, has taken after his father and is studying to become a writer.

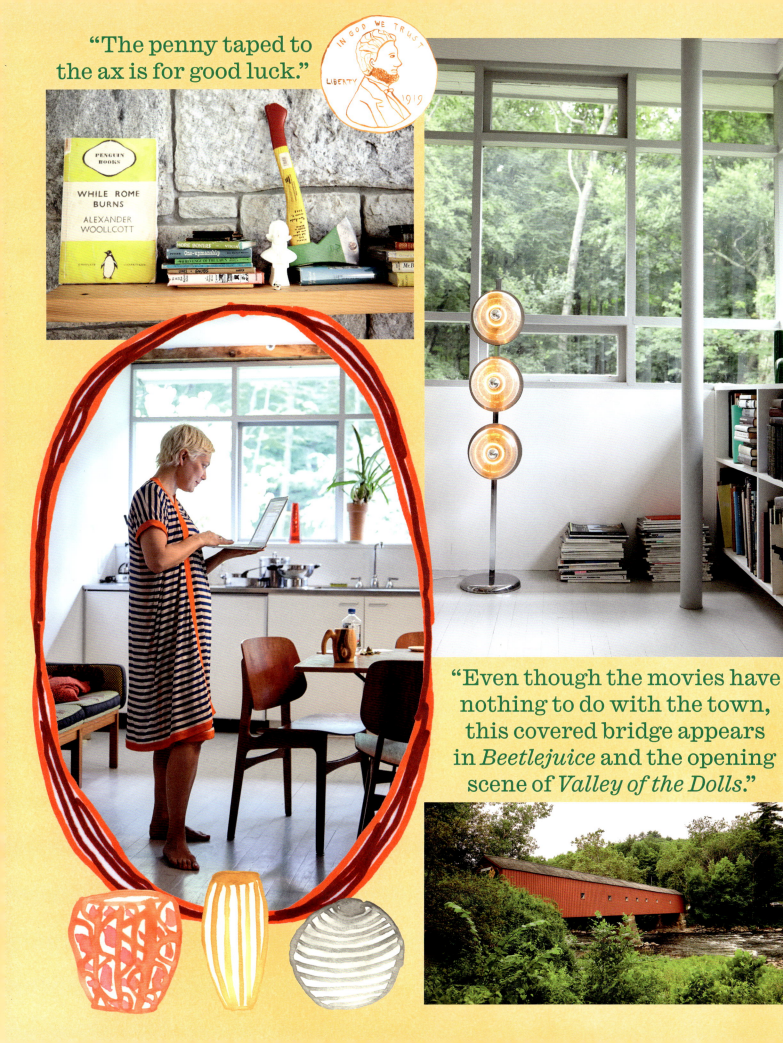

"The penny taped to the ax is for good luck."

"Even though the movies have nothing to do with the town, this covered bridge appears in *Beetlejuice* and the opening scene of *Valley of the Dolls*."

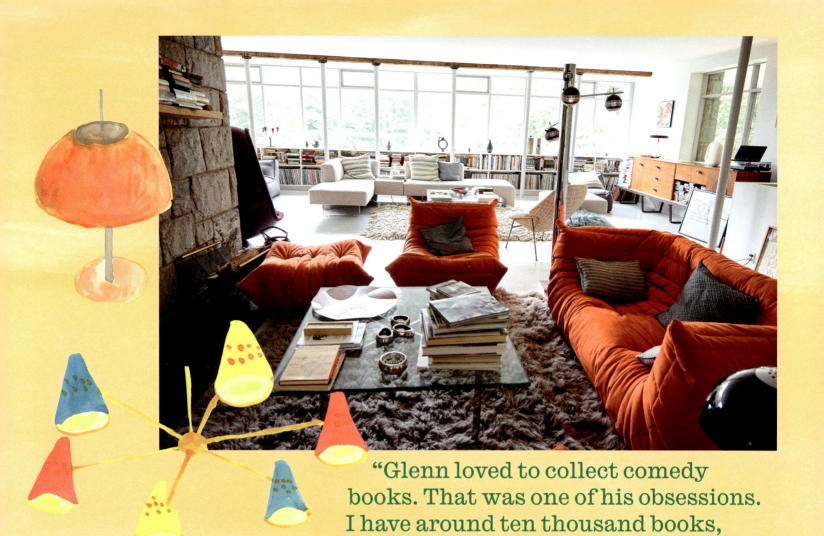

"Glenn loved to collect comedy books. That was one of his obsessions. I have around ten thousand books, between NYC and Connecticut."

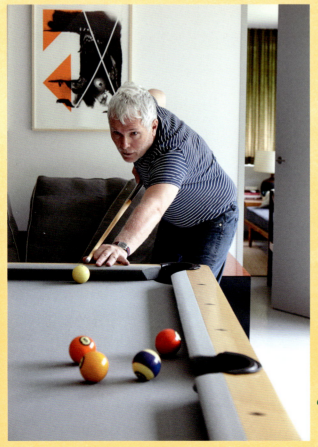

"The pool table was custom-ordered in gray to go with the house."

"Glenn would constantly vacuum. He explained it to me once by saying it's the only time nobody ever bothers him. When you're a writer you need time to mull over ideas."

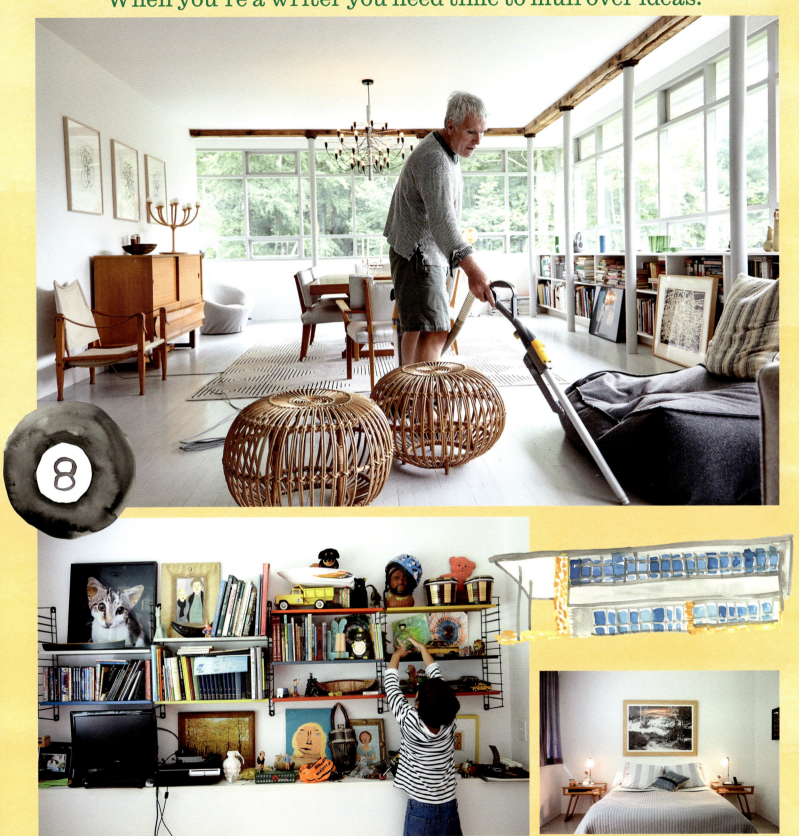

Glenn O'Brien & Gina Nanni with Oscar

Arrow the amazing diving dog

"Our landscape designer put in the little bridge so we could walk to the pool from across the stream."

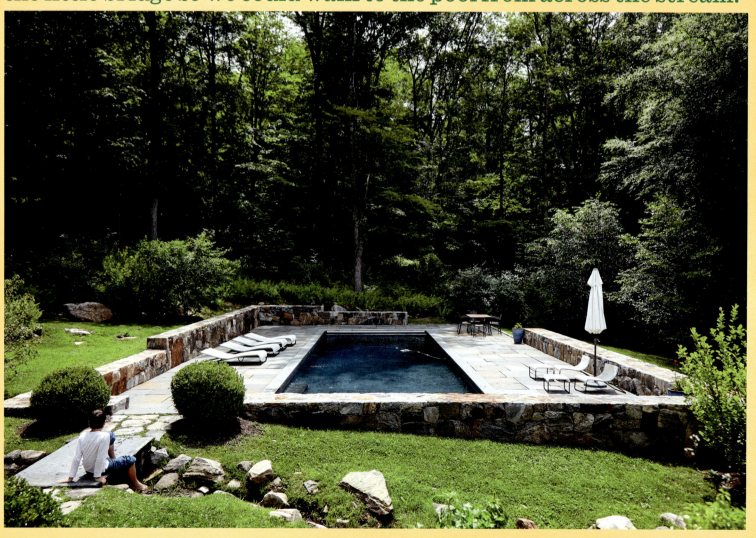

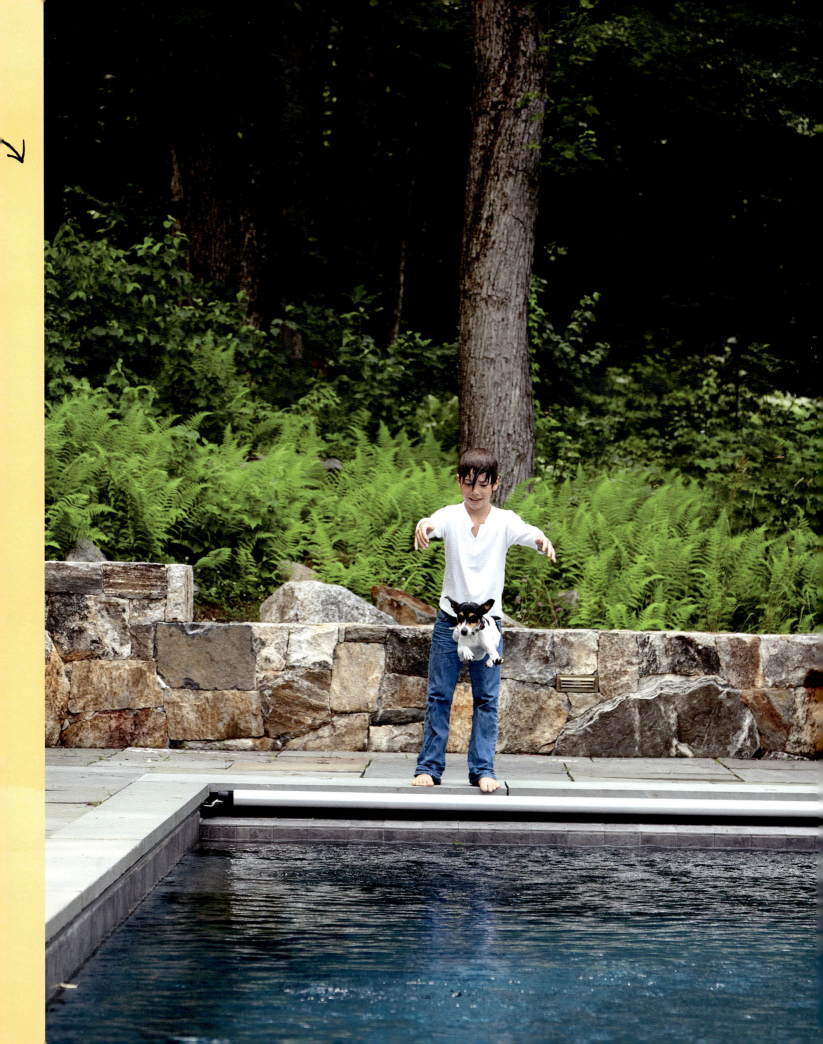

"That rug that resembled dreadlocks was a housewarming gift from the decorator, Ricky Clifton. He later told me he found it on the street. Luckily, we'd already had it thoroughly cleaned."

A note from James Brown

Glenn O'Brien & Gina Nanni with Oscar

Hi Glenn, Gina + Oscar.

Glenn what was your first big break as a writer?
Getting hired by Andy Warhol and learning how to work.

Gina what 3 pieces of ceramics do you covet the most please draw + label them ↓ ↓ ↓

- Beatrice Wood gold chalice
- Lagardo Tackett peanut
- Georges Jouve red cylinder

Oscar draw your favorite bank note ↓

Glenn what were the 4 most fun things that happened while you were filming TV Party
① *George Clinton saying it was cool.*
② *Being mistaken for Debbie Harry in my blonde wig on a Halloween show.*
③ *Pretending the show was over so The Mutants, a band from S.F., would leave. (They did.)*
④ *Walter Steding getting worried when David Bowie put on his hat and went into the bathroom for a half hour.*

Gina what do you like about fashion?
I like meeting people with a different, unique point of view.

Glenn what do you like about art?
It makes you see things differently. It can be beautiful and funny at the same time.

Oscar what do you like about money?
you can buy things

BRANDI SELLERZ-JACKSON & JON JACKSON

with Jaxon, Jedi & Jupiter in Pasadena

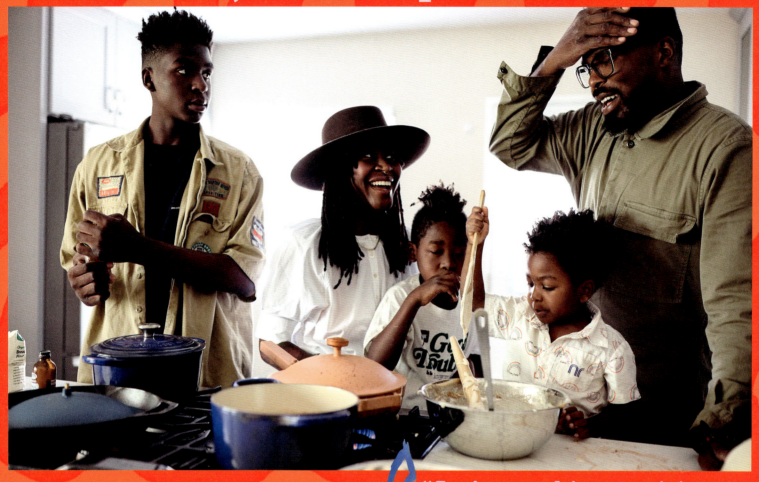

Part II of Coltrane's *A Love Supreme* plays over the speakers, fusing with the commotion in the kitchen. Pancakes are on the menu at the Jackson family's Pasadena bungalow. "The house is loud," says Brandi. "But I can go outside my door and hear the birds sing. There are parrots that hang out on the telephone lines. Real parrots. It's crazy." Brandi and Jon were both studying music when they met at Belmont University in 2001. "It's hard to remember a time when we weren't together." Their three boys—Jax, Jedi, and Jupiter—span twelve years from the oldest to youngest. "Jax is preparing to leave the house for college. But then, minutes later, we're talking to Jedi about things in second grade that are very real to him. And at the same moment, we're talking to our four-year-old about why he can't put dirt in his mouth. So it's a trip." The house offered serenity after years of living in central Los Angeles. "We can see the mountains, and the backyard is filled with citrus trees—grapefruit, lemons, and oranges. It's exactly the stillness that our family needs."

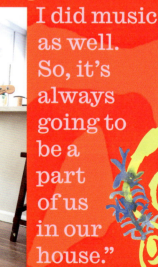

"Jon's a working musician. I did music as well. So, it's always going to be a part of us in our house."

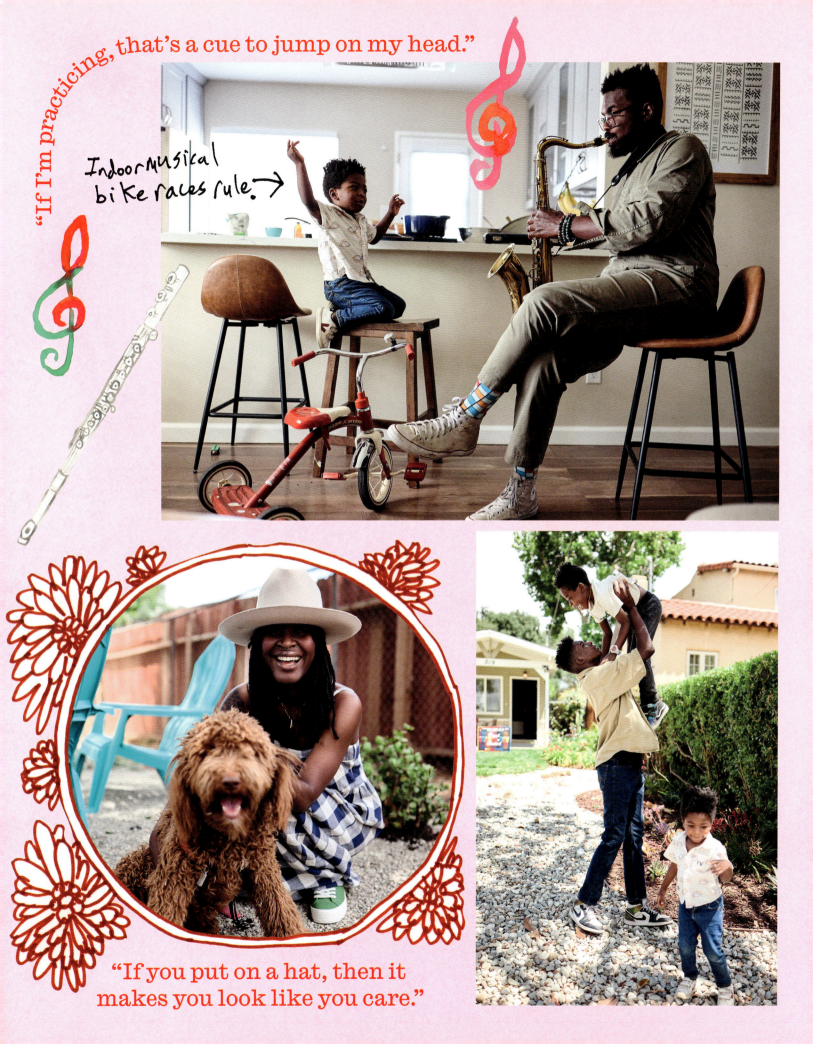

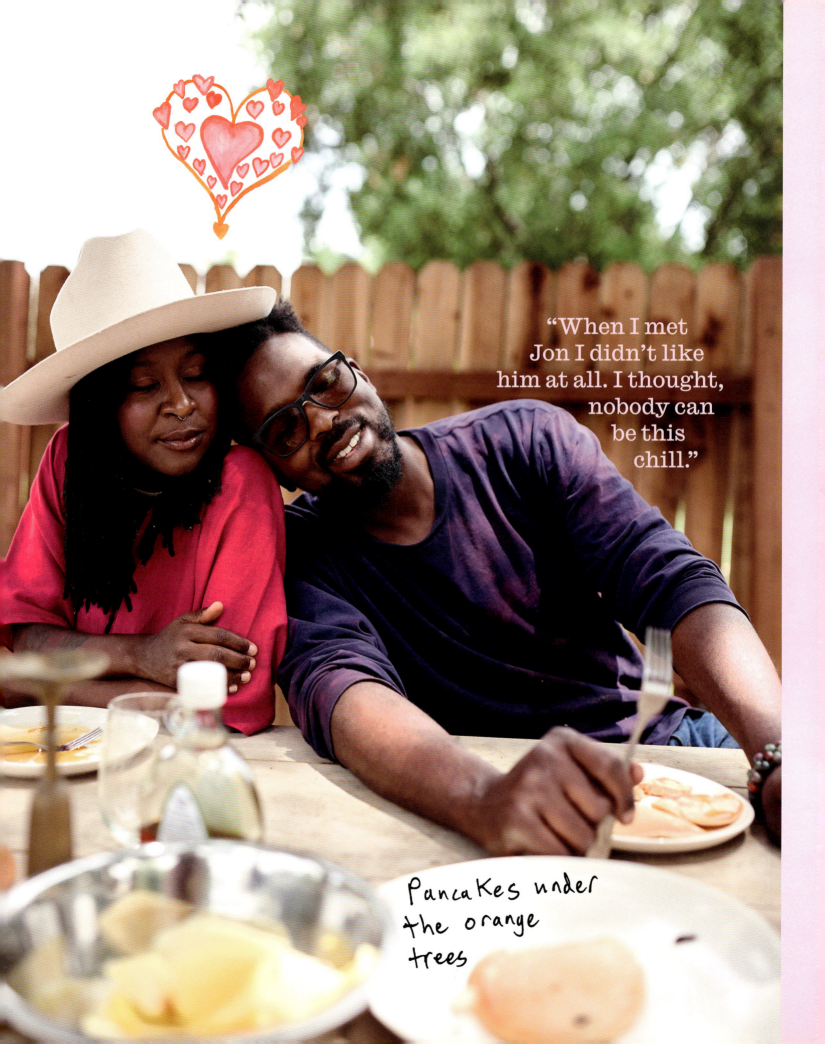

"When I met Jon I didn't like him at all. I thought, nobody can be this chill."

Pancakes under the orange trees

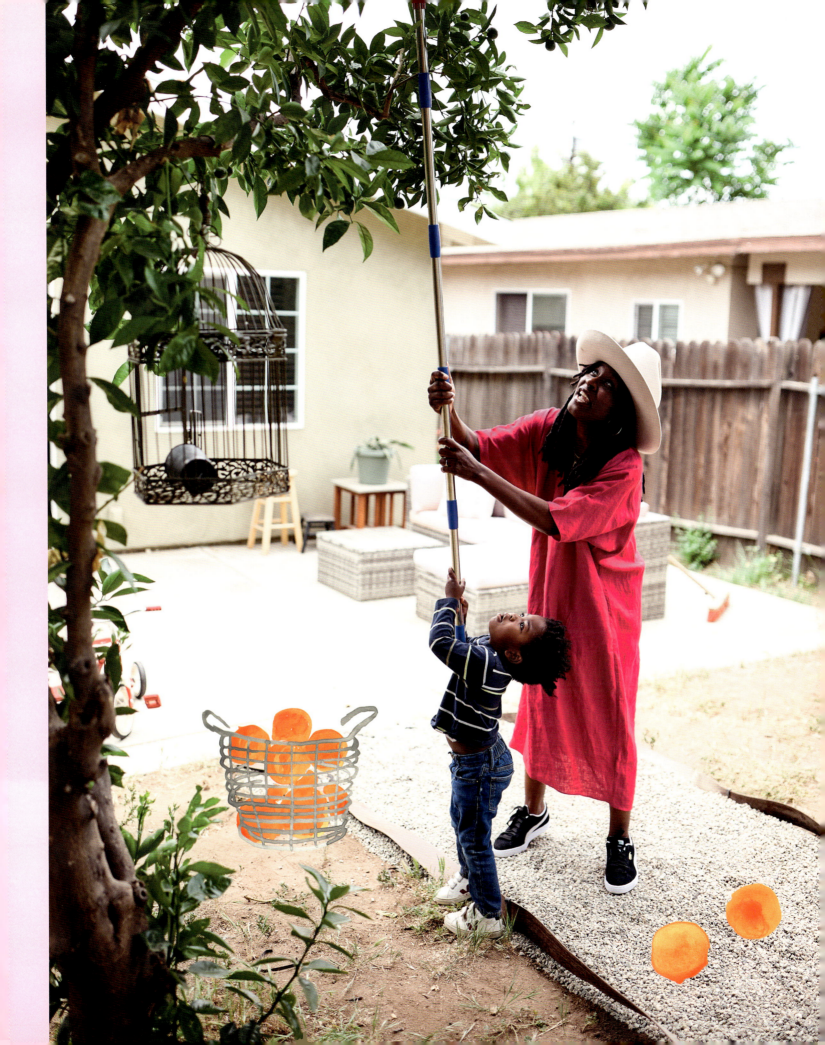

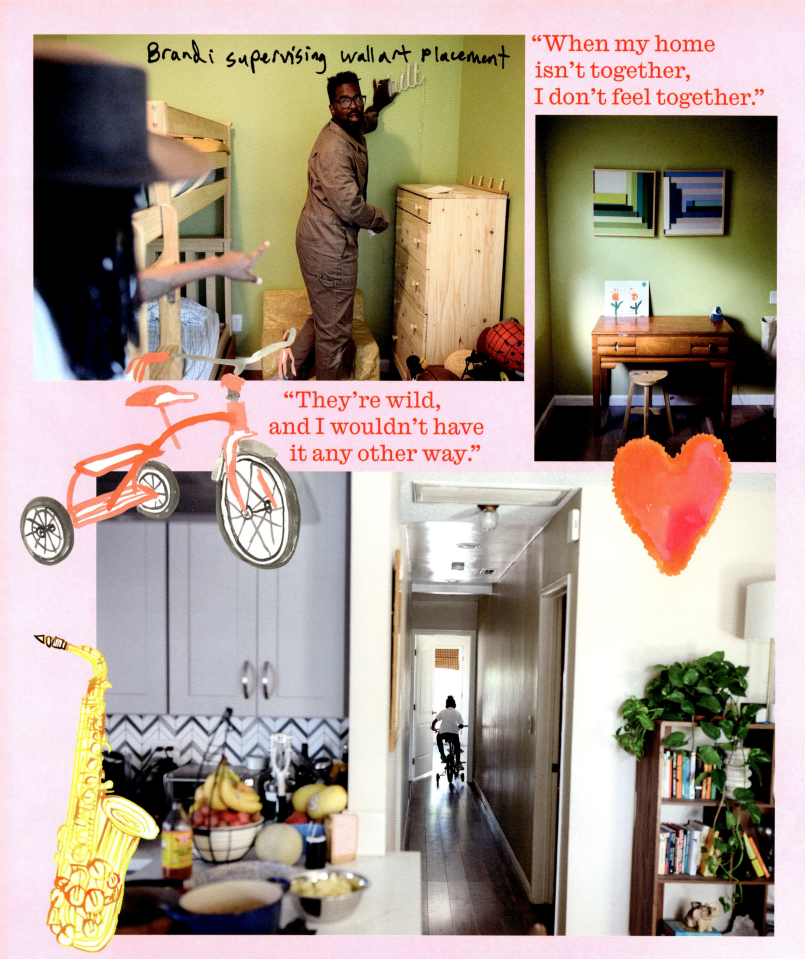

Hi Brandi, Jon, Jaxon, Jedi + Jupiter! Jaxon could you design a sign for your bakery?

Brandi could you design a hat inspired by Nashville?

Jon could you design a family MVP award?

Jedi could you draw a comic starring you?

What are your family's 8 favorite music tracks?

1. Ebony Eyes (Stevie Wonder)
2. A Love Supreme (Coltrane)
3. Overjoyed (Stevie Wonder)
4. Young, Gifted, + Black (Nina Simone)
5. Hey Pocky A-Way (The Meters)
6. What A Fool Believes (Doobie Bros)
7. Freedom (Pharrell)
8. The Greatest (King)

KENYA STABLER & BEAU CAILLOUETTE

with Coco Olema & Effie Drake in San Francisco

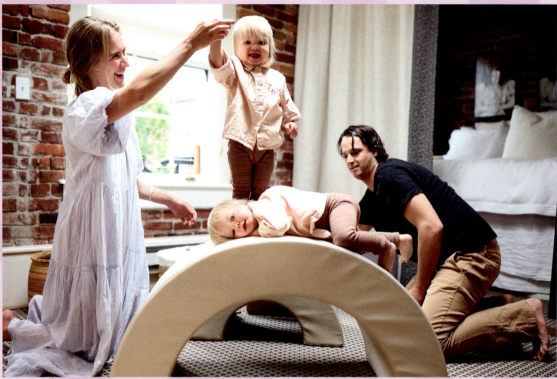

"They are independent but want to feel part of everything we're doing."

"**We always wanted two kids and loved the idea of twins,**" says Beau. "Very much manifested it," adds Kenya. "My older siblings are twins, and my mom was a children's clothing designer. I always match them. I take a lot of pride in finding unique pieces. It's a fun opportunity to be creative and have fun with it." The house is on a historic stretch of Old Ohio Street, located in one of the buildings that survived the earthquake of 1906. "Up until we had the girls, it was pretty eclectic," says Kenya, who is an interior designer. "There is something special about raising kids in the heart of the city. We wanted to set roots downtown, while making it feel private and comfortable for us as a family. The girls want to be a part of everything. The playroom, kitchen, living room, and dining room are all open to each other so they can always join in."

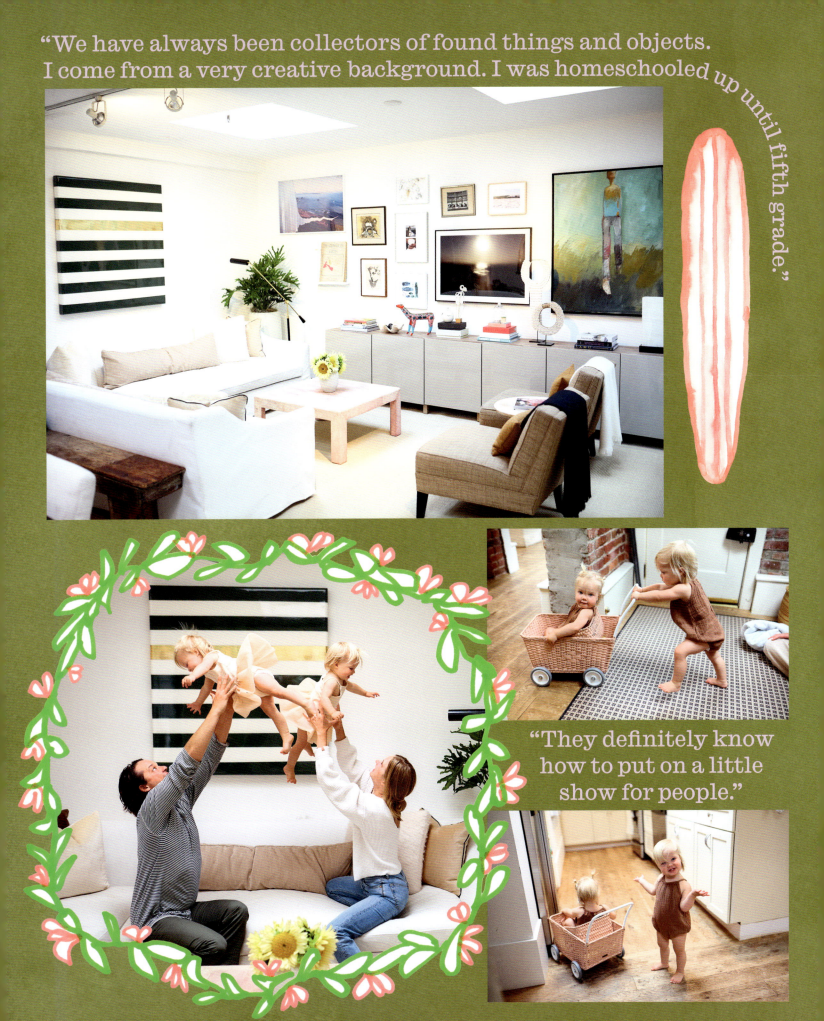

"We have always been collectors of found things and objects. I come from a very creative background. I was homeschooled up until fifth grade."

"They definitely know how to put on a little show for people."

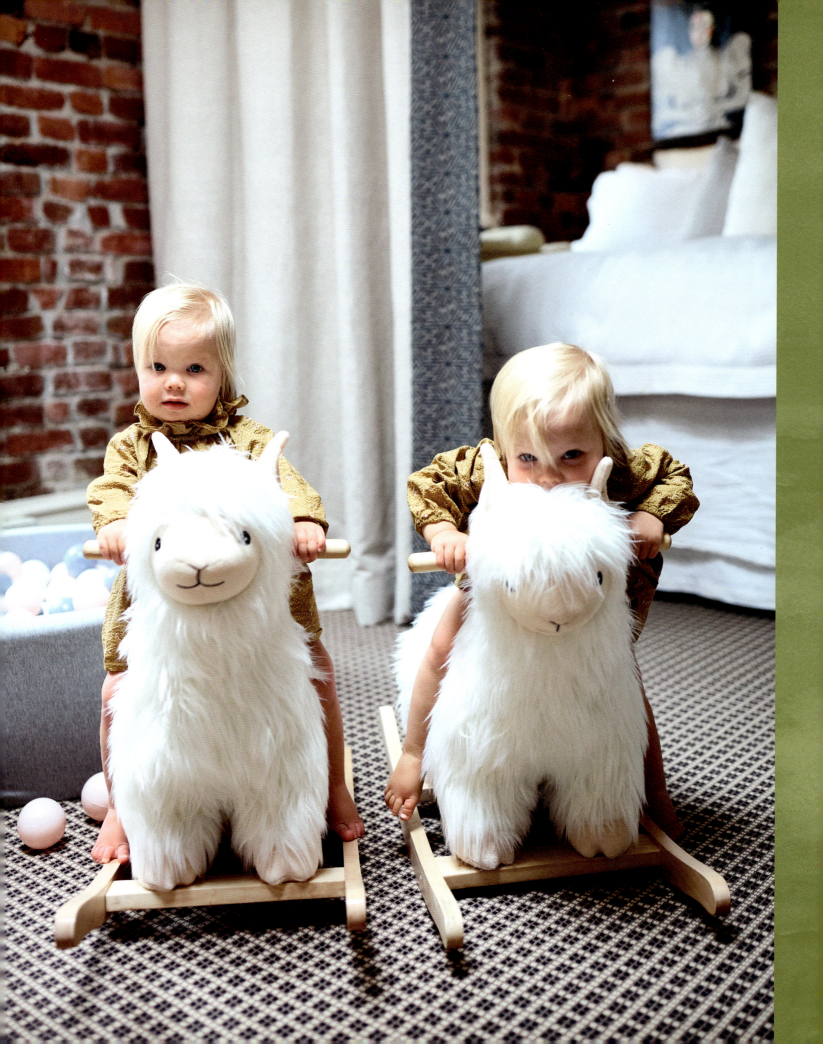

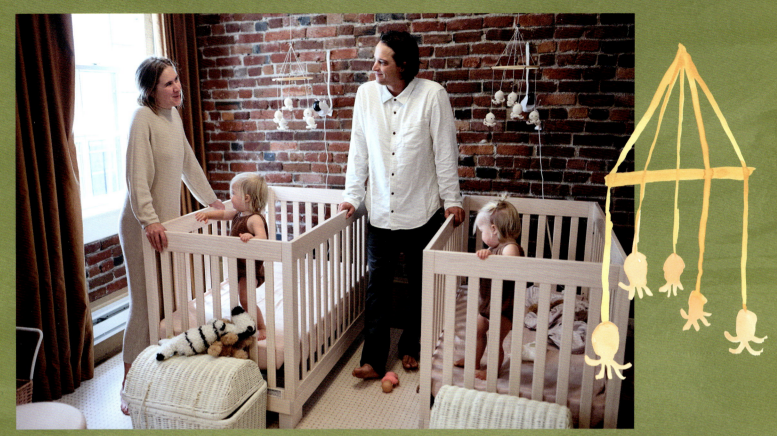

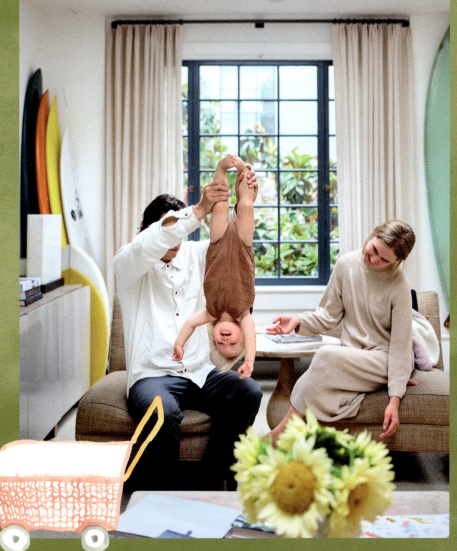

"We don't have a garage. We don't have really any spot to hide anything."

"With twins, you have to remind yourself that they're two individuals and you're dealing with two different kids. They have their similarities, but they also have different personalities."

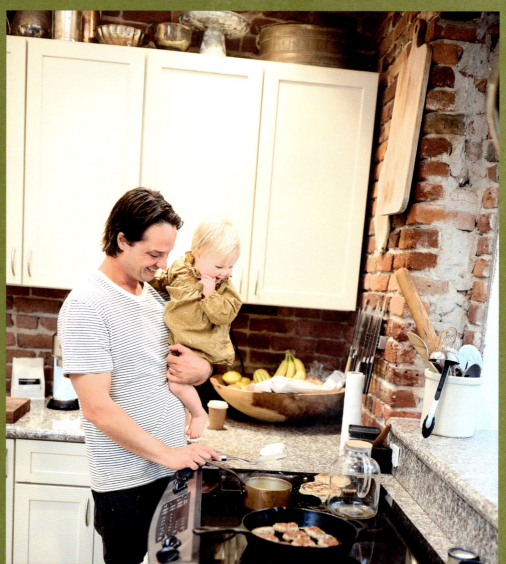

Brass fish by Sergio Bustamante

Kenya Stabler & Beau Caillouette with Coco & Effie

Hi Kenya, Bean, Coco + Effie! Kenya could you design and create toys for a new playroom for Coco + Effie?

Repurposed doll clothing and accessories made from their old/favorite/stained clothing and blankets so they can keep them.

Bean could you design your dream surf + fish shack?

Kenya could you design a bike for Coco?

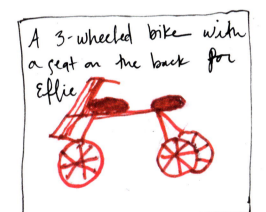

A 3-wheeled bike with a seat on the back for Effie

Bean could you design a car for Effie?

Pink Convertable Van

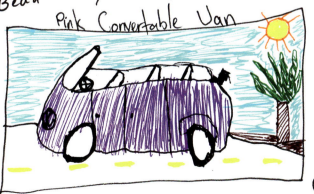

1. Long Driveway
2. Fruit Orchard
3. Wild Flower Fields
4. Veggie Garden
5. Car Storage
6. Outdoor Shower
7. Outdoor Kitchen
8. Pool
9. Left Point

OLIVIA VILLANTI & GUILLAUME GUEVARA

with Lalo in Mexico City

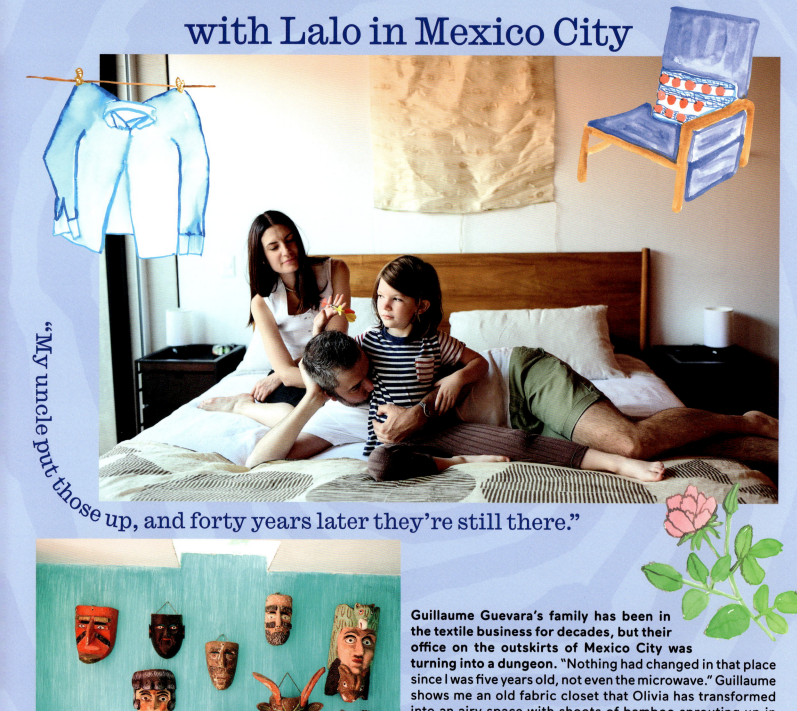

"My uncle put those up, and forty years later they're still there."

Guillaume Guevara's family has been in the textile business for decades, but their office on the outskirts of Mexico City was turning into a dungeon. "Nothing had changed in that place since I was five years old, not even the microwave." Guillaume shows me an old fabric closet that Olivia has transformed into an airy space with shoots of bamboo sprouting up in the center. She now uses the building as the office for Chava Studio, a handcrafted clothing line she operates in collaboration with Guillaume's family. "Guillaume's grandfather set up the office here, and I think that's where the charm lies. The skylights we created let in these beautiful pools of light, but it still feels preserved." Their home is a seven-story town house in the historic San Miguel Chapultepec neighborhood. The house is newly constructed, but they appreciate the history of the area and rooftop views of Mexico City.

"The six flights of stairs are really good for your butt."

"We go almost every Sunday to La Lagunilla market. There are always vendors selling so many interesting things that you wouldn't find otherwise. There's a guy that makes these stools, they're super irregular-looking and have some interesting forms."

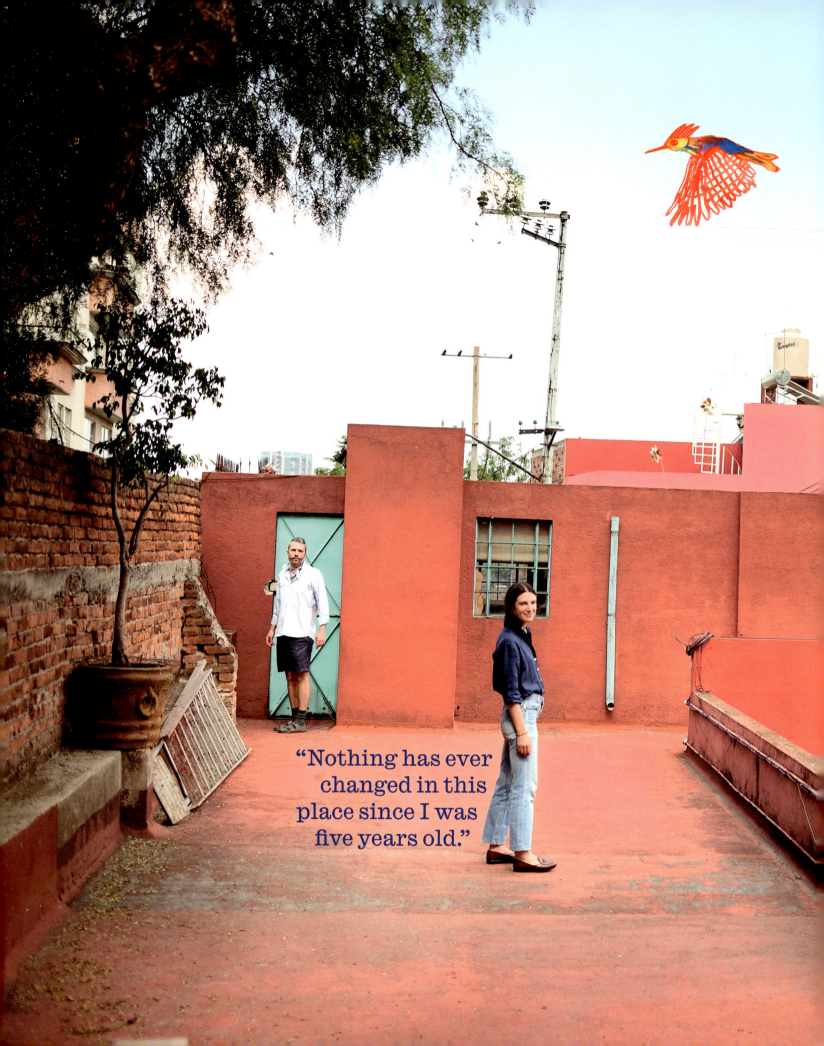

"Nothing has ever changed in this place since I was five years old."

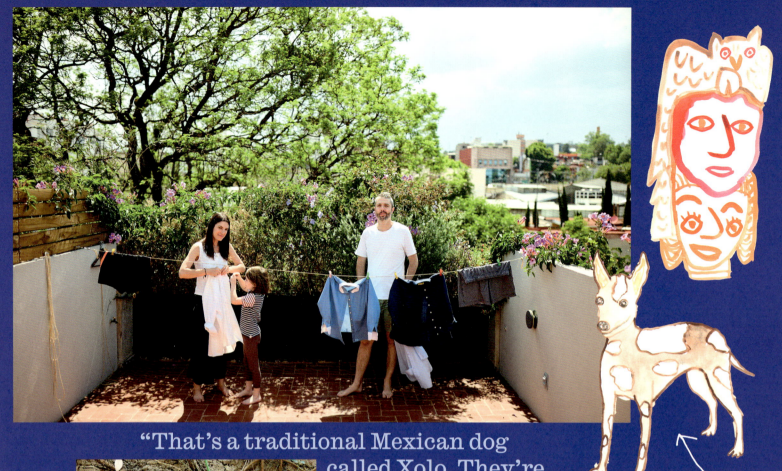

"That's a traditional Mexican dog called Xolo. They're probably the ugliest dog in the world. They don't have hair. It's like our watchdog."

I ♥ Xolo dogs

"This is our old-school alarm system."

Olivia Villanti & Guillaume Guevara with Lalo

Hi Olivia, Guillaume + Lalo. Guillaume could you draw + label your favorite street in Mexico City?

Olivia what are your 6 favorite fabrics ever

1. Scabal's silk corduroy ♡♡♡
2. Zephir Soyella (cotton voile by Alumo)
3. Twill Silvano by Alumo
4. Josef stter's cupro (a deadstock cupro still)
5. Most denims that are raw and unwashed and more than 12 ounces
6. Soyella cotton (also by Alumo — so silky!)

[map labels: CHAVA, ORTEGA, BARRAGAN, ARCHIVO, GENERAL FRANCISCO RAMIREZ, LABOR]

Lalo could you draw your family

Olivia, Guillaume + Lalo what are your favorite burgers of all time?

butcher & sons, Diner NY (BK), Raoul's (NY), Minetta Tavern, Five Leaves (NY-BK), Petit Trois (LA) Anella (BK)

Could you design the Ninjuki stand

[Ninjuki stand drawing]

JORDAN REBELLO & JOHN THOMSON
with Wynter in Ventura

"Wynter's such a go-getter and also just kind of knows herself. She's so confident and independent."

"We've lived in deserts, lived in cities, lived in the country, and now we're living on the beach," says John. "Surfing, skating, making art, making music, hanging out in our backyard by the fire… It's awesome. Wynter falls right in with it. She's super comfortable and confident. And we now have a little boy named Bodhi in the house, too. He's been amazing and we're looking forward to spending more time with him." John and Jordan both grew up thrifting and connected over that passion. They recently opened a vintage-goods store in Ventura. "We love the search," says Jordan. "Everything I think is cool is probably at least thirty years old," says John. "Used stuff is just as good. Why not use it until it can't be used anymore?"

"We like to deck out the yart." (Yard + art = yart.)

"Jordan says 'I like to dress wild, but also keep it mellow.'"

"Wynter also loves Johnny to brush her hair. He's more gentle."

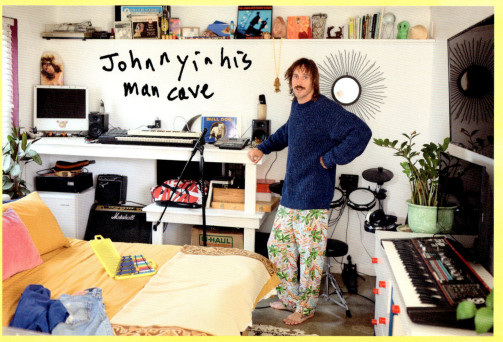

132 Jordan Rebello & John Thomson with Wynter

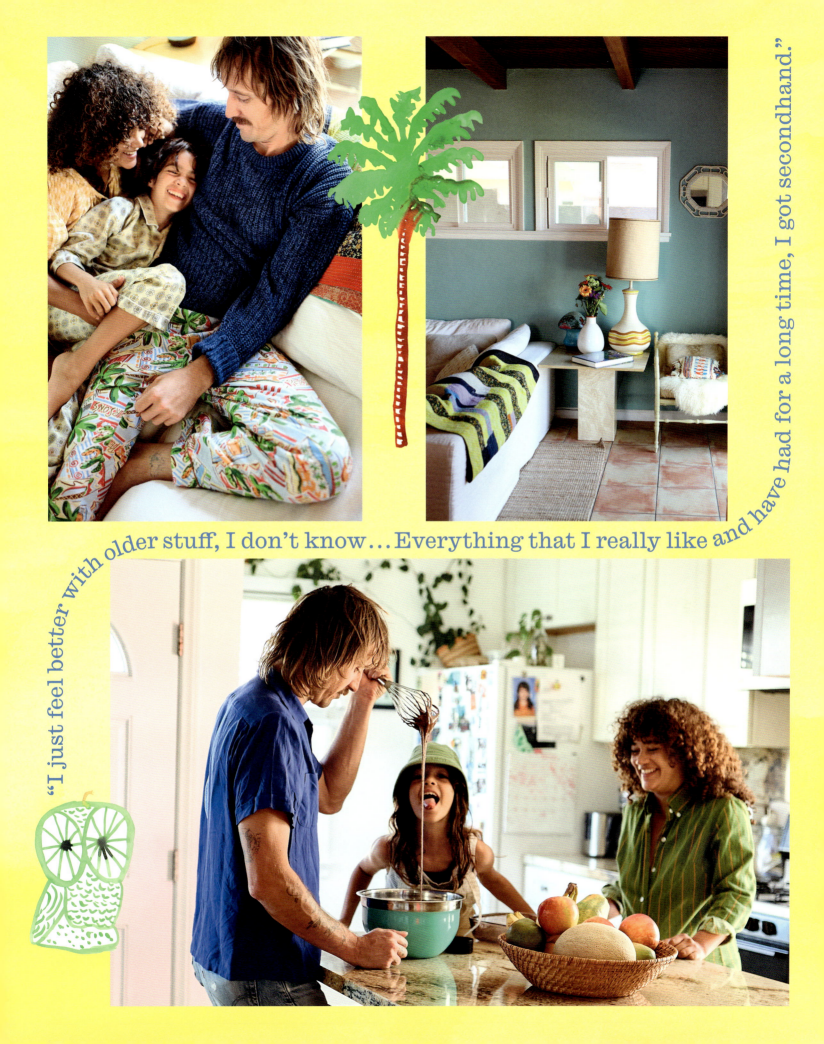

"I just feel better with older stuff, I don't know… Everything that I really like and have had for a long time, I got secondhand."

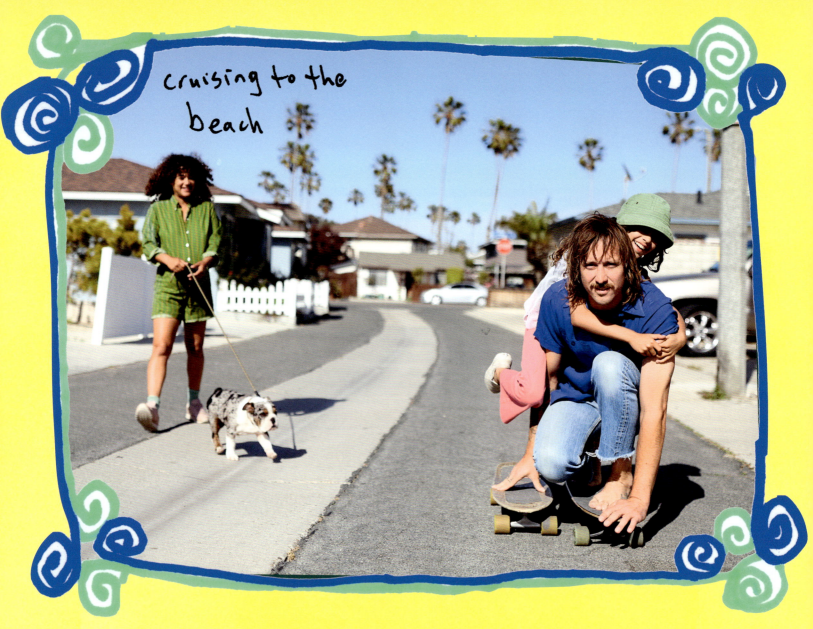

cruising to the beach

"I've been playing around with the tufting gun; it's really fun. The idea was to make pillows, mirrors, weird wall covers, and hanging artwork."

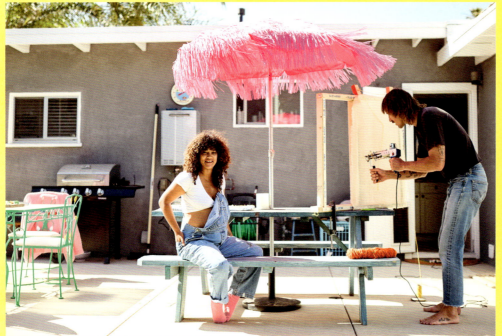

Hi Jordan, John + Wynter! Could you design your dream "modern" doll house?

John what would be your 6 ultimate musical instrument vintage finds

① Anything that works and is a good deal or free. Like my Marshall amp was dumped on the sidewalk when I found it, brought it home and plugged it in...

②

③ 60's Ludwigs Drums

④ 8 Track Recorders

⑤ Anything Sylvish

⑥ Fender Musicmaster with Rosewood Fretboard 50's-60's era

Jordan what are your 6 favorite vintage finds

① Silk Nightgowns from the 20's.
② 70's bell bottoms
③ Tiki Home Goods
④ 60's glassware
⑤ Rugs!!
⑥ Vintage baby clothes

Could you draw your ultimate family camper?

CRIS & MARCELO ROSENBAUM
with Bertha Miranda & Ian in São Paulo

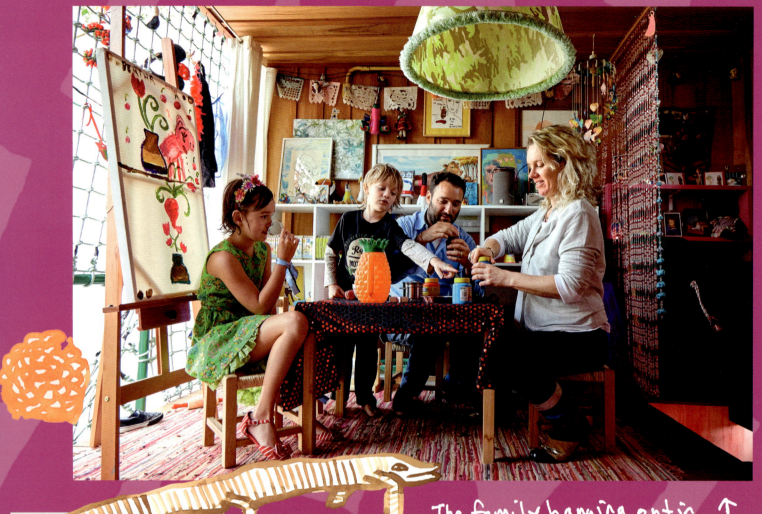

The family hanging out in the kids' backyard treehouse

"Putting the house together was a great dream for us. All of the time it is very crazy, full of kids and friends," says Cris. "But we work a lot, too." Marcelo is an interior designer known for styling some of Brazil's trendiest restaurants, shops, and clubs. The couple is also heavily involved with A Gente Transforma (People Transform), an institute that promotes access to design and architecture in low-income and indigenous communities. Their passion for traditional Brazilian craft and "ancestral learning" is displayed throughout the family's vibrant São Paulo home. "The style is modern, but it's rooted in very traditional elements," says Cris. "The house is a place that brings people together. We love to receive friends and family and share meals."

Ian sitting in a Sergio Rodrigues Sheriff chair

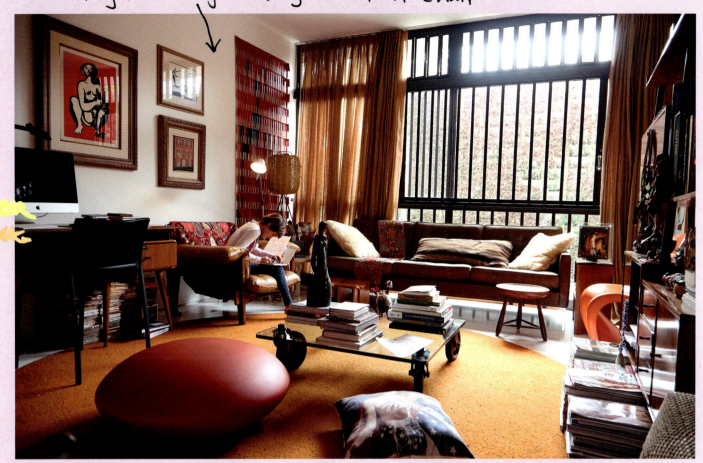

← The figure on the red background is a print from Emiliano Di Cavalcanti. He was famous for working to make art free of European influence.

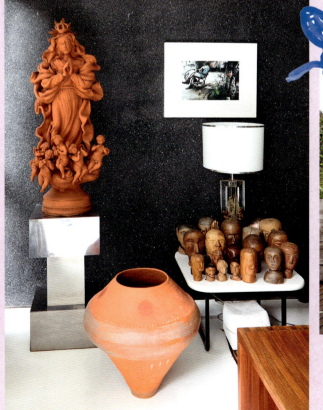

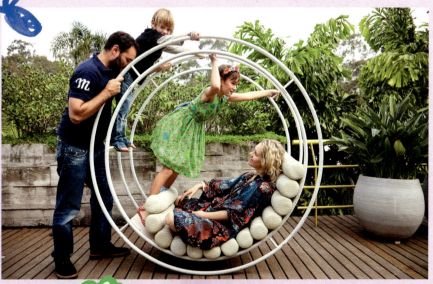

Cris and Marcelo made this wheel chair for a Casa Vogue editorial.

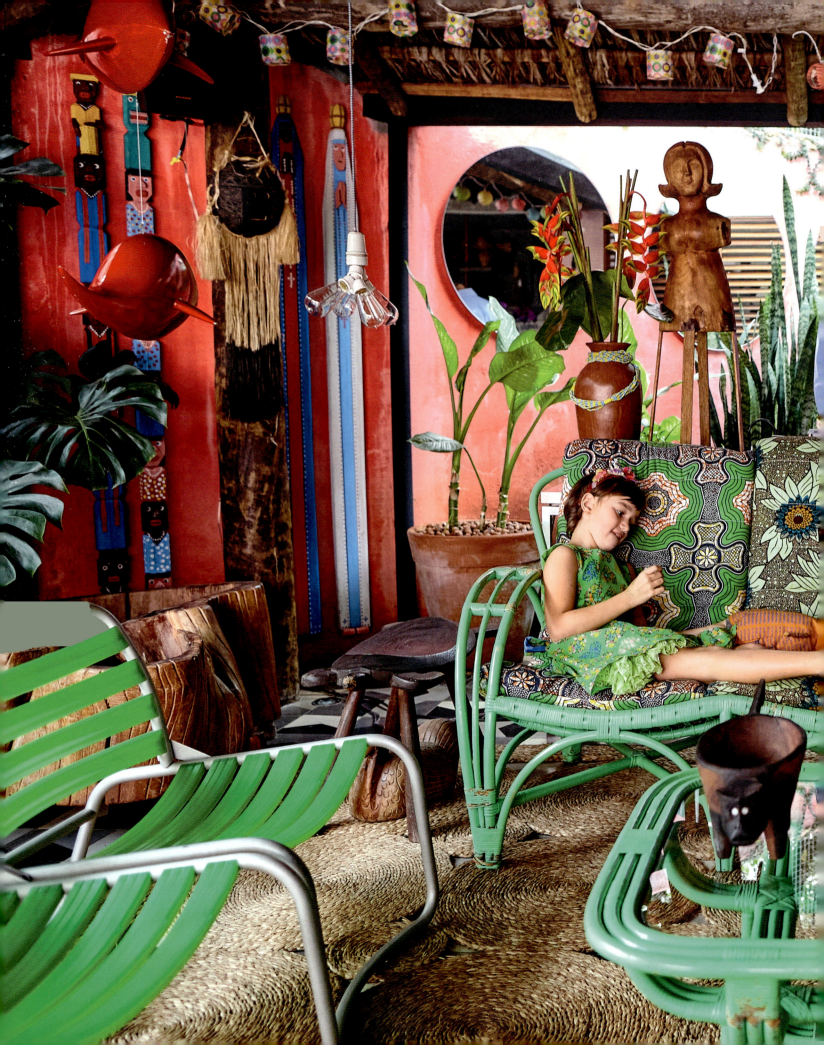

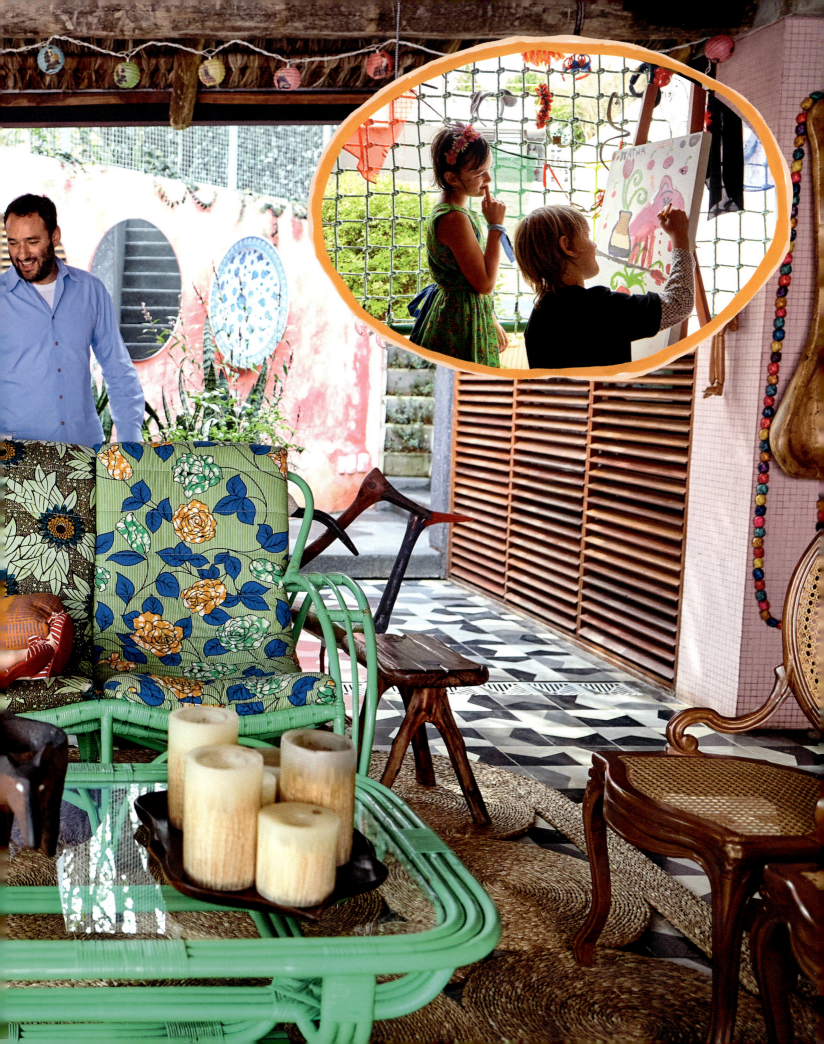

"Marcelo brought a very modern style to a very old house."

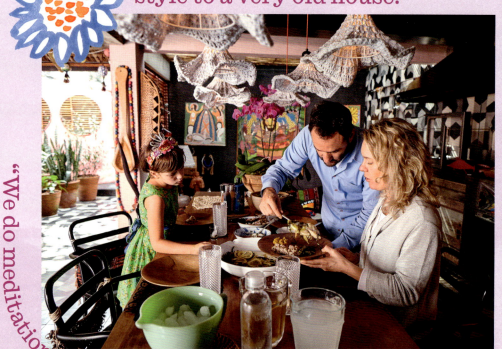

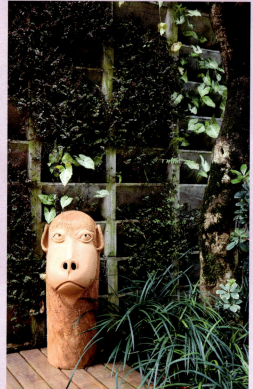

"We do meditation here, and put a lot of candles and drink wine with friends. It's full of souvenirs from our travels."

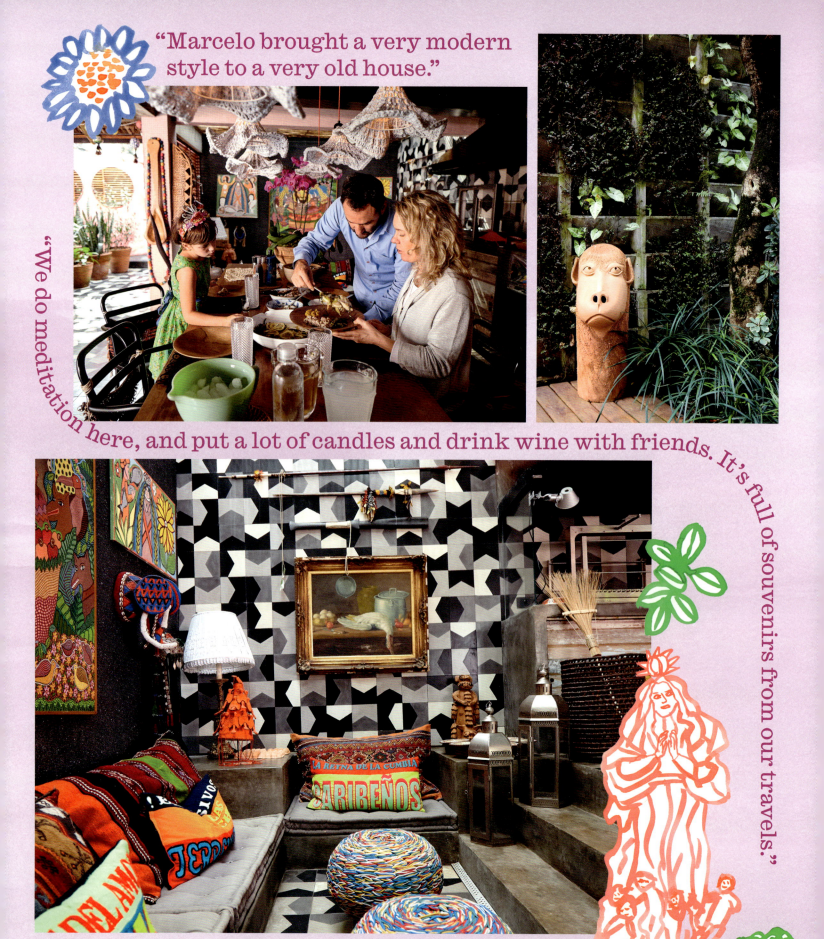

Cris & Marcelo Rosenbaum with Bertha Miranda & Ian

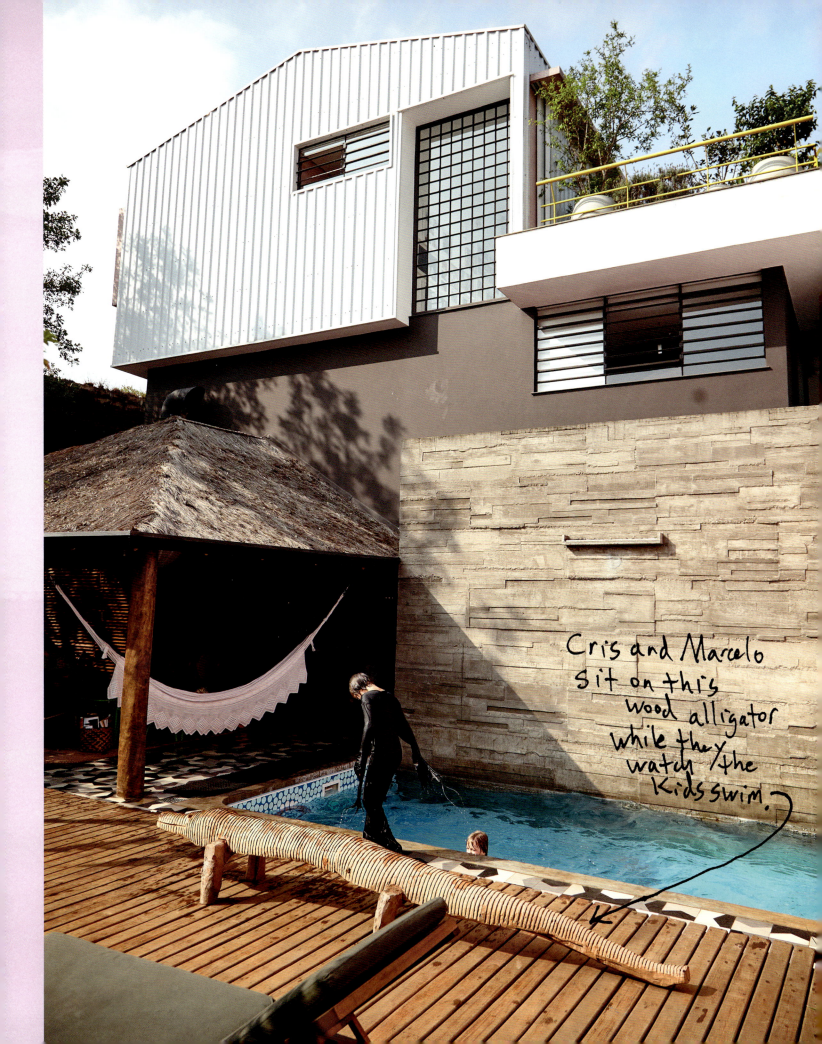

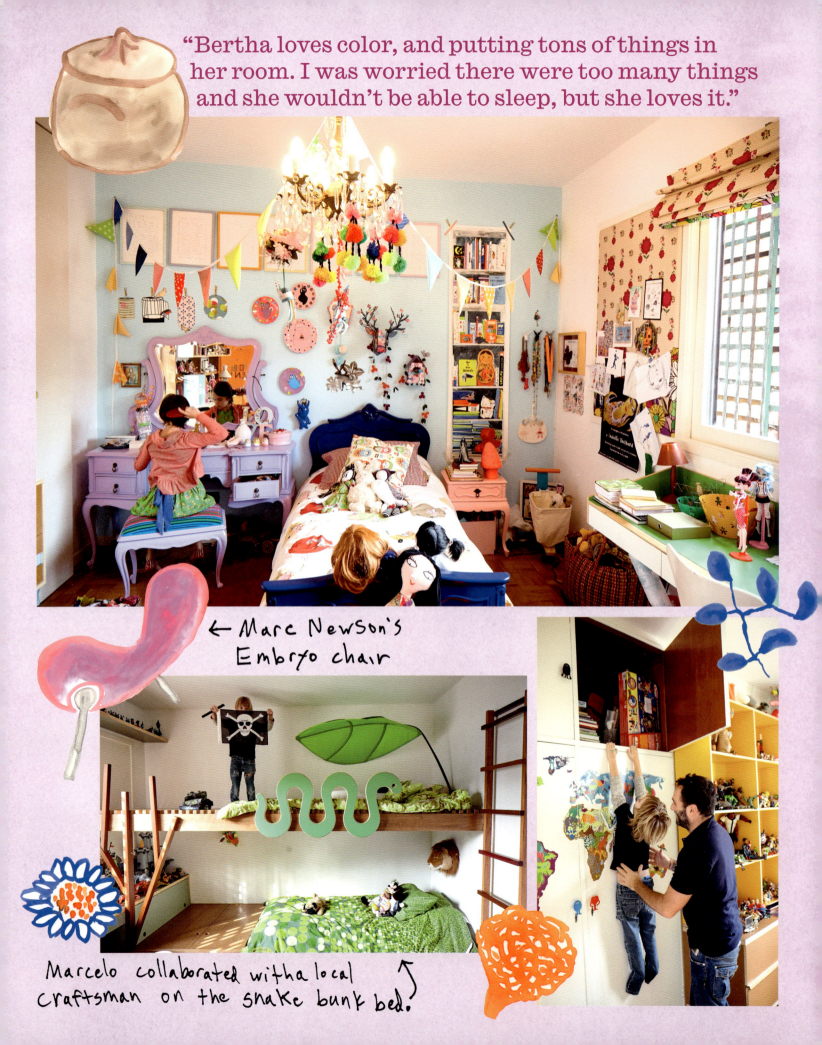

"Bertha loves color, and putting tons of things in her room. I was worried there were too many things and she wouldn't be able to sleep, but she loves it."

← Marc Newson's Embryo chair

Marcelo collaborated with a local craftsman on the snake bunk bed.

Hi Marcelo + Cris. Marcelo could you design a TeePee ↓
Cris can you design outfits for you and Marcelo to wear at Disney World ↓

Could you draw 6 things that we should discover about Brazil

what is unique about São Paulo?
A DIVERSIDADE E O CAOS

Could you draw a map of São Paulo w/th your favorite places marked ↓
Could you design a helicopter ↓

MINHA CASA

MITCH ALFUS
with Sofi Fleur, Alik & Mila in Wainscott

"A 1967 El Dorado convertible. Red leather seats, which are ripped, but I like them that way."

"I'm very shy, but you provoke me and get me going and once I get going, it's hard to stop."

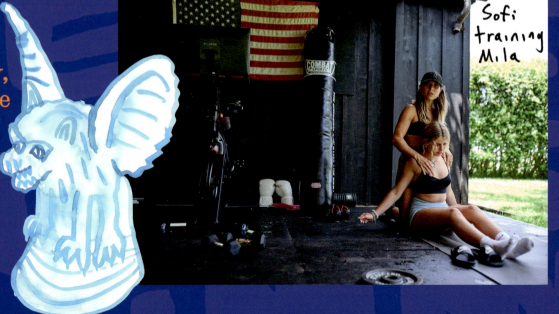

Sofi training Mila

"I'm the Leather King. Internationally renowned. Father of three. Dedicated to my children. Dedicated to my work. Single, in shape, and committed to being the best person I can with love and kindness. Period." I first met Mitch fifteen years ago in the lobby of the Soho Grand. I was with my future parents-in-law, and there was Mitch, wearing a black bird mask and going totally wild. We've been friends ever since. "I create my own style, Todd. I don't know what the word is for this. The compound is a two-acre spread where the children can romp, play, party, study, and enjoy being near the beach. With the dogs running, the fire blazing outside and in. I wanted it to have a clean, relaxing effect with Balinese furniture. There's a lot of leather mixed with wood."

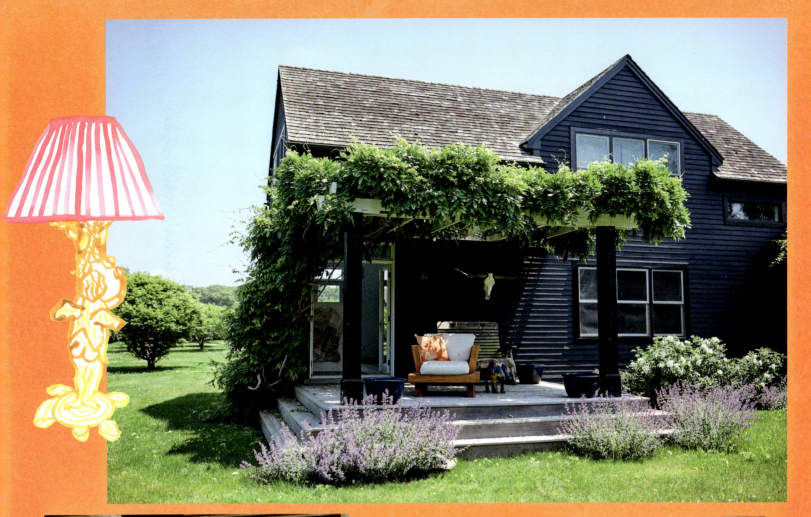

Chrome Hearts mousetrap →

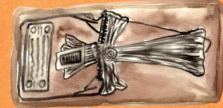

"I create my own style."

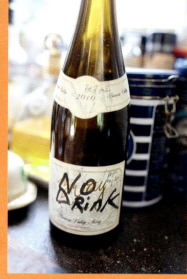

Mitch labeled the good wine "No Drink."

"I'm the Leather King. The finest and most experienced leather skin dealer in the world. Look it up."

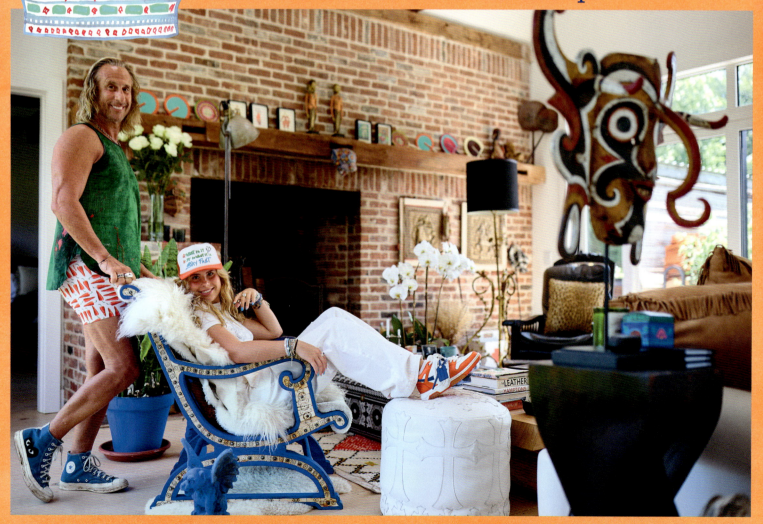

"This table is ninety percent a tribute to the unusual, eccentric things that my best friend, Richard, who owns Chrome Hearts, has made for friends. I like putting them out there because it reminds me of him every day."

Mitch Alfus with Sofi Fleur, Alik & Mila

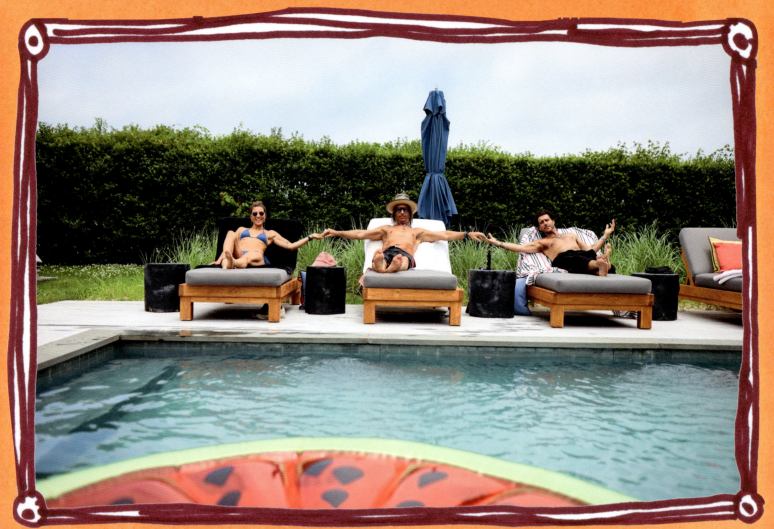

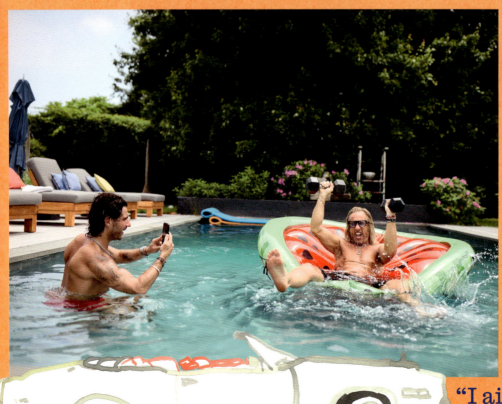

"I ain't passing no reins. I'm going to spend everything before I'm dead."

Hi Mitch, Sofi Fleur, Alik + Mila. Sofi could you write out an exercise plan to keep Mitch the strongest leather king in the Hamptons?

Drink less, play more, laugh easily ; love fiercely. Move your body at least 10 min each day & eat healthy, drink lots of water.

Alik could you design yourself a leather jacket to wear to the beach? Mitch could you design a high fashion tracking device to keep tabs on your kids?

Mila could you design a surfboard?

Alik → Sofi could I get a story of Mitch embarrassing you in front of your friends?

Mitch what are 4 tips you could give a new parent?

① In a short time this will seem like a long time ago. (Enjoy it while you can...)

② I'm pretty sure I have no idea!

③ I'm not smart enough to know how not smart enough I am.

④ Run to the rescue w/ love & peace will follow..

Libra LEATHER Sonar Tracking Device

me on school Bus
Dady
Full Moon Baby

CHANELLE & BEN KALFAS
with Felix in Newtown

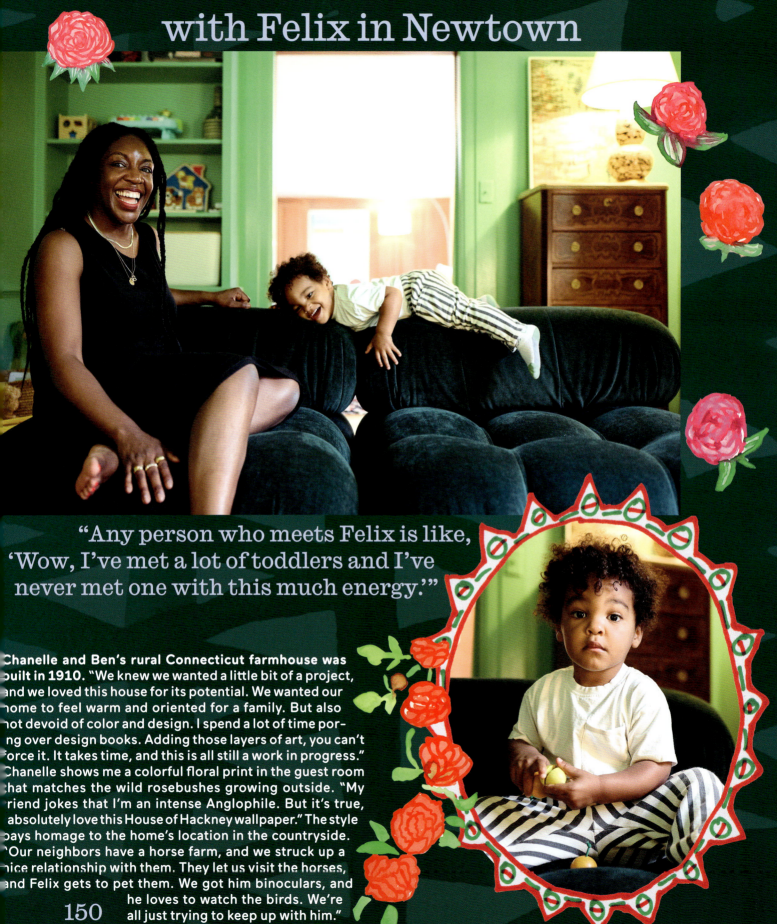

"Any person who meets Felix is like, 'Wow, I've met a lot of toddlers and I've never met one with this much energy.'"

Chanelle and Ben's rural Connecticut farmhouse was built in 1910. "We knew we wanted a little bit of a project, and we loved this house for its potential. We wanted our home to feel warm and oriented for a family. But also not devoid of color and design. I spend a lot of time poring over design books. Adding those layers of art, you can't force it. It takes time, and this is all still a work in progress." Chanelle shows me a colorful floral print in the guest room that matches the wild rosebushes growing outside. "My friend jokes that I'm an intense Anglophile. But it's true, I absolutely love this House of Hackney wallpaper." The style pays homage to the home's location in the countryside. "Our neighbors have a horse farm, and we struck up a nice relationship with them. They let us visit the horses, and Felix gets to pet them. We got him binoculars, and he loves to watch the birds. We're all just trying to keep up with him."

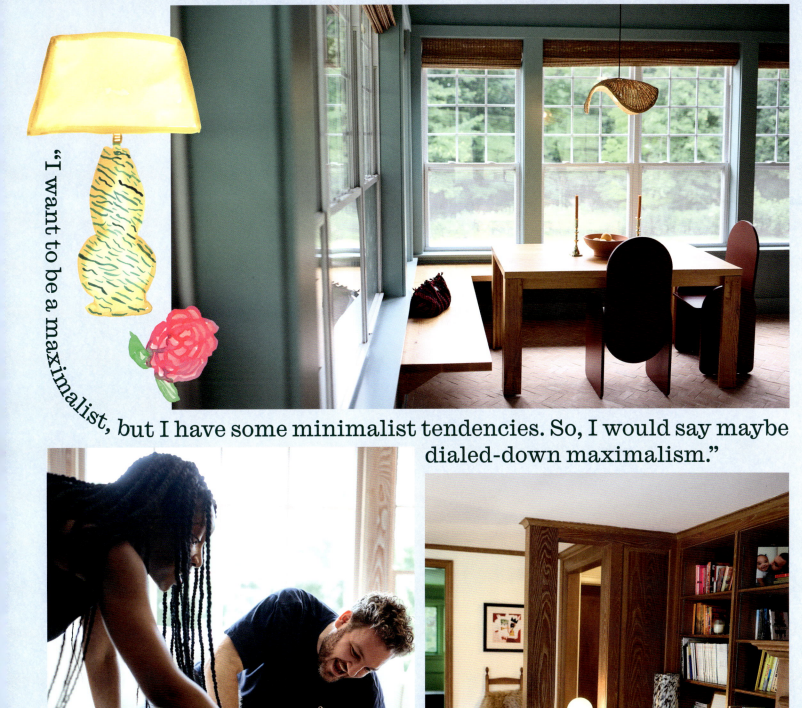

"I want to be a maximalist, but I have some minimalist tendencies. So, I would say maybe dialed-down maximalism."

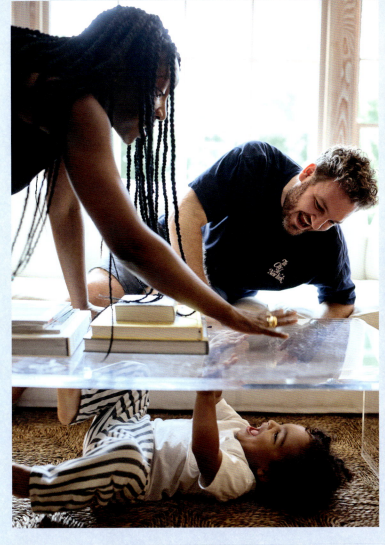

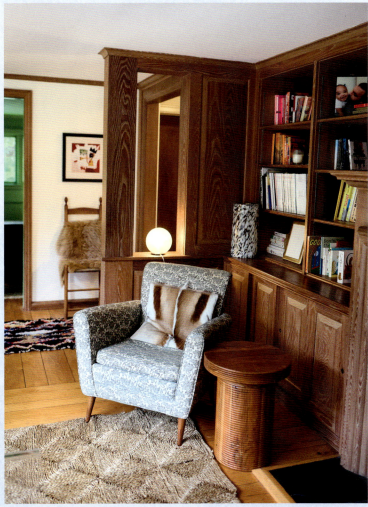

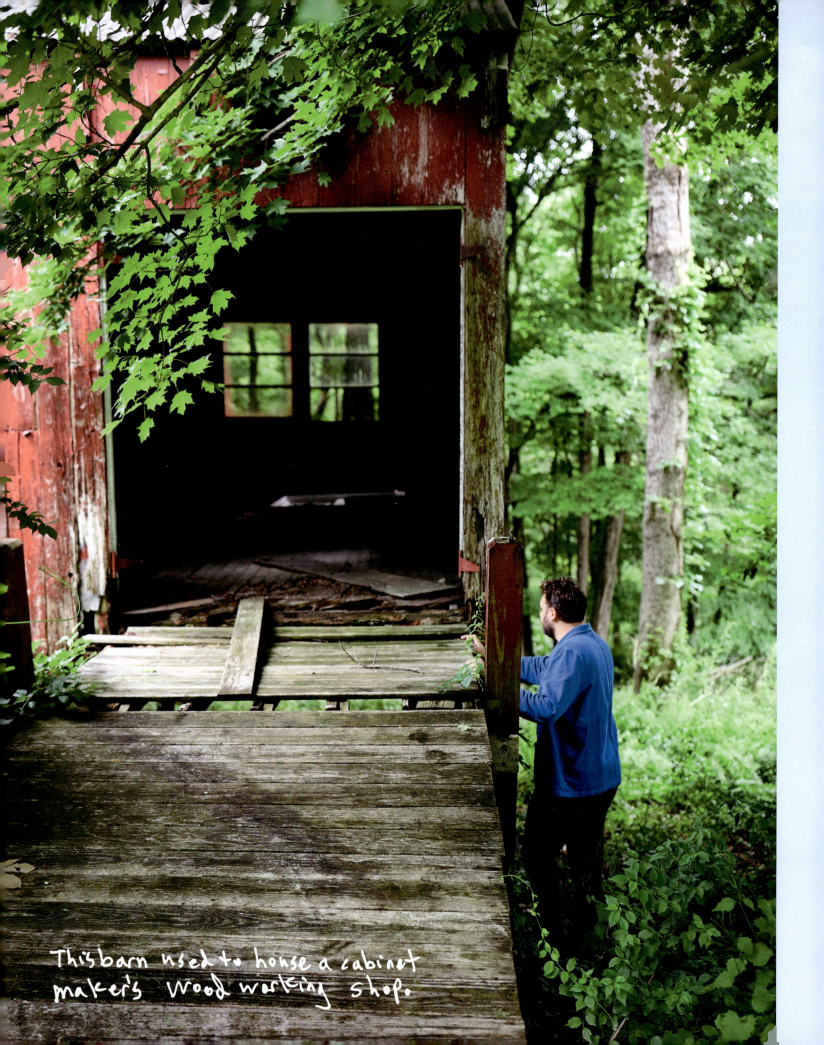

This barn used to house a cabinet maker's woodworking shop.

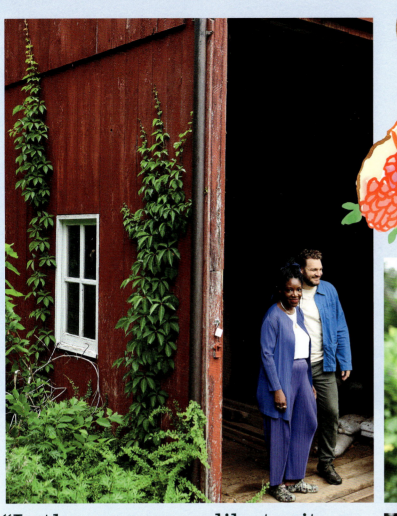

"If I could exclusively wear one designer line all the time, it would be Pleats Please by Issey Miyake. I've worn it to very fancy things, and I also wear it when hanging out around the house."

"In the summer we like to sit outside, have a drink, watch the sunset, and listen to the birds."

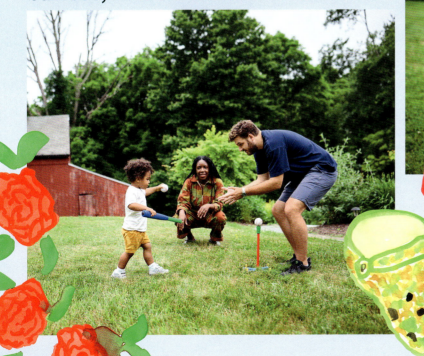

These flowers were planted by the previous owners and attract an amazing number of honeybees.

Chanelle & Ben Kalfas with Felix

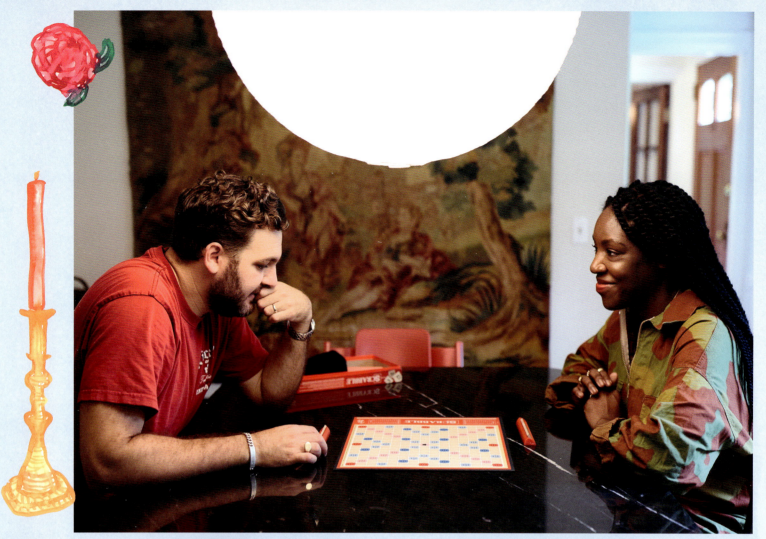

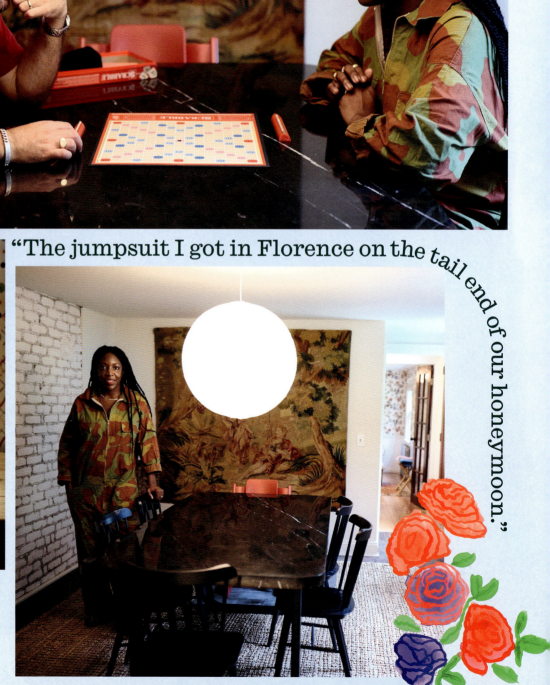

"The jumpsuit I got in Florence on the tail end of our honeymoon."

"Can't wallpaper the whole house, so it's just trying to create little moments."

Hi Chanelle, Ben + Felix! Chanelle could you design Felix a chair for your green room?

← cushiony back!

← wide, plush bottom for lounging

Ben + Chanelle could you design a play area for Felix inside your barn?

climbing ladders leading to a fireman's pole that ends in a ball pit.

Ben could you draw a new flower garden for your house?

Chanelle how has living in the country been different from your expectations?

For one, I've learned to live with bugs. Otherwise, I've been surprised by my absolute joy + comfort being idle, and I find that something I can't do when we are in the city. Lastly, I find projects energizing vs. stressful.

Ben what are 6 things you like about country life?

① Space
② Quiet
③ Apples
④ Never Ending list of projects.
⑤ The joy Felix gets out of the new experiences
⑥ The creativity Chanelle brings in making the place our own.

ASHLEY TORRANCE & GYASI

with Juliette, Olivia & Estella in Nashville

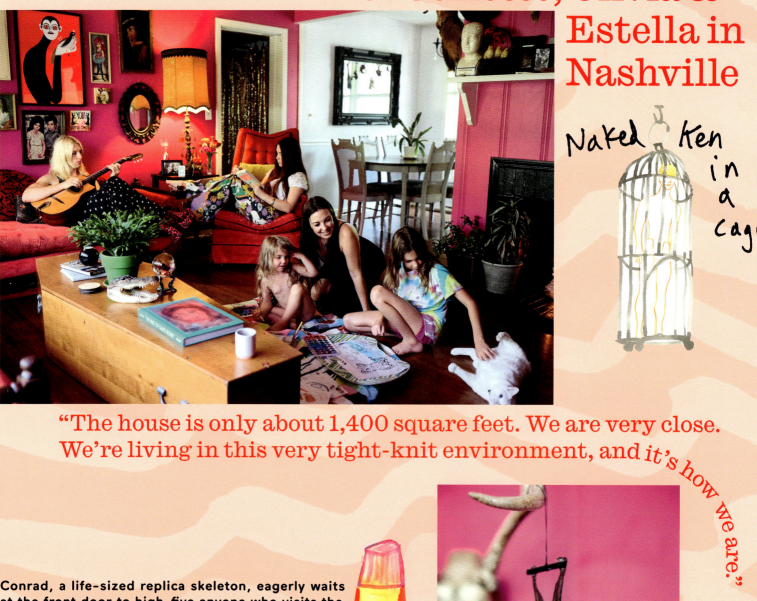

Naked Ken in a cage.

"The house is only about 1,400 square feet. We are very close. We're living in this very tight-knit environment, and *it's how we are.*"

Conrad, a life-sized replica skeleton, eagerly waits at the front door to high-five anyone who visits the Torrance family's mid-century ranch home in East Nashville. "I have an eclectic macabre style," says Ashley. "I think that stems from having a degree in mortuary science and just finding a light in the dark, putting the fun back in funeral." The living room is adorned with striking fuchsia pink walls and taxidermies, leading back to husband Gyasi's recording studio. Gyasi, who is active in the Nashville music scene, stands tall in platform shoes and a glittering glam rock outfit designed by Andrew Clancey. They share their home with their three daughters, Estella, Olivia, and Juliette, and their beloved cat, Jack. "It's creative chaos," says Ashley. "Everyone's in their own world, but we exist in a bubble together."

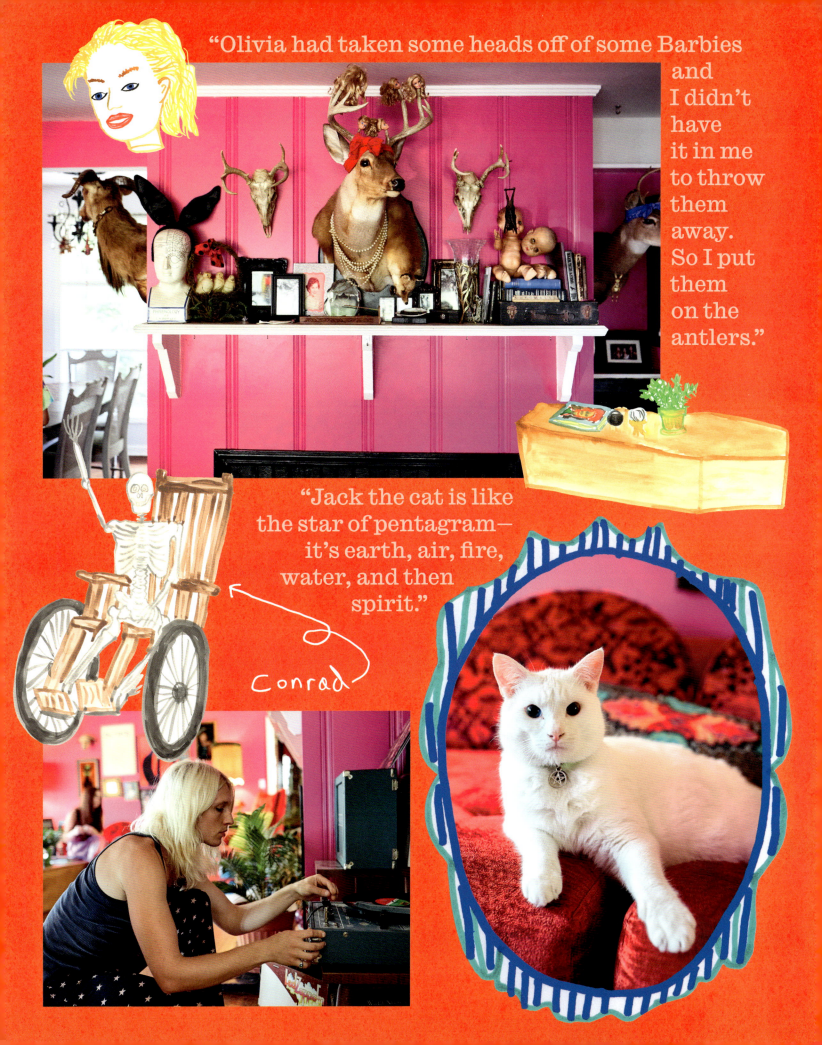

"Olivia had taken some heads off of some Barbies and I didn't have it in me to throw them away. So I put them on the antlers."

"Jack the cat is like the star of pentagram— it's earth, air, fire, water, and then spirit."

Conrad

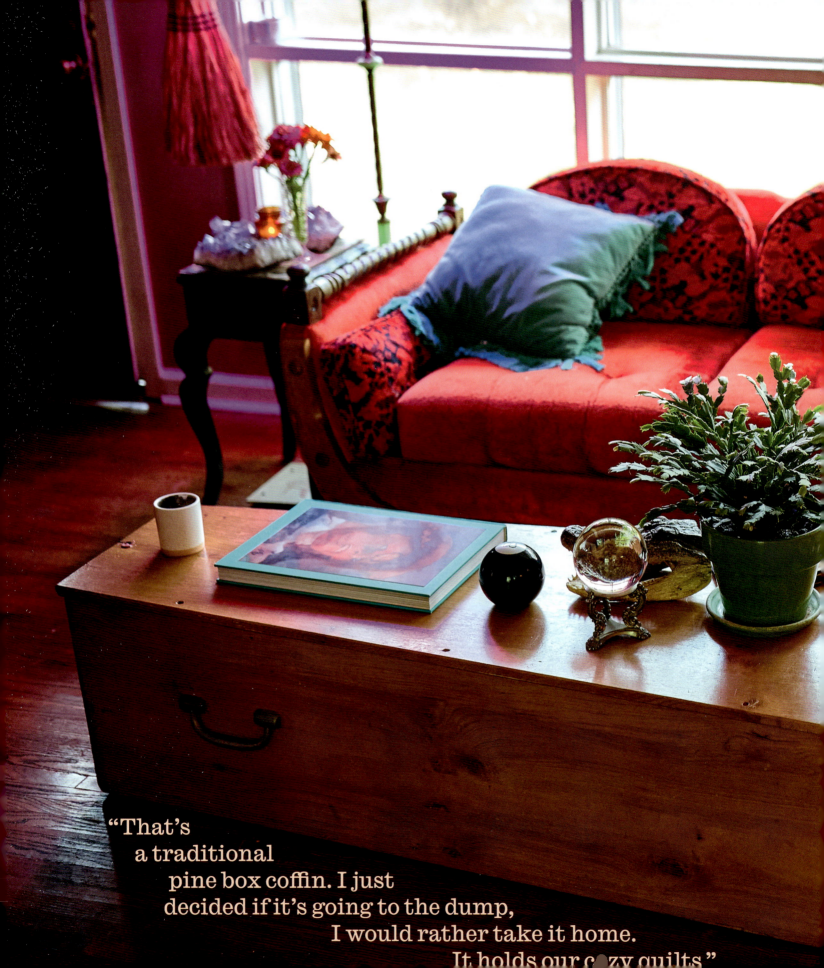

"That's a traditional pine box coffin. I just decided if it's going to the dump, I would rather take it home. It holds our cozy quilts."

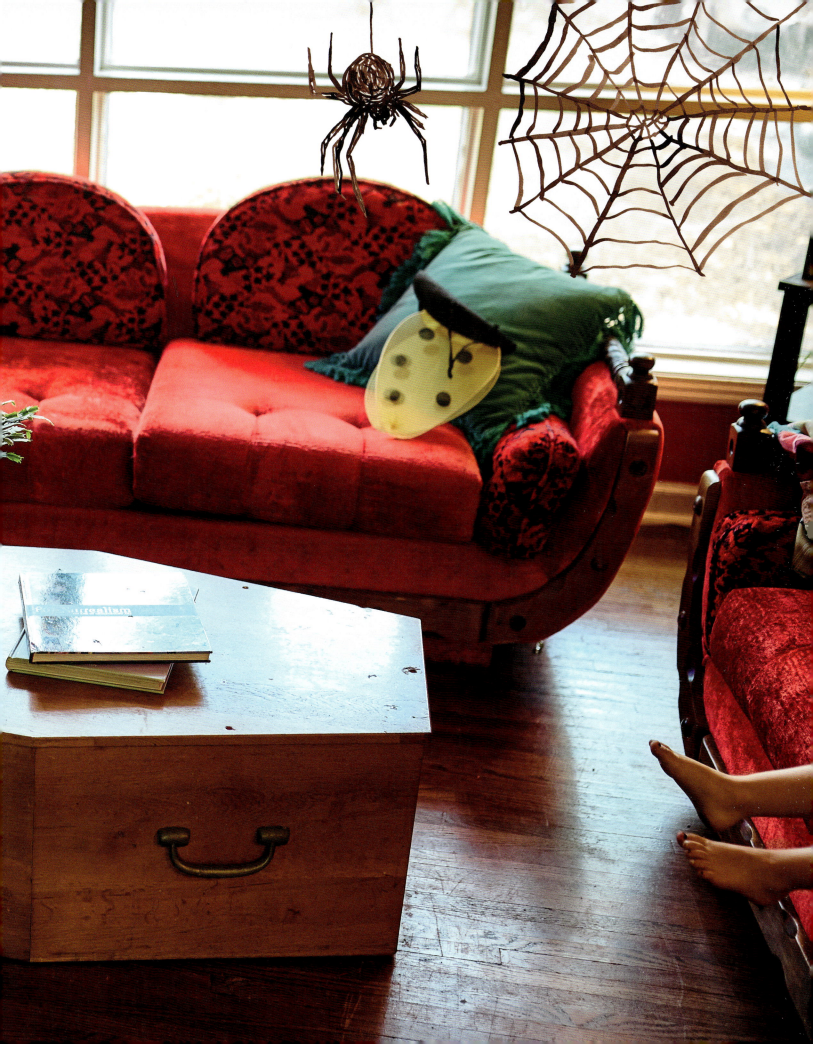

"Gyasi lives and breathes his music. He is forever practicing. It is his craft. He is never without a guitar or a pen, because he's also a writer."

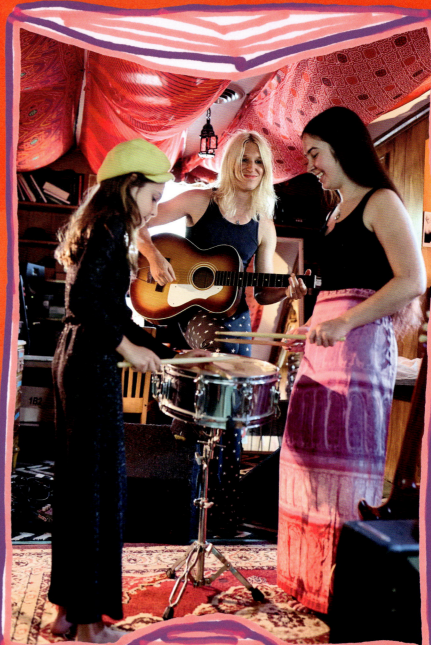

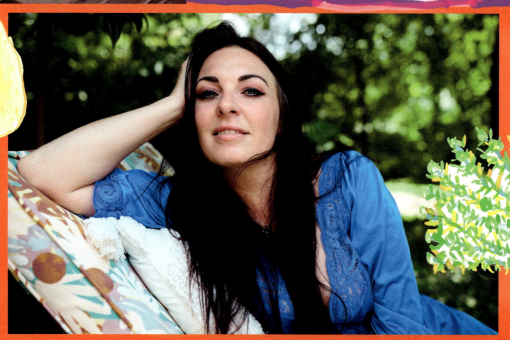

"I went straight out of high school into mortuary science college."

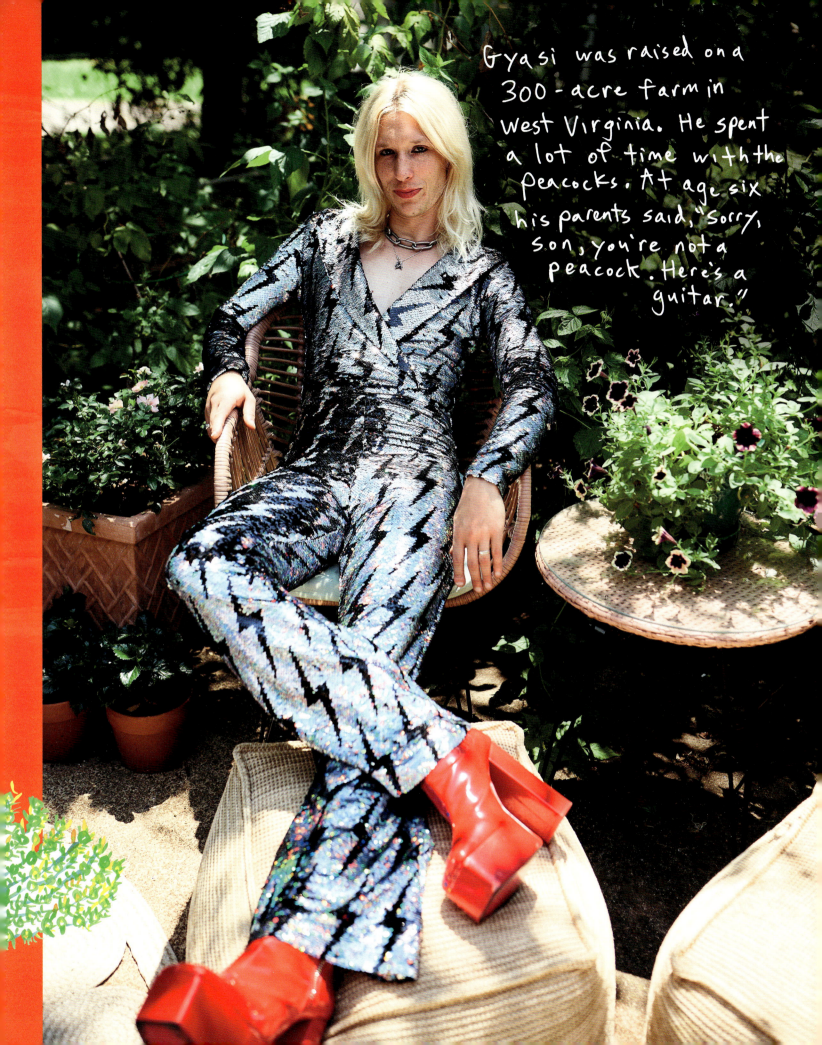

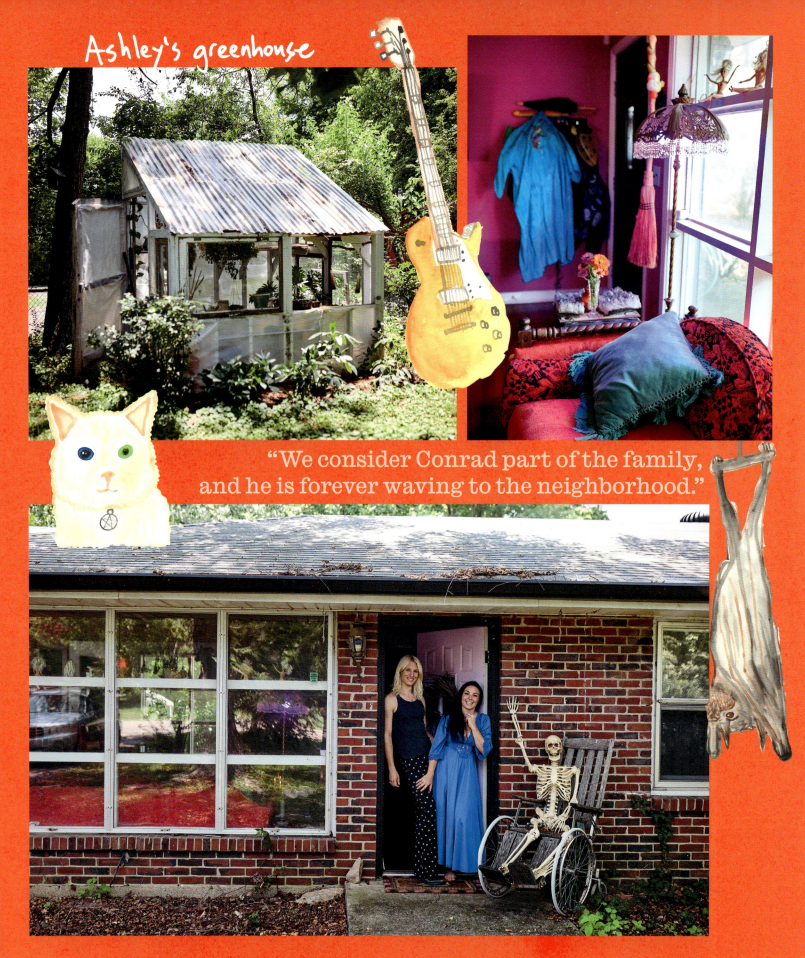

Ashley's greenhouse

"We consider Conrad part of the family, and he is forever waving to the neighborhood."

162 Ashley Torrance & Gyasi
with Juliet, Olivia & Estella

Hi Ashley, Gyasi, Juliette, Olivia + Estella! Ashley as a retired Mortician, what are the 6 best things about Mortuary Science?

① People are just dying to see you.
② Mortuary humor.
③ Your mortality is forever in check!
④ Sense of dignity
⑤ Fresh floral scents
⑥ All the hilarious things the body does after death

Gyasi could you design sequin stage shoes for Estella ⤵

Juliette what was something crazy that happened at Woodstock? The insane mudslide that was created after the rain on day 3.

Olivia could you and Estella do a drawing of Frida Kahlo's parrot ⤵

could you draw a chart of Gyasi's waking time ⤵

AMANDA & CHRISTOPHER BROOKS
with Coco & Zach in Oxfordshire

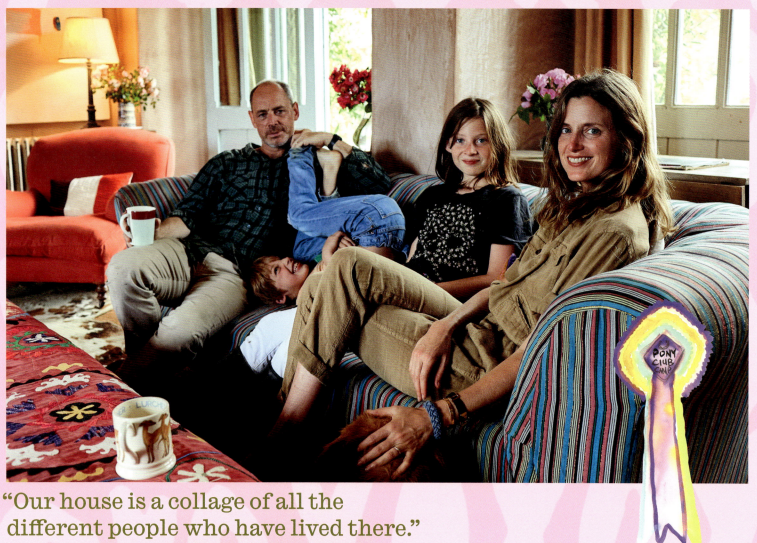

"Our house is a collage of all the different people who have lived there."

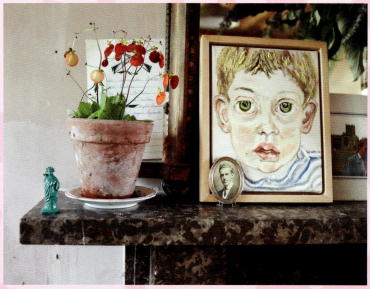

I visited the Brooks family twelve years ago and thought of those photos when putting together this book. "So much has evolved since then," says Amanda. "You captured a very specific moment in time when we'd just moved in and the house was a blank slate." The building was constructed in 1820—a carriage house on a large estate known as Sarsden. After many years in New York City, the couple was ready for a fresh start. "Traveling five months of the year for work was untenable for me. Since moving here, I have been focused on being a parent. Christopher has reclaimed his farming life. It's like we started our adult lives over. Polo, the beautiful white horse I photographed, is still alive and enjoying his golden years on the farm."

"I had left fashion, I thought, and I was looking for a new identity, to be honest. And Christopher maybe the same, like he was an artist in New York, but being an artist in England is very different from being an artist in New York. And that was the beginning of him reclaiming his farming life."

Sailor

Zach riding Porque the KuneKune pig

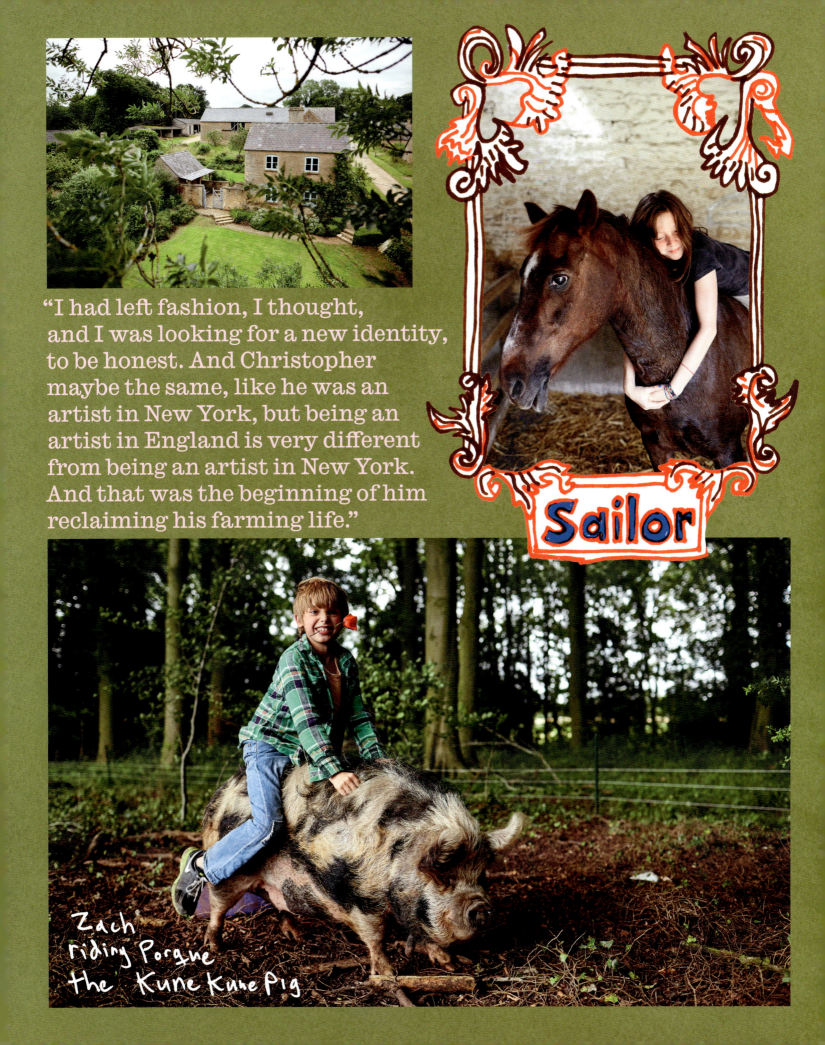

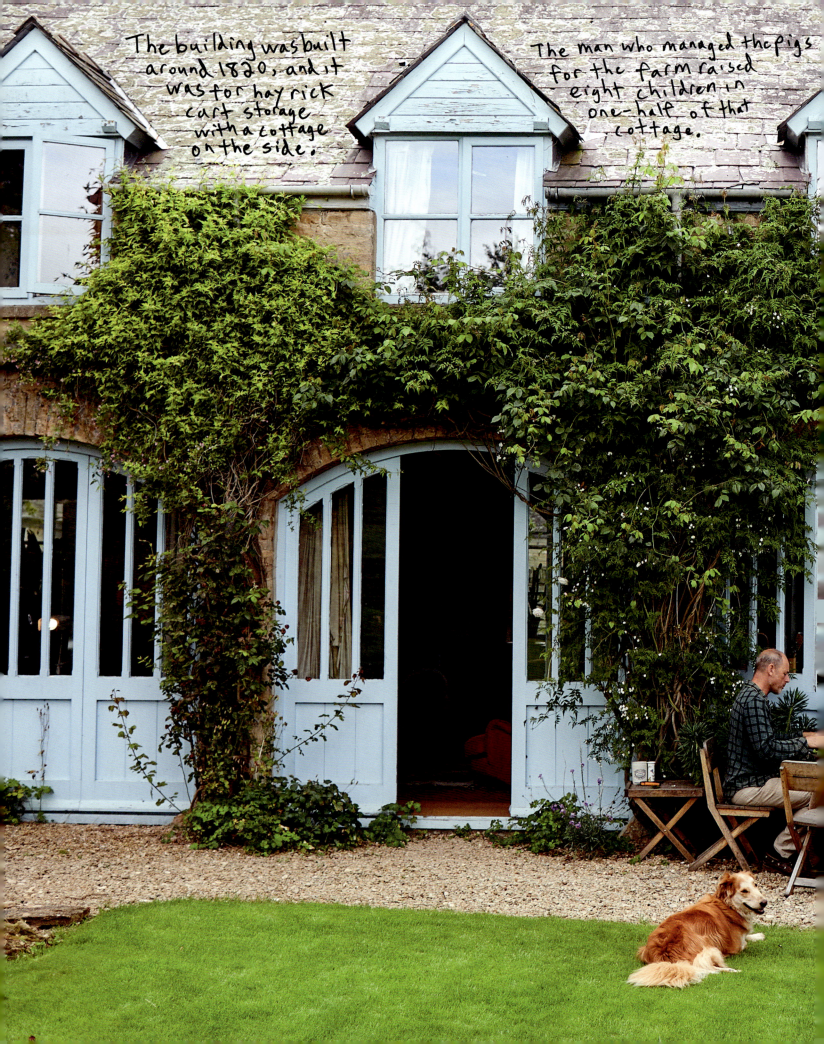

The building was built around 1820, and it was for hay rick cart storage with a cottage on the side.

The man who managed the pigs for the farm raised eight children in one-half of that cottage.

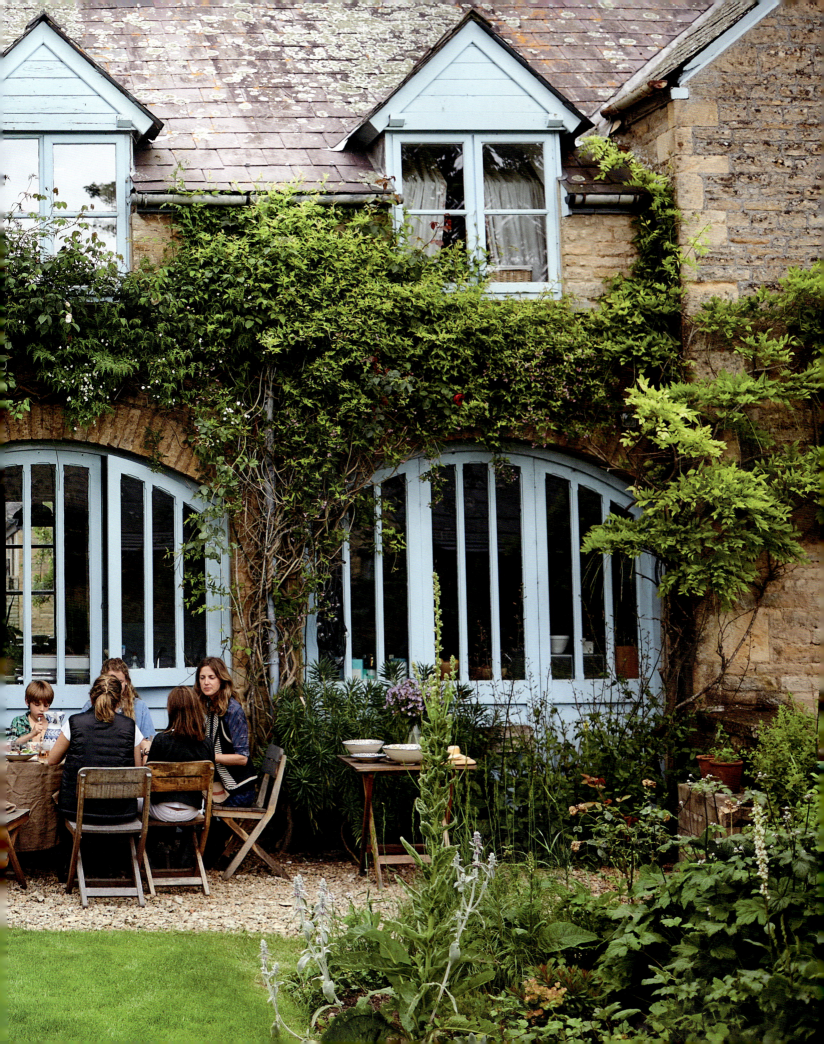

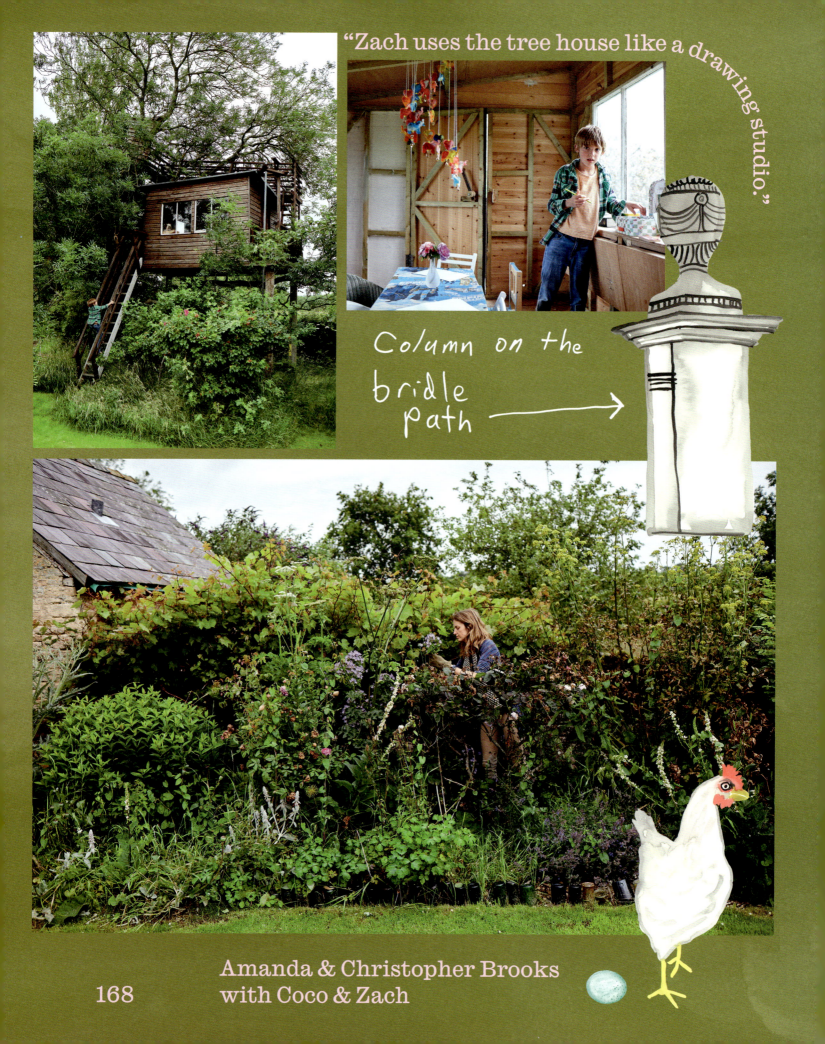

"Zach uses the tree house like a drawing studio."

Column on the bridle path →

Amanda & Christopher Brooks with Coco & Zach

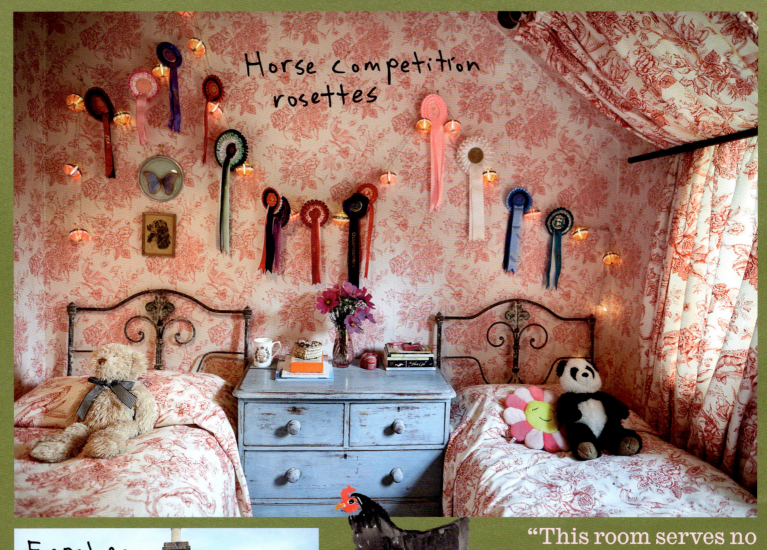

Horse competition rosettes

Espalier pears ↘

"This room serves no function now; no one is small enough to sleep in that bed. But we don't have the heart to change it."

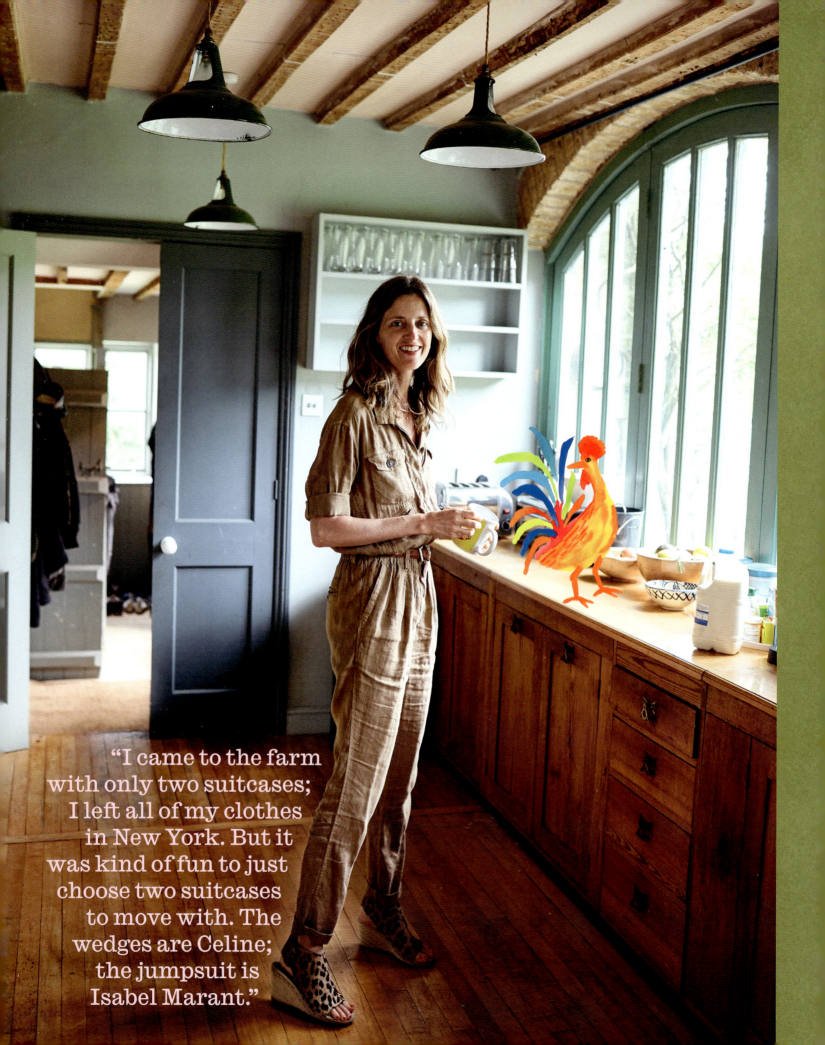

"I came to the farm with only two suitcases; I left all of my clothes in New York. But it was kind of fun to just choose two suitcases to move with. The wedges are Celine; the jumpsuit is Isabel Marant."

Hi Amanda, Christopher, Coco and Zach! Coco what are your 6 favorite things about horses?

① The feeling (sorry for sounding like a hippy) of jumping through the air
② Their personalities
③ The way they look
④ How they can tell how you feel
⑤ Their humor (funny things)
⑥ How they can trust you

Zach could you draw yourself on a dragon →

Amanda what are the 6 most beautiful things about the English countryside?
① early wheat in the fields
② horses and horses and horses
③ 400 year old trees
④ "Cow parsley" aka Queen Anne's Lace
⑤ Strawberries
⑥ Dry stone walls

Christopher what are your 4 favorite things to do around the farm
① Check up on young trees I have planted
② going beserk with a weed whacker
③ night walking cross country
④ Watching the weather coming across the valley at us.

Christopher + Amanda could you draw your dream living room for your new barn ↓ label

Coco whats a good word to know for SAT's?
 antidisestableshmentarianism (sorry for spelling)

Amanda what has living in England taught you?
 How much being outside contributes to my general well being.

concrete staircase with wood steps. Concrete has the wood shuttering imprint on it.

concrete ceiling
scaffolding plank walls
70's wood speakers
Big opening broken down into windows and doors
moroccan rugs
hole at floor level turned into a floor level window

VADIS TURNER & CLAY EZELL

with Gray & Vreeland in Nashville

"I like to explore the fine line between, like, what's ugly and what's fabulous."

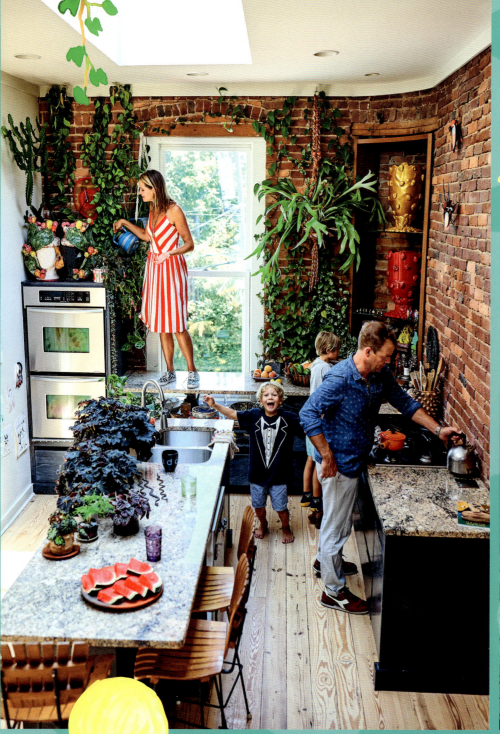

The floor is lava.

"I clearly have no meter on volume," says Vadis. "I mean, if I like it, it matches. We went with a sort of joie de vivre—fun and bright. There isn't a room the kids don't inhabit and play in." Vadis and Clay had been living in New York for a decade when they decided to move back home to Nashville with their family. "So many exciting people and things were blossoming here," Vadis says. Their Second Empire–style home was built in 1880 and survived the great fire of 1916. "I love amplifying color and living in color," says Vadis, who has a background in design and taught at Pratt Institute. "I explore the fine line between what's ugly and what's fabulous. Sometimes I see something ugly, and I'm like—if I don't buy it, who will? I must rescue it."

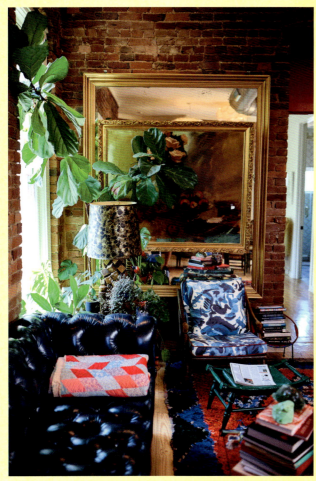

↰ The living room features Vadis's plant problem.

↳ Monster chair by Brett Douglas Hunter

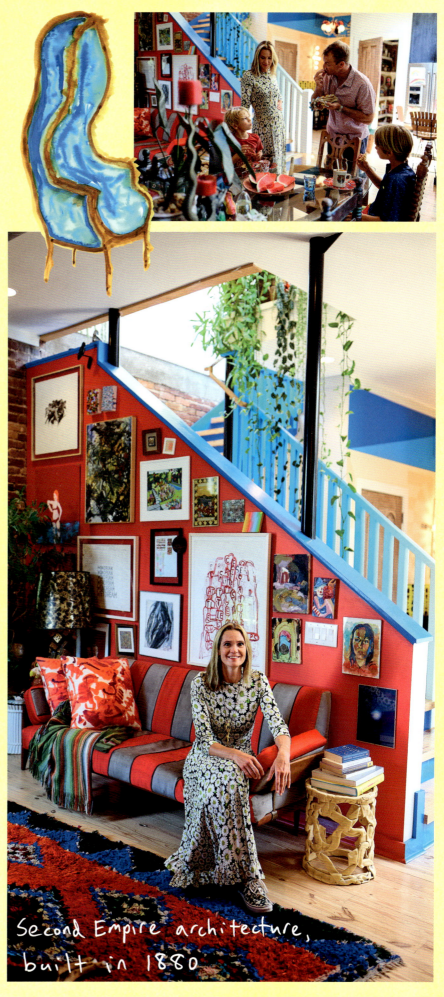

Second Empire architecture, built in 1880

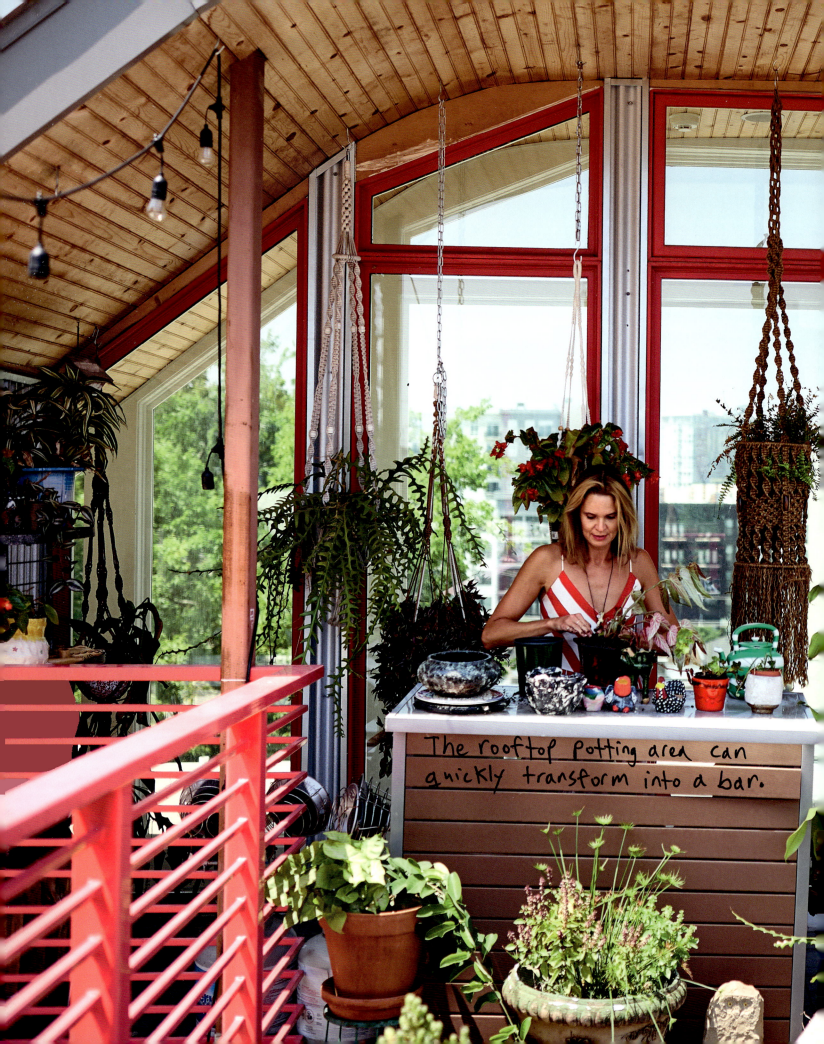

The rooftop potting area can quickly transform into a bar.

Mesopotamian portal wall art by Kelly Diehl and Elizabeth Williams

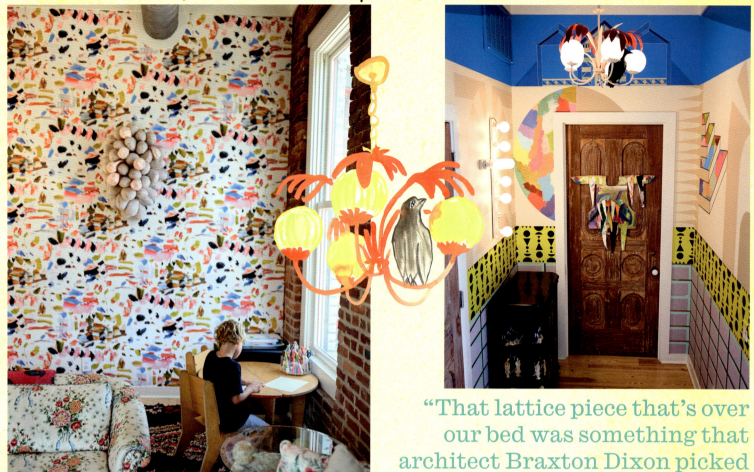

"That lattice piece that's over our bed was something that architect Braxton Dixon picked off of a sunken riverboat near Natchez, Mississippi."

"Chintz country-club-vibe floral couches and shag black leather rug."

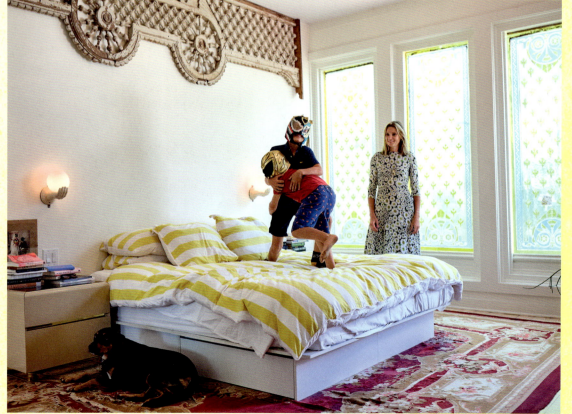

"These wild ideas are such important parts of our home that I had no creative control over, but I trusted local artists that they want to do their best and they want to do something exciting."

Lucha libre mask →

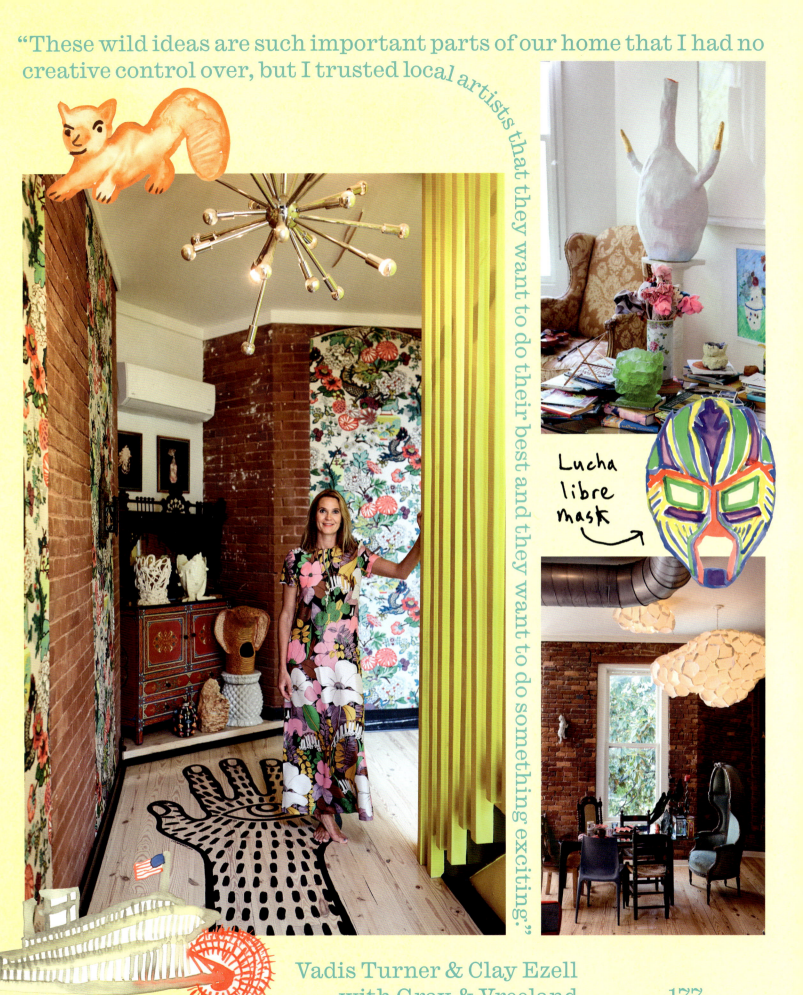

Vadis Turner & Clay Ezell
with Gray & Vreeland

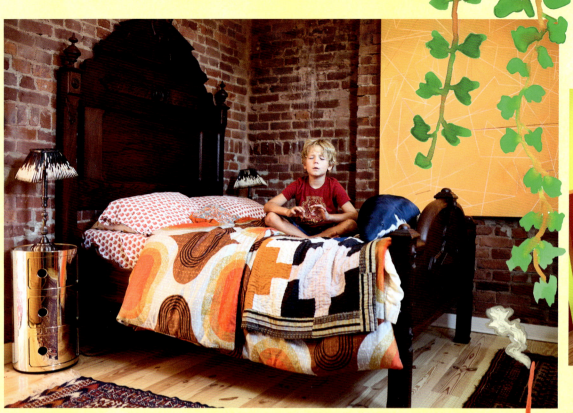

"He picked up meditating at preschool."

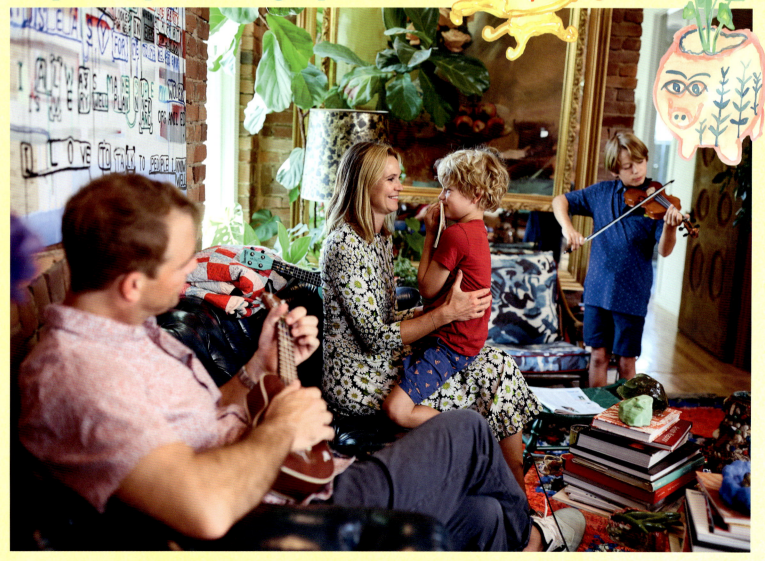

Hi Clay, Vadis, Gray + Vreeland! Clay can you tell me a tall tale about fishing? ♥

Two Summers ago, Gray, Vreeland and I were fishing for Bass on Old Hickory Lake when we thought we got hung up on a log. I pulled and pulled on the hook to get back my lure, and then the log started swimming away! Fifteen minutes later we reeled in a 55", 60lb Flathead Catfish. It was so old it had barnacles on its face.

Vadis could you design a candelabra inspired by Motherhood? ♥

Gray could you give me a recipe for a dish you would like to cook? ♥

PIE
ingredients:
blueberries
pie crust
flour
sugar
lemon
eggs

Grilled cheese
Pancakes
Fries
pie
mix together.
pie crust.
brush with
egg yolk

IN 2007 I MADE A REAL CHANDELIER OUT OF TAMPONS

Vreeland could you draw your dream Monster truck ↘ ♥

Vadis could you + the fam design a corn hole? ♥

♥ THANK YOU TODD SELBY

PREM & PUNEET KUMTA
with Sabina, Rajan & Ishaan in San Francisco

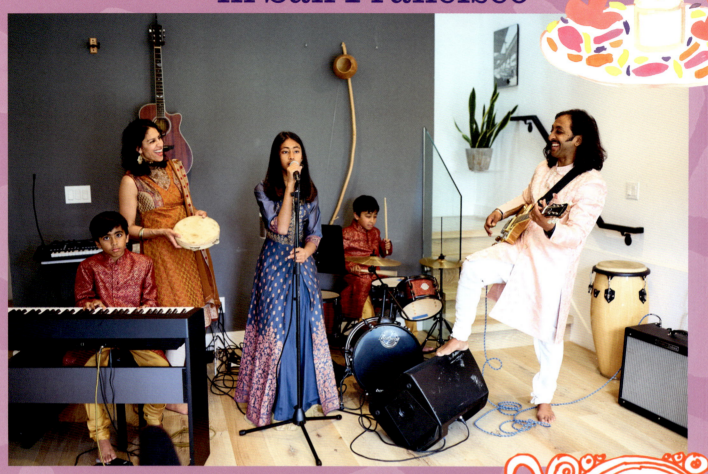

> "We have a band where my daughter, Sabina, sings; our older son, Rajan, plays keys; and our younger son, Ishaan, is the drummer. I play guitar, and then Puneet does percussion."

"Our vibe is just tons of energy and fun," Prem tells me about the Brazilian capoeira music he plays with his family. "We had our first major show last May. My daughter sings, the middle son plays keys, and the youngest is a drummer. I play guitar, and Puneet does percussion. Playing onstage provides a lot of life lessons. A big one is, if you mess up, just keep going. Get through it, move forward. Because no one in the audience is going to know." Prem and Puneet met in 1999 during their rave days and have been together since. He works in advertising, and she is a social worker in San Francisco. Color is everywhere in their household. "We have a quirky sense of design. We like functional things, but we're also very fortunate to have some cool contemporary art by underground graffiti artists and street artists. We try to bring that color palette to the furniture, and we're definitely very into plants. It's common in Indian culture to wear bright, beautiful clothing for weddings. In America, we have fewer opportunities to dress up like this, so being able to do so when we rock out is fun."

Prem's berimbau

"An arti [ritual] is a way for us to bless our kids, but it's also a symbolic gesture to our connectedness as a family. We are in essence shining our goodwill upon them."

"If we're not the loudest people in the room, we're close to it."

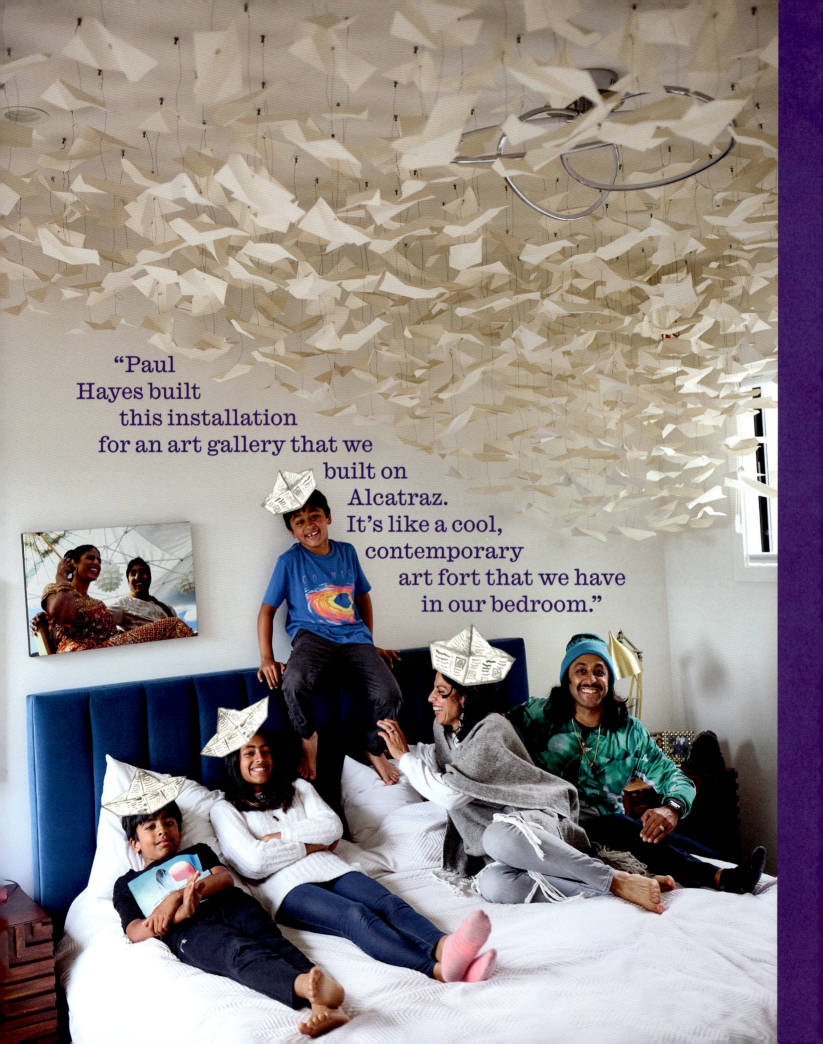

"Paul Hayes built this installation for an art gallery that we built on Alcatraz. It's like a cool, contemporary art fort that we have in our bedroom."

Puneet, Prem, Sabina, Rajan + Ishaan. Sabina could you write a story for your brothers? In Antartica there were 3 penguin siblings who were recruited by the PFBI to be kid spys. One of their missions sent them off to Mumbai, India, to learn from Yogi Master John John. As it turned out, John John was a double agent working for Demacia, the PFBI's enemy agency. The evil yogi master had stolen a magical red book for Demacia. The siblings were briefed about their next mission, to steal the book back. In order for that to happen, they had to sneak into Demacia's headquarters. Once inside the room with the book, the siblings had to sneak past the lasers and security cameras with their ninja spy moves. In the middle of the room was a pedastel with the book inside it. Anibas opened the book with her brothers crowded beside her, wondering what made the book so valuble. Then they all got sucked in.....

Rajan could you draw a new piano

Ishaan could you design a new drum set

Puneet could you design an incredible rave for your 20 something self

Prem could you design the ultimate dance battle

NIKKI FENIX
with True & Brave in Portland

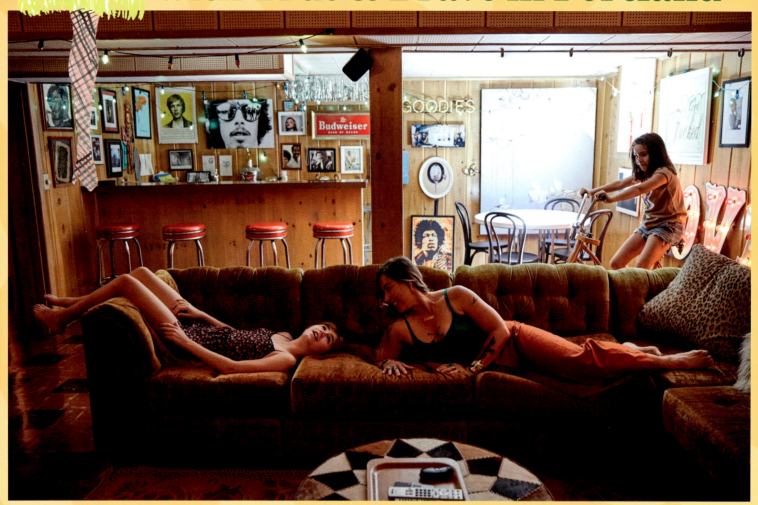

"The house came with forty coat hooks in the entry to the basement bar; this meant it had been a place to gather, a party house. We loved that part of the story."

Nikki and Jonny have a studio in the back of their house for painting, prop building, and ceramics. Jonny is an artist and production designer, and was away for a job when I visited. "Jonny and I are both drawn to art and music. Our first date was Coachella. We're always drawing with the kids, taking pictures, and encouraging them to think creatively. Sometimes neighbors or the kids' friends will walk into our house and feel confronted—maybe the bull's head with giant "ribbed horns" is too sexually free? But that piece is a comment on toxic masculinity. Art always draws people into conversation, and we love that honesty. Nothing is off the table; everyone is open and free here."

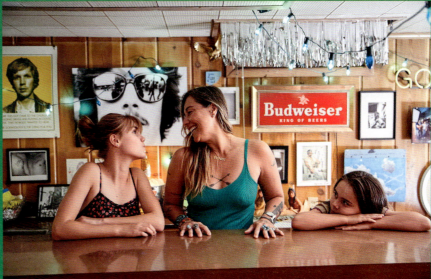

"It was great to grow the girls in a place that felt really grounded in nature, with a lot of mountains, rivers, and creative people all around us."

"Along the mantel were a hundred cigarette burns, revealing where they put down their cigarettes to play pool or to dance!"

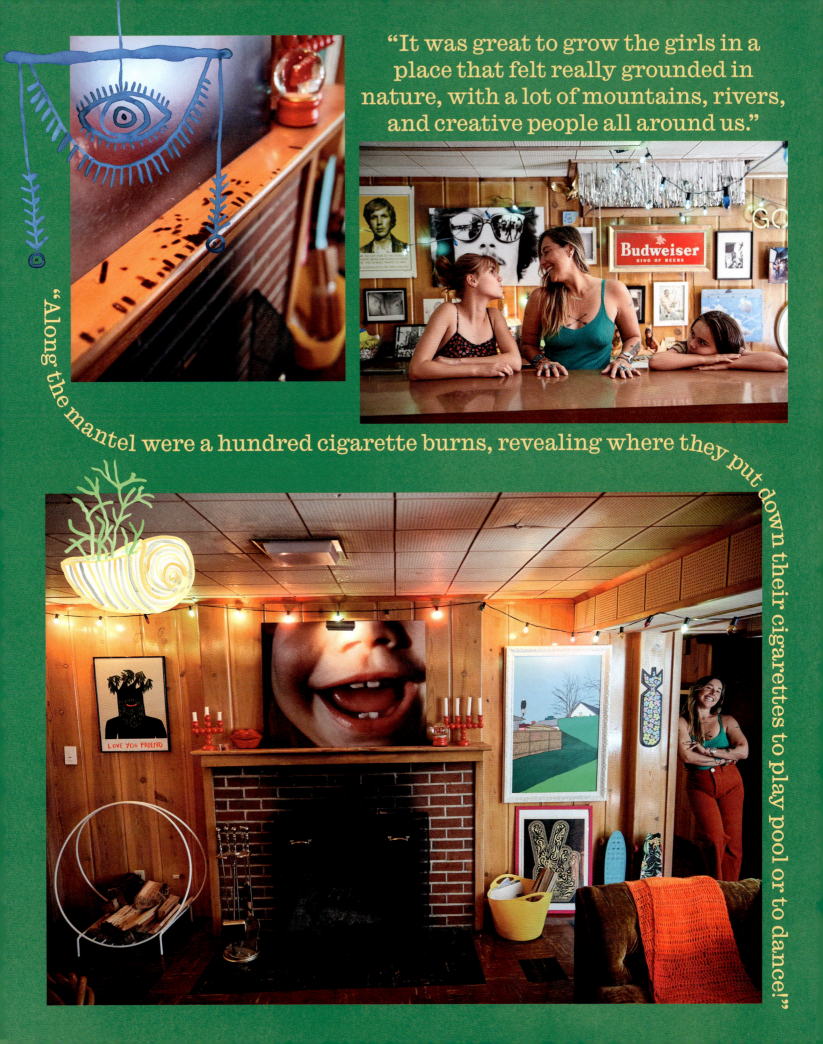

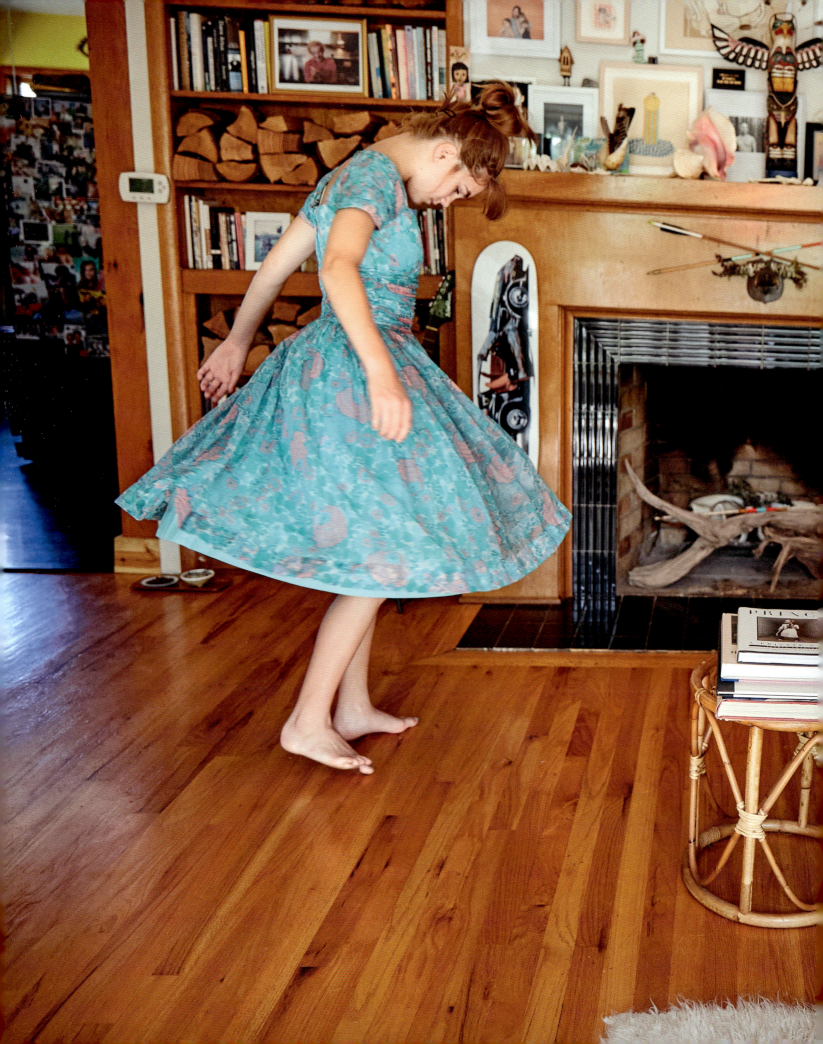

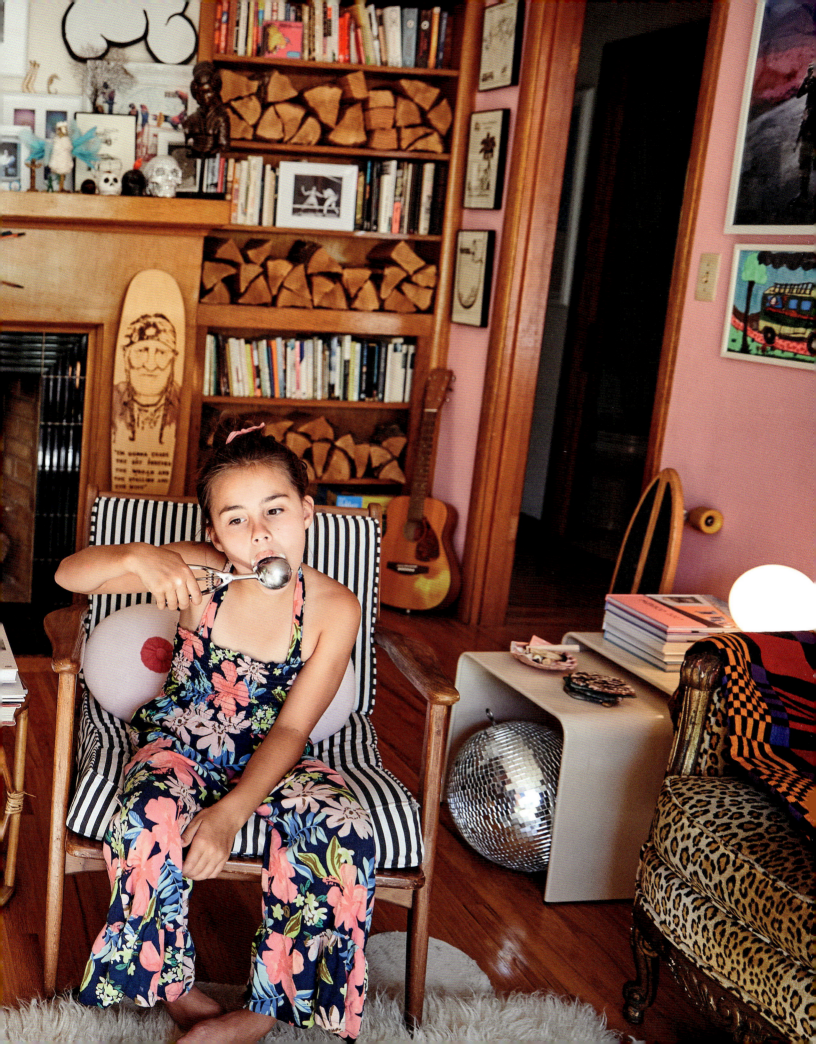

"I worked it out with the city of Portland to get all their damaged signs that they were going to recycle. So [two-year-old] Brave and I built a tree house for a week, and then we went on a trip in the van."

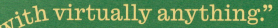

"Jonny can go into his studio and come out with virtually anything."

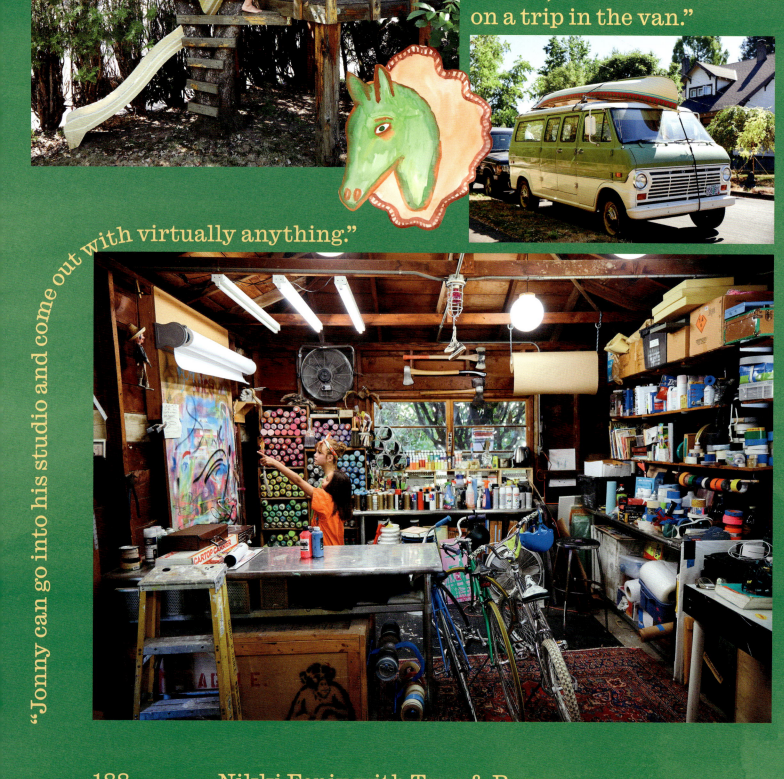

Nikki Fenix with True & Brave

The bull's head is a comment on toxic masculinity.

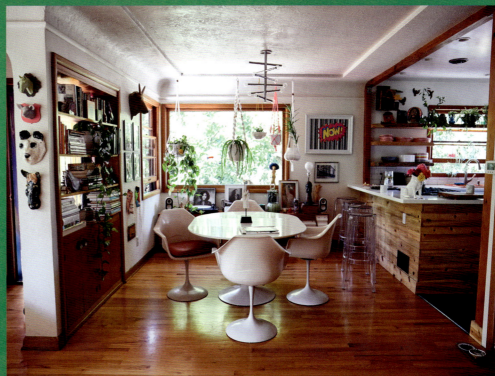

"We have always collected pieces that speak to the heart, from travels and adventures, objects from the past, art from our friends and peers."

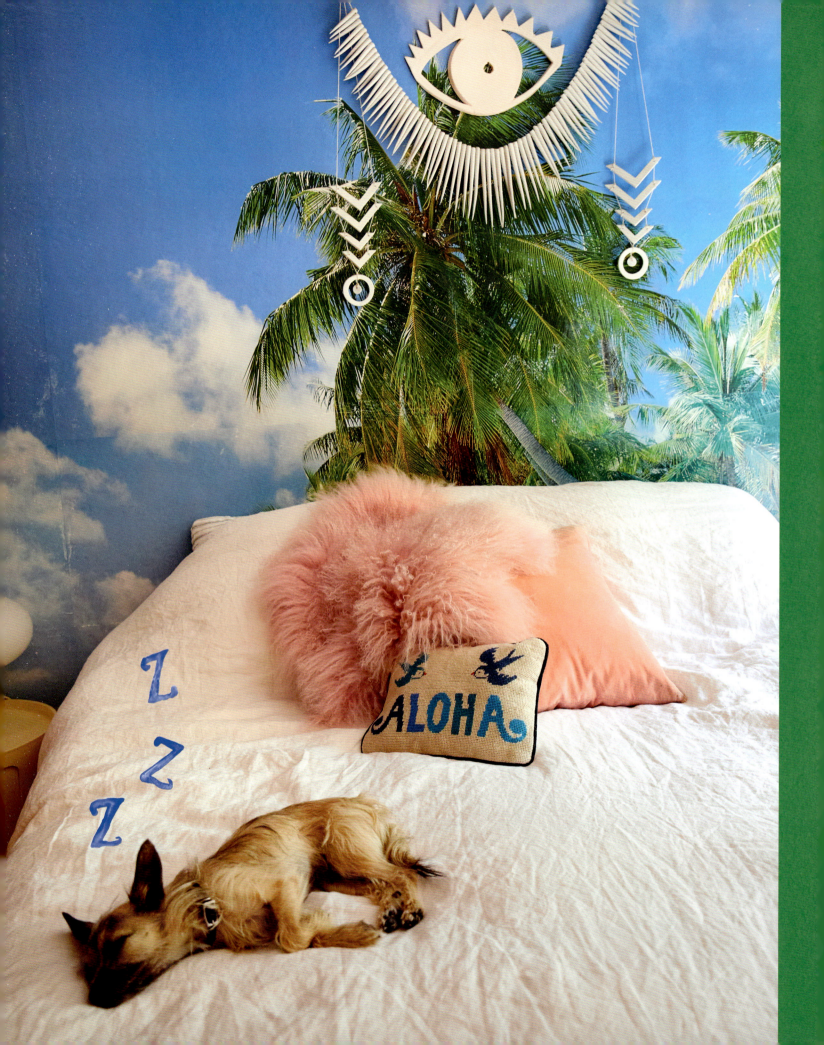

Hi Nikki, True + Brave!
 True will you design a house for your turtle when it grows up →
 Brave will you design a van for your turtle to drive →

Nikki will you draw your dream Bondi Beach chill shack →

Nikki how can kids go "beyond the selfie?"
Being creative! Expressing ones favorite colours, patterns, textures. SAYING something true to YOU.

True + Brave draw ~~what are~~ your favorite possessions →

All GLASS WITH RETRACTABLE SHADES.

Brave: true:

"Steevie"

All boys!!

ERIC ROSS & KATHERINE LINCOLN

with Clay & Julian in Brooklyn

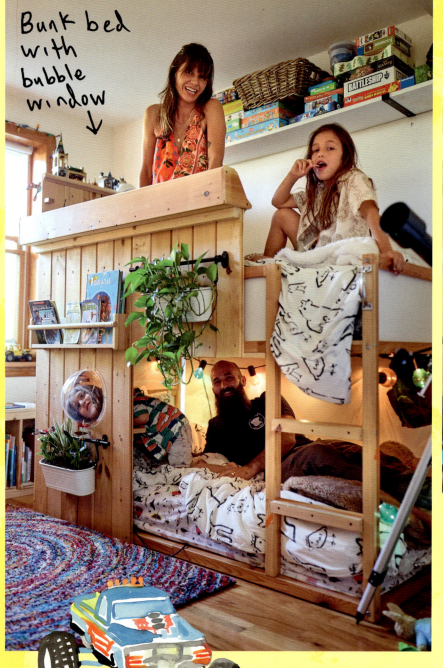

Bunk bed with bubble window ↓

"Since Eric and I met when we were nineteen, we've always made stuff."

Clay and Julian's toys include a drill press, blowtorch, rotary flex shaft, and motorcycle lift. It's all stuff that I would be scared to operate myself, but in the family's workshop everyone is having fun. "It's eclectic but functional," says Katherine. "We try to make it more than a dirty metal shop. The rugs, the natural wood. The art on the walls and countertops everywhere." The space is not only home to Eric's custom motorcycle fabrications and Katherine's jewelry; it's a second living room. I ask what it's like sharing the workshop with two kids. "It's not quite as fluid as we would like it," says Eric. "But there are magical moments when it all comes together," Katherine says.

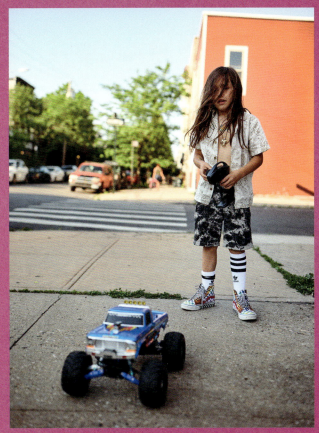
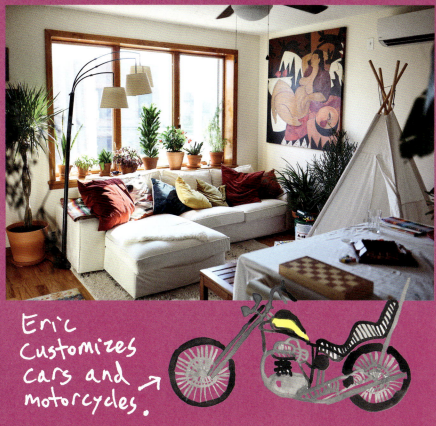

Eric customizes cars and motorcycles.

"We've been down in Red Hook for almost fifteen years. It's changed so much, when we moved here I used to call it the land of misfits."

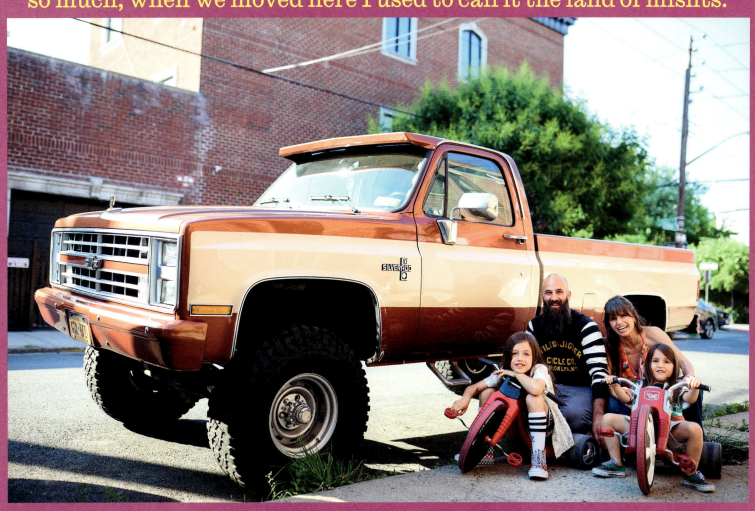

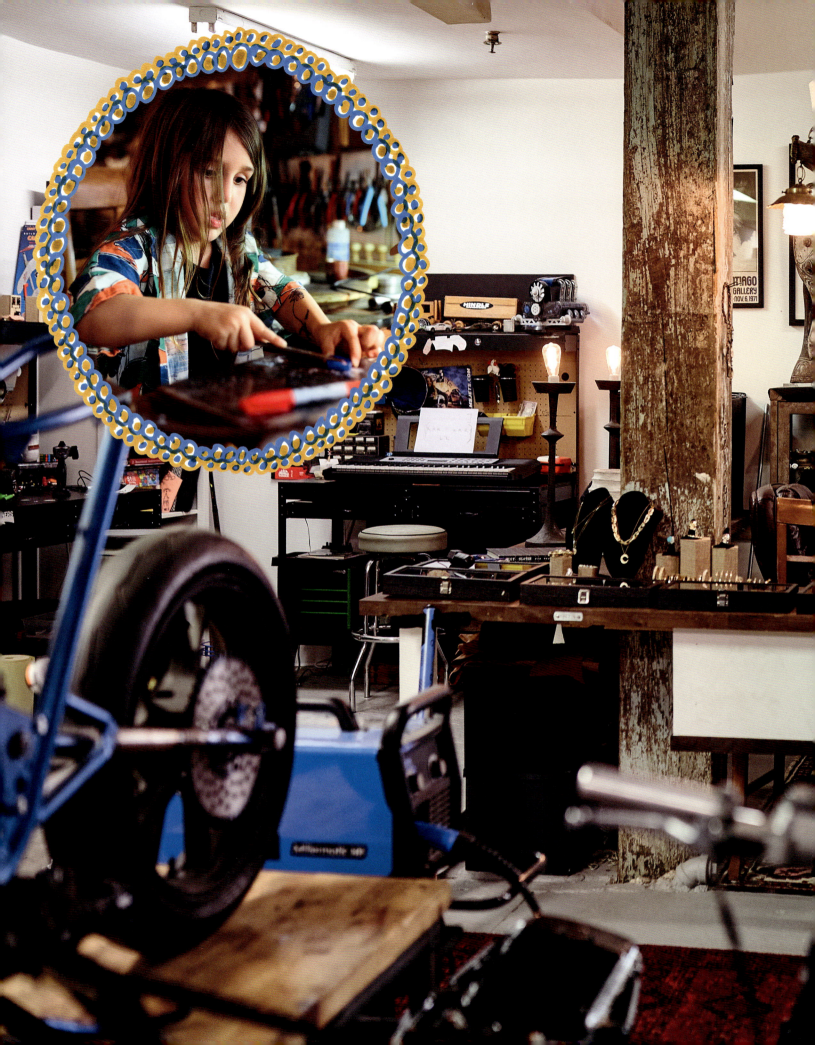

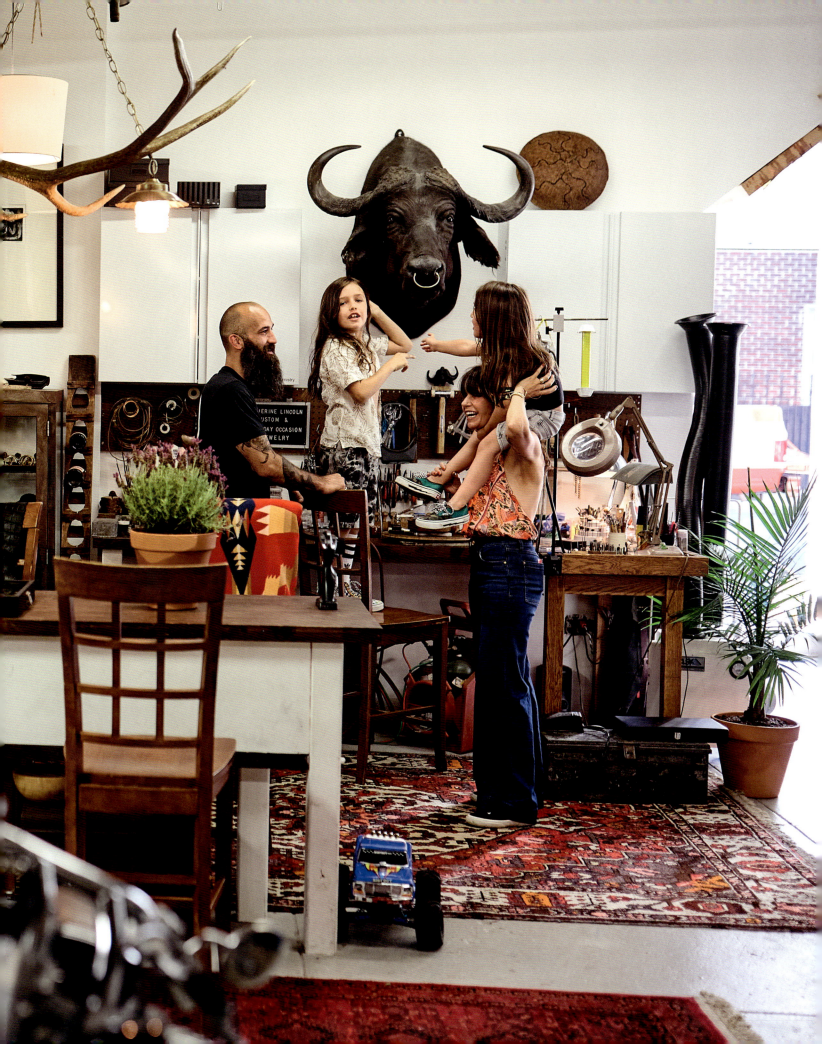

The afternoon sun creeping into the studio

"We try to have a functional space for the boys, to incorporate them in our daily tasks and projects. Afford them the space to investigate."

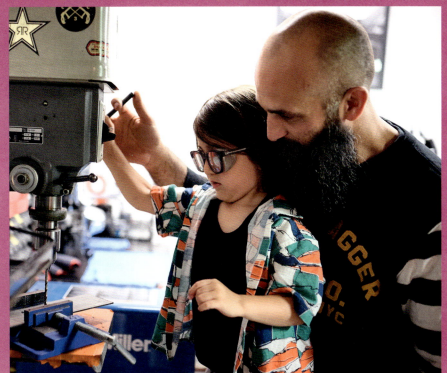

These machines are operated by kid professionals - don't try at home.

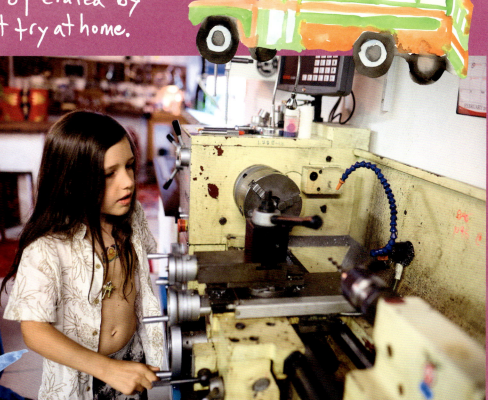

Eric Ross & Katherine Lincoln
with Clay & Julian

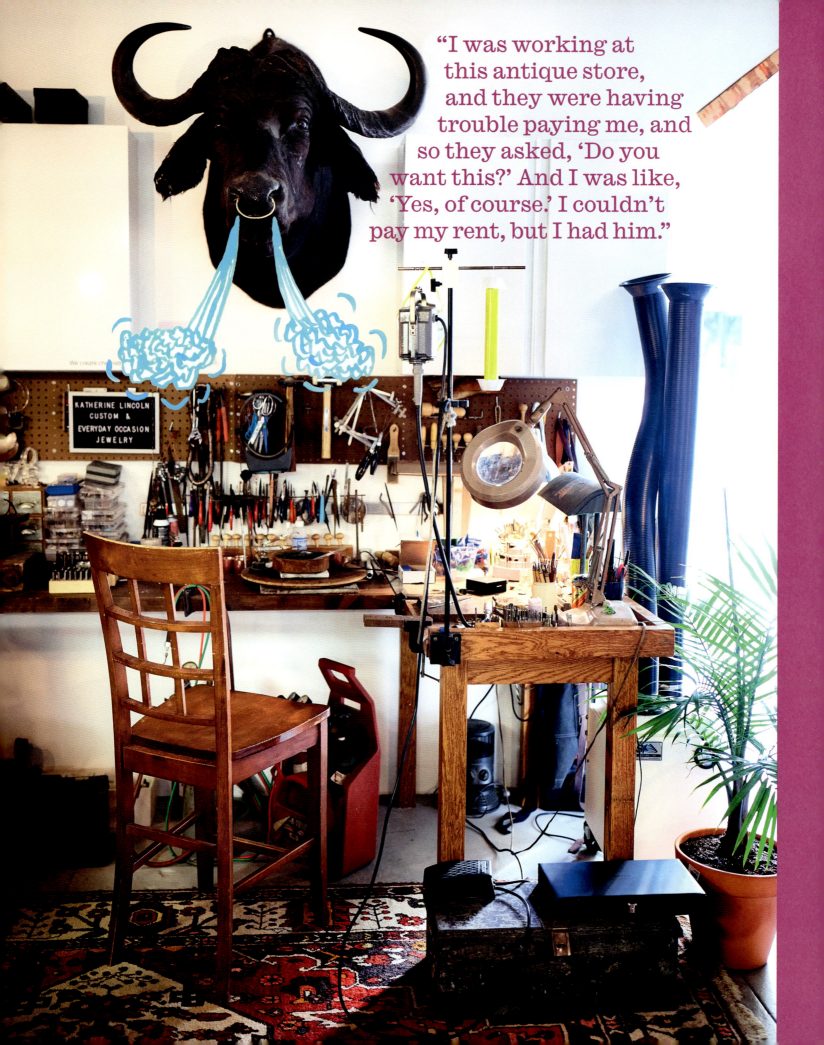

"I was working at this antique store, and they were having trouble paying me, and so they asked, 'Do you want this?' And I was like, 'Yes, of course.' I couldn't pay my rent, but I had him."

Hi Katherine, Eric, Clay + Jules! Jules could you draw a collection of your keys? Clay could you draw a cat with a cool hairstyle?

Eric could you design the ultimate RC car course for your kids?

Katherine could you design a ring for everyone in your family?

Signet Rings - with everyone's individual crest

Eric/Papa - the gears of our crew that makes everything work ♥ (alexandrite)

Jules - sweetest protector brother - winking eye with a side of silly (Rubies, black diamond)

My two wolf pups - symbol of loyalty and wild spirit (topaz, alexandrites)

Clay - surfing waves and working hard w/ focus (aquamarine)

Katherine + Eric what are some somewhat dangerous but very fun activities for kids?

① Use the drill press to make stuff.
② Use the torch to age the wood on their treasure chest
③ Use rotary flex shaft to drill/carve wax models for jewelry
④ Operate the motorcycle lift.
⑤ Use impact gun to tighten nuts an bolts
⑥ Change the fan belt on the truck with the engine run (hahaa kidding)

MAYA MORI & MICAH KASSELL

with Ethan, Aidan, Frankie & Coco in Portland

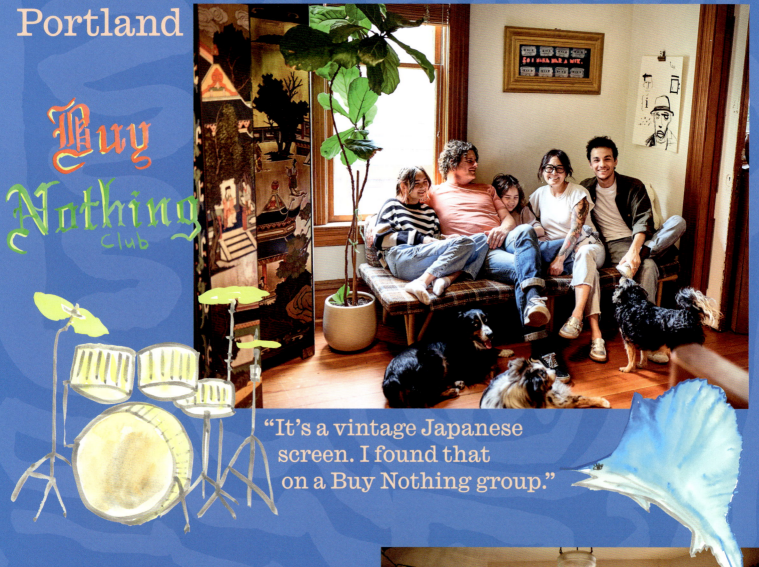

"It's a vintage Japanese screen. I found that on a Buy Nothing group."

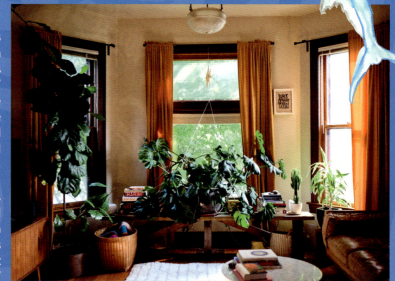

It's a rare quiet moment at **Maya Mori and Micah Kassell's house.** Two Australian shepherds nap beside the couch as daughters Frankie and Coco are drawing upstairs. This nineteenth-century Victorian is home to the Mori/Kassells' four children and three dogs. "I'm not really sure why we got a third dog," says Maya. "I think it was my fault." The house was once a church parsonage before it was picked up and moved six blocks to its present location. The tall ceilings and light-filled spaces create the perfect canvas for the Mori/Kassell family to channel their creativity. Maya is half Japanese—a cultural heritage that shines through in her kids' music and art. The local public school has a Japanese immersion program that all four children attend. "The house is a little bit chaotic," says Maya. "That's our style. It's not polished or new, but it has a lot of history and layers to it."

"Each of the plants in my tattoo signifies one of my kids. There's a big pink peony, and that is Coco. It has a lot of beauty and delicacy. There's deep purple plum-colored hellebore, and that's Frankie. She is very private and protective, but also very beautiful. Ethan is a fern, because he's very strong, steady, and even-tempered. I chose a native berry for Aidan, as he's a balance of sweet and prickly. Micah is represented by a Japanese beetle. We always joke about it because Japanese beetles are really beautiful, but they're actually pests."

Coco with her oni

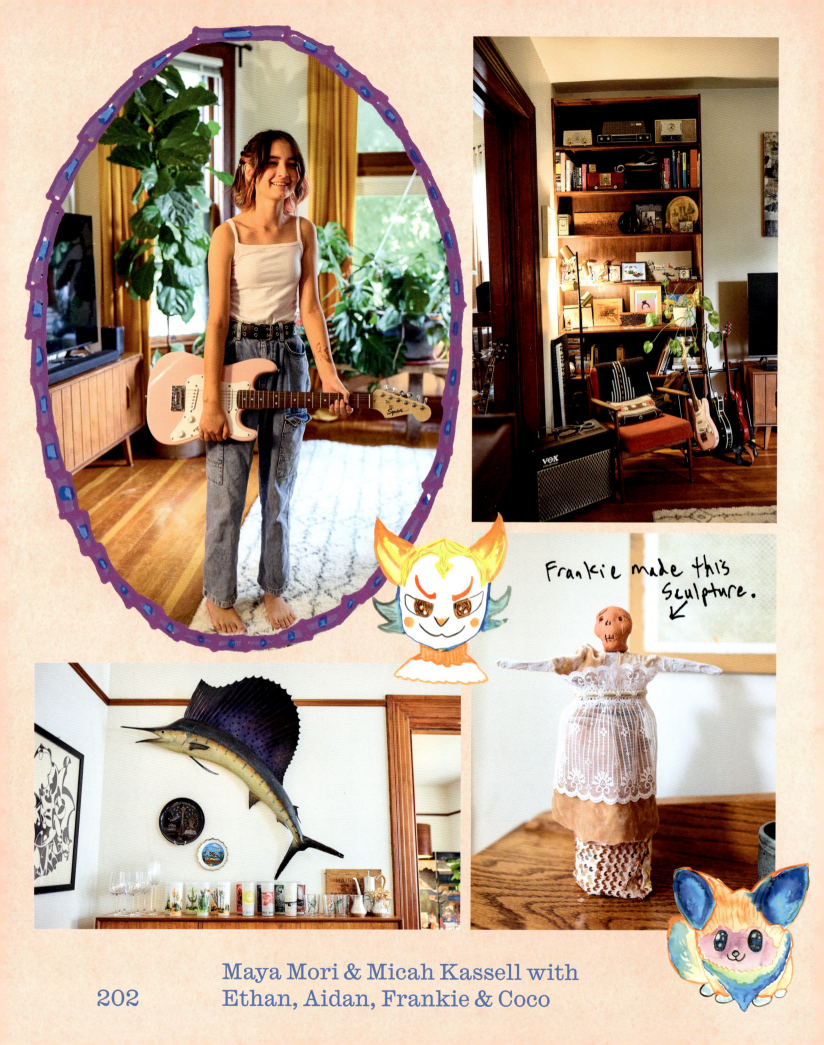

Maya Mori & Micah Kassell with
Ethan, Aidan, Frankie & Coco

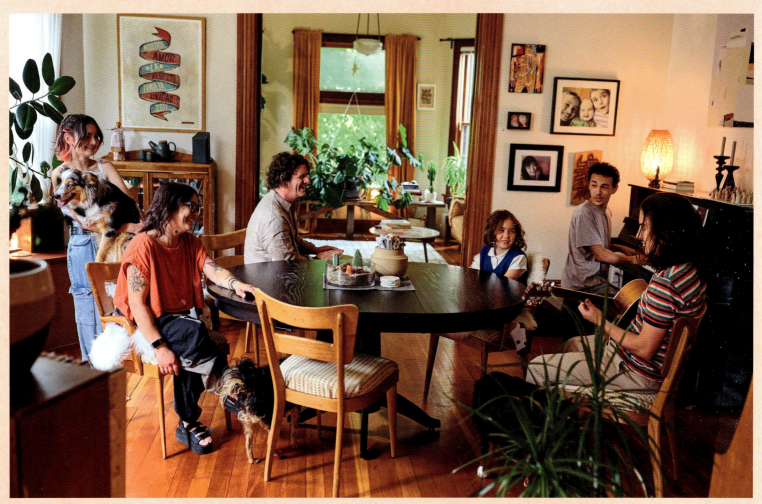

The whole family in the dining room with Aidan on guitar and Ethan on piano.

"All the kids love anime and manga."

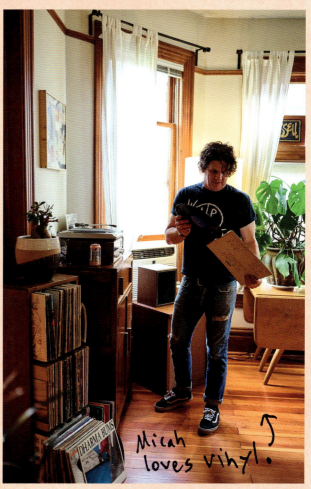

Micah loves vinyl.

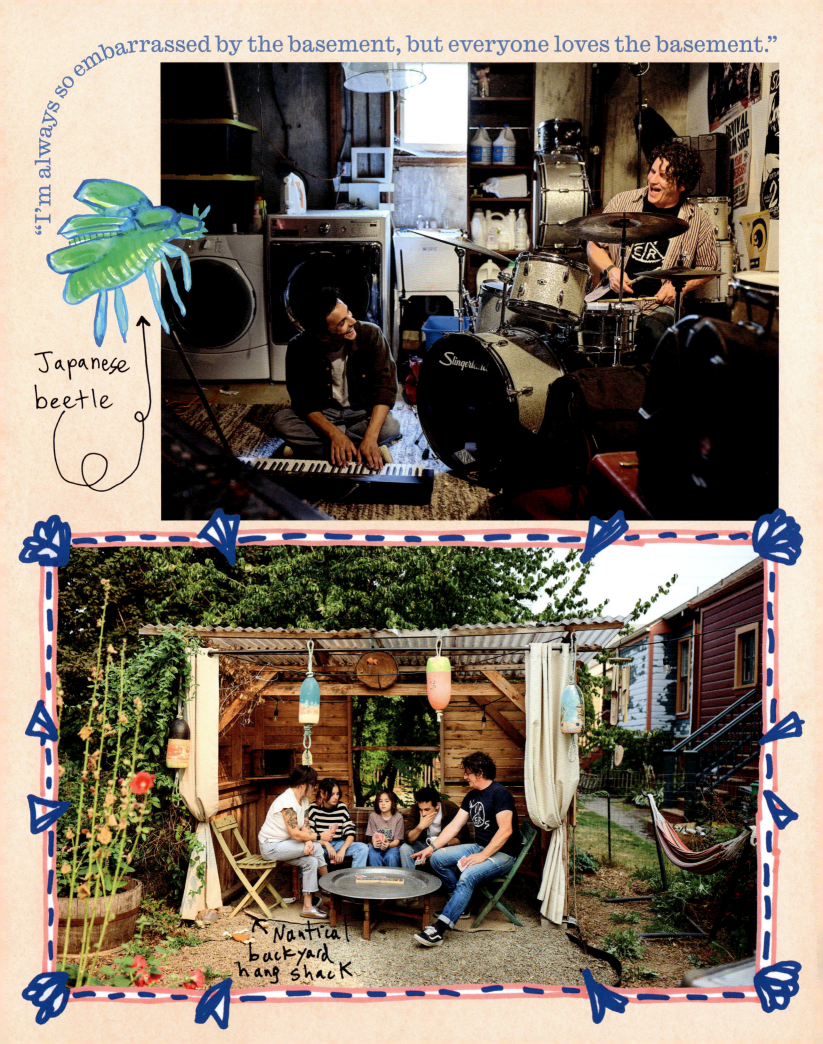

"I'm always so embarrassed by the basement, but everyone loves the basement."

Japanese beetle

Nautical backyard hang shack

Hi Maya, Micah, Ethan, Aidan, Frankie + Coco! Coco could you draw an anime with knives + coffee? Frankie could you draw a plastic baby wearing cool clothes ↗

baby anime ← | no head :D | bad anatomy

Terrifying

Aidan could you draw some late night storyboards ↗

berries and cream

Micah could you draw info graphics about drumming ↗

HOW TO DRUM | ① GRAB THE STICKS | ② STRIKE THE DRUM | REPEAT UNTIL SMOOTH

Maya could you draw a tennis trophy for yourself to win ↗

Ethan could you draw a grand piano made out of food ↗

piano?

SERENA MITNIK-MILLER
with Wild & Una Faye Moon in Malibu Canyon

Double Kid ATV demolition derby

"There are a lot of pancakes in our life, and I feel very grateful because the kids love pancakes. So, I make pancakes every day."

"It's called the Moon Abode. And the moon rises over that mountain in a really glorious way." The landscape is a green oasis surrounded by sandy, rugged hills as we look out from above the cowboy pool. There are five small pools and tubs on the property—including a wood-burning tub, a clawfoot tub, and one for the animals to grab a drink. "It all started with the crazy eighties jacuzzi in the bedroom. It was gnarly and I had to get rid of it, so after that it was an open space. Tubs just kind of started coming to me." A desert Southwest color palette is accented by plants, toys, and carefully chosen objects throughout the home. "I love utilitarian objects, like ceramics to eat on and drink from. But I also love useless objects that are beautiful and open shelves just to display them." Serena had always dreamed of having a studio right on the property. "A space for work, enough room for the kids, places for people to come and stay, and a garden. I still wake up every day and can't believe I live here."

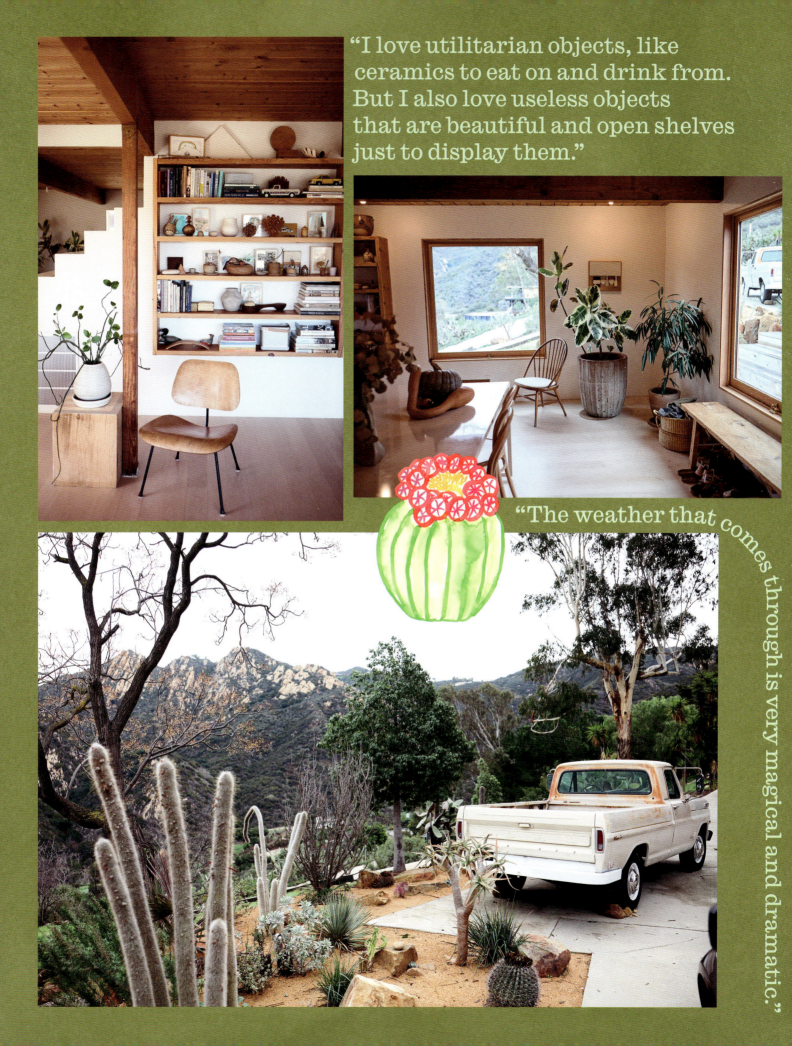

"I love utilitarian objects, like ceramics to eat on and drink from. But I also love useless objects that are beautiful and open shelves just to display them."

"The weather that comes through is very magical and dramatic."

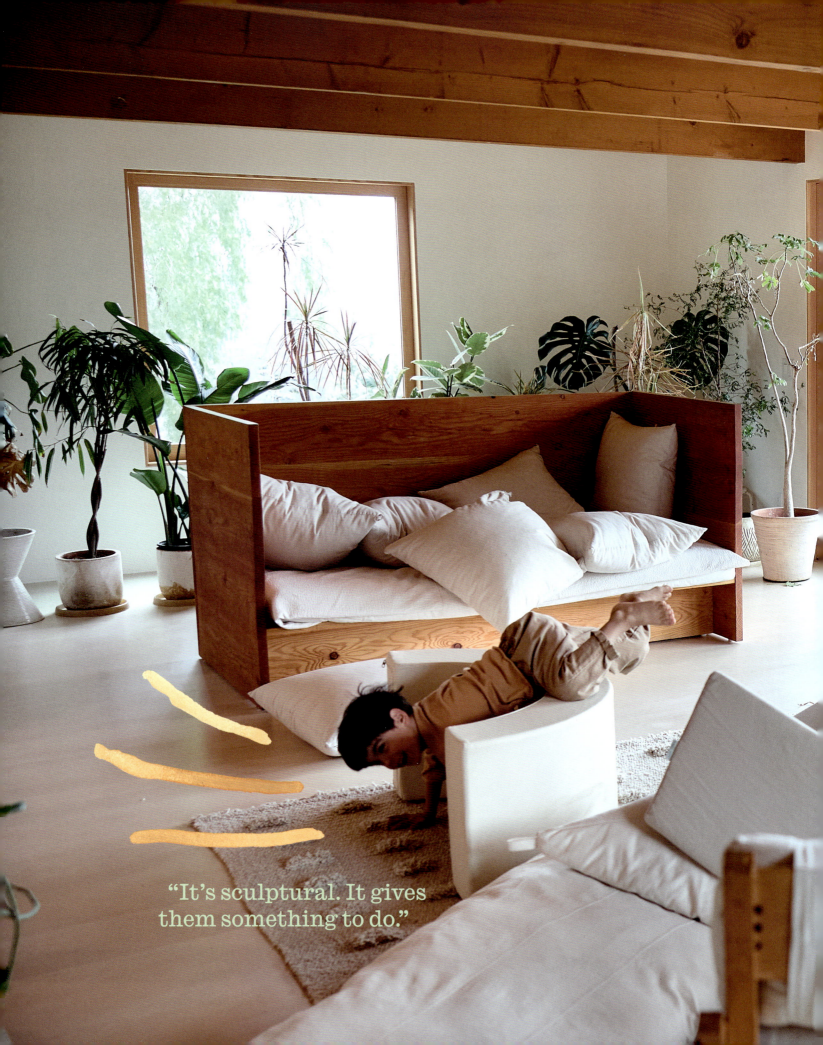

"It's sculptural. It gives them something to do."

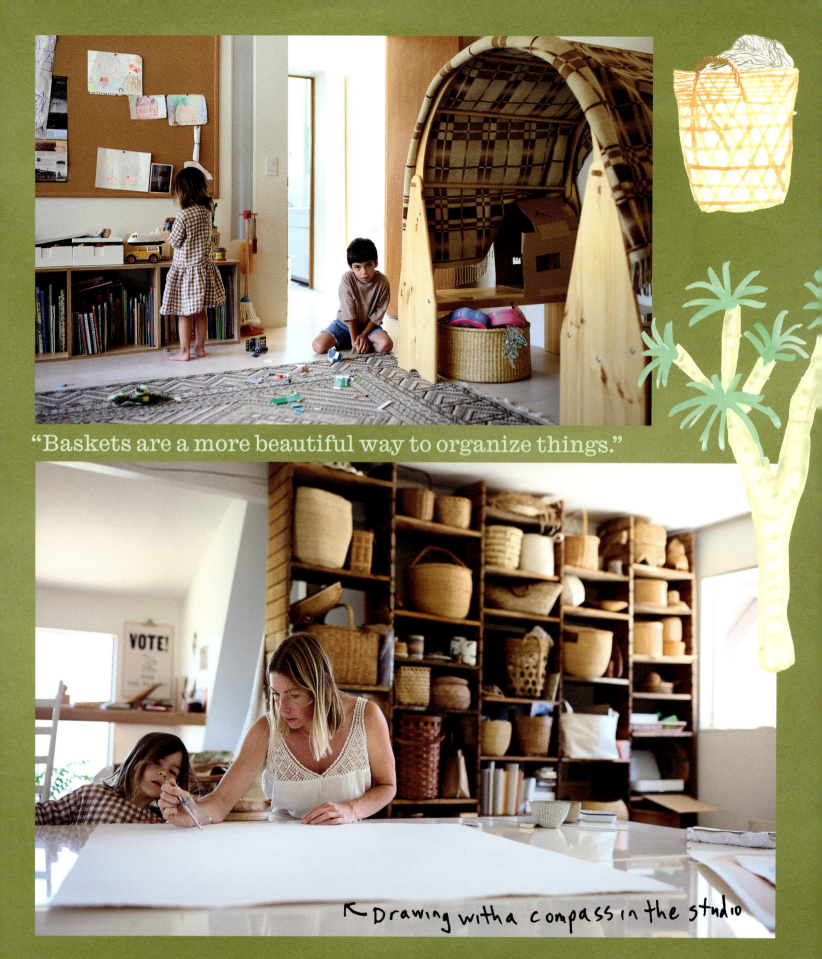

"Baskets are a more beautiful way to organize things."

↖ Drawing with a compass in the studio

Serena Mitnik-Miller with
Wild & Una Faye Moon

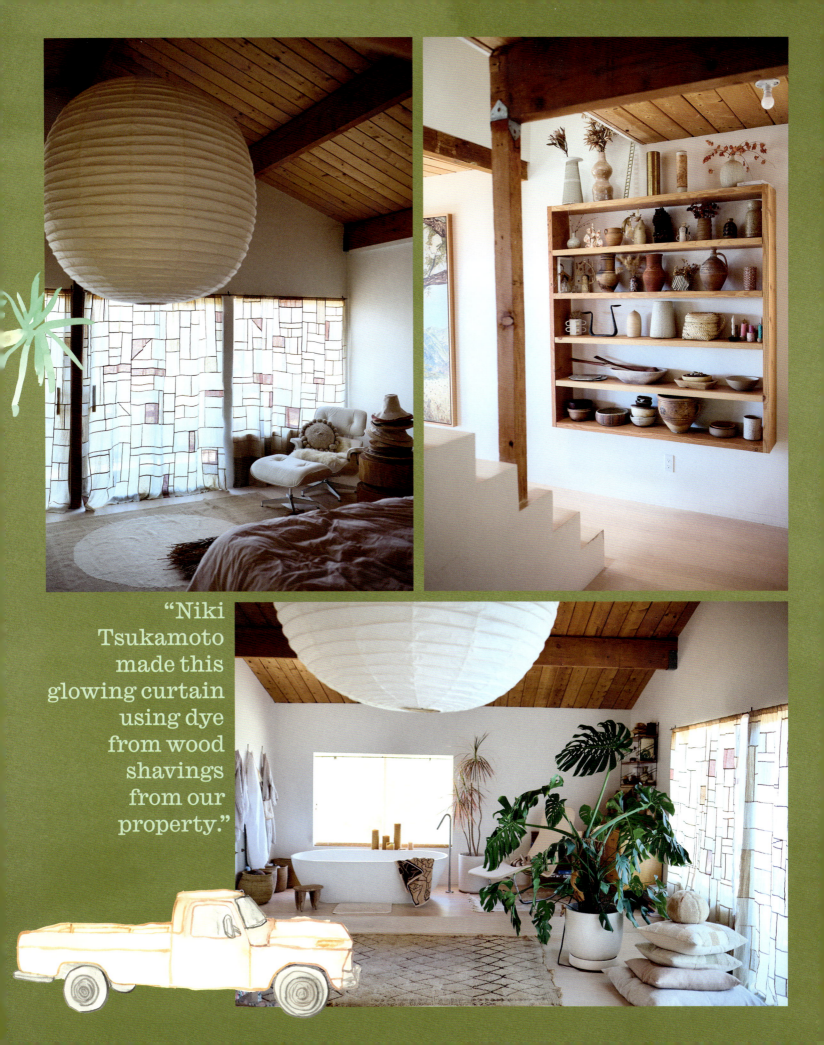

"Niki Tsukamoto made this glowing curtain using dye from wood shavings from our property."

The wall hanging is a traditional raincoat from Mexico.

"Every hat is almost perfect."

"Wild gets a hammer and nails out and starts building stuff out of these wood scraps."

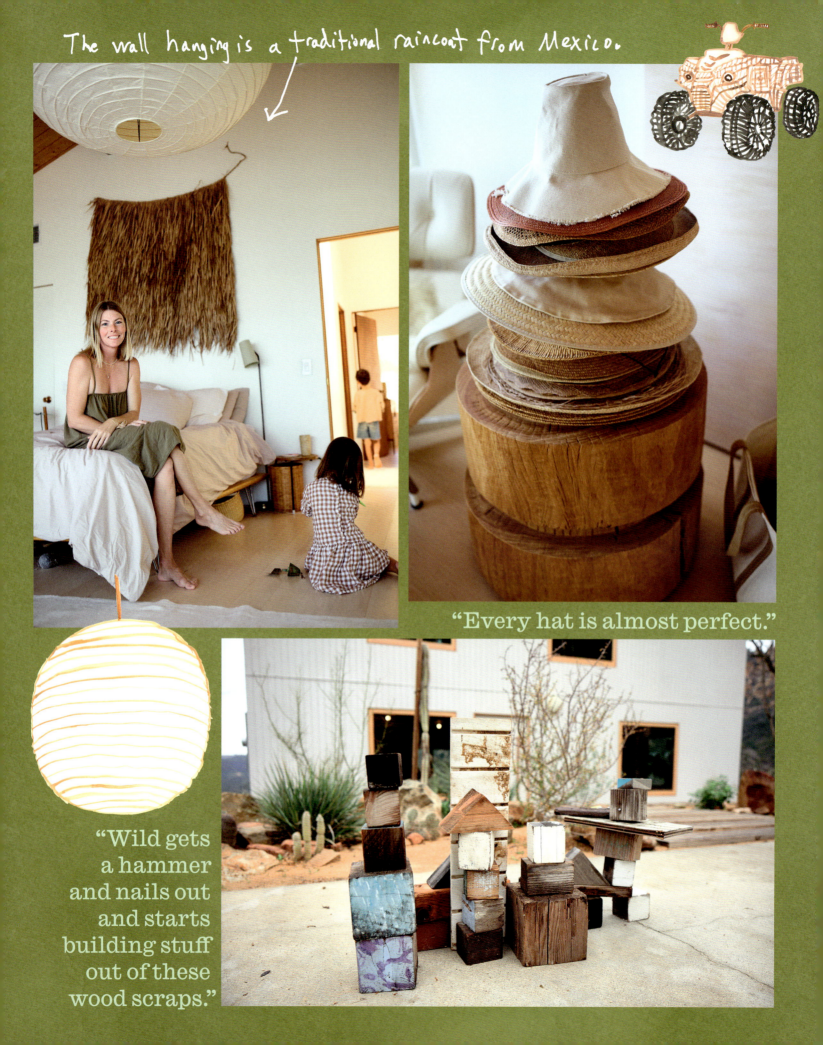

Hi Serena, Wild + Una! Serena could you draw the basket of your dreams?

Wild could you draw your ultimate fort?

Serena what are 6 things you love about baths?

① Warmth -
I love a super hot bath

② Soothing
I always add epsom salts or other bath salts or essential oils

③ Tranquility
the bath is a end of day ritual for me once the kids are asleep.

④ Ritual
I love to light candles or watch the sunset

⑤ Calm
after a bath I alway feel calm and ready to sleep

⑥ Alone time to reflect on my day and find peace

Serena how are ways we can raise children more wild? — Go outside! I alway try to keep my kids busy and off screens. I have invested in many outdoor toys and attractions for the kids. We garden and skate and scooter and jump on the trampoline and love hitting the beach. And sometimes they just love playing in the dirt!

KYOHEI & MIKIKO OGAWA
with Sena, Kouki & Yuka in Hayama

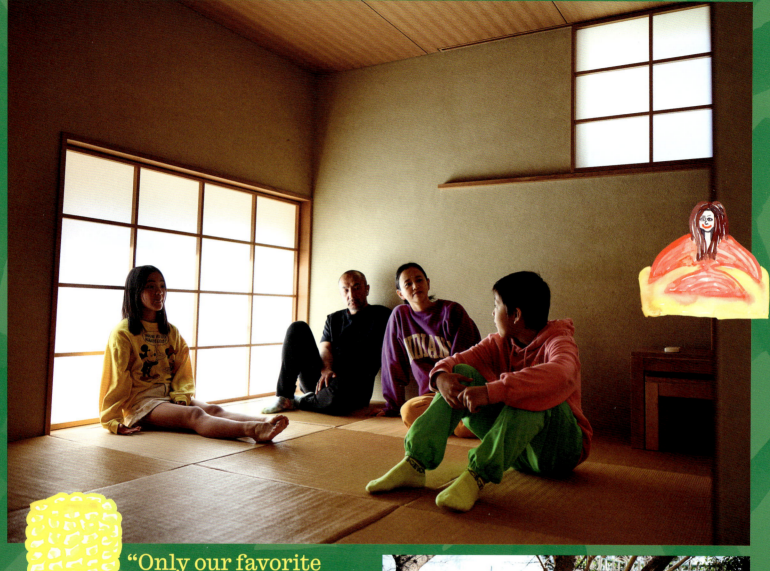

"Only our favorite things can become a part of this home."

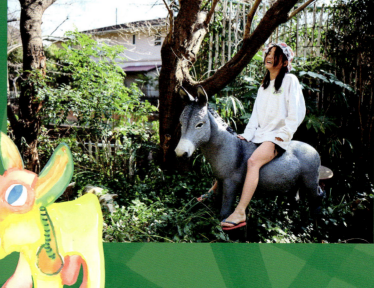

The Ogawa family is full of contradictions. Kyohei, a fashion stylist, wears mostly black. Yet Mikiko tells me, "We avoid black things as much as possible and enjoy spending time in color." The austere minimalism of the home collides with unabashedly colorful accents, Japanese vintage objects, and retro-French ephemera. They bought the house next door and made it into a 1970s grandma house guest suite. Somehow it works in contrast with the traditional tatami room and funky living room decor. "Everything in the living room centers around the sofa," says Kyohei. "The Isamu Noguchi coffee table is a masterpiece that has been painted to my personal taste."

Baby Yuka

The Ogawa house is an all-white box filled with color.

"T-shirt, pants, and beach sandals in summer. Ralph Lauren sweater and engineer boots in winter. It is my uniform, every day!"

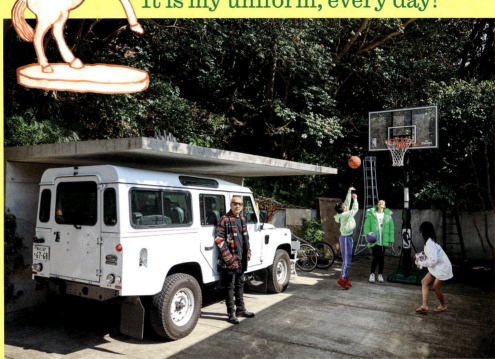

←The seated dolls are out for Hinamatsuri (Doll Festival). Hina dolls are a type of Japanese celebratory decoration that are displayed for a week during the year.

Kyohei & Mikiko Ogawa with Sena, Kouki & Yuka

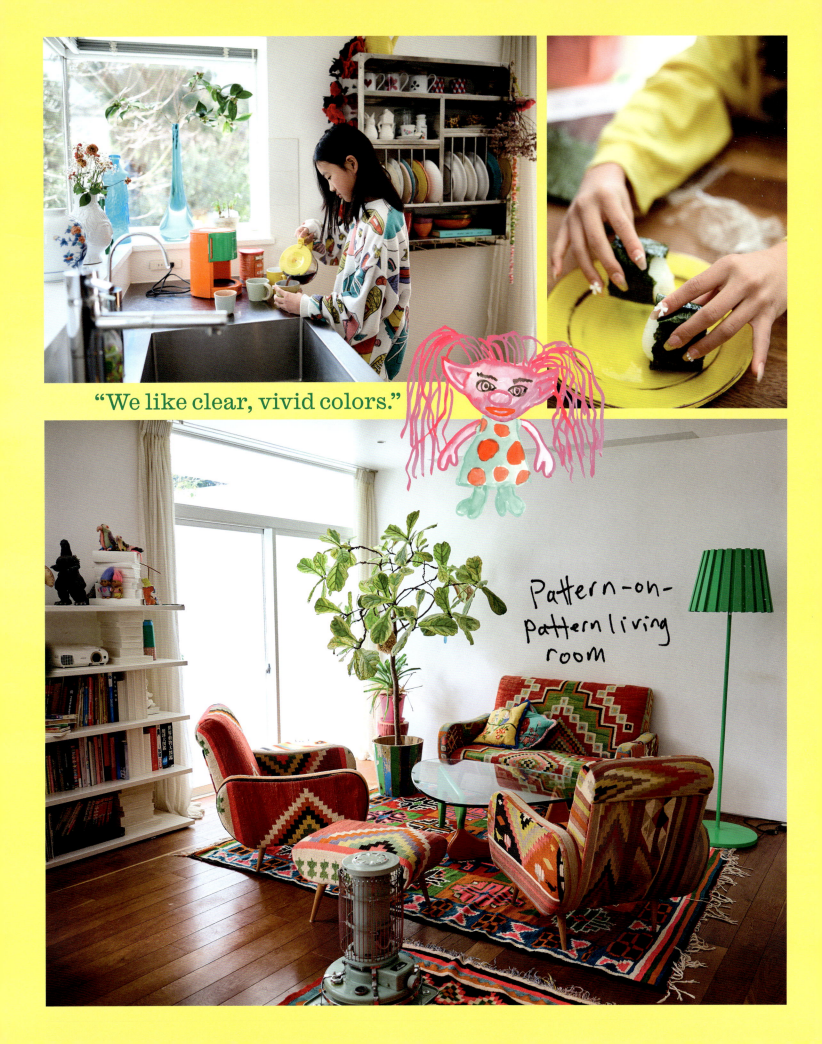
"We like clear, vivid colors."

Pattern-on-pattern living room

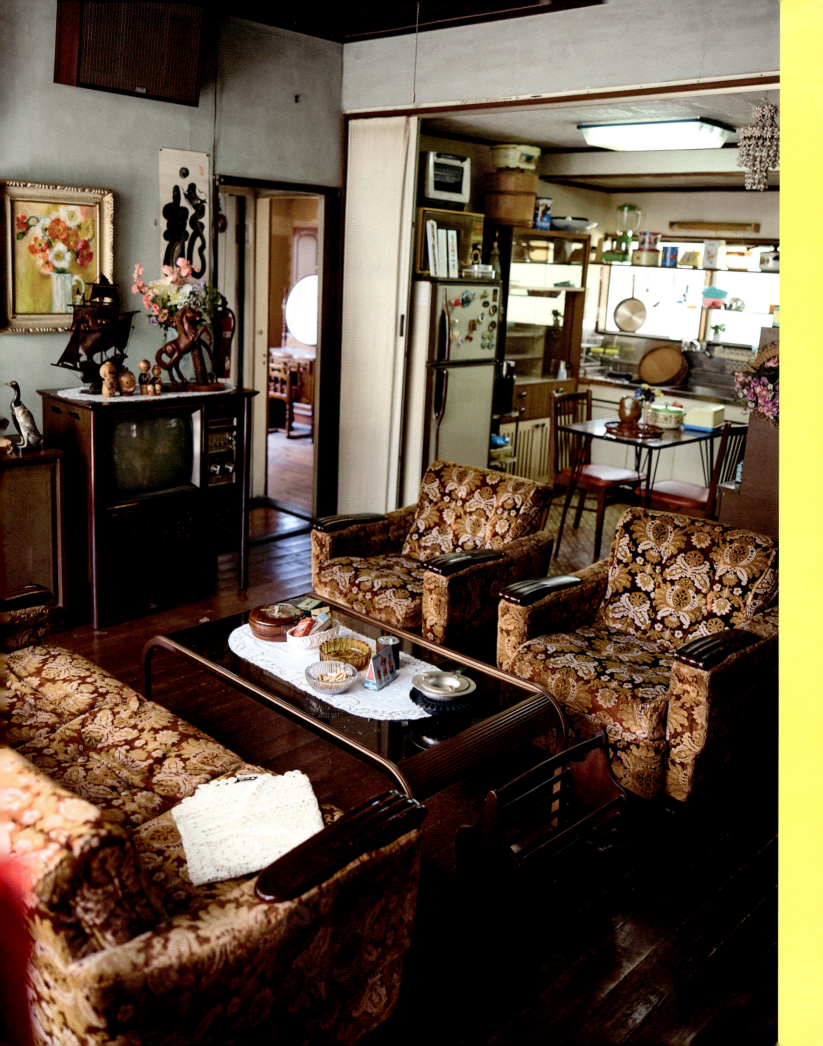

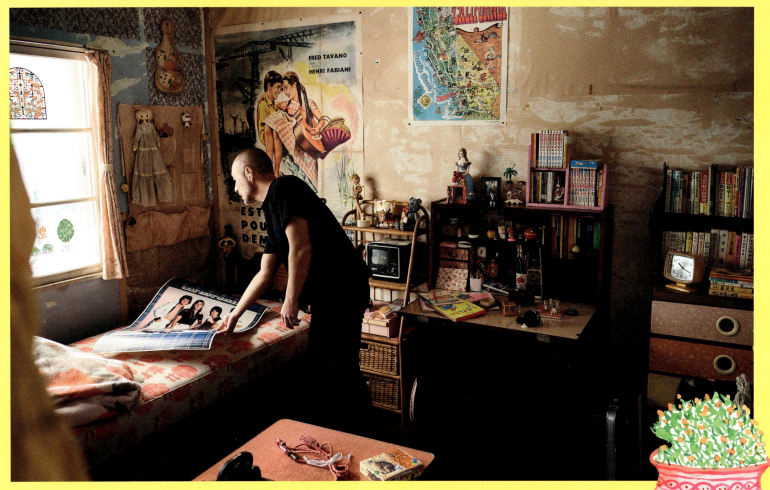

They bought and renovated the house next door. ⤺ This room has been re-created with the image of a young girl's room in mind, adding a few missing items to what was originally there.

Pet rock →

This garden shed is being converted into a photo studio. →

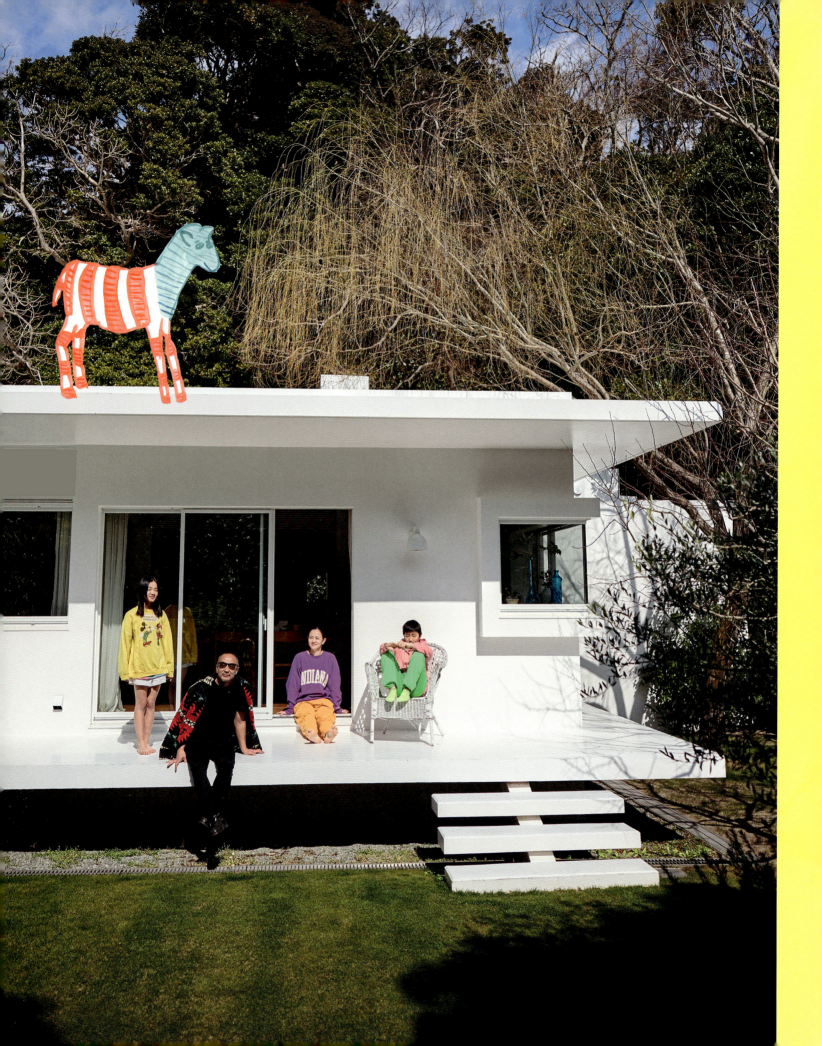

Hi Ogawa-san, Mikiko-san, Kouki-kun & Yuka-chan! Ogawa-san could you draw some items for "grandma's room" in your studio next door ↷

JAPAN MADE CARPET!! '70s
made in JAPAN.

Mikiko-san could you draw Sparta rice growing ↷

Yuka-chan could you draw some nail art inspired by Kpop ↷

Kouki-kun could you draw a lion ↷

Ogawa-san + Mikiko-san could you draw some of the colorful things in your house ↷

Yuka-chan could you draw your dad's face ↷

BRYAN & MEGAN EDWARDS

with Arlo Rey & Max Wylder in Nashville

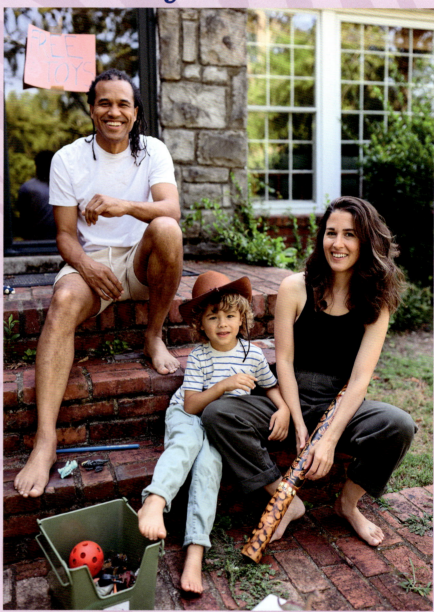

"Arlo said, let's have a yard sale, but let's give everything away for free."

"Tap dancing for him, Irish dancing for me," says Megan, who connected with Bryan on a dance tour in 2005. "One night we were out with the cast and crew at a club, and Bryan and I were the last to leave the dance floor." Since then, Megan danced her way into a second career as a photography agent. "When they asked for my resume, I said, 'I don't have that, but I will do an Irish dance for you.'" Bryan recently started a custom furniture company and built most of the furnishings in the house. "The chairs, sofa, lighting, case goods, all of it." The couple's art collection includes several expressive sculptures made by Bryan's grandfather John J. Maluda. Three-year-old Arlo Rey is already making his own creative contributions, jamming out on the golden keytar he made with his dad in the wood shop.

"All the busts in our house were created by my grandpa. He was an aerial photographer in World War Two."

"Decorated with 90 percent furniture that I've made. Chairs, sofa, lighting, all of that."

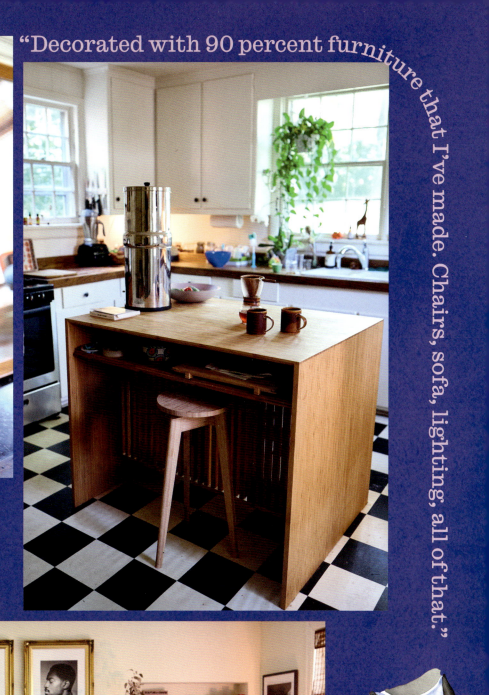

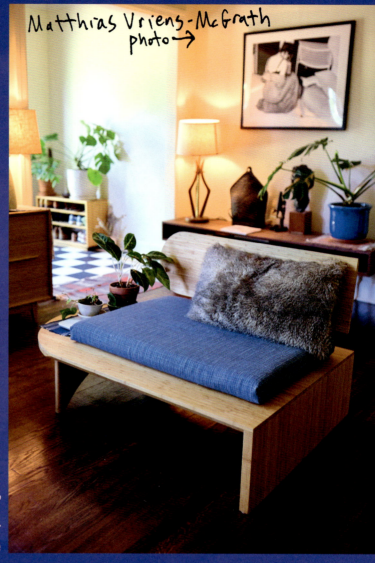

Matthias Vriens-McGrath photo →

"The furniture I make has a Japanese mid-century modern vibe, using only sustainable materials like bamboo, plywood, and brass."

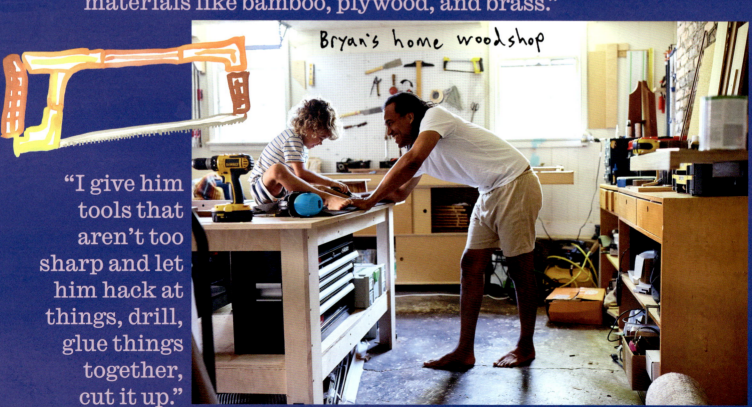

Bryan's home woodshop

"I give him tools that aren't too sharp and let him hack at things, drill, glue things together, cut it up."

"Bryan and I met as professional dancers."

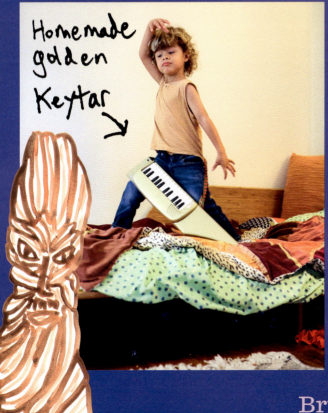

Homemade golden Keytar

Megan's grandfather was in a Kentucky bluegrass band. "It's cool to have a folk music tradition run through."

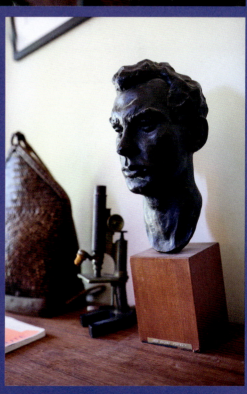

Bryan & Megan Edwards with Arlo Rey & Max Wylder

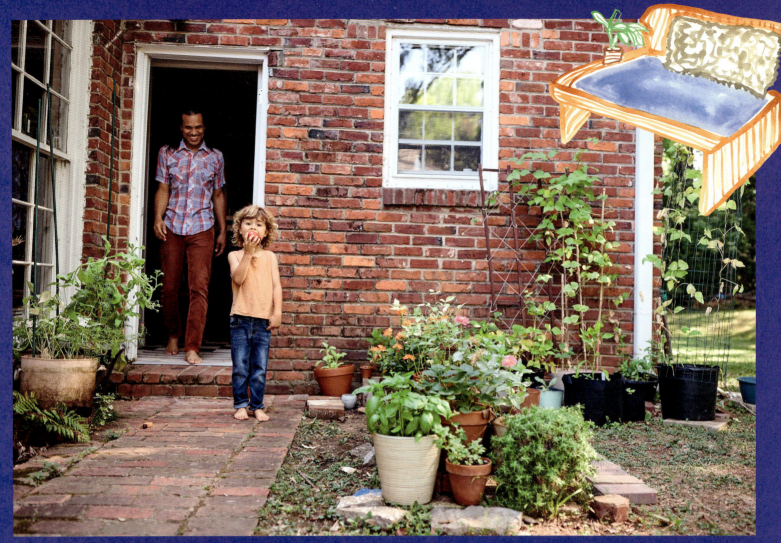

"Arlo goes to school on a farm with goats and chickens."

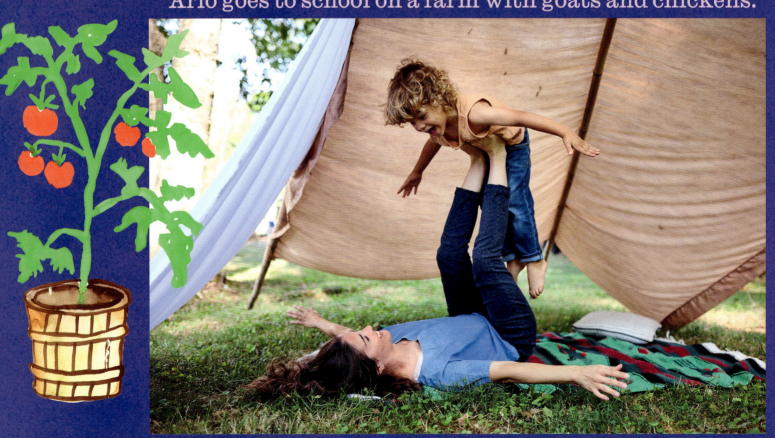

Hi Megan, Bryan, Arlo + Max! Arlo could you draw a fort surrounded by monsters + spiders →

Bryan could you design a kitchen island for a knight →

Megan what is special about Irish step dancing?

Pulling it out as my "party trick" at any social event!

Bryan what is special about American style tap dancing?

SWAGER

Could you design an underground lair for Allen the gopher →

LISA MOIR
with Finn & James in Mill Valley

"If it's not raining, we do a bath outside. We light the candles. Sometimes we bubble bath and sometimes we eat hamburgers in there."

Songbirds can be heard from every room in Lisa Moir's Mill Valley cottage. They are feasting on berry trees, which line the property. She moved here in 2020 with her son, Finn, and daughter, James, and instantly fell in love with the home's indoor-outdoor charm. Snake plants, ivy, and fern lead to the backyard, which features a copper clawfoot tub used for after-school doll parties, candlelit meditations, and bubble baths. A communal Buddha statue is lovingly cared for. "We'll go to the farmers' market and replenish the flowers together. It's a little spot to meditate." Lisa combines Japanese influence with a love of handmade objects purchased directly from California artists. "It's modern eclectic, with salvaged treasures," she says. "As a single parent with two kids, I've built this little life here in California. Our focus is just on time together."

"I like peaceful serenity when I'm at home. At work, I like more intense color, but here I just like to have peace."

"He loves his sister. She runs him. She's a boss. And they adore each other."

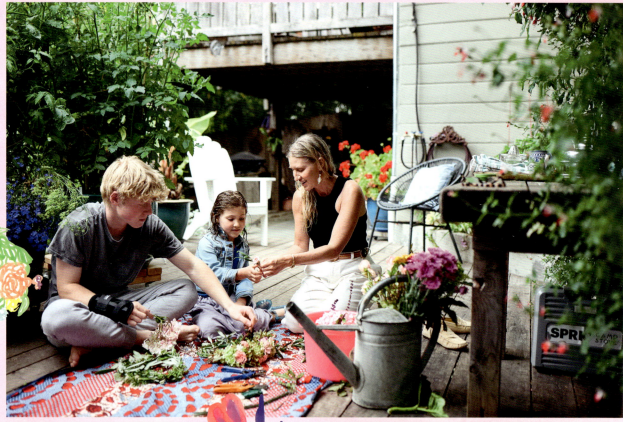

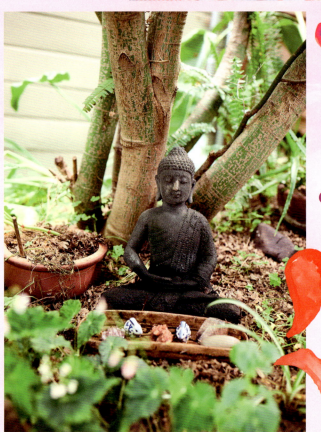

"Once a week we replenish Buddha's flowers together."

"All of the floors and ceilings in here are actually from a chicken coop."

Lisa Moir with Finn & James

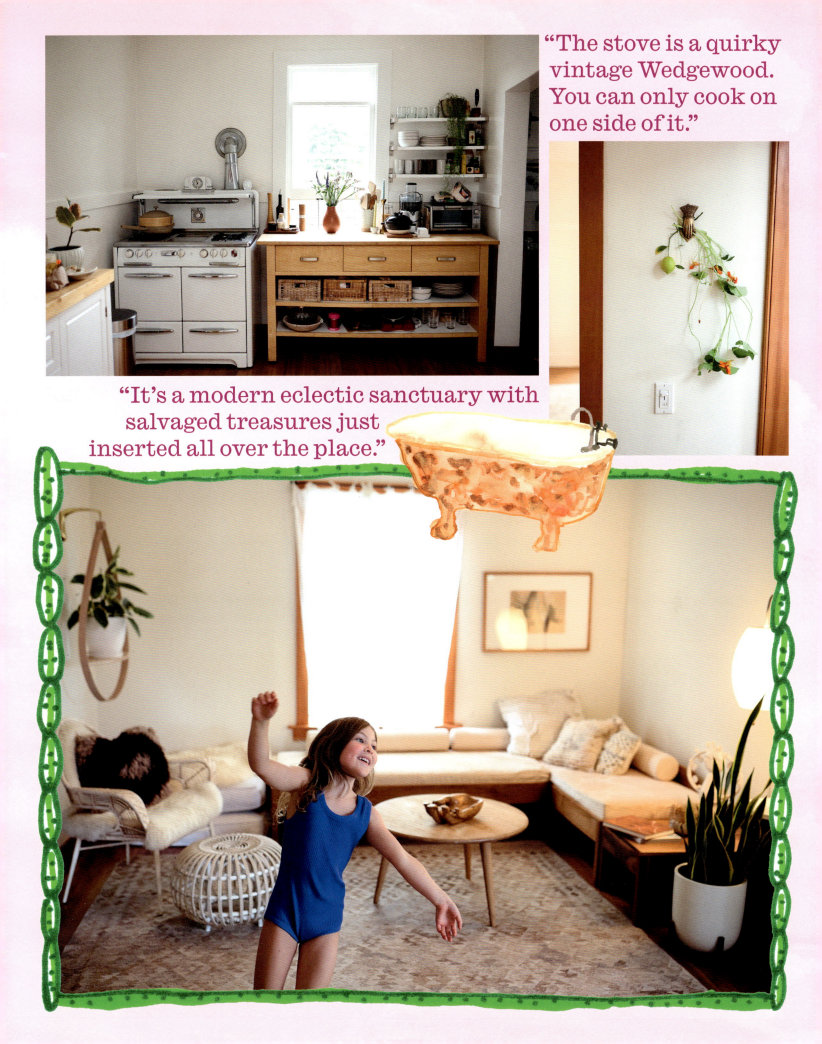

"The stove is a quirky vintage Wedgewood. You can only cook on one side of it."

"It's a modern eclectic sanctuary with salvaged treasures just inserted all over the place."

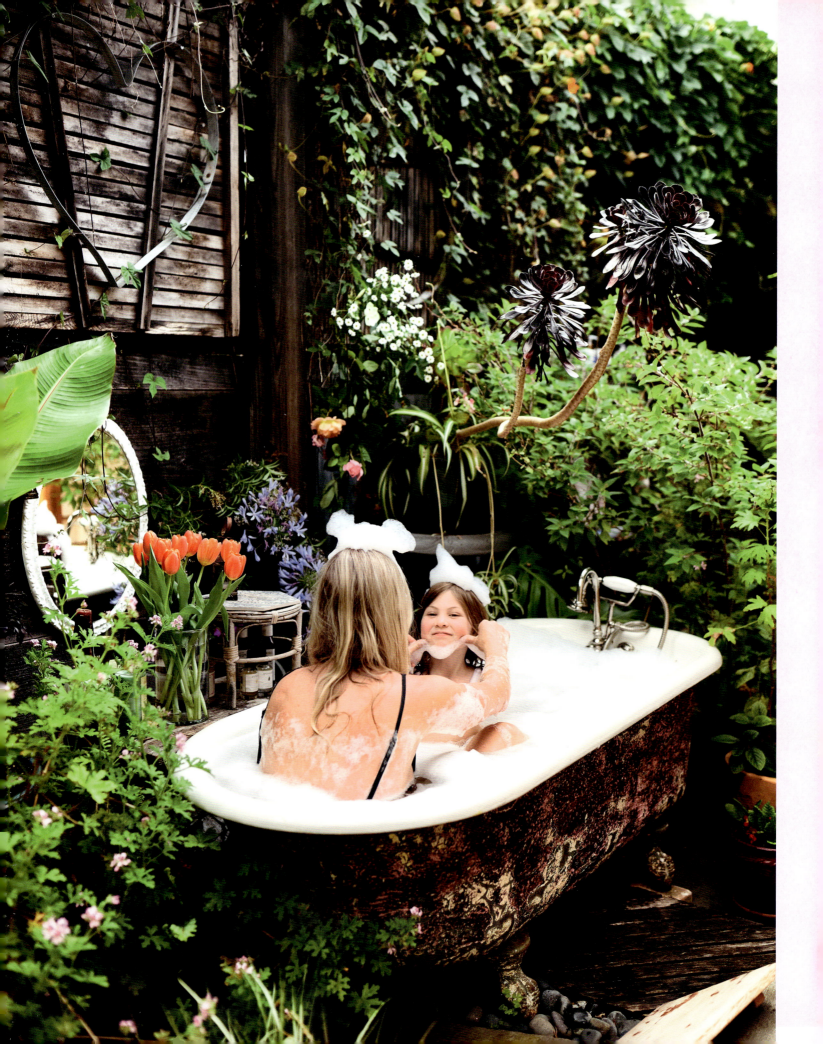

Hi Lisa, Finn + James! Lisa could you design a river house for you + the kids ♪

James could you design a new musical instrument for your brother ♪

Finn could you design a horse for your sister to ride ♪

Lisa could you tell us the cloud story?

Once Upon A Time there lived a lonely Unicorn in a magical forest that believed she was the only one of her kind. One day she met a frog at a pond who told her there were many more like her she just had to find them. So she hitched a ride on a magical cloud made of glitter and rainbows, accidentaly stepping on his eye (who knew clouds had eyes?) and he screamed out, that was when she discovered he could speak too! He agreed to travel the world with her until she found her kind... TBC......

ANDI BAKOS & JARRETT REYNOLDS
with Sho & Beni in Portland

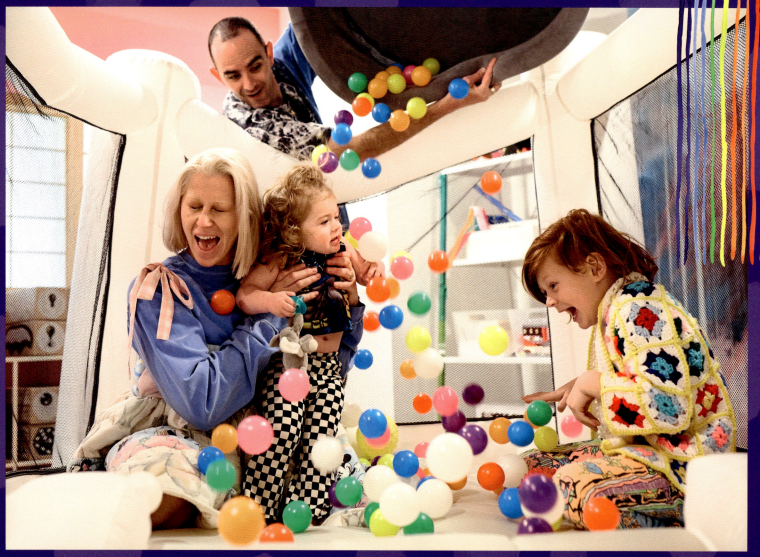

"Jarrett's a hoarder but he's also a minimalist, and I'm a full-out maximalist, forever dedicated."

"The selling point for us was that the owners were a Japanese family," says Andi. "Jarrett and I both love Japan. He responds more to the history of craft and artistry. I respond to the futuristic side, the twinkling lights, the weird bars, the strange and unusual. Once we saw that the bottom floor had a tatami room, we knew this was the house for us." They kept many of the natural wood elements in place but painted most of the house white—with the occasional pink accent wall. "We just wanted to spruce it up and make it white, bright, minimal, and modern," says Andi. She describes her husband as a minimalist, and herself as a "maximalist, forever dedicated."

"Jarrett definitely responds to the craft history, the artistry, and the quiet side of Japan. I respond more to the futuristic side, the twinkling lights, the weird bars, like, the strange and unusual."

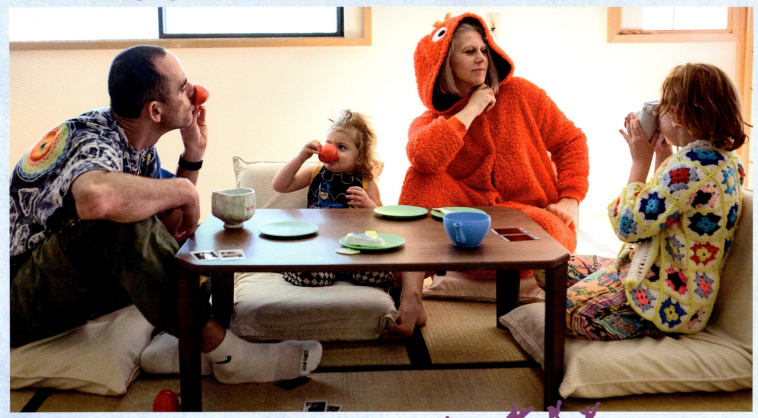

"If this house were just mine and mine alone, there would be four things in it. And it would be so cold and horrible. Andi's the one who makes it warm and fun."

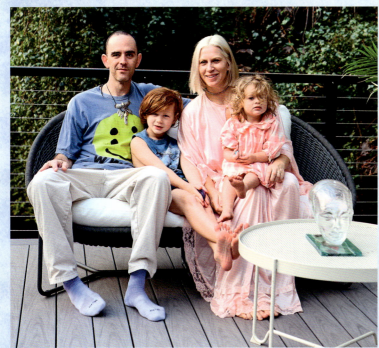

More bounce to the ounce

"I idolize Rick Rubin and I thought it would just be funny to put him into the shrine there."

"Somebody had abandoned a grocery cart on the side of the road. So, I cleaned it up and had it powder-coated in white."

Andi Bakos & Jarrett Reynolds with Sho & Beni

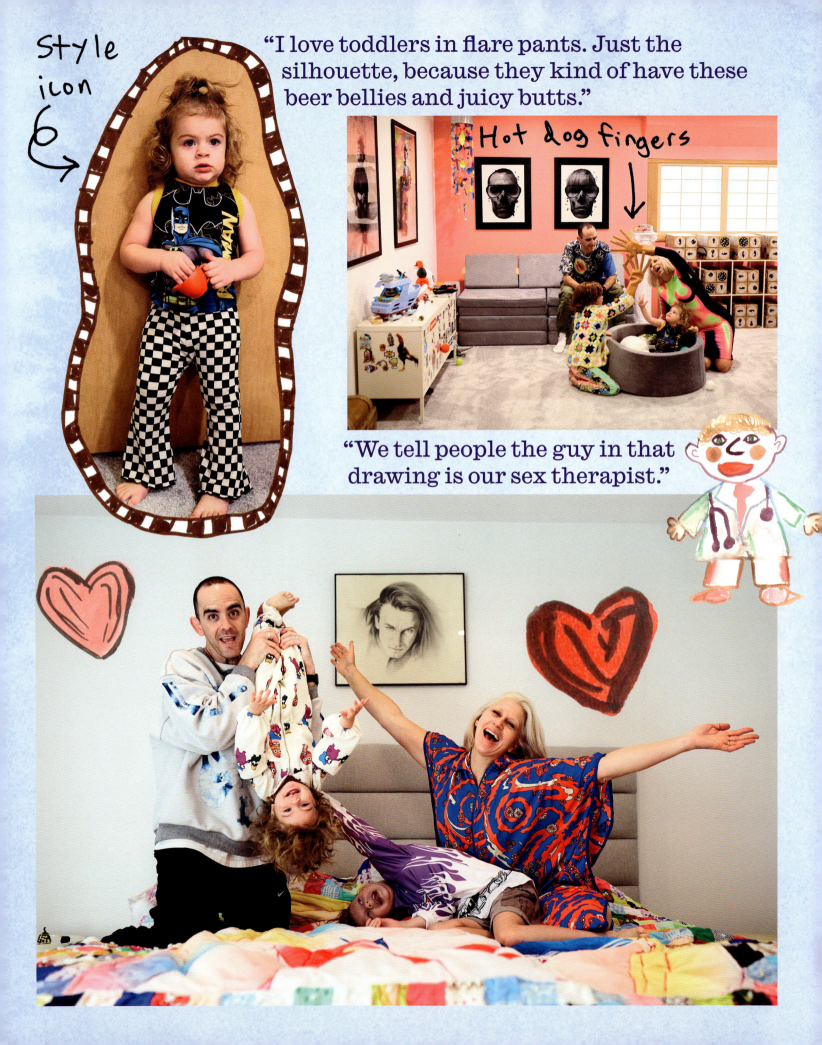

Hi Andi, Jarrett, Sho + Beni! Jarrett tell me your philosophy relating to couches? Don't try to find the perfect couch... let it find you. This process takes longer but it's way less stressful.

Sho whats good about feet and melons?
"Feet have toes and they are strong and they can defend things. Melons are healthy and yummy!"

Andi what are the 6 best items you have thrifted for your kids?
① TODDLER BATMAN SWEATS ← BATMAN FIGURE
② 70'S CROCHET CARDI
③ 90'S LAURA ASHLEY FLORAL BUBBLE SUIT
④ PINK FUR COAT Y2K
⑤ MOTORCROSS PANTS WORN CASUALLY
⑥ YELLOW TODDLER SWEATSUIT IN JAPAN

Sho could you draw a pet snake for you and Beni ↓

Andi could you draw the strangest sight you saw in Tokyo ↓
Sho could you draw a tarantula for your parents ↓

PETS
FORGOTTEN PET STORE + AMUSEMENT PARK ON A ROOFTOP
ALMOST ABANDONED. I WENT TO VISIT A LOT

Jarrett could you draw your favorite items/objects you have seen in Japan ↓

← maisen salt
MAISEN

← vending machine

← canned coffee
UCC BLACK COFFEE

not sure why they're all food related.

TSUYOSHI & YUMI YAMASHITA
with Yuma & Aitaro in Setagaya

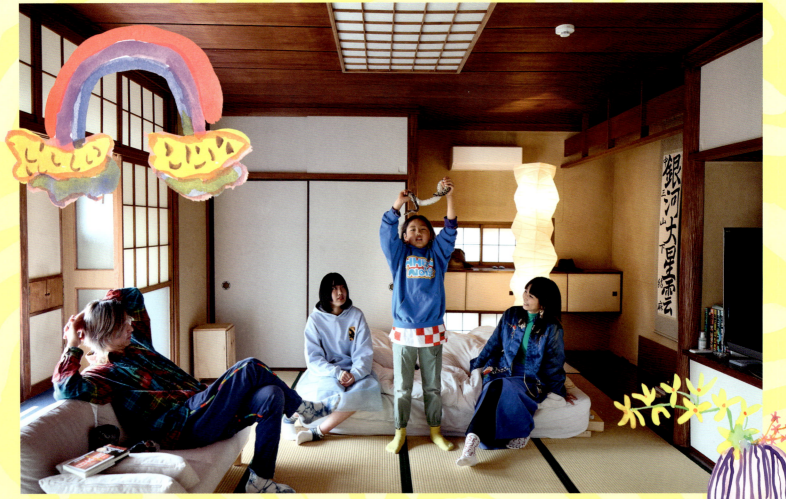

"We each have our own worldview, but we come together here."

"Our family is the best rock 'n' roll band," says Tsuyoshi. "We're always there to help each other and enjoy our time." Their home was built seventy-five years ago in the traditional Sukiya style. "Our garden has a wabi-sabi philosophy. It brings us happiness to feel the four seasons and enjoy the plum and apricot flowers," says Tsuyoshi. Yumi runs a fashion brand, Style Wars Tokyo, and Tsuyoshi is a bar owner and musician. They are passionate about Japanese craftsmanship, art, and clothing. "We appreciate tradition, but we like to add our own cultural inspirations for a twist," says Tsuyoshi. "I love Morocco," adds Yumi. "It feels natural for me to include Moroccan items, along with Japanese and primitive styles. They all work together and somehow match in our house."

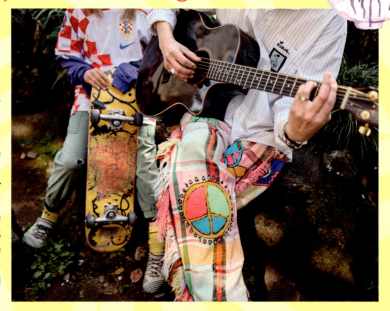

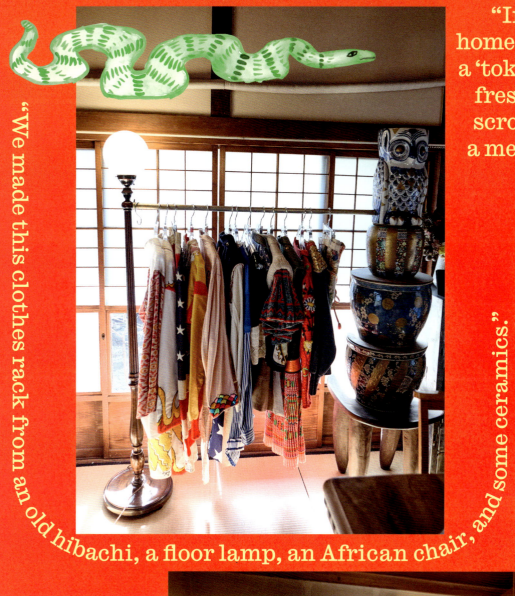

"We made this clothes rack from an old hibachi, a floor lamp, an African chair, and some ceramics."

"In traditional Japanese homes, there is a space called a 'tokonoma' decorated with fresh flowers and hanging scrolls. Our scroll features a menacing Tom and Jerry and a drippy vase."

Embroidered European beekeeping hood ←

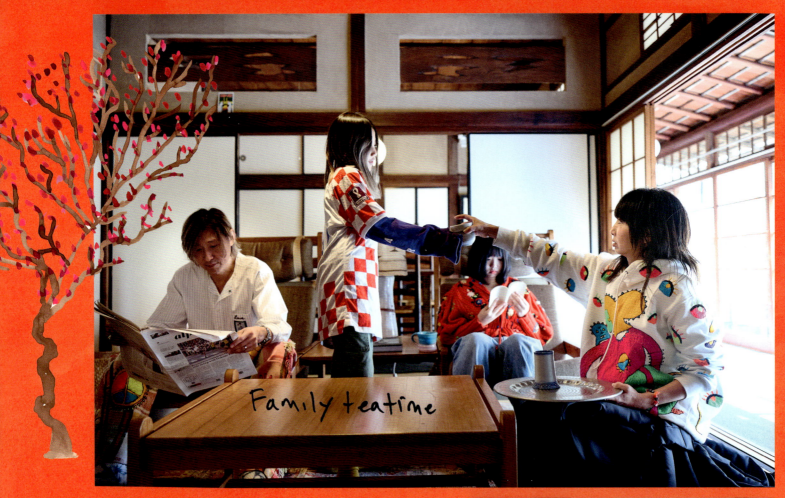

Family teatime

"Our brand is a one-of-a-kind brand that creates products using antique fabrics and clothing. This jacket is a custom-made piece based on a vintage silk jacket."

"We've had tanuki [raccoon dogs] appear, a pair of pigeons settle in, and plum and apricot flowers bloom, making us feel the presence of nature and the changing seasons even in the city."

Tsuyoshi & Yumi Yamashita
with Yuma & Aitaro

Hi Yumi-san Tsuyoshi-san Yuma-san and Aitaro Kun! Tsuyoshi-san what are 6 great memories from Golden Gai?

① Two couples were formed and married
② The night Japan beat Ireland (Rugby World Cup 2019)
③ The night the drunk peeed on the floor
④ Time spent with Orimo-san (He passed away. He was an Alcoholic) (He was 48)
⑤ When the costmer comes back
⑥ Time spent with Ken-san (He is the first employee) (dead of corona He was 69)

Yumi-san could you design an outfit for a pink panther?

Yuma-san could you write a wish for this year in calligraphy?

Aitaro-Kun could you draw your snake doing something fun →

Yumi-san could you draw the clothing rack you made ↓

Tsuyoshi what are your 6 favorite albums to play at your bar?

① The Heart of Saturday Night (Tom Waits)
② Let IT BLEED (THE ROLLING STONES)
③ Let's Get It On (Marvin Gaye)
④ Getting Ready (Freddie King)
⑤ Transformer (Lou Reed)
⑥ Fire On the Bayou (The Meters)

BOO SIMMS & SEAN MONTES

with Mavis & Bertie in Long Beach

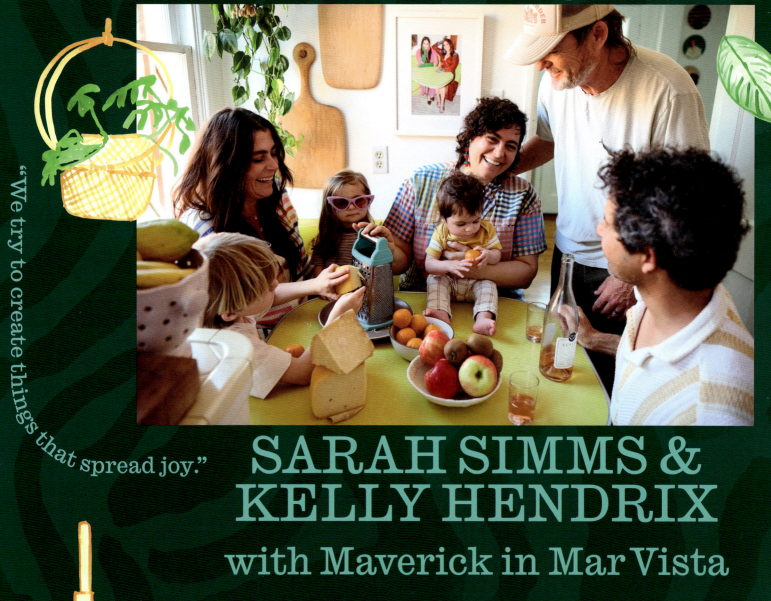

"We try to create things that spread joy."

SARAH SIMMS & KELLY HENDRIX

with Maverick in Mar Vista

Cajun barbecue shrimp is simmering at Boo Simms's house. Her twin sister, Sarah, brother-in-law, Kelly, and nephew, Maverick, are visiting for dinner, a family tradition on Sundays. Boo and Sarah co-own Lady & Larder, which sells locally sourced cheese and charcuterie boards in Santa Monica. "We love family-style cooking," says Sarah. "It's just the opposite of fussiness. We live in an area with such profound produce year-round, so we try to have fun with it." Boo jumps in. "If you give a kid a tie-dyed carrot you found with them at the farmer's market, their eyes go to that and they get excited. I think adults are the same way." The house was built in 1947, part of the historic Wrigley neighborhood. "Sean built a lot of the pieces," says Boo. "We put up all the shelving and made sure the kids' play stuff was easy to reach. The decor is a mix of our two styles. We have lots of pops of color, Moroccan rugs, mid-century and vintage stuff, and furniture that's easy to clean because of the kids. The living room, kitchen, and dining room are all basically one space, which is great so we can cook and play and chill together."

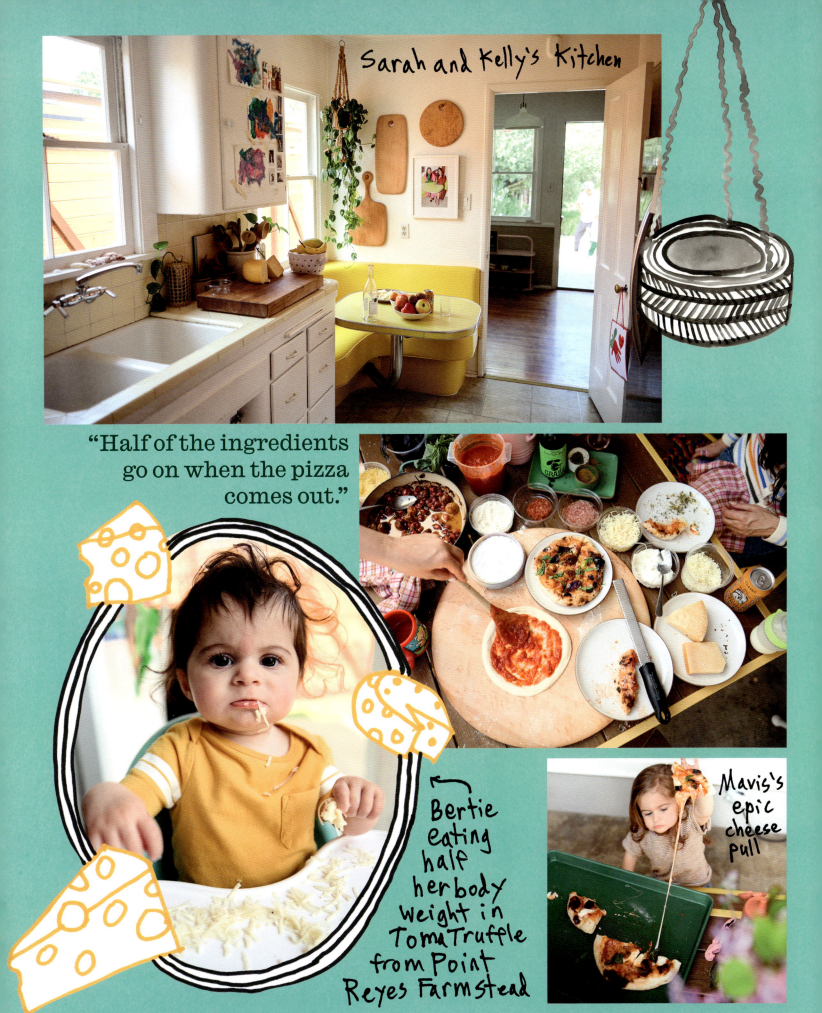

Sarah and Kelly's Kitchen

"Half of the ingredients go on when the pizza comes out."

← Bertie eating half her body weight in Toma Truffle from Point Reyes Farmstead

Mavis's epic cheese pull

"The house includes a lot of natural wood with pops of bright colors. Bright and playful."

Boo Simms & Sean Montes with Mavis & Bertie; Sarah Simms & Kelly Hendrix with Maverick

"Our Fuerte avocado tree is the perfect climbing tree and tree to read under. It is the heart of the backyard."

"Mavis's croissant legs."

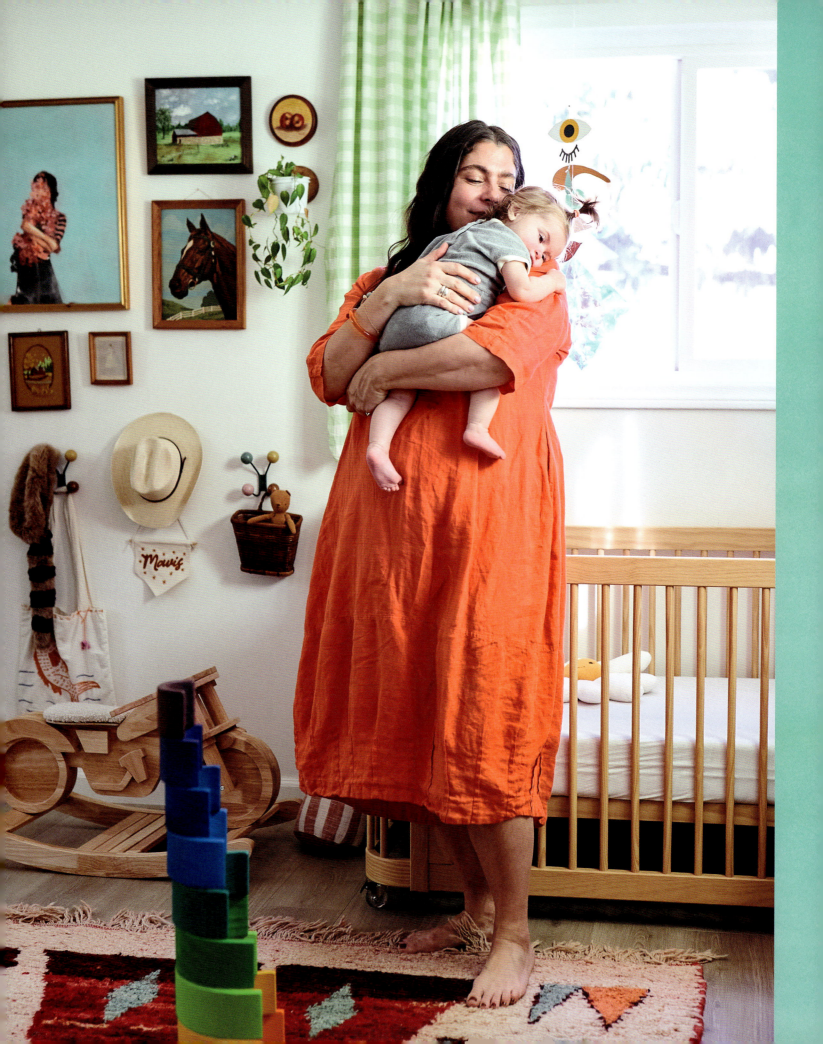

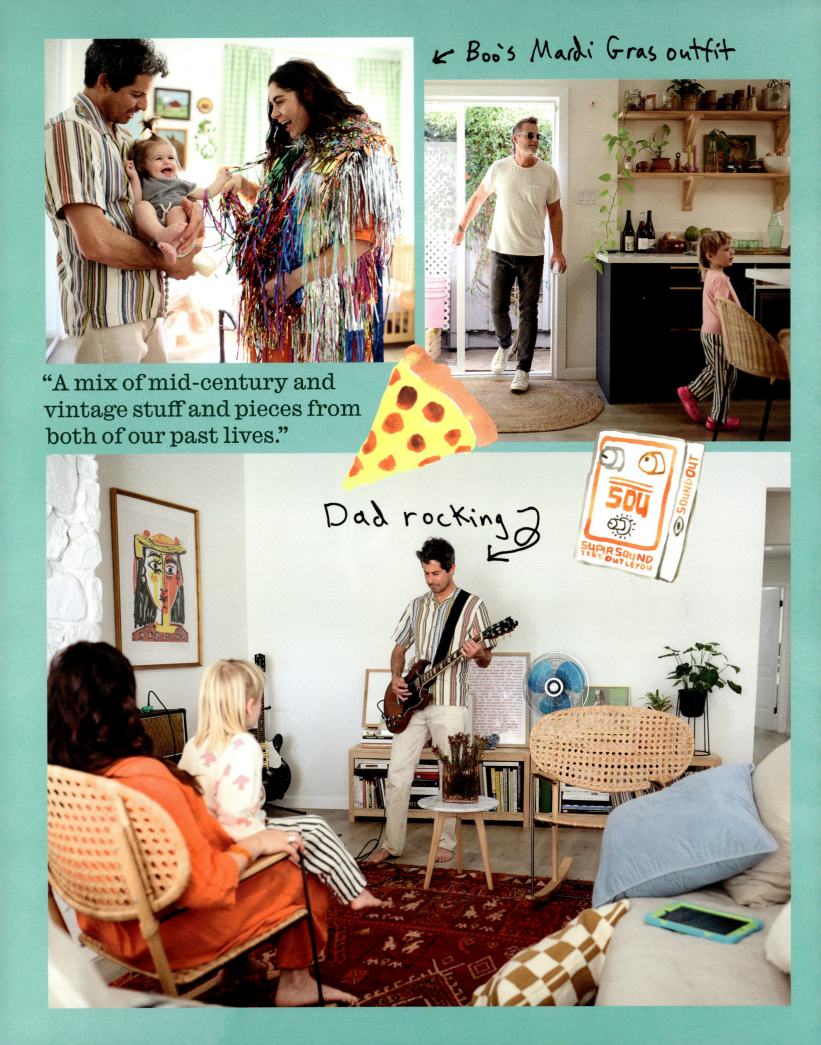

← Boo's Mardi Gras outfit

"A mix of mid-century and vintage stuff and pieces from both of our past lives."

Dad rocking

"Candles add the final touch of color and dreaminess to dinner."

"I look at cheese boards in almost a romantic way. After all, we eat with our eyes."

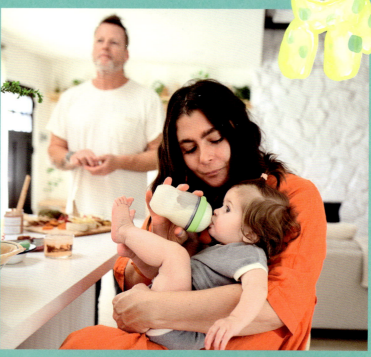

Boo Simms & Sean Montes with Mavis & Bertie; Sarah Simms & Kelly Hendrix with Maverick

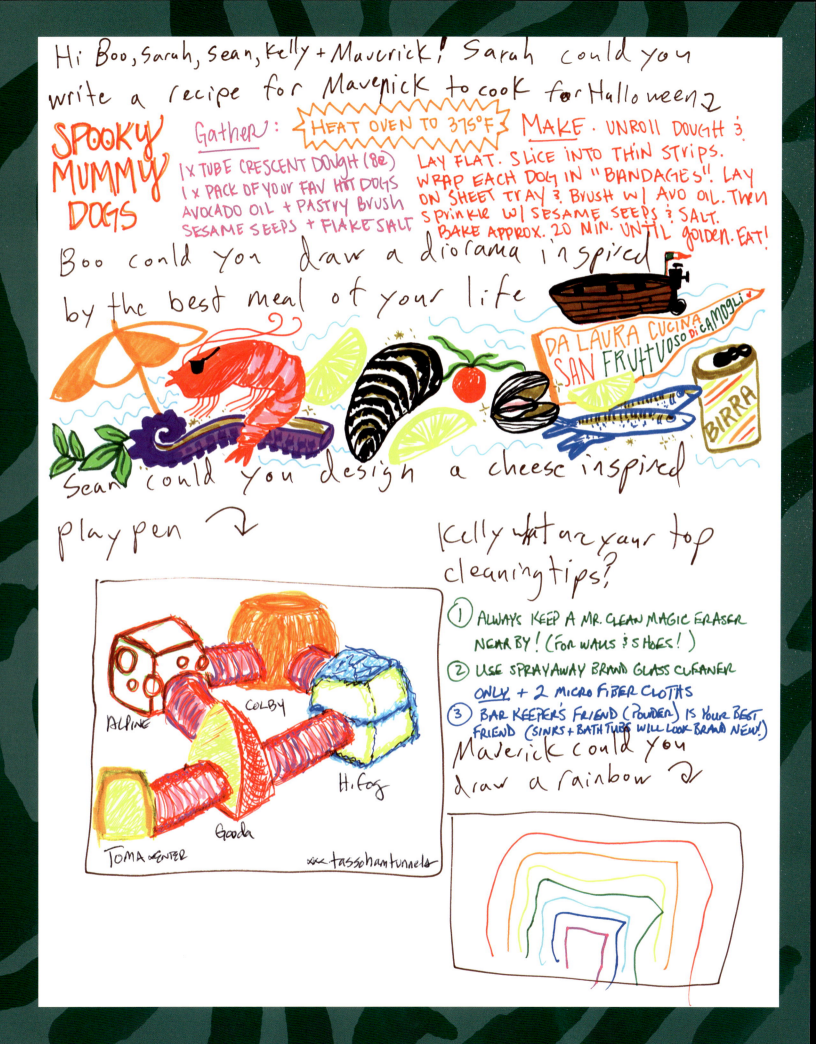

LAWREN HOWELL & KRIS MOLLER
with Louisa, Peter & Phoebe in Ojai

"The table is one walnut tree trunk that branches off in two."

"I'm inspired by the vernacular architecture of any place," says Lawren. "And in Southern California, we have so much to enjoy. Spanish homes, modern and mid-century homes, or Craftsman homes like this." The property is tucked away in the foothills of Ventura County. It includes a small glass-walled studio, a swimming pool, a fire pit, and a garden. The family's first move was to open up the floor plan and add more exterior doors. Lawren has also been installing woodwork around the house, and refreshing the old fireplace is next on her list. "We're following the style of the house but adding a splash of color, fun tile, or cool upholstery. Certain pieces are so unique you don't bother much about how it's going to work. It's just a statement, and everything else has to be quiet around it."

"Sometimes I just fall in love with something and I don't bother too much how it's going to go with everything else."

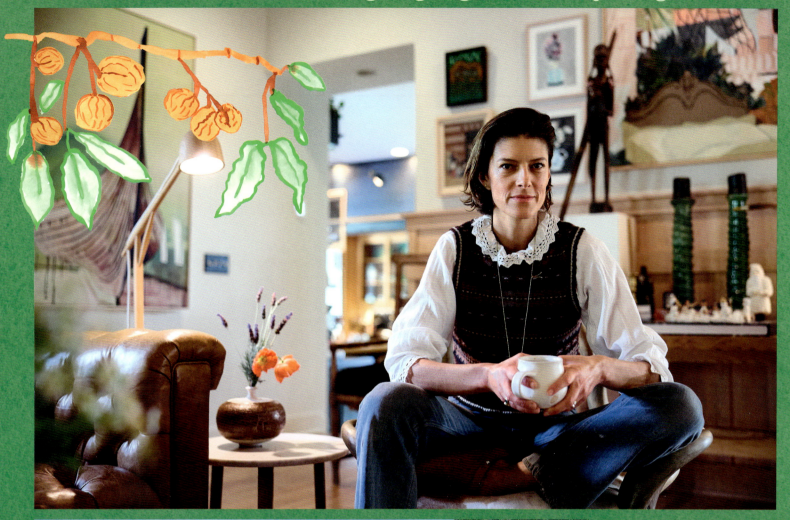

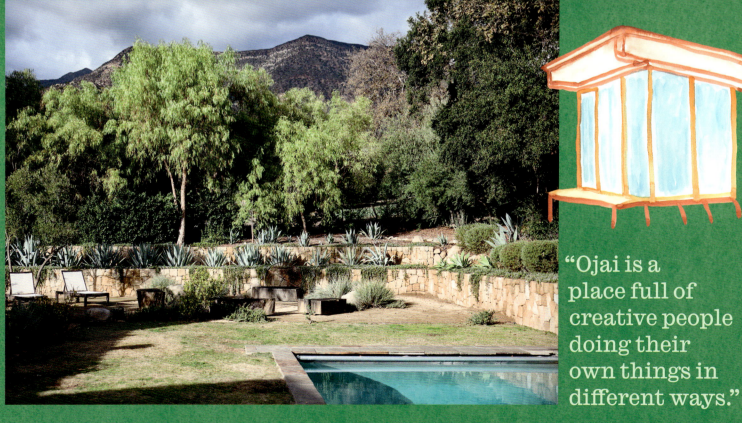

"Ojai is a place full of creative people doing their own things in different ways."

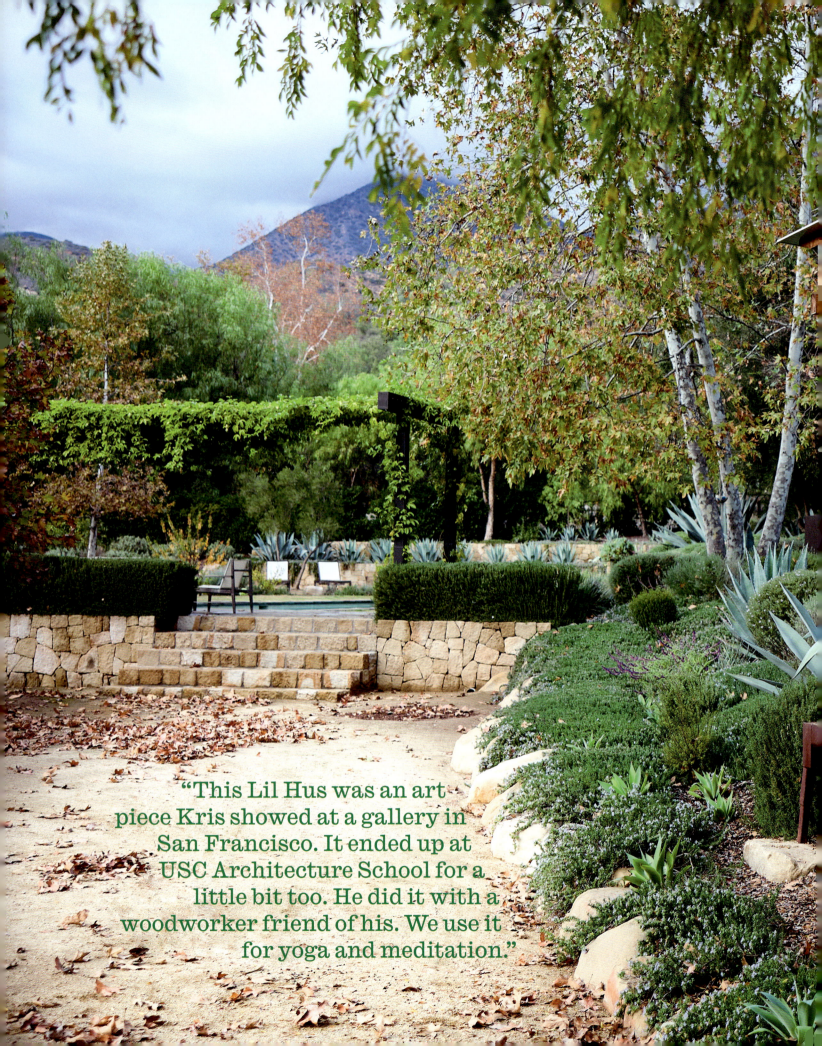

"This Lil Hus was an art piece Kris showed at a gallery in San Francisco. It ended up at USC Architecture School for a little bit too. He did it with a woodworker friend of his. We use it for yoga and meditation."

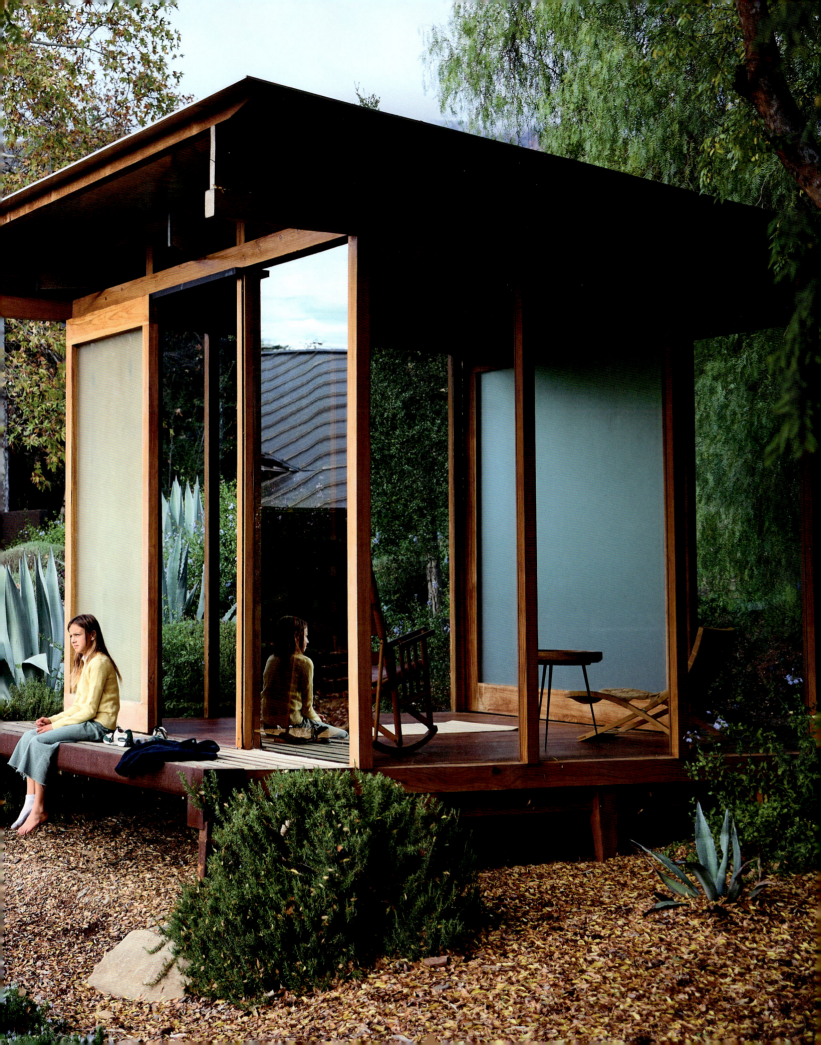

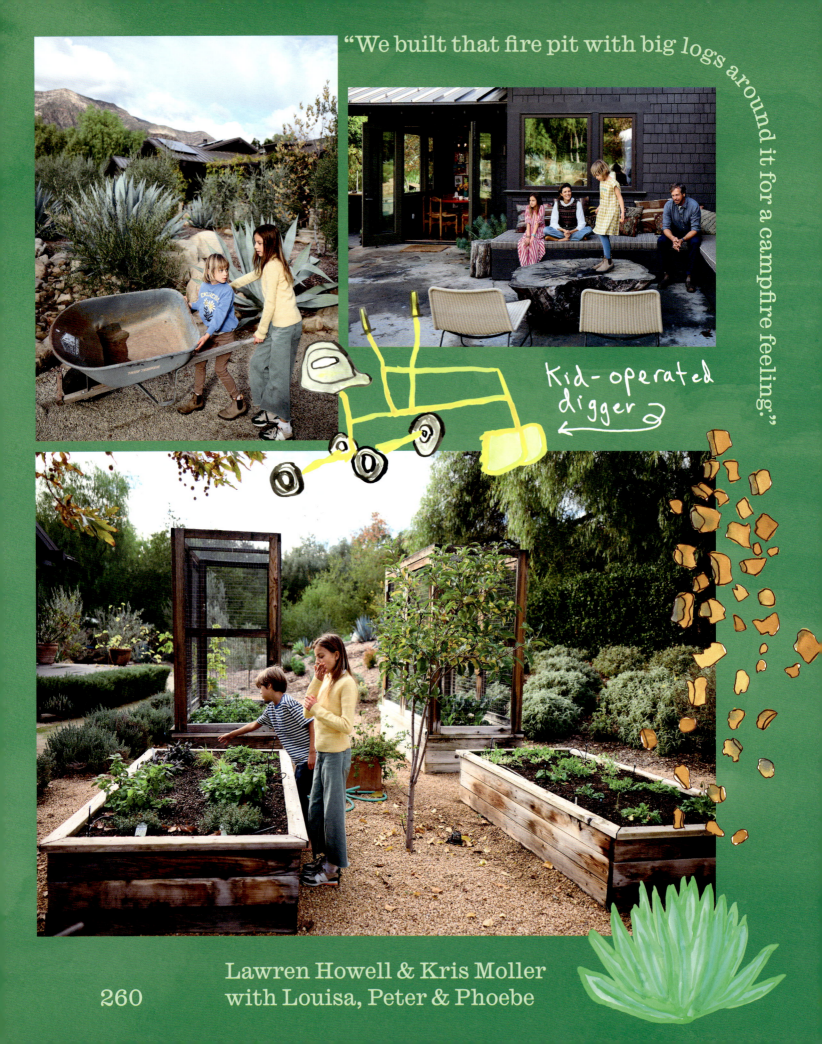

"We built that fire pit with big logs around it for a campfire feeling."

Kid-operated digger

Lawren Howell & Kris Moller
with Louisa, Peter & Phoebe

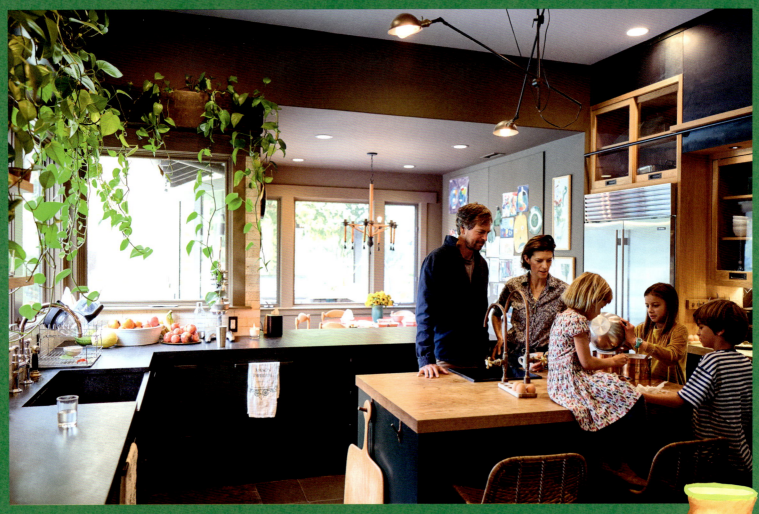

"I love the rough-hewn wood and industrial feel of Gjelina Take Away in Venice, and their designer, Alex Lieberman, helped me bring that feeling to the kitchen."

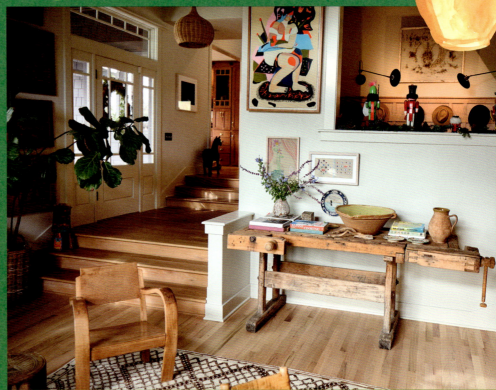

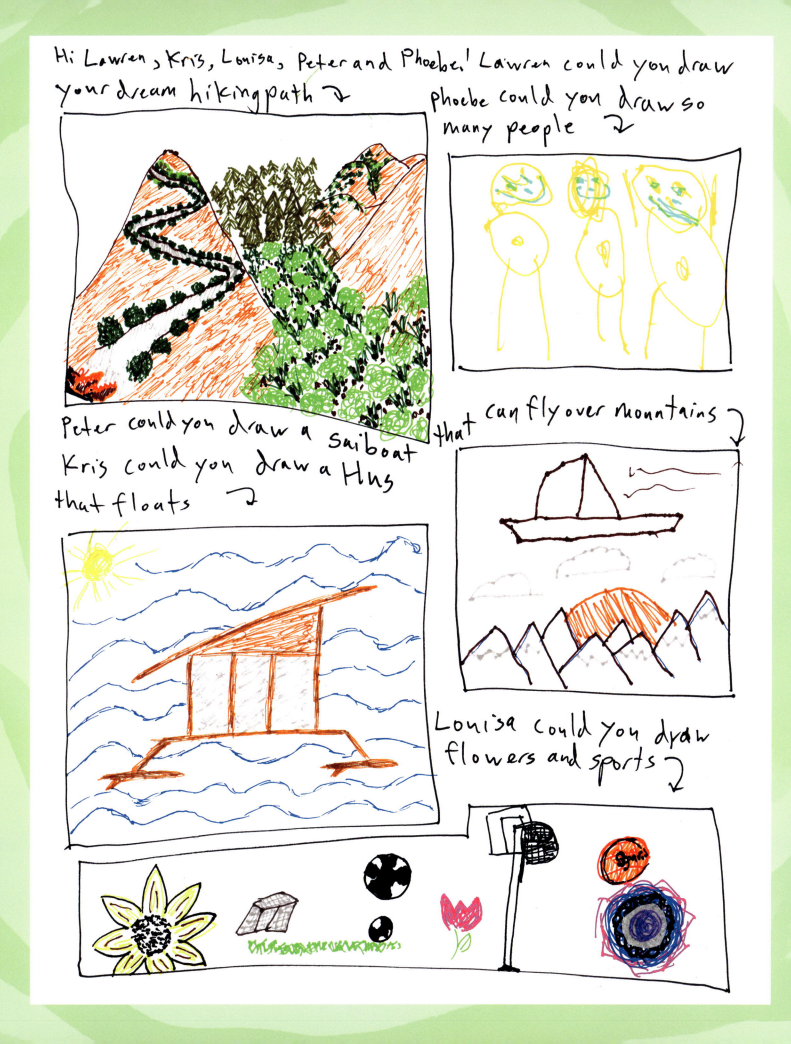

ATSUSHI KUMADA & SACHIYO OISHI

with Sai in Tokyo

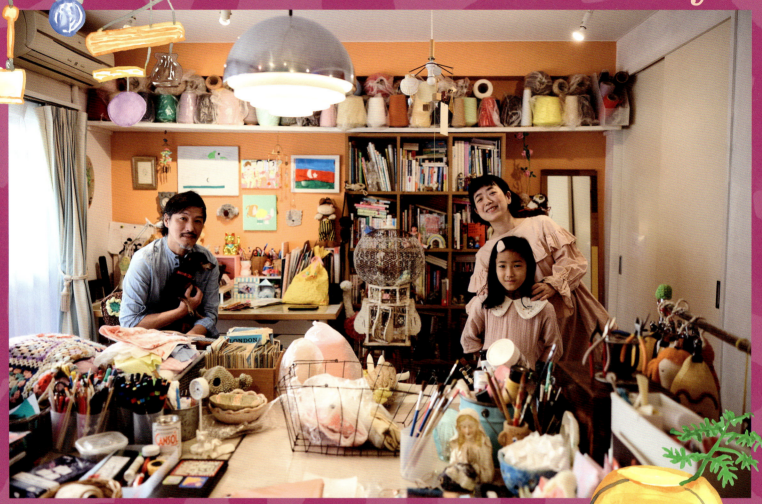

"We sometimes argue about who is the best at drawing."

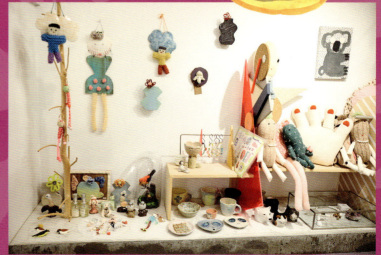

No two walls are the same in Sachiyo Oishi's house. "We display a wide assortment of art I have made," she says. "Paintings, decorative plates, lamps, pillows…as well as pieces from artists I've met. The house is chaotic but has an unexpected order. It has a mix of wabi-sabi simplicity and maximalist tendencies. Somehow it all blends harmoniously and creates a fun atmosphere." Sachiyo's style carries over to her store, Cikolata. "I started the shop with the idea of only selling useless items. I believe that unnecessary things bring richness to our hearts." Family time at home is full of craft projects, drawing, and music. Sai often helps her dad write songs and is frequently found practicing her ballet steps throughout the home. Their dog, Pinko, is one of the most rambunctious pets featured in this book. She is known to claw through the sofa at night and snatch Sai's food right off her plate.

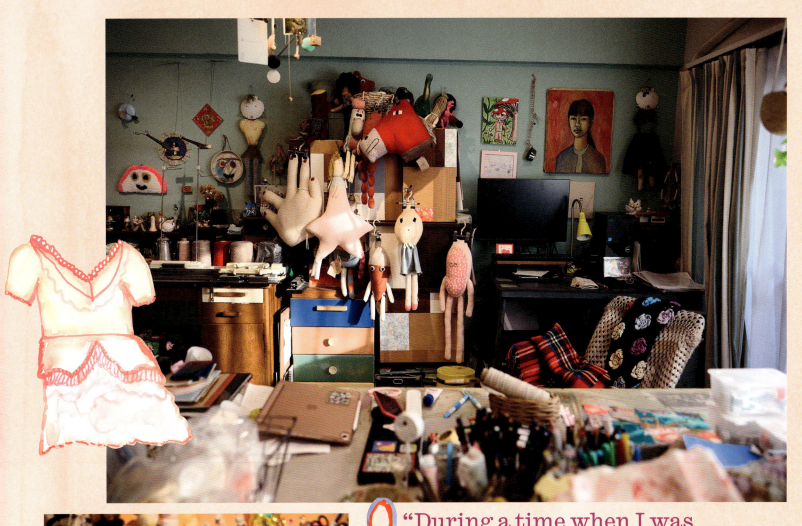

"During a time when I was constantly thinking about clothes for work and feeling frustrated, I wanted to make something completely different, so I started making lamps."

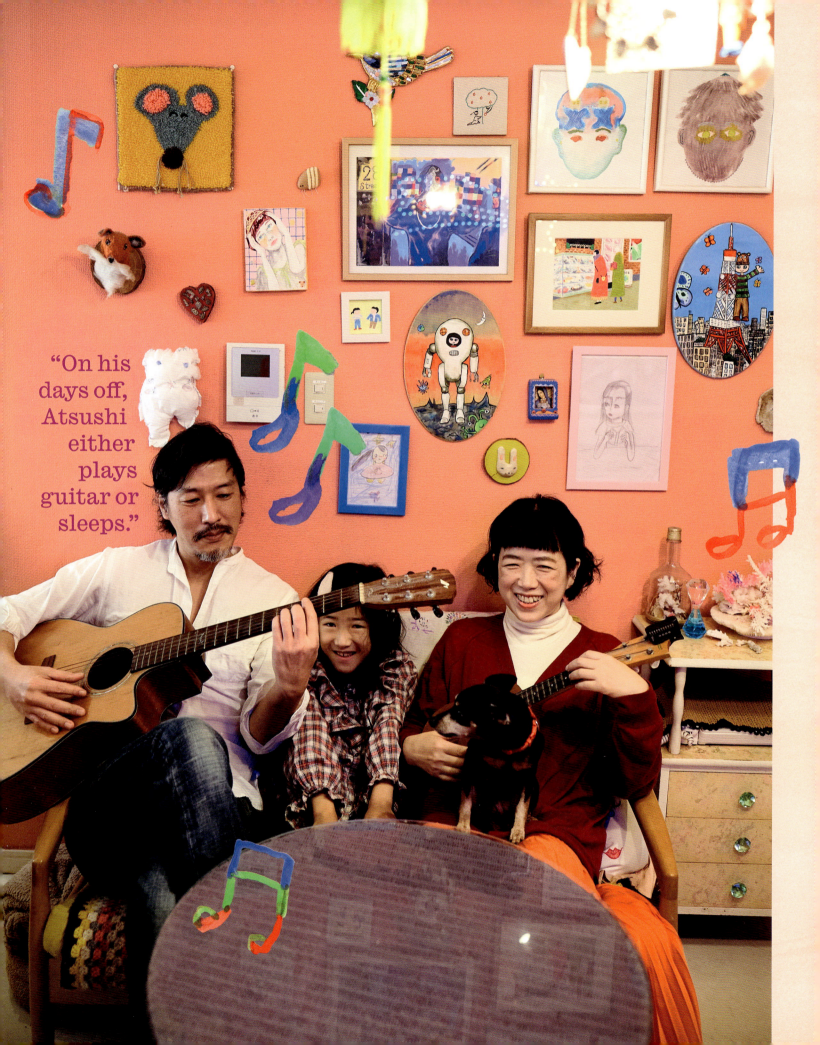

"I've been using that sewing machine for over twenty-five years, since I bought it on loan when I was an art college student in London."

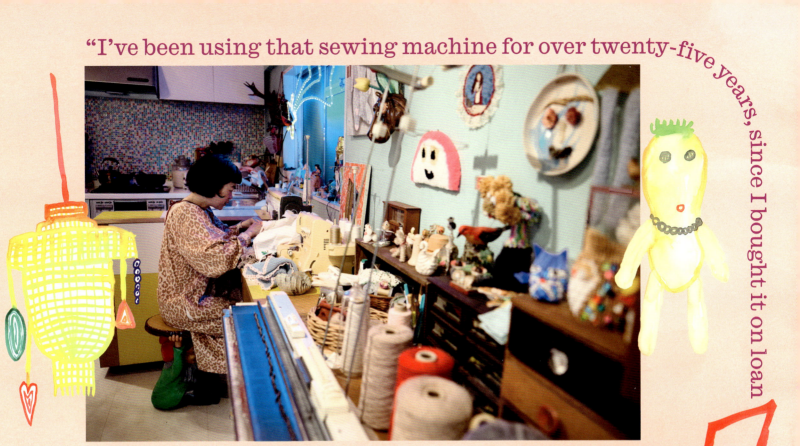

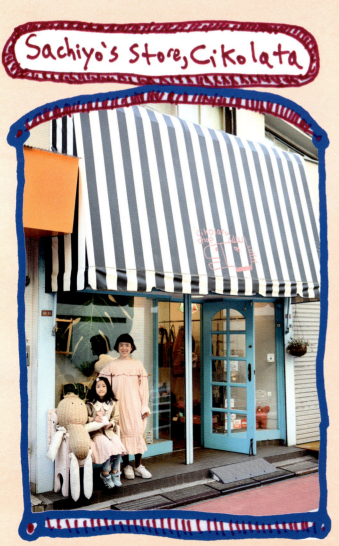

Sachiyo's Store, Cikolata

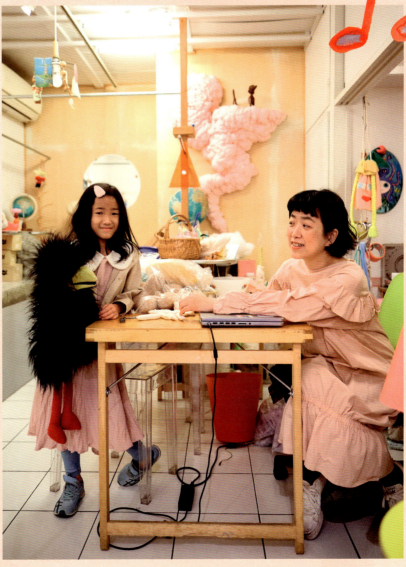

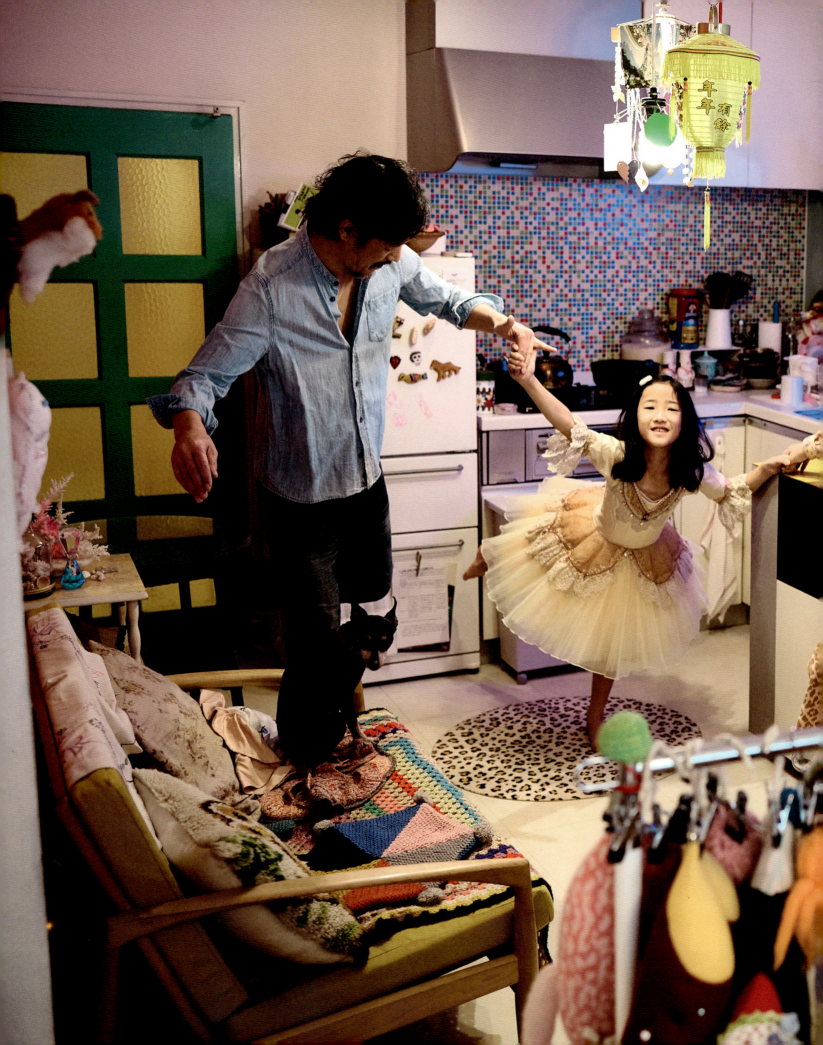

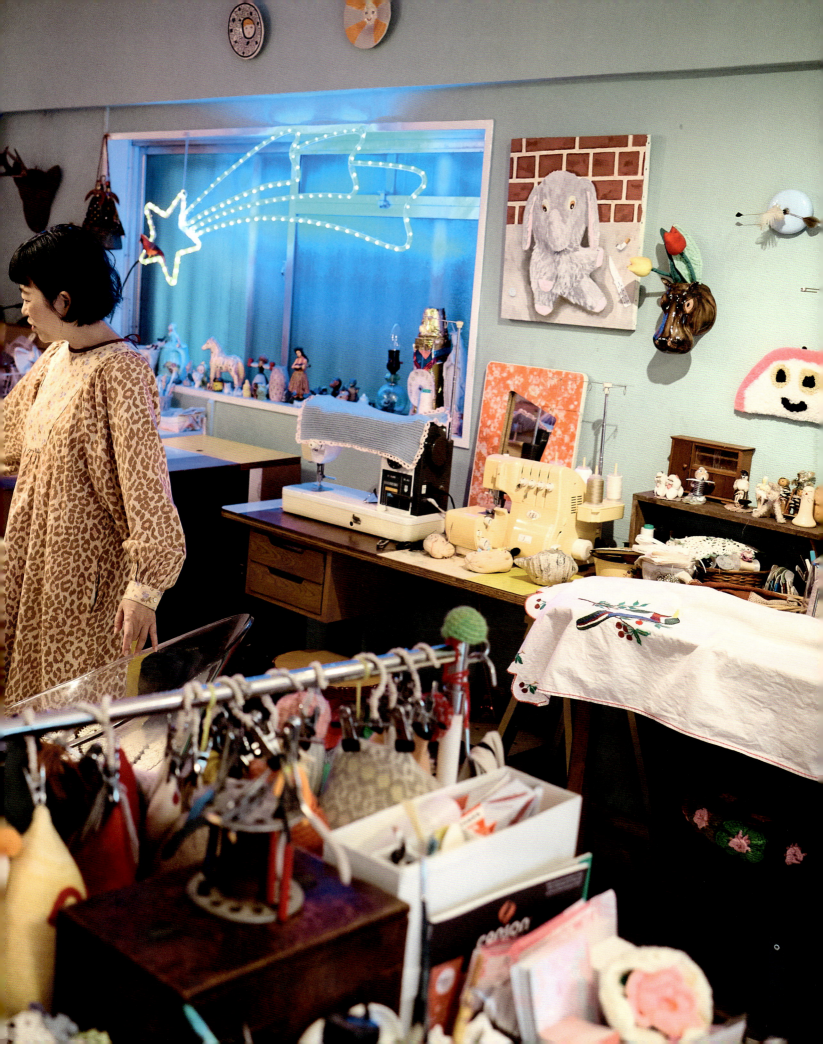

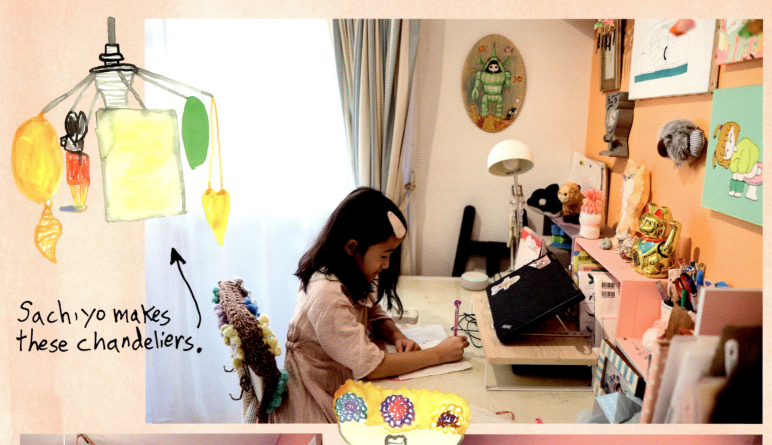

Sachiyo makes these chandeliers.

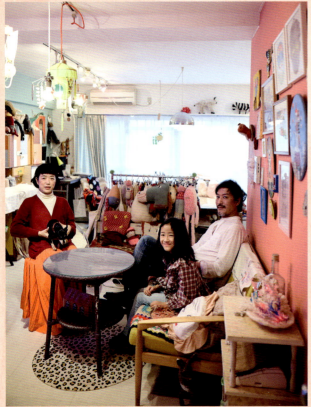

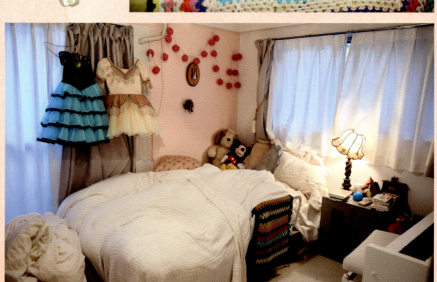

"I like clothes that are a little unique and make me feel fun."

Atsushi Kumada & Sachiyo Oishi with Sai

Hi Sachiyo-san, Atsushi-san and Sai-chan! Sachiyo-san could you draw a family of your stuffed dolls ↘

Sai-chan could you draw Peanut playing music ↘

Atsushi-san could you draw and label your favorite French wine you ever drank ↘

Sachiyo-san could you design an outfit for your dog Pinko. ↘

Sai-chan could you draw some very small people ↘

KATIE REARDON SELLON & BEN SELLON

with Sammy in Portland

"Sammy was just, like, our little buddy that we were missing."

"It was a cool fort," says Katie. "Which is exactly what we were looking for. And we really wanted a house with a story. The previous family rebuilt it in the fifties and sixties. The dad's sister was one of the first female architects in Oregon and had to work under an abbreviated name so people wouldn't know she was a female on the blueprints, which we still have. The dad did all the wood-working, like the living room sofa and coffee table. And the mom sewed the curtains, pillows, and cushions. We wanted to take the baton and keep running with it." The Sellons immediately fell in love with the earthy feel and brown wood tones. "If you mix brown with another cool brown, it's kind of jazzy," says Ben. They call the house their best thrift find ever, and it's filled with thrifting gems. "Older items can have a lot of beauty," says Ben. "But there are also mundane objects that have withstood the test of time and are still doing their thing. We have both genres in the house." Katie mentions their pit bull, Ollie. "We got him from a rescue organization, so we thrift our pets, too."

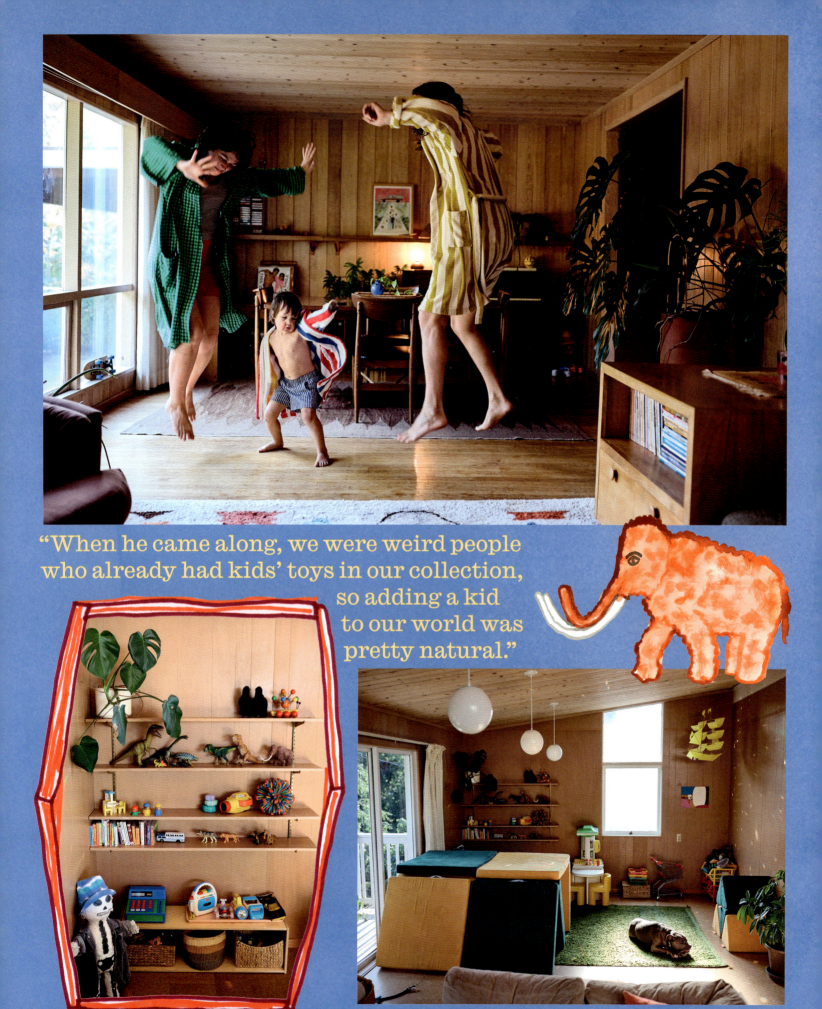

"When he came along, we were weird people who already had kids' toys in our collection, so adding a kid to our world was pretty natural."

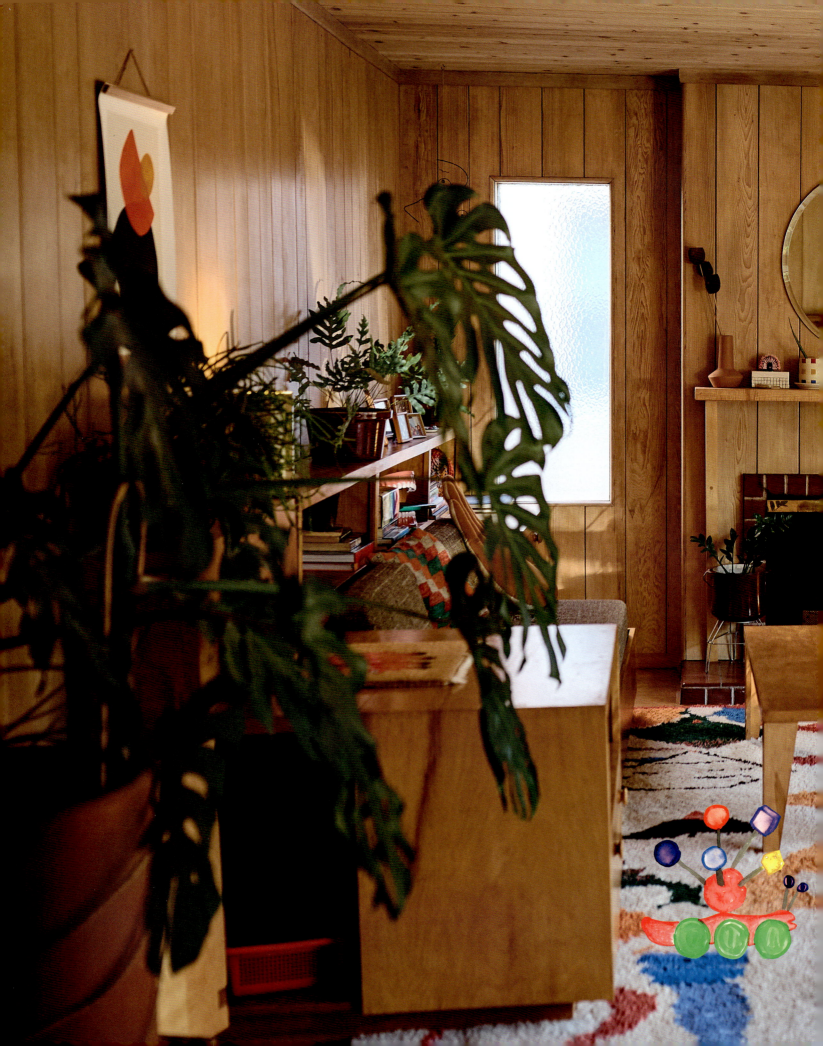

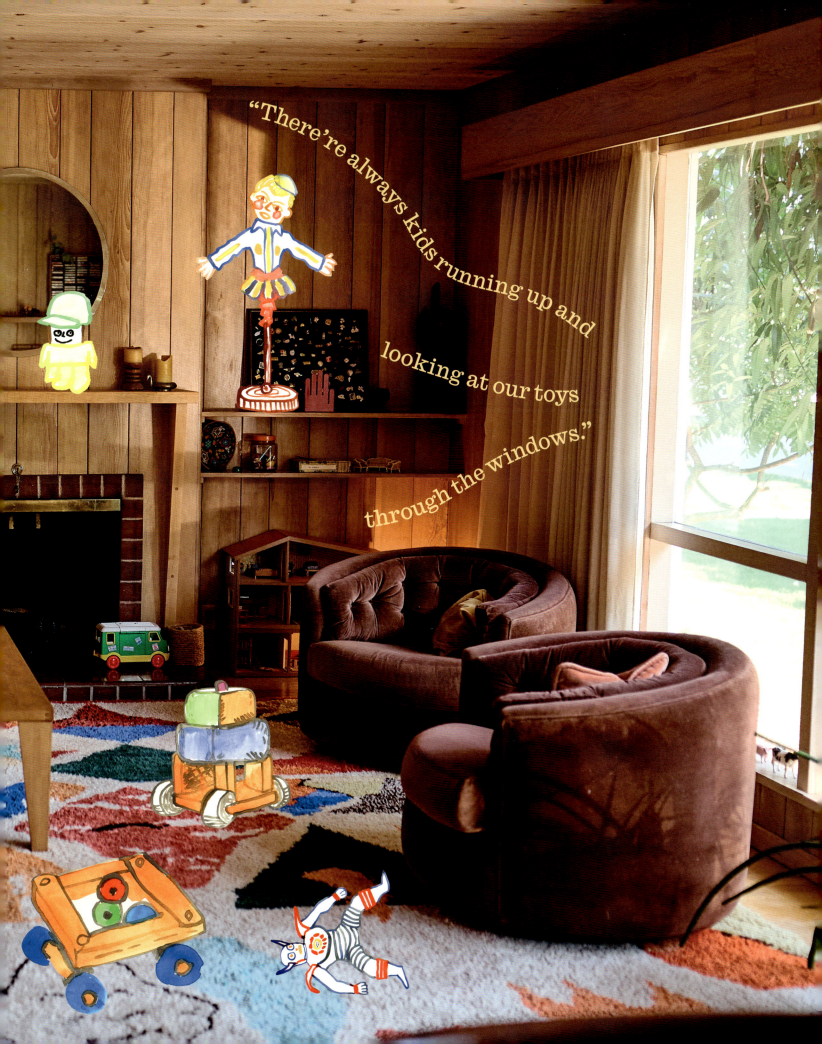

"Oftentimes Ben will be doing music and I'll be doing quilting. We have a his-and-hers basement; it's our favorite room in the house."

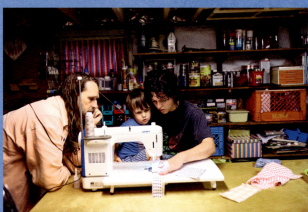

They honeymooned in the van.

"Our 1987 Dodge Ram van. It's two-tone brown. Everything we love is brown."

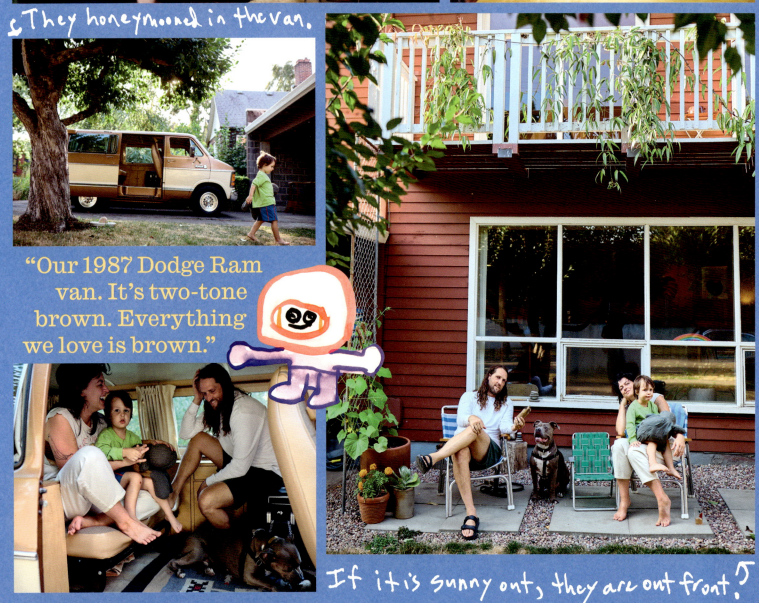

If it is sunny out, they are out front.

Katie Reardon Sellon & Ben Sellon with Sammy

Hi Ben, Katie + Sammy! Sammy once upon a time there was a dragon who.....

...ATE STRAWBERRY ICE CREAM *NO SPOON!*

~~baseball hat~~
~~golf~~
~~musical~~
Katie could you design a ~~pinball~~ game inspired by vintage japanese toys? (label)

Ben could you design + label 3 musical instruments inspired by your childhood?

INTERLOCKING HAT STACK TOWER.

TINY CASIO
THE BEST MICROPHONE EVER MADE.
HANDS

Ben + Katie could you give me a recipe for the ultimate "finger noodles"?
(AS DICTATED BY SAMMY)

1. "COOK IT ALL UP"
2. "TAKE OUT THE BOX"
3. "PUT THEM ON YOUR FINGERS"

And draw the finger noodles

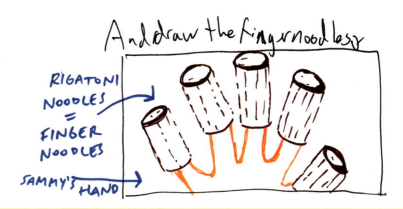
RIGATONI NOODLES = FINGER NOODLES
SAMMY'S HAND

AMANDA MERTEN & TYLER ASH
with Tallulah & Winona in Los Angeles

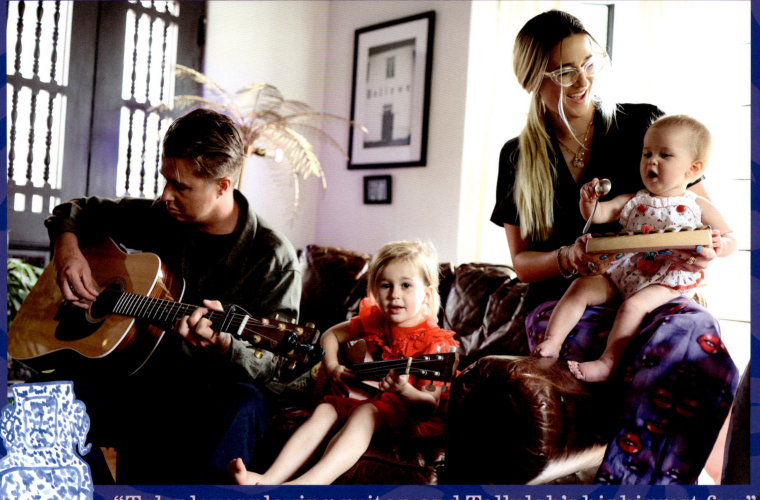

"Tyler loves playing guitar, and Tallulah's his biggest fan."

"Everything in the house started making its way higher up, to be out of the children's reach," says Amanda. "Climbing on counters, stepping up on chairs. It's impending doom." While the kitchen knives are stashed beneath an old cow head and porcelain vase high on a shelf in the corner, everything at kids' height was made for having fun. Art supplies, musical instruments, electric cars, and dolls—the toy vortex culminates in a chaotic playpen called "The Octagon." "We know the kids like to just dump everything out and be able to see it, so over time it's been fully taken over by every toy under the sun." Amanda was raised in Las Vegas. "I love Wild West desert imagery." Tyler is from Venice Beach. "Surfing, skating, graffiti, palm trees. I love it all." They were drawn to the home's Spanish revival style. "The vaulted ceilings and arched doorways feel so inviting," says Amanda. Tyler's favorite piece of furniture is the comfy leather couch. "The big thing for me is just a space to relax, watch a movie, and hang out with the kids."

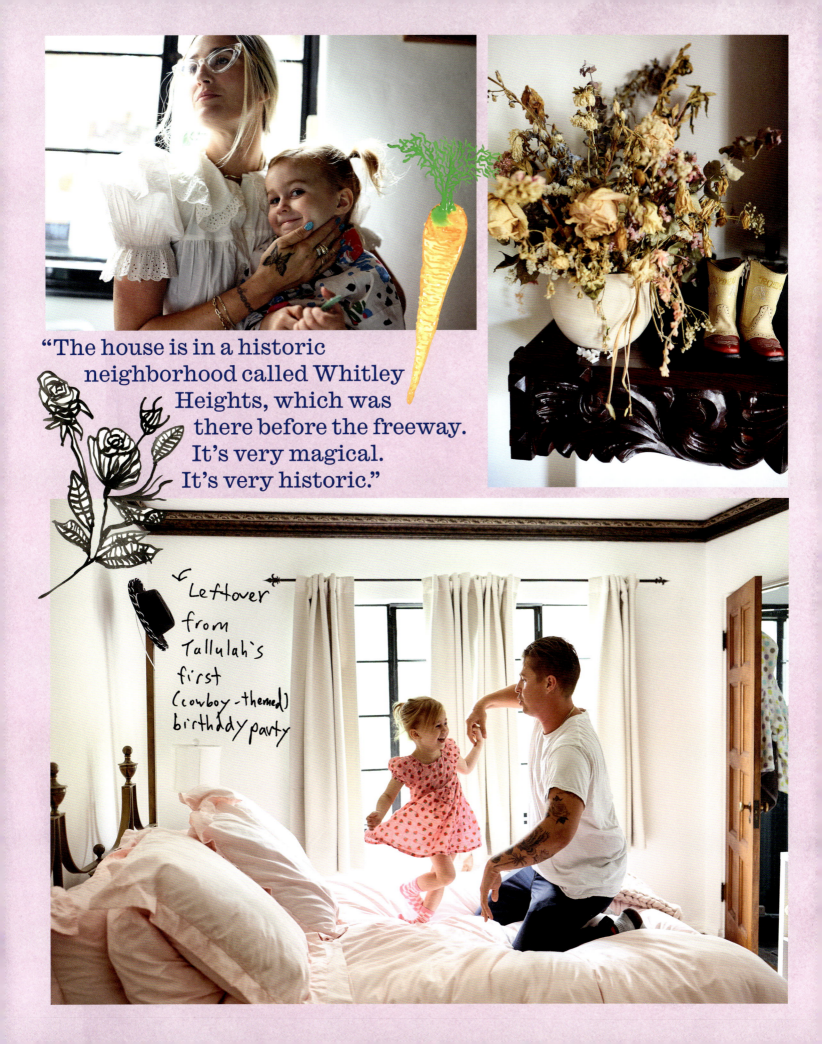

"The house is in a historic neighborhood called Whitley Heights, which was there before the freeway. It's very magical. It's very historic."

Leftover from Tallulah's first (cowboy-themed) birthday party

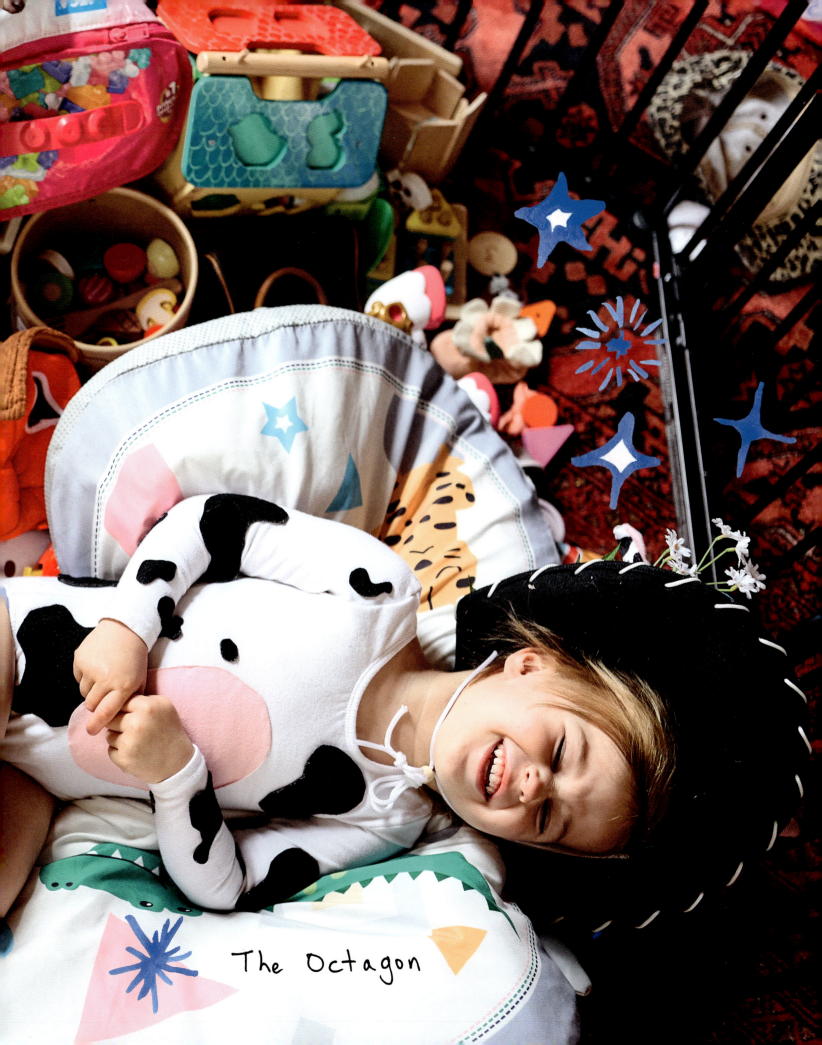

The Octagon

"Every California girl needs a Jeep. Tallulah got hers a little early in life. She rides around on the patio. She gives her friends rides; otherwise it's collecting dust most of the time. But when she gets the chance, she's cruising."

"My Gucci denim hat with matching sandals with a Molly Goddard red silk taffeta dress. I like to keep the brim down on the hat; it makes me feel like I'm invisible."

Amanda Merten & Tyler Ash with Tallulah & Winona

Hi Amanda, Tyler, Tallulah + Winona. Amanda could you draw fashionable cats? Tyler could you draw your daughters names

Tallulah could you draw some flowers + monsters?

Tyler what are 6 ice cream flavors inspired by your youth in Venice Beach?
① MINT CHIP
② HALF BAKED
③ COFFEE
④ COFFEE
⑤ COFFEE
⑥ AND Coffee

Amanda what are your 6 favorite places to thrift + eat in Las Vegas?

① **Peppermill** — BEST NEON, CUTEST WAITRESS OUTFITS, RAINBOW SUGAR!

② **Komol** — YUMMY THAI! MY FAV TOM KHA SOUP :)

③ **Linda Michoacan** — A STAPLE, ALWAYS DELISH!!

④ **Savers** — CLASSIC VEGAS THRIFT, MULTIPLE LOCATIONS

⑤ **Charleston Outlet** — TRIED + TRUE

⑥ **Glam Factory Vintage** — CUTE VINTAGE! CUTE PRICES!

ARMIN BUEHLER & KATJA HOLTZ
with Flynn & Otis in Atlantic Highlands

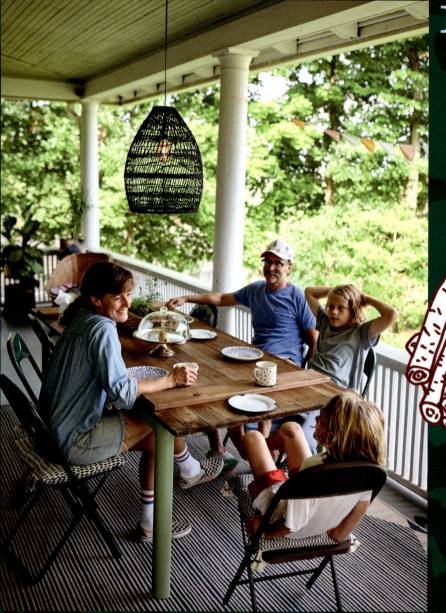

"It's my lifelong dream that I finally fulfilled in my forties."

Katja and Armin found their home during the pandemic. It was fully furnished and decorated for an estate sale (that never happened). So they bought the house with everything in it. "It was this or nothing at all," says Armin. Katja is eager to tell me about the home's previous owners—a fisherman and his wife, a painter. "He lived to be 102 and was in the navy, so he always had a deep relationship with the water. To me, the old buoys, beach wood, and antique frames are all art objects that we've inherited." Katja has upcycled much of the old furniture and decor by hand. "I strip it, paint it, and sand it. I try everything. I give it a new-old look—it's never perfect. When you work on a cabinet or a table with your hands, you feel a connection. We live with their spirit here." Armin admires the artistry his wife has put into the house. "It's a collage of nautical artifacts and modern pop art. It's all Katja, and it's always changing. I come back from a work trip and the dining room is painted black, our garden is transformed, or my nightstand and lamp are gone. It drives me crazy."

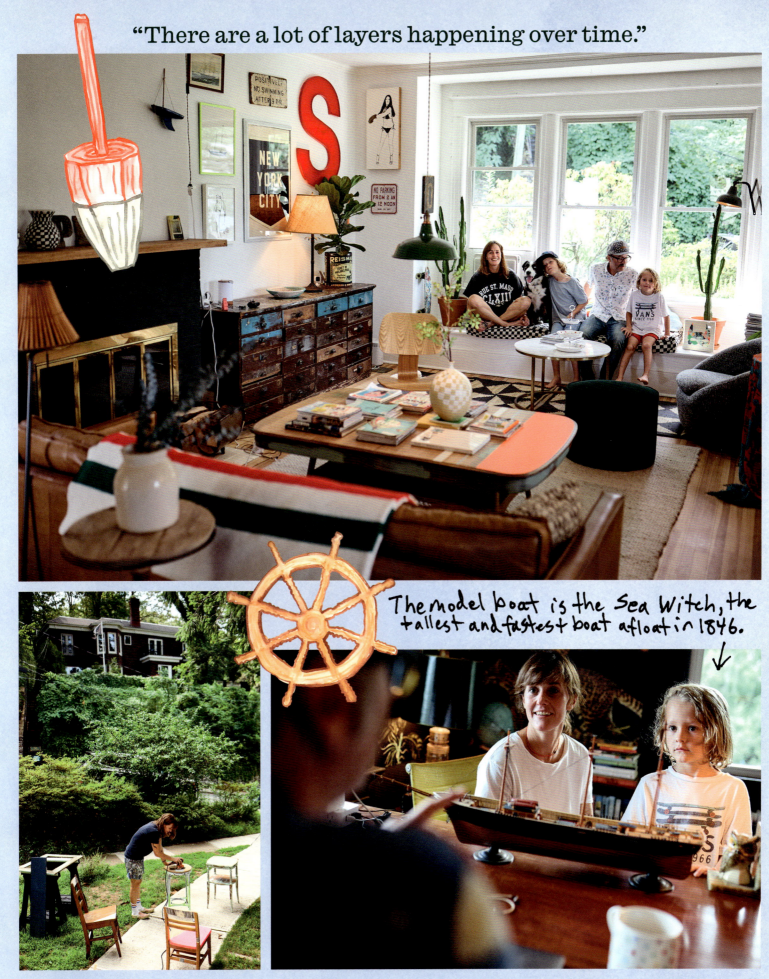

"There are a lot of layers happening over time."

The model boat is the Sea Witch, the tallest and fastest boat afloat in 1846.

"I like to strip it or sand it. I try everything. Sometimes I mess it up."

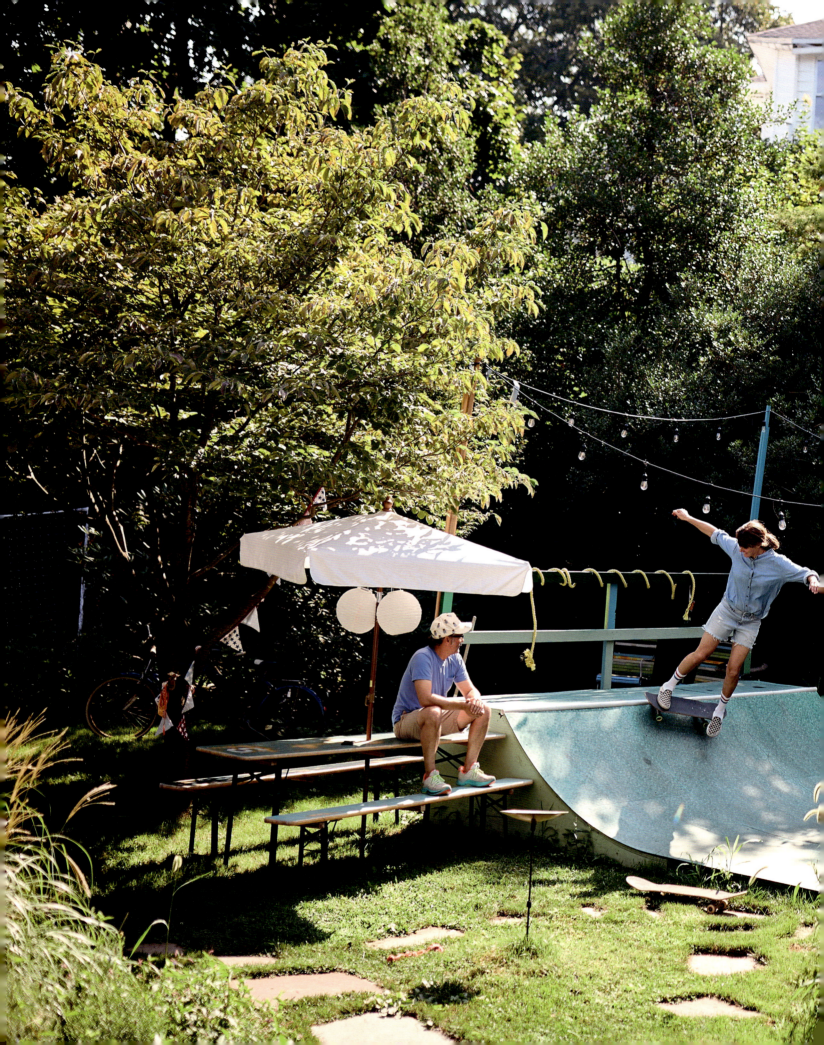

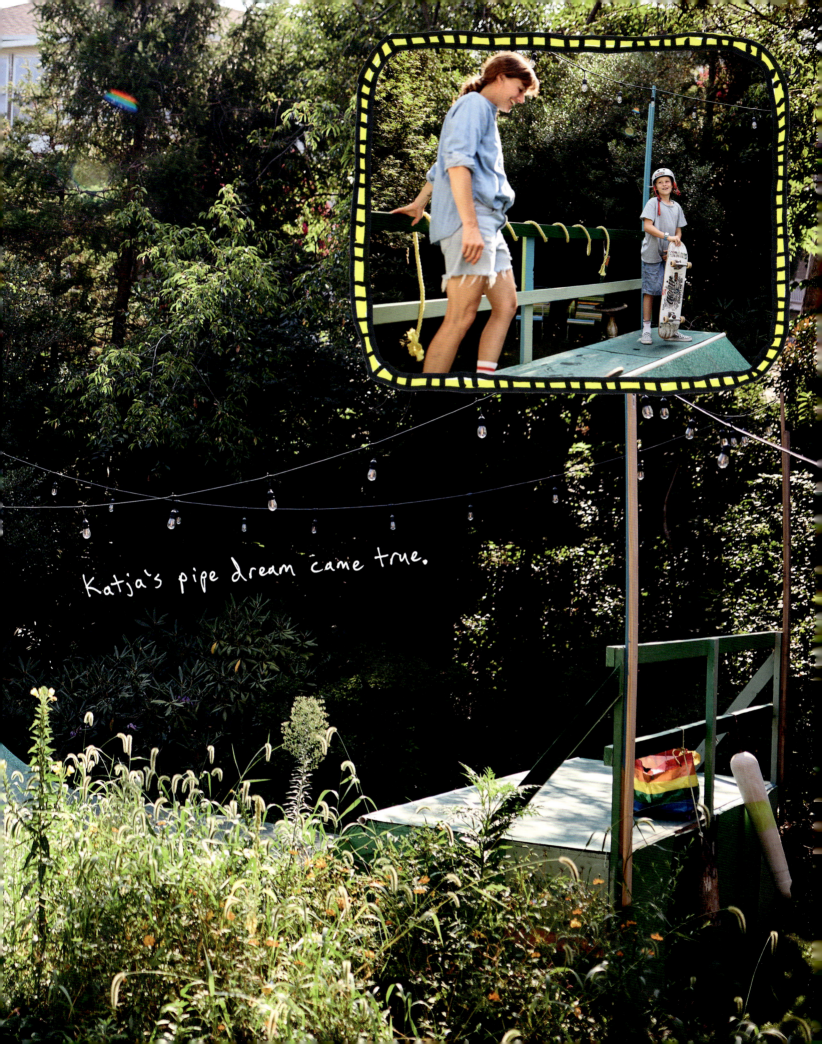

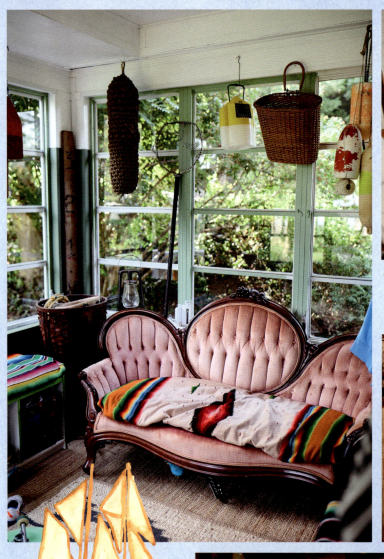

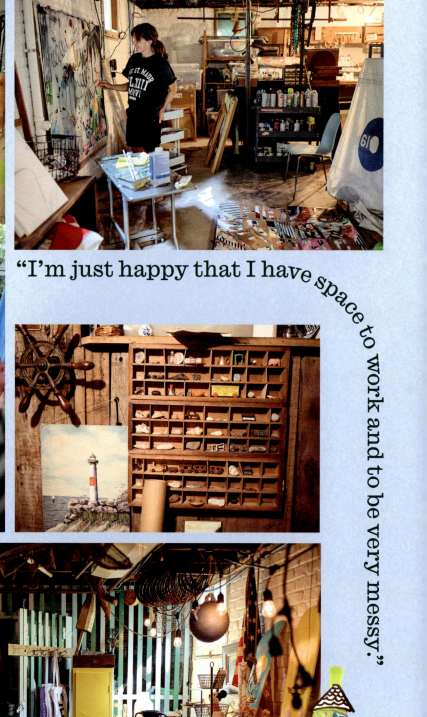

"I'm just happy that I have space to work and to be very messy."

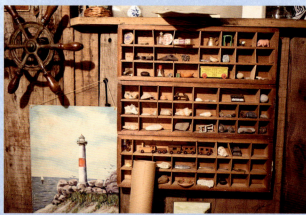

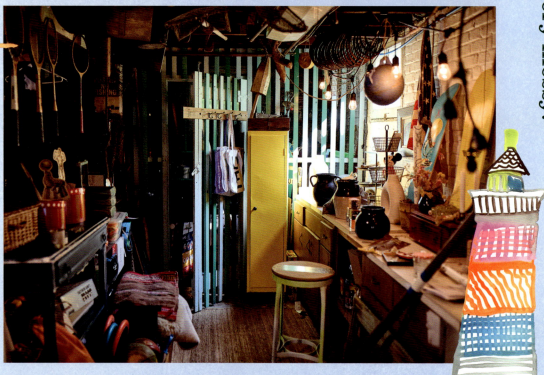

"We moved into this house and it came with a 102-year-old fisherman's collections. We never met him, but we live with his spirit here."

Armin Buehler & Katja Holtz with Flynn & Otis

Hi Katja, Armin, Flynn & Otis! Armin could you design a sailboat faster then the Sea Witch?

Katja could you design a sailboat slower then the sea witch?

Flynn could you design a slime launcher?

Otis could you design a drone to fly around your dog?

Can the whole family each design a weather vane?

FRANCESCA BONATO & NICO MALLEVILLE

with Leon, Santos & Fleur in Bora Bora

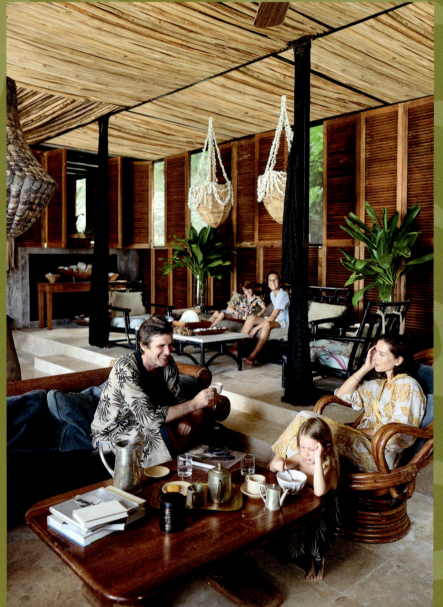

The bungalows and wicker chandeliers are from the iconic 1960s Hotel Bora Bora.

"I don't think the kids know how fortunate they are," says **Francesca**. "Being surrounded by the wind, the water, the sand, and the air. It is a lucky way of life. It's new to me, but for them this is normal." Francesca and Nico run Coqui Coqui, a boutique hotel and perfumery with several locations worldwide. Nico's enthusiasm for agriculture, landscape, architecture, and natural scents brought him to Bora Bora, which the family now calls home. Their multiunit residence sits on a motu—a small island off the main island that is only accessible by boat. "Motu is freedom for us. We have space for creativity, space for work, time for manual work in the garden, in the orchard, or cleaning the beach." Francesca emphasizes their appreciation for sustainability and upcycling. "Our bungalows were originally built on another part of the island. We dismantled them, numbered every piece, transported them on barges, and rebuilt them. It was a big adventure, but with the help of great local artisans we were able to give them new life."

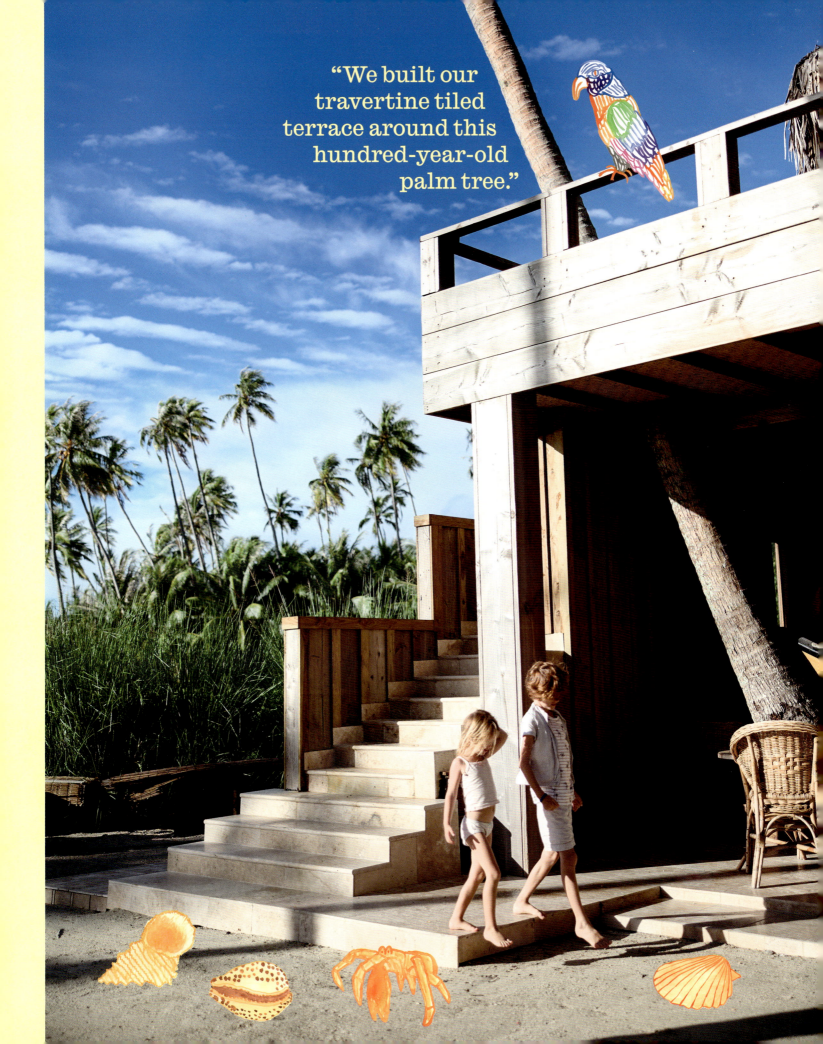

"We built our travertine tiled terrace around this hundred-year-old palm tree."

Nicolas does the cooking, Leon catches fish, and Francesca gets vegetables from the neighbors and boats to town to shop.

"We cook every meal— on a desert island there are no deliveries!"

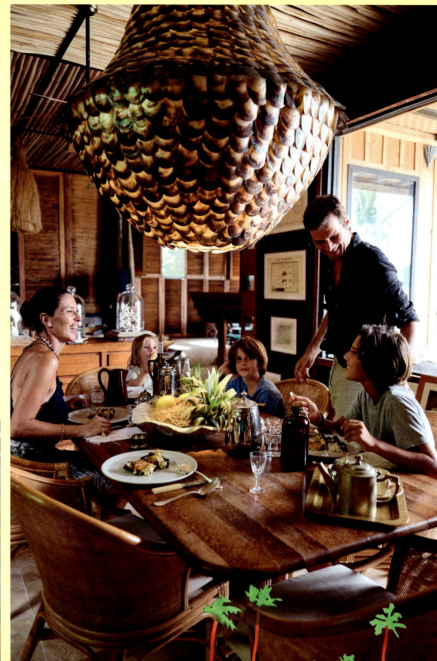

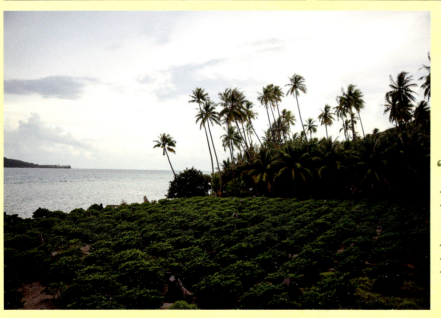

"Flower pickers come to this plantation next door every other night at three a.m. to pick tiaré flowers. That is the time they are closed and are the most moist."

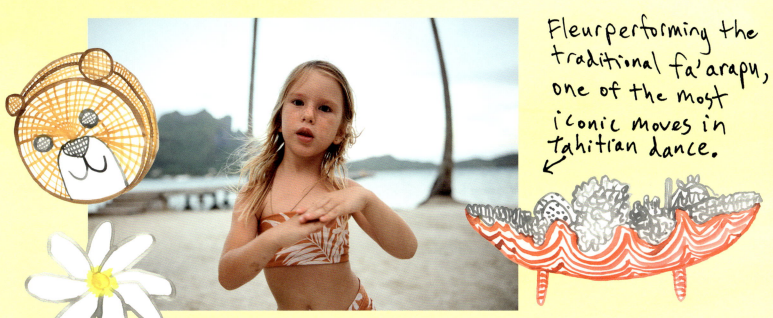

Fleur performing the traditional fa'arapu, one of the most iconic moves in Tahitian dance.

"When it is very hot outside, we love to stay inside the house, painting, reading, playing together."

Francesca Bonato & Nico Malleville
with Leon, Santos & Fleur

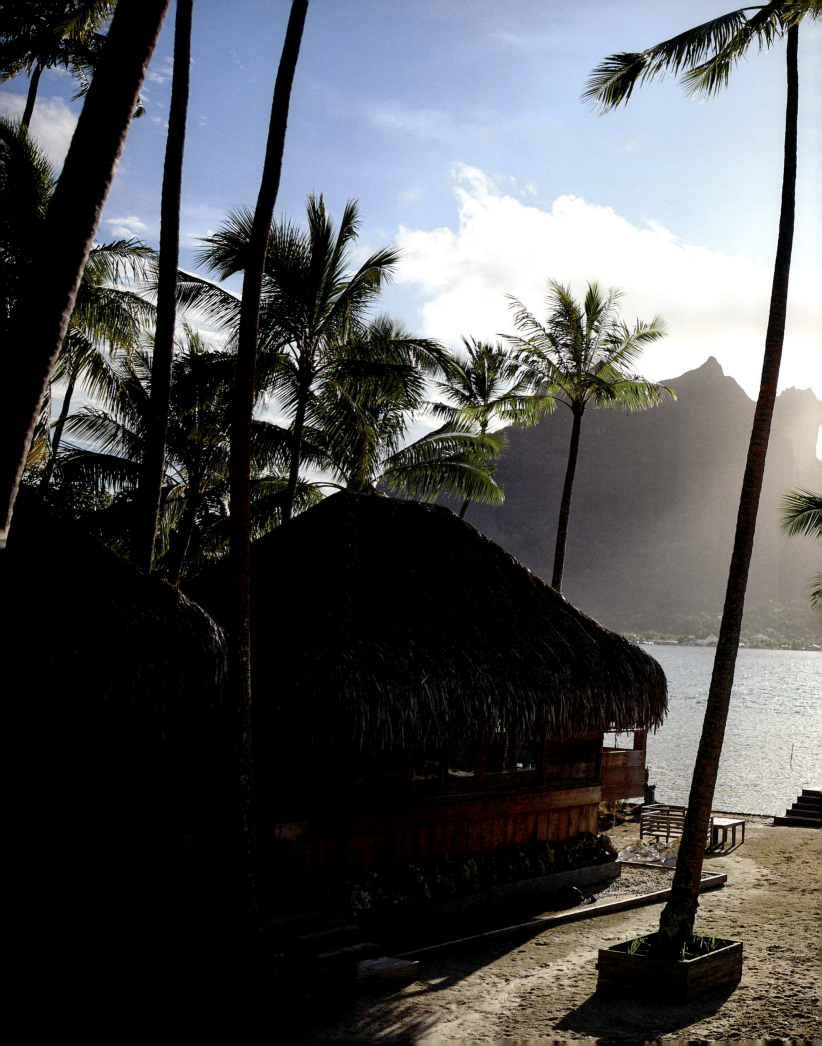

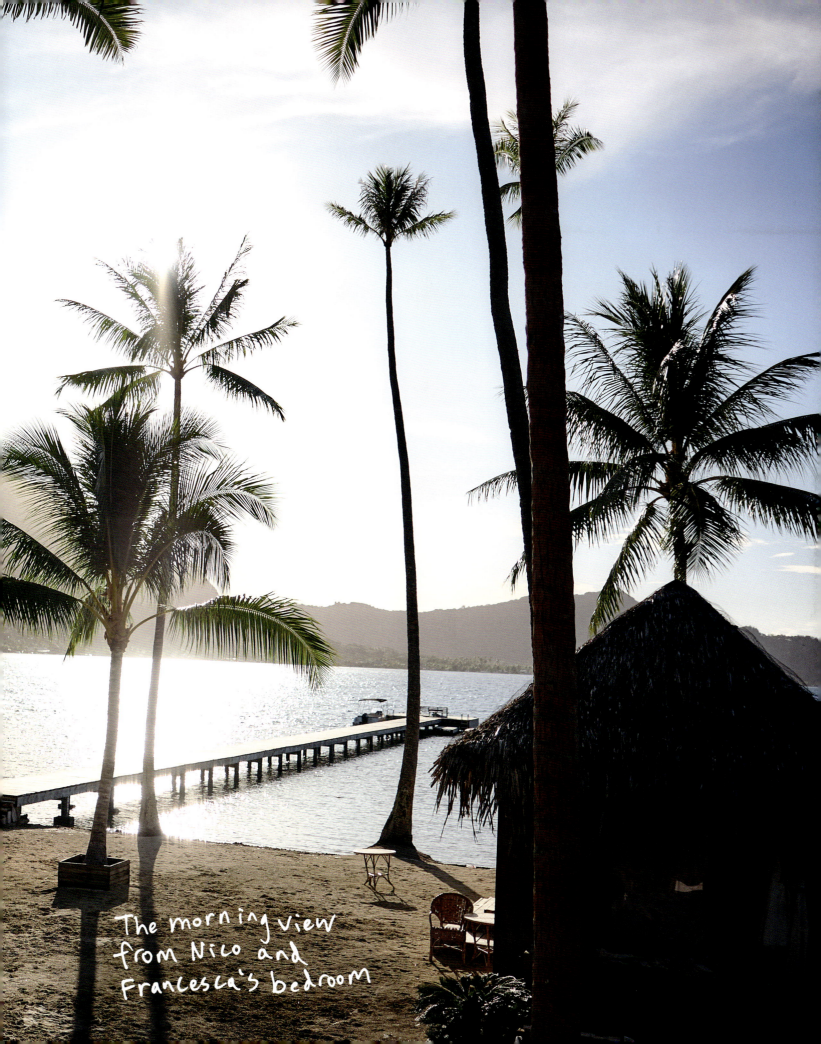

The morning view from Nico and Francesca's bedroom

"We found this big 'umete' (Tahitian for 'bowl') in an old boutique in Mo'orea. Its surface is entirely covered in etchings from the Austral Islands. We filled it with our beachcombing findings: shells, corals, stones…"

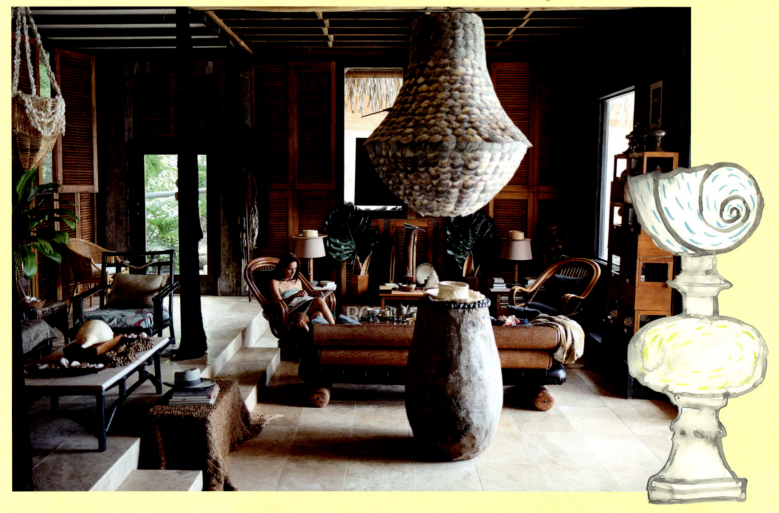

ACKNOWLEDGMENTS & THANK-YOUS

Thanks to all the families who invited me (and my camera) into your homes.

MY FAMILY:

Danielle Sherman—for all your support and help editing, designing, creative input!
Ella and Simone—for being my inspirations and painting with me!
The whole Sherman, Selby, and Friedman families—love you!

ACKNOWLEDGMENTS:

Camilla Ferenczi—producing, managing, and making this book happen.
Michael Kortlander—writing the intros and helping me with the Introduction.
Elana Schlenker—designing the book.
Kari Stuart at ICM Partners—being a radical smart agent!
Tia Ikemoto—also great agenting!
Dave Steiner at Meister Steiner—all legal work with the book.
Adam Kleifield—all image processing and scanning.
Risa Nakazawa and Me-san from The Bee's Knees Inc. and A-GENT TOKYO—for organizing, translating, and making my Japan shoots radical.
Amy Yvonne Yu—word up to the Yu Tang for finding great families in the Bay Area and around the world.
Murray Bevan and Showroom 22—finding inspiring families in New Zealand, production, and being my go-to in Auckland.
Libby Callaway—finding inspiring families in Nashville!

Damaris J. Coulter and The Realness—finding incredible subjects in New Zealand.
Kazumi Yamamoto and Casa Brutus—suggesting astonishing families in Japan.
Michael Reid and R & Company—connecting me with Serban Ionescu.
Mikhail Gherman and Karen Walker—all your support and friendship.
Fanny and Bill Gentle—your recommendations and being cool.
Dani Wassel and the Rainbow Kids—all your Los Angeles recommendations.
Jason Sturgill—I call him TIPS for a reason! Guiding me right in Portland.
Lucinda East Kennedy—all your astounding Auckland recommendations.
Sally Singer—years of sage advice.
Ehrin Feeley—photo agent with the words of wisdom.
Serena Mitnik-Miller—smart ideas from Topanga to Malibu.
Francesca Bonato and Nicolas Malleville—lifestyle inspiration, and endless love.
William Eadon—creative visionary.

CREATIVE GENIUS CONSULTANTS:

Ken "Day One" Erke, Addie Pampalone, Audrey De Shong, Kath Volpe, Emily Huzienga, Fatima Litim, Tara Donovan, Mike Black, Alex Frias, Mark Hunter, Melissa Erke, and Renee Case

ABRAMS TEAM:

Holly Dolce—editor extraordinaire!
Deb Wood—for creative shepherding of the book.
Asha Simon—assistant editor making it happen.
Danielle Youngsmith—designer at Abrams.
Lisa Silverman—managing editor.
Denise LaCongo—production manager.

Editor: Holly Dolce
Designer: Studio Elana Schlenker
Design Manager: Danielle Youngsmith
Managing Editor: Lisa Silverman
Production Manager: Denise LaCongo

Library of Congress Control Number: 2023945550
ISBN: 978-1-4197-6902-3
eISBN: 979-8-88707-309-5

Copyright © 2024 Todd Selby

Cover © 2024 Abrams

Published in 2024 by Abrams, an imprint of ABRAMS. All rights reserved. No portion of this book may be reproduced, stored in a retrieval system, or transmitted in any form or by any means, mechanical, electronic, photocopying, recording, or otherwise, without written permission from the publisher.

Printed and bound in Italy
10 9 8 7 6 5 4 3 2 1

Abrams books are available at special discounts when purchased in quantity for premiums and promotions as well as fundraising or educational use. Special editions can also be created to specification. For details, contact specialsales@abramsbooks.com or the address below.

Abrams® is a registered trademark of Harry N. Abrams, Inc.

195 Broadway
New York, NY 10007
abramsbooks.com

COLOR BY NUMBER
The picture is on p. 294.

SCAVENGER HUNT
Flower pancakes: p. 206
Bicycle built for two: p. 286
Neon clock: p. 41
Porcelain grenade: p. 107
Plastic pineapple: p. 136
Pierre the raccoon: p. 238
White shoe with checkered socks: p. 113
Hand light: p. 176
Yellow trash can: p. 35
Dog rear end: p. 203

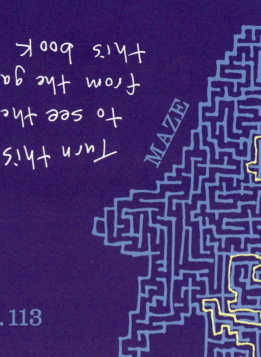

MAZE

Turn this around to see the answers from the games inside this book.

SELBY'S CROSSWORD CHAOS

ACROSS
2: RAUMPLAN
6: CANOE TRIPS
7: RAVE
9: CARRIAGE HOUSE
14: *A LOVE SUPREME*
16: WRITER
17: BROWN

DOWN
1: HORSE
3: LEATHER KING
4: DINNER
5: TATAMI
8: WHARENUI HARIKOA
10: CLAWFOOT TUB
11: HIGH FIVE
12: GLAM ROCK
13: BAMBOO
15: BIG

CAN YOU FIND THESE ITEMS?

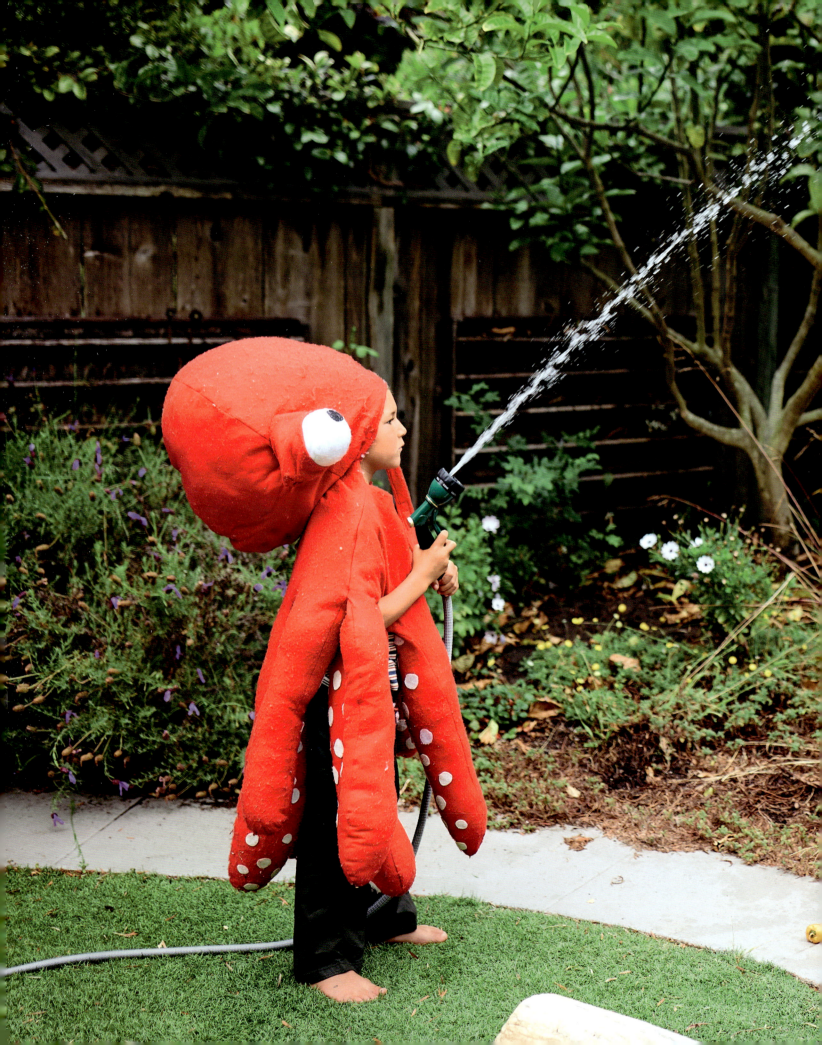

SELBY'S CROSSWORD CHAOS

All the answers can be found throughout the book. For the answer key turn to p. 301.

ACROSS

2. Architectural movement of Gidon's grandfather's house.
6. The Duluth duffel bag in Maurice's collection was designed for these aquatic adventures.
7. Prem and Puneet's common interest in the 1990s.
9. The Brooks family's home was once this part of a large 1820s estate.
14. This John Coltrane song provides the soundtrack for the Sellers-Jackson family's pancake breakfast.
16. Oscar's aspiration, following in his father's footsteps.
17. Main color in the Sellons' house.

DOWN

1. The Brooks's Polo is a member of this species.
3. Mitch's professional title.
4. Sunday family tradition at Boo's house.
5. Room type that convinced Andi and Jarrett to buy their Portland house.
8. Māori term for a domicile radiating jubilation.
10. This copper-bottomed amenity serves a multifaceted purpose in Lisa Moir's bucolic retreat.
11. At the entrance to the Torrance home, a bony greeter named Conrad offers this gesture.
12. Gyasi's sartorial splendor is derived from this musical genre known for its ostentatious attire and glittering accoutrements.
13. The Villanti-Guevara family's office features this rapidly growing plant at its center.
15. Sonia and Rachel's nickname for their Tokyo apartment, inspired by a movie.